Uncanny
Spectacle

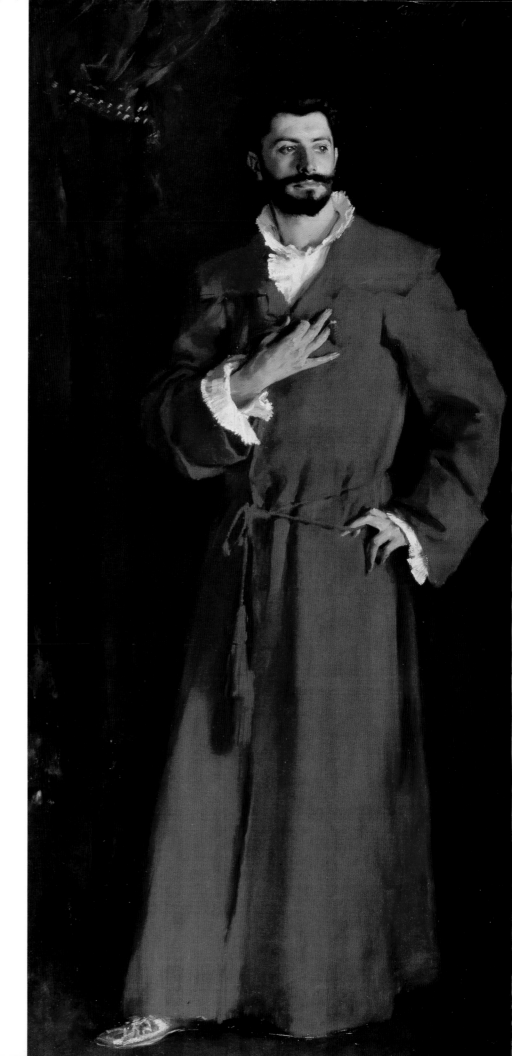

Uncanny Spectacle

The Public Career
of the Young
John Singer Sargent

Marc Simpson
with Richard Ormond
and H. Barbara Weinberg

Yale University Press
New Haven and London

Sterling and Francine Clark Art Institute
Williamstown, Massachusetts

Published in conjunction with the exhibition *Uncanny Spectacle: The Public Career of the Young John Singer Sargent* at the Sterling and Francine Clark Art Institute, Williamstown, Massachusetts, 15 June–7 September 1997.

Frontispiece: John Singer Sargent, *Dr. Pozzi at Home*, 1881, oil on canvas, 80 1/2 x 43 7/8 in. Armand Hammer Collection, UCLA at the Armand Hammer Museum of Art and Cultural Center, Los Angeles, California.

Designed by Frank Tierney.
Set in Adobe Garamond type by Amy Storm.
Printed in the United States of America by Thames Printing.

Simpson, Marc.
 Uncanny spectacle: the public career of the young John Singer Sargent / Marc Simpson; with Richard Ormond, H. Barbara Weinberg.
 p. cm.
 Published to accompany the exhibition of the same title held at the Sterling and Francine Clark Art Institute, June 15–Sept. 7, 1997.
 Includes bibliographical references and index.
 ISBN 0-300-07177-9 (cloth) — ISBN 0-931102-38-3 (pbk).
 1. Sargent, John Singer, 1856–1925 — Exhibitions. 2. Sargent, John Singer, 1856–1925 — Psychology. I. Sargent, John Singer, 1856–1925. II. Ormond, Richard. III. Weinberg, H. Barbara (Helene Barbara). IV. Sterling and Francine Clark Art Institute. V. Title.
ND237.S3A4 1997
759.13 — dc21
97-5781
CIP

A catalogue record for this book is available from the British Library.

The paper in this book meets the guidelines for permanence and durability of the Committee on Production Guidelines for Book Longevity of the Council on Library Resources.

10 9 8 7 6 5 4 3 2 1

Contents

Foreword

By the time John Singer Sargent was thirty years old, he had established himself as one of the singular painting talents of his era. Immensely gifted as a draftsman and colorist, he honed his talents through rigorous training and a sympathetic environment. Sargent during his twenties produced a stream of exhibition works that made him a force in the art world — the painter whose efforts everyone waited for, rushed to see, had opinions about. Henry James, musing several years after seeing one of the exhibition pictures, noted that Sargent's amazing works offered "the slightly 'uncanny' spectacle of a talent which on the very threshold of its career has nothing more to learn."

Of course Sargent did learn throughout his entire career, yet the efforts of his early maturity — among them *Carolus - Duran, Fumée d'ambre gris, El Jaleo, The Daughters of Edward D. Boit*, and *Madame X (Virginie Avegno Gautreau)* — remain monumental works that color our sense of this entire period in the history of art. Sargent has been the subject of monographic books and exhibitions that examine the complete career, that focus on one work in depth (most recently the great project devoted to *El Jaleo*), and a bevy of recent shows that look at the "private" paintings, "his own works," or "the impressionist years." But until now no one has looked concertedly at the way Sargent sought to present himself and shape the public perception of his talent.

The collection of the Sterling and Francine Clark Art Institute includes several of the key paintings necessary for presenting this subject. Sterling Clark's affection for Sargent's works was formed early and endured throughout his career as a collector — *Fumée d'ambre gris*, for example, was bought in 1916, within three years of Clark's first important art purchases. It is considered the first significant work by an American artist to enter his collection. I hope that this project, in which we bring together our collection, our research library, and the abilities of our capable staff, matches the Clarks' ambition in founding this institute.

I want to take this opportunity to express my appreciation to guest curator Marc Simpson and to his fellow catalogue authors

Richard Ormond and H. Barbara Weinberg. They have worked hard to make a worthwhile contribution to the study of late nineteenth-century art, and to provide — with Sargent's glorious works as foundation and inspiration — an exciting museum exhibition based on thorough and insightful research.

MICHAEL CONFORTI

Acknowledgments

The project owes its being to the good graces of the Sterling and Francine Clark Art Institute; the invitation to conceive and undertake *Uncanny Spectacle*, and the institution's continuing support of it, is a source of wonder and pleasure for me. Director Michael Conforti's concern with each detail of the exhibition and catalogue is particularly inspiriting, as has been the significant commitment of the board of trustees to the enterprise. The exhibition and this accompanying book have involved the efforts of the entire Clark staff. I am especially grateful to Steven Kern, former curator of paintings, for the initial suggestion that I develop a project devoted to Sargent; to Sue Canterbury, assistant curator, who has been an ideal comrade in exploring the subject of this exhibition, making significant contributions toward the accuracy of this book and working on a series of revelatory programs; and to Mary Jo Carpenter, who has guided this publication from its inception to its fruition. Gifford Eldredge has made planning the installation a pleasure; Paul Dion and his colleagues transformed the plans to reality. Martha Asher has overseen registrarial tasks with consummate professionalism, while Beverly Hamilton, Noël Wicke, Lisa Jolin, and Sharon Clark have handled vast quantities of administrative tasks with grace and good cheer. In the Clark Art Institute library, Sally Gibson and Susan Roeper were exceedingly helpful; Peter Erickson not only devoted a great deal of time to the mechanics of substantial interlibrary loan requests but also read and carefully responded to the text. I am grateful to my supervisors at the Getty Information Institute's Bibliography of the History of Art, especially Kristin L. Buckwalter and Jill Lewis, who demonstrated great flexibility in allowing me to focus on *Uncanny Spectacle* as the need arose.

I owe a great debt of gratitude to my colleagues Richard Ormond and H. Barbara Weinberg. Not only have their published insights on matters related to Sargent shaped this project's content, but our recent conversations and their contributions to this catalogue have taught me afresh.

Elaine Kilmurray (who, with Richard Ormond, is preparing the Sargent catalogue raisonné) has been a paragon of enthusiasm and collegiality; Sargent's admirers are indeed fortunate in having such an insightful, dedicated, and generous person at work on the artist. She has contributed mightily to this project. Warren Adelson and Elisabeth Oustinoff, both of the Adelson Gallery (and both of whom are also involved in the catalogue raisonné project), have been laboring long in the realm of Sargent studies; they, too, have been generous with their thoughts and insights.

The text of the catalogue has benefited from the careful and critical readings by Elizabeth Johns, Troy Moss, Alexandra Murphy (who gave inspired assistance concerning Parisian archives), and an anonymous reader for Yale University Press. The editorial process was continued with great patience by Judy Metro and Noreen O'Connor at Yale University Press.

Others who have been helpful beyond the call of duty are: Donald Anderle and William Dabars (Getty Research Institute, Resources Collections); Lowell W. Bassett (Isabella Stewart Gardner Museum); Kathryn L. Beam, Mark Chaffee (Hatcher Graduate Library, University of Michigan); Ruth Berson (Jane Voorhees Zimmerli Art Museum, Rutgers University); Robert Carswell; Kay Childs, Rachel Lyn Honig, Dara Mitchell, Peter Rathbone, and Suzanne Waugh (Sotheby's New York); Margaret C. Conrads (The Nelson-Atkins Museum of Art); Eva Crider (Archives of American Art, Smithsonian Institution); Hilarie Faberman (Stanford University Museum of Art); Trevor Fairbrother (Seattle Art Museum—provider of the difficult-to-obtain *La Libre Revue*); Gordon R. Fairburn; Stuart Feld (Hirschl & Adler Gallery); Stephanie Hedrich (The Metropolitan Museum of Art); Erica E. Hirshler, Julia McCarthy, Karen L. Otis, George T. M. Shackelford, and Carol Troyen (Museum of Fine Arts, Boston); Jo-Ann Irace (Sawyer Library, Williams College); Patricia Junker (Fine Arts Museums of San Francisco—colleague and fellow enthusiast in matters archival); Geneviève Lacambre (Musée d'Orsay); Nancy Little; Patricia Mainardi (City University of New York); James Maroney;

David Nisinson; Louise Norton (Bridgeman Art Gallery); Karen Richter (The Art Museum, Princeton University); Martha Ward (University of Chicago); and Richard York (Richard York Gallery). Scott Shields (NEA curatorial intern in the American Art Department, Fine Arts Museums of San Francisco), A. Jean Coyner, and Rosalie Gomes were admirable researchers, seeking out recalcitrant materials with diligence, care, and, in Ms. Gomes's case, inspired timing.

The owners of Sargent's early exhibition works have been unfailingly kind in sharing information, photographs, and—the greatest of sacrifices for collectors—the works themselves to make this project a reality. Among the institutional lenders, special notice must be accorded the Museum of Fine Arts, Boston (Malcolm Rogers, Theodore E. Stebbins, Jr., Jim Wright, Kim Pashko), The Metropolitan Museum of Art (Philippe de Montebello, Mahrukh Tarapor, John K. Howat, H. Barbara Weinberg, Marceline McKee, Herb Moskowitz, Trine L. Vanderwall, Beatrice Epstein), and the National Gallery of Art (Earl A. Powell III, Nicolai Cikovsky, Jr., Franklin Kelly, Ann Halpern, Stephanie Belt) for their seminal support. Our other institutional lenders have been exemplary colleagues: Albright-Knox Art Gallery (Douglas G. Schultz, Laura Catalano); The Art Institute of Chicago (James N. Wood, Judith A. Barter); The Taft Museum, Cincinnati (Phillip C. Long, David Johnson); Des Moines Art Center (I. Michael Danoff, Teri A. Coate, Deborah Leveton, Margaret A. Willard, Rose M. Wood); The Nelson-Atkins Museum of Art (Marc F. Wilson, Cindy Cart); the Tate Gallery (Nicholas Serota, David Jenkins, Maggie Stratton); The Armand Hammer Collection, UCLA at the Armand Hammer Museum of Art and Cultural Center (Henry T. Hopkins, Susan Lockhart); Musée du Petit Palais (Thérèse Burollet); Musée Rodin (Jacques Vilain, Claudie Judrin); Museum of American Art of the Pennsylvania Academy of the Fine Arts (Daniel Rosenfeld, Elyssa Kane); Philadelphia Museum of Art (Anne d'Harnoncourt, Darrel Sewell, Nancy Wulbrecht); Virginia Museum of Fine Arts (Katharine C. Lee, David Park Curry, Lisa Hancock, Kathleen Schrader); Fine Arts Museums of San Francisco (Harry S.

Parker III, Steven A. Nash, Timothy Burgard, Jane Glover, Sonya Knudsen); and The Corcoran Gallery of Art (David C. Levy, Jack Cowart, Linda Crocker Simmons, Cristina Segovia).

Private lenders suffer an even greater disruption to their lives by participating in enterprises such as this. To them we extend our deep thanks: Rita Fraad, Hugh and Marie Halff, Mr. and Mrs. Harry Spiro, Mr. and Mrs. Peter G. Terian, Mrs. John Hay Whitney, and others who wish to remain anonymous.

Finally, to my mother and my wife—both of whom sacrificed our weekends and evenings together so that this project could come about: many thanks.

M.S.

Lenders to the Exhibition

Museum of Fine Arts, Boston

Albright-Knox Art Gallery, Buffalo

The Art Institute of Chicago

The Taft Museum, Cincinnati

Des Moines Art Center

The Nelson-Atkins Museum of Art, Kansas City

Tate Gallery, London

The Armand Hammer Collection, UCLA at the Armand Hammer
Museum of Art and Cultural Center, Los Angeles

The Metropolitan Museum of Art, New York

Musée du Petit Palais, Paris

Musée Rodin, Paris

Museum of American Art of the Pennsylvania Academy of the Fine
Arts, Philadelphia

Philadelphia Museum of Art

Virginia Museum of Fine Arts, Richmond

Fine Arts Museums of San Francisco

The Corcoran Gallery of Art, Washington, D.C.

National Gallery of Art, Washington, D.C.

Rita Fraad

Hugh and Marie Halff

Mr. and Mrs. Harry Spiro

Mr. and Mrs. Peter G. Terian

Mrs. John Hay Whitney

Anonymous lenders

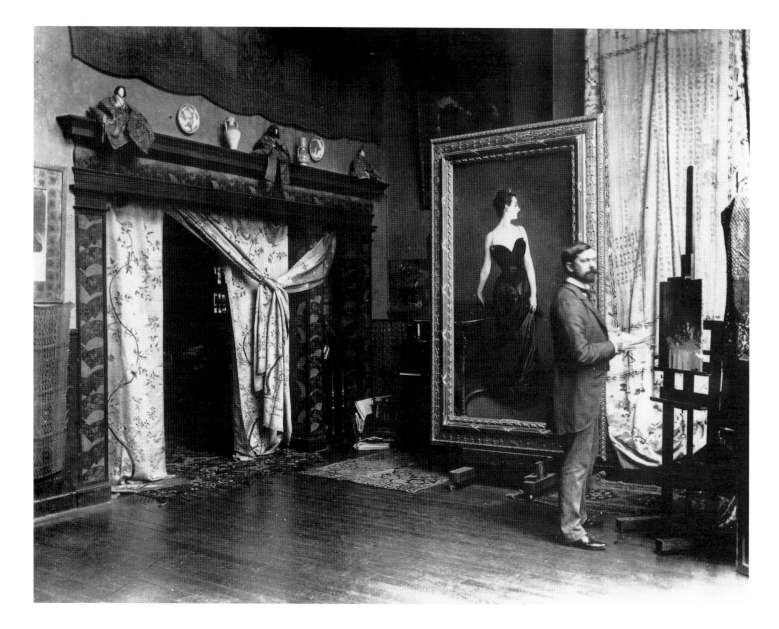

Sargent in his studio in Paris, 41 boulevard Berthier, ca. 1884. Photographs of Artists,
Collection I, Archives of American Art, Smithsonian Institution.

Introduction

RICHARD ORMOND

The story of John Singer Sargent's early exhibition history is more involved and complex than has generally been recognized. The diversity of venues where he chose to exhibit reflects the different painting styles he was experimenting with and the range of influences to which he was responding. It also reflects a canny eye for the market. In retrospect, Sargent's success may seem to have been a certainty, but it did not look that way to the young man struggling to make it to the top in a fiercely competitive environment. And one in which, for all his cosmopolitan polish, he remained a foreigner.

In terms of the highly political French art world, where battles between the establishment and the avant-garde, between this ideology and that, raged incessantly, Sargent belonged and was seen to belong to the modernist camp. In terms of conservative taste — and we are talking of the early 1880s, not the 1890s — his art was regarded as daring and provocative. We tend to see French art of the time in terms of polarities, academics versus impressionists, without understanding the wide spectrum of styles that in reality existed between left and right. Sargent was left of center, to borrow a modern political phrase, firmly linked to avant-garde tendencies in his small figurative works and plein-air landscapes, and boldly original in the large set pieces he sent to the Salon. If the Sargent of the dashing sketch whom we see at the Cercle de l'Union artistique or the influential Galerie Georges Petit, in company with Henri Gervex, Jules-Charles Cazin, Carolus-Duran, Alfred Stevens, Ernest-Ange Duez, Albert Edelfelt, Giovanni Boldini, Claude Monet, and others of the avant-garde and the *juste milieu*, appears to be an artist of a different stamp from the formal portraitist of the Salon, this is not a distinction that either he or his contemporaries would have recognized. The young Sargent was exploiting new techniques in the febrile world of the Paris studios with enormous creative force and intelligence. He was experimenting first in one idiom then in another, but this diversity represents facets of the same artistic personality. He was not a painter in search of an identity.

In terms of reputation, Sargent was well aware that he would be judged on the pictures he submitted to the Salon. This was the forum

that mattered, where success in the wider world was measured and ca-
reers made or blighted. A lesser talent might have played it safe. Sar-
gent's tactic was to take the Salon by storm and to achieve recognition
of his modernist style on his own terms. His pictures were highly orig-
inal and dramatic, they undermined conventional ideas of good taste,
they won him critical acclaim, but they did not transform Sargent into
an established master, nor did they stimulate vast quantities of new
patronage.

The three masterpieces of Sargent's Paris period, *El Jaleo* (see fig.
19), *The Daughters of Edward D. Boit* (see fig. 17), and *Madame X
(Virginie Avegno Gautreau)* (cat. 26) were begun or completed within
eighteen months of each other, during a period of intense creative en-
ergy, and exhibited at successive Salons in 1882, 1883, and 1884. The
first is a theatrical scene so vividly painted that it has the air of an ac-
tual scene, and painted so freely that it might be a sketch blown up to
the scale of life. *The Daughters of Edward D. Boit* breaks all the rules of
formal composition by showing four girls scattered round a room with
a large blank space in the middle, while *Madame X* matches stylized
design to an erotic beauty with stunning effect.

All three pictures share a common concern with spatial relation-
ships and subtle effects of light and dark inspired by Velázquez. All
three are mysterious in mood and shot through with psychological
ambiguities and tensions. All three are painted in a subdued palette of
grays and blacks offset by brilliant highlights and vivid patches of
color.

The kind of pictures that Sargent was exhibiting at the Salon in
the early 1880s, interchanging portraits and subject pictures with easy
fluency, represented a high-risk strategy. They were designed to stand
out and to startle, and they did. Sargent's success in terms of column
inches in the papers was quite extraordinary. In Salon after Salon the
critics wrote of him as a major figure, discussed individual pictures at
length, and ranked him alongside the great names in French art. No
other foreign artist of the time got anything like such attention from
critics of the Salon, or enjoyed so much publicity. For an artist still in
his twenties, it was a brilliant beginning.

Then came the debacle of *Madame X* at the Salon of 1884. In the
eyes of the world Sargent had gone too far, he had lost his balance on
the tightrope of taste and had fallen among the decadents and *intran-
sigeants*. Reviews of the picture were, in fact, mixed (some critics
praised the work), but the verdict of the Establishment was against
him. The failure of *Madame X* represented the failure not simply of a

single picture but of a whole strategy. Sargent had counted on gaining acceptance of his avant-garde style that would build his reputation picture by picture. After seven years of sustained effort he had suffered a humiliating setback, and he faced the possibility of failure. It is scarcely surprising that he went through a *crise de confiance*, spoke of giving up art altogether, and soon abandoned Paris for London.

Involvement in the Salon and French avant-garde circles had never blinded Sargent to opportunities in America and England. The pictures he sent to both countries throughout the late 1870s and early 1880s were designed to nurture his reputation and to make him known internationally. He exhibited portraits and landscapes in traditional and more unconventional venues, and the pictures by which he was represented were carefully chosen. He must always have been aware that he might one day settle in either America or England, and that he must prepare the ground beforehand. One of the virtues of this project is to document what pictures he was showing where, and how thoughtfully he was placing his work. In America, in particular, his pictures were generally well received and made Sargent better known than even he realized when he made his first professional visit in 1887.

London won out over Paris, New York, and Boston. Sargent finally settled there in 1886 and remained for the next forty years. It was not an easy transfer, for his work was disparaged as French and modern in the deeply conservative stronghold of the Royal Academy. Success came from an unexpected quarter. The public overlooked the startlingly modern impressionist techniques of Sargent's masterpiece, *Carnation, Lily, Lily, Rose* (cat. 35), so beguiled were they by the vision of two girls lighting Chinese lanterns at twilight. The picture was the star of the 1887 Royal Academy exhibition and helped Londoners to overcome their prejudice against Sargent's peculiar modern style.

In the same year, he departed for America to paint *Mrs. Henry G. Marquand* (see fig. 36) in what was to prove a rare triumph; he was treated as a celebrity and loaded with portrait commissions. From here on, Sargent was to become one of the great figures of the age, the "Van Dyck of our times," as his friend Auguste Rodin dubbed him. Sargent's prodigious talent assured him the success he deserved, and in retrospect it is difficult not to feel that it was a foregone conclusion, so perfectly were his style and panache matched to the spirit of the age. In the 1880s, however, Sargent faced a tough battle to gain acceptance, in spite of critical acclaim, and for a moment it looked as if his career hung in the balance.

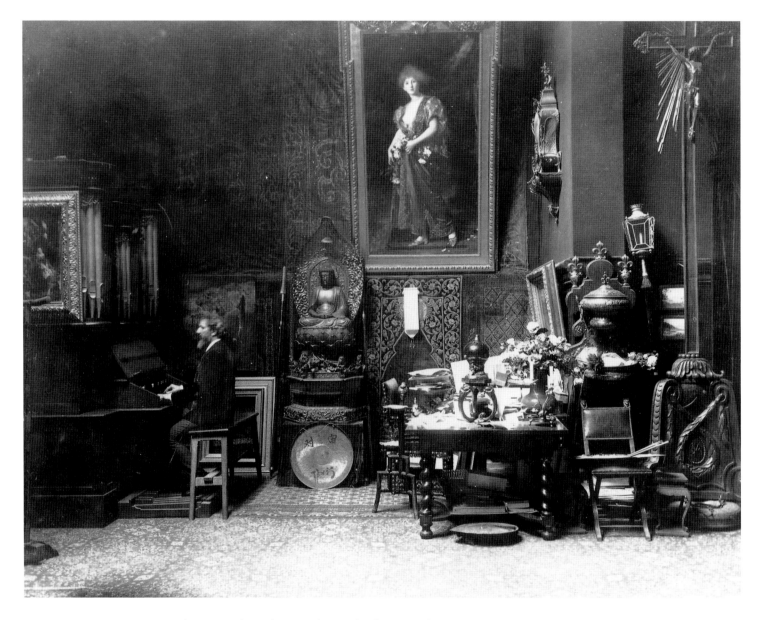

1. Carolus-Duran in his studio, Paris. Photographs of Artists in Their Paris Studios, Archives of American Art, Smithsonian Institution.

Sargent and Carolus-Duran

H. BARBARA WEINBERG

Late nineteenth-century Paris was irresistible to aspiring artists of all nationalities. In government and private academies and independent ateliers, they learned the skills necessary to emulate French art, which many international patrons and critics deemed the world's finest. A successful and versatile Parisian portraitist who also gained substantial repute as an instructor, especially of Americans, was Carolus-Duran, in whose teaching studio the young John Singer Sargent enrolled in May 1874.

When American painter Will H. Low recalled Carolus-Duran's atelier in an unpublished autobiography, he noted with pleasure that when he had joined the class in 1873 at the age of about twenty, he was the youngest by a year. However, "his proud title as the infant of the class was soon lost with the advent of John Sargent into its ranks." Low continued:

> He made his appearance in the Atelier Carolus-Duran almost bashfully, bringing a great roll of canvases and papers, which un-rolled displayed to the eyes of Carolus and his pupils gathered about him sketches and studies in various mediums, seeming the work of many years; (and John Singer Sargent was only seventeen) . . . an amazement to the class, and to the youth [Low] in particular a sensation that he has never forgotten.
>
> The master studied these many examples of adolescent work with keenest scrutiny, then said quietly: "You desire to enter the atelier as a pupil of mine? I shall be very glad to have you do so." And within a few days he had joined the class.
>
> Having a foundation in drawing which none among his new comrades could equal, this genius — surely the correct word — quickly acquired the methods then prevalent in the studio, and then proceeded to act as a stimulating force which far exceeded the benefits of instruction given by Carolus himself.[1]

Sargent, born in Florence, had studied at the city's Accademia delle Belle Arti intermittently during the early 1870s.[2] In 1873 he met several young foreign painters — the Britons Edward Clifford and

Heath Wilson and the Americans Edwin White, Walter Launt
Palmer, and Frank Fowler — who turned the Sargent household on
via Magenta into an Anglo-American gathering spot. When Dr.
Fitzwilliam Sargent asked these artists where his son John should con-
tinue his studies, Wilson, who had taught art in Edinburgh, London,
and Glasgow, chauvinistically urged that he be sent to London. By
contrast, the Americans strongly favored Paris, which had become the
magnet for international art students by the early 1870s.

In December 1873, the Accademia closed for two months while its
administrators and professors worked to reform its organization and
rearrange its teaching assignments. Sargent drew and studied art on
his own in and around Florence, resuming classes when the Accade-
mia reopened in March 1874. Shortly thereafter, Sargent's father seems
to have decided to move the family to Paris in order to nourish his
son's prodigious talent. In a letter to his friend, lawyer George Bemis,
Fitzwilliam Sargent noted on 23 April 1874: "Every One says that Paris
will be the best place to find such advantages as we wd like to give
him, and consequently we propose to take him to Paris & remain
there as long as the weather &c will permit. And perhaps we may even
ven[ture] on a winter there. If we can get him into the Atelier of some
first rate painter we flatter ourselves (perhaps it is a parental delusion)
that he will make something out of himself more than common."[3]

In a letter to Mary T. Austin on 25 April 1874, young Sargent
himself seemed less determined to abandon the Accademia — although
he called it "the most unsatisfactory institution imaginable" — and to
move on from Florence to Paris to continue his studies:

> We are packing up in order to leave in the first week of May. . . .
> Our destination has been changed by reports of Cholera in
> Venice and of unique artistic training in Paris, so that we are
> bound for the latter place. . . . The Academy in Paris is probably
> better than the one here and we hear that the French artists un-
> doubtedly the best now-a-days, are willing to take pupils in their
> studios. I do not think however, that I am sufficiently advanced
> to enter a studio now, and I will probably have to study another
> year at the Academy. We go to Paris now for a short time to
> make enquiries about this, which will decide whether we go to
> Paris or not for next winter.[4]

After this haphazard departure from Florence, the Sargents
reached Paris on 16 May 1874. At first they were in a state of confu-
sion. Sargent told Heath Wilson on 23 May that he and his family had

been so "busy looking for an apartment and visiting the galleries and Exhibitions. . . . that we have not yet made any very thorough enquiries about ateliers."[5] Yet the young artist chose his course of study with astonishing alacrity. On 20 May, four days after his arrival, Sargent talked about studios with Palmer, who recorded the encounter in his diary.[6] Palmer had been in Paris since November 1873 and was enrolled in Carolus-Duran's teaching atelier. In his letter of 23 May to Wilson, Sargent confirmed that Palmer had told him about Carolus-Duran's studio. He also told Wilson that, having seen in the Salon Carolus's works and those of other possible instructors, he had decided that he preferred Carolus's instruction and his style to those of Jean-Léon Gérôme or Alexandre Cabanel.

> An artistic friend with whom I had sketched last winter in Florence and whom I met unexpectedly on the Boulevard a day or two ago, gave me the most particular information I have yet received on the subject. He told me that he was himself in the atelier of M. Carolus Durand whom he prefers to any other artist in Paris, both as a teacher and as a painter. My friend says M. Durand takes more interest in each of his pupils and that his atelier is less crowded and contains more gentlemanly scholars than is the case with the others, so that I dare say I shall go to that atelier rather than to Geromes or Cabanel's. . . . Besides I admired Durand's pictures immensely in the salon, and he is considered one of the greatest french artists. With Geromes pictures I was rather disappointed, they are so smoothly painted, with such softened edges and such a downy appearance as to look as if they were painted on ivory or china. Their colouring is not very fine either.[7]

On 26 May, accompanied by his father, Sargent visited Carolus-Duran's atelier on the boulevard du Montparnasse, where he created the vivid impression that Low — and others — would long remember.[8] On 30 May, Fitzwilliam Sargent wrote to his own father, "We have placed John in the Studio of a rising painter."[9]

Sargent recorded his impressions of the studio in a letter to Wilson on 12 June 1874: "It is now almost three weeks since I entered the atelier of M. Carolus-Duran, a young and rising artist whose reputation is continuously increasing. He is chiefly a portrait painter and has a very broad, powerful and realistic style. I am quite delighted with the atelier, where with the exception of two nasty little fat Frenchmen, the pupils are all gentlemanly, nice fellows." After describing the haz-

ings that were usual in the ateliers of Gérôme and Cabanel, he added, "[W]e hear that it is a common reproach among the artists against Cabanel & Gerome that they should continue to hold the office and receive the salary of professors, while they only occasionally visit the studio in a stately manner without taking much individual interest in each of the pupils." By contrast, he noted: "Duran comes regularly twice a week to our atelier and carefully and thoroughly criticises the pupils' work staying a short time with each one. He generally paints a newcomer's first study, as a lesson, and as my first head had rather too sinister a charm, suggesting immoderate use of ivory black, he entirely repainted the face, and in about five minutes made a fine thing out of it, and I keep it as such."[10]

Because Sargent did not fully investigate the available instructional resources before deciding to study with Carolus-Duran, it seems the happiest coincidence that the young American's master was so well suited, stylistically and temperamentally, to encouraging him. Sargent remained in the studio until it closed for the summer on 3 July and, after visiting his family in the French countryside, returned to Paris to resume — and increase — his instruction in late August or early September 1874.[11] Sargent attended Carolus-Duran's atelier regularly until the winter of 1878–1879.

In choosing to study with Carolus, Sargent rejected the most obvious alternative: one of the three painting ateliers in the Ecole des beaux-arts, the bastion of academic orthodoxy. The pride and pinnacle of the French national art instruction system, the Ecole was located on the rue Bonaparte in the Latin Quarter of Paris.[12] Reforms of 1863 had made the school's curriculum comprehensive for the first time. While the Ecole remained tuition-free and open to any male applicant of any nationality who appeared likely to profit from his studies, it now offered three orders of teaching: life drawing in the *école proprement dite*, open only to matriculants; practical instruction in drawing and painting from life in three newly created ateliers to which admission was granted directly by the masters in charge; and lectures on anatomy, perspective, art history, and other subjects, open to most art students who applied.

The competition for matriculation in the Ecole was daunting: as many as two hundred students entered the rigorous semi-annual *concours des places*, but only seventy (with ten alternates) were admitted each semester. It was easier to join one of the painting ateliers: a student would merely ask the *chef d'atelier* for permission to enroll. The ateliers, founded under the direction of Gérôme, Cabanel, and Isidore

Pils, remained discrete for at least eighty years, each generating its own series of "begats" in its *chefs*.

New painting students began work as *aspirants*, drawing in the Ecole's ground-floor cast gallery. Their promotion to the life classes upstairs was marked by hazing, ranging from standing on stools and singing patriotic songs to being stripped of their clothes and daubed with paint. They were then bound into servitude to the atelier — stoking the coal stove, procuring supplies, tracking down errant models — until newer students arrived. The studios were notoriously overcrowded, dirty, smoky, and roaring with noise that subsided only when the *patron* arrived for his semi-weekly visits. The master usually imposed exacting standards in draftsmanship before permitting his students to paint; he demanded that they refresh their drawing skills by returning to the plaster casts from time to time; and he honored the abiding beaux-arts credo — "drawing is the probity of art" — even when criticizing their painted studies.

Students wishing orthodox academic training but unable to enter the Ecole often enrolled in the private Académie Julian, founded in 1868. Upon payment of monthly tuition, men and women (who were excluded from the Ecole until 1897) could study in one of the many large ateliers that Rodolphe Julian rented throughout Paris under teachers who were the artistic alter egos of Gérôme, Cabanel, and their colleagues at the Ecole.

The improved Ecole des beaux-arts and the flourishing Académie Julian challenged the independent ateliers overseen by individual artists. Marc-Charles-Gabriel Gleyre, for example, with whom many of the future Impressionists studied, closed his teaching studio in 1863. Several autonomous studios endured, however, and new ones were founded. Thomas Couture, for example, had closed his teaching studio about 1863, possibly in response to competition from the beaux-arts ateliers, but he continued to offer instruction in his version of Venetian High Renaissance technique in Paris and then at Villiers-le-Bel, near Ecouen, until his death in 1879. Léon Bonnat accommodated a group of students who asked him to supervise their study in 1865. By then he had acquired a reputation as a portraitist who mediated between tradition and innovation, conjoining an academic armature with a painterly mode derived from seventeenth-century Spanish painting.

Although pursuing instruction in an independent atelier such as Bonnat's might have seemed an uncertain path to success, American students were willing to take a chance. By the time Sargent arrived in

Paris, Bonnat's studio had attracted sixteen aspiring American painters, whereas only thirty-eight Americans had enrolled at the Ecole ateliers by the end of April 1874: four in the studio of Pils, seven in that of Cabanel, and twenty-seven in that of Gérôme, who would remain the most popular beaux-arts teacher among the Americans.

In 1874, Carolus-Duran's studio was much newer and less tested than Bonnat's and much more radical in rejecting academic strictures. In the fall of 1872, Robert Hinckley, an American art student who had been studying with Bonnat, asked Carolus-Duran to criticize his work. Carolus-Duran refused, but told Hinckley that he would offer regular instruction if Hinckley organized a studio. Within a year, some twelve students had joined the atelier, including the Americans Will Low and James Carroll Beckwith. Carolus-Duran's teaching studio was distinguished by the youth of its *patron* (he was thirty-four years old in 1872, while Bonnat was thirty-nine and Gérôme was forty-eight), its small size, the predominance of Britons and Americans in its ranks, its accessibility to female students — who received criticism (on separate premises) from both Carolus-Duran and Jean-Jacques Henner — and, most important, its emphasis on painting rather than on drawing. The studio flourished until Carolus closed it in 1888, attracting ninety Americans in all, of whom Sargent was probably the sixth to enroll.[13]

Carolus-Duran, born Charles-Emile-Auguste Durand in 1838 in Lille, in French Flanders, had little academic training. He had studied in the municipal drawing school and in the studio of François Souchon, a pupil of David's.[14] His exposure to one of the greatest French provincial collections in Lille's Musée des beaux-arts stimulated his durable enthusiasm for the paintings of the old masters, from which he would derive all of his subsequent "instruction." Moving to Paris in 1853, fifteen-year-old Carolus-Duran — as he then began to call himself — painted from the old masters in the Louvre and enjoyed freedom from any teacher's constraints.

In 1858 financial problems forced Carolus-Duran to return to Lille, where living costs were lower and where he found patronage for portraits. A prize in a city-sponsored painting competition allowed him to return to Paris in 1859 and to work from life at the Académie Suisse, where models were available but no instruction took place. Carolus-Duran became friendly with Henri de Fantin-Latour at Suisse's, and with the art critic Zacharie Astruc, a native of Lille; he also met Gustave Courbet and entered the avant-garde circle of Fantin-Latour, Alphonse Legros, Félix Bracquemond, and Edouard Manet.[15]

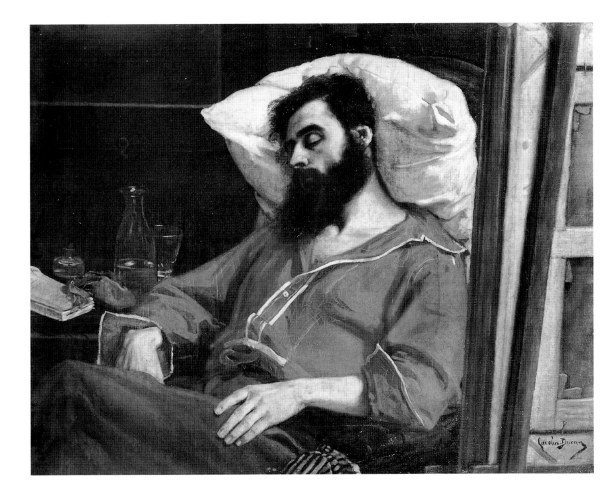

2. Carolus-Duran, *The Convalescent*, 1861. Oil on canvas, 39 x 49 5/8 in. Musée d'Orsay, Paris.

He shared their interest in realism and in Venetian and Spanish art.

Carolus-Duran's most ambitious early work, and a convincing testimonial to his affiliation with realism, was a large, multifigured composition, *Visit to the Convalescent*, of 1861. The artist later destroyed it, except for two fragments — one depicting a dog and another, now titled *The Convalescent* (fig. 2), showing an exhausted artist, dressed in a brilliant red shirt, slumped near his easel. Presumably a self-portrait, this fragment reflects Carolus-Duran's serious illness of a few years earlier and his awareness of Courbet's works. *Visit to the Convalescent* provoked controversy because of its candor, but it was awarded the Prix Wicar by the city of Lille. The proceeds allowed Carolus-Duran to leave in 1862 to begin four years of travel and study in Italy. Visiting Rome and Venice, he was fascinated by Venetian

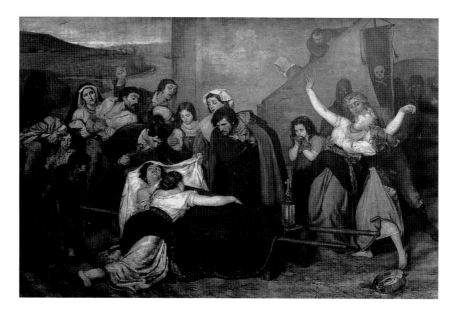

3. Carolus-Duran, *The Assassination*, 1866. Oil on canvas,
 18 1/2 x 26 1/2 in. Musée des beaux-arts, Lille.

painting and particularly struck by Velázquez's *Pope Innocent X* (1650;
Doria-Pamphili Gallery, Rome).

Carolus-Duran achieved success with his first Salon submission in
1866. Together with a portrait, he showed a large-scale realist painting,
The Assassination (fig. 3), which he had completed in Italy. Not only
was he awarded a medal that exempted him from further jury
scrutiny, but he sold the painting to the French government for the
Musée des beaux-arts in Lille for 5,000 francs (about $1,000). This
sum allowed Carolus-Duran to travel again; he spent two years in
Spain, from 1866 to 1868, copying works by Murillo and Velázquez.[16]
During subsequent visits to England he examined and copied works
by other practitioners of the baroque mode: Thomas Gainsborough,
Sir Joshua Reynolds, and Sir Thomas Lawrence.

As a mature artist, Carolus-Duran painted some idealized nudes
and religious stories, as well as landscapes, and he experimented with
still life and with sculpture in the manner of Jean-Baptiste Carpeaux.
In 1878 with the assistance of at least six American students, including
Sargent, Beckwith, and Fowler, he completed a mural, *Gloria Mariae
Medicis* (fig. 4), for the ceiling of the Palais du Luxembourg.[17] None-
theless, he established a reputation primarily as a portraitist, enlisting a
style based on the international painterly tradition for engaging family
portraits and many commissioned works.

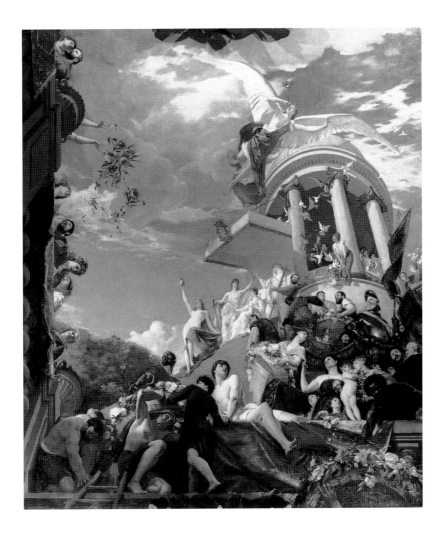

4. Carolus-Duran, *Gloria Mariae Medicis (The Triumph of Marie de Médici)*, 1878. Ceiling for the Palais du Luxembourg, now preserved, Musée du Louvre, Paris.

Carolus-Duran's first important early portrait summarized his art-historical affections. *The Woman with a Glove* (fig. 5), a life-size image of his new wife, the pastelist and miniaturist Pauline-Marie-Charlotte Croizette, alludes to Titian's *Man with the Glove* (ca. 1520; Musée du Louvre, Paris) in its title; to Velázquez in its limited space and mono-chromatic palette; and to the tradition of elegant English portraiture in the subject's graceful pose. The glove echoes a similar device in Manet's *The Balcony* (1868–1869; Musée d'Orsay, Paris), in which the figure at the right pulls on a glove rather than removing it. At the 1869 Salon (where *The Balcony* also appeared) *The Woman with a Glove* was awarded a second-class medal. The French government's acquisition of the painting in 1875 for the Musée du Luxembourg confirmed Car-

5. Carolus-Duran, *The Woman with a Glove*, 1869.
Oil on canvas, 90 x 64 1/2 in. Musée d'Orsay, Paris.

olus-Duran's growing reputation as one of the most successful masters of female portraiture during the Third Republic. By 1872, Carolus was *hors concours* in the Salon, and his works — usually one or two portraits and an occasional subject picture — appeared without fail in the annual displays through 1886.[18]

Despite its reference to Manet, *The Woman with a Glove* signals Carolus's defection from realism and his willingness to court patrons and to please critics. Paul Mantz astutely characterized Carolus's new position in an 1869 Salon review in the *Gazette des beaux-arts:* "Who

6. Carolus-Duran, *Marie-Anne Carolus-Duran (The Artist's Daughter)*, 1874. Oil on canvas, 51 1/4 x 33 1/2 in. Fine Arts Museums of San Francisco, Mildred Anna Williams Collection, 1941.26.

would have imagined that this painter, who began so violently and who even sought reality à la Courbet, would eventually believe in the rustling of silk gowns, the mysterious poetry of a pearl-gray glove, the chimerical hats of a first-rate modiste?"[19] Jules Castagnary, one of the few dissenters from the chorus of praise that *The Woman with a Glove* had provoked, complained in 1872: "It is an entirely exterior portrait, a surface likeness as it were, a study of a woman's attire or rather of an elegant pose."[20]

Surface likenesses, elegant attire and poses, as well as droll dialogues with tradition, characterize other portraits by Carolus-Duran. His *Marie-Anne Carolus-Duran (The Artist's Daughter)* (fig. 6) is a cousin of the elegant Infanta Marguerita of Velázquez's *Las Meninas* (1656; Museo del Prado, Madrid). This portrait and Carolus's many

7. Carolus-Duran, *Mlle de Lancey*, 1875. Oil on canvas, 62 x 83 in. Ville de Paris, Musée du Petit Palais.

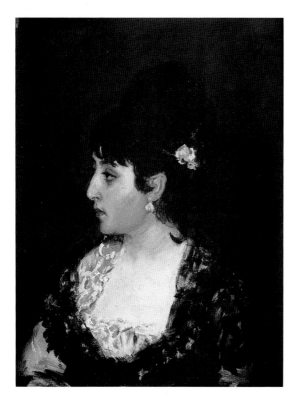

8. Carolus-Duran, *Spanish Lady*, 1876. Oil on panel, 10 1/2 x 8 1/4 in. Sterling and Francine Clark Art Institute, Williamstown, Massachusetts.

other images of children also recall Francisco Goya's interest in youthful subjects. Carolus-Duran's self-consciously glamorous *Mlle de Lancey* (fig. 7) quotes the pose and gesture that Antonio Canova had used to portray Pauline Borghese as Venus (1808; Borghese Gallery, Rome). Dressing that idealized prototype in fashionable costume, Carolus-Duran also invoked the mannered frontality of Ingres's *Madame Philibert Rivière* (1804; Musée du Louvre, Paris) and the overt sensuality of Manet's *Olympia* (1863; Musée d'Orsay, Paris).

By contrast, Carolus-Duran's direct and freely rendered *Spanish Lady* (fig. 8) avoids the pretensions that such partisans of realism as Castagnary decried. Even in a full-length portrait, like that of his New York-born pupil, Lucy Lee-Robbins (fig. 9), Carolus-Duran could eschew the mannered brilliance of *Mlle de Lancey*. A muted setting and an elaborate but understated hat and gown focus attention on the eloquent face.

Departing from his customary role as a painter of fashionable Parisiennes, Carolus-Duran produced a late homage to the directness of Velázquez in *The Artist's Gardener* (fig. 10). Like the Spanish master's portrait of his studio apprentice, Juan de Pareja (1650; Metropolitan Museum of Art, New York), Carolus-Duran's depiction of a familiar workman relies on a thinly painted background, lush foreground impastos, and monochromatic palette.

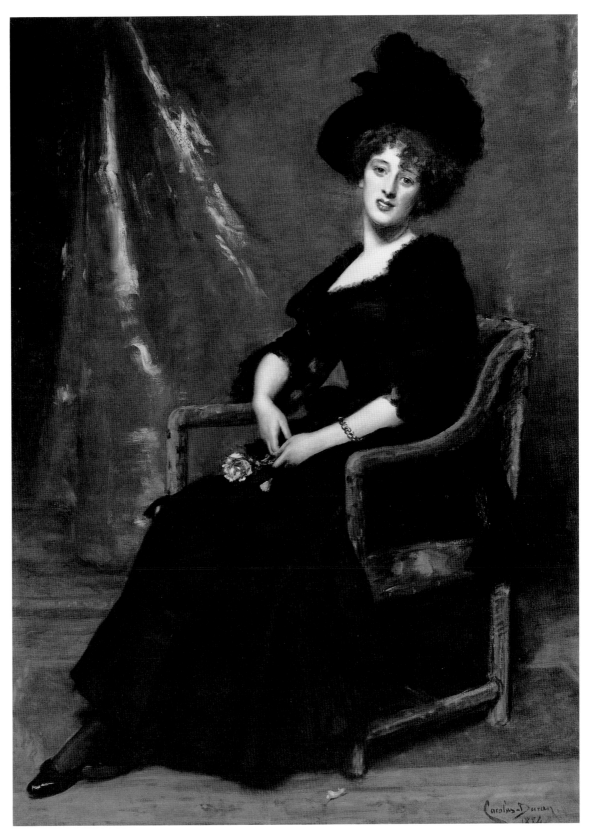

9. Carolus-Duran, *Lucy Lee-Robbins*, 1884. Oil on canvas,
67 1/4 x 50 1/4 in. The Chrysler Museum of Art, Nor-
folk, Virginia. Gift of Walter P. Chrysler, Jr. 71.627.

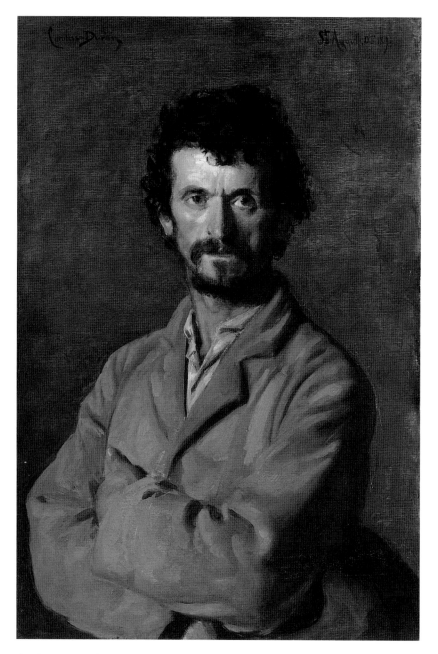

10. Carolus-Duran, *The Artist's Gardener*, 1893. Oil on canvas, 31 7/8 x 21 11/16 in. Sterling and Francine Clark Art Institute, Williamstown, Massachusetts.

Although he renounced realism in favor of an ingratiating — and lucrative — portrait business, Carolus-Duran avoided academic orthodoxy, espousing the traditions of Titian, Velázquez, and English baroque artists, rather than the heritage of classical antiquity, exemplified by Raphael, Poussin, and David. Similarly, as a teacher, Carolus-Duran offered an alternative to the beaux-arts emphasis upon drawing. His students' correspondence and reminiscences document his methods.

For example, in the fall of 1873 Will Low had left Gérôme's beaux-arts studio to join Carolus-Duran's atelier. There he found "a radical innovation in the teaching of painting." He explained:

> We were all, no matter what our previous lack of familiarity with colour had been, given a model, a palette and brushes, and told to render what we saw.
>
> We apparently saw some very curious aspects of nature, if the report of our vision could be judged by our productions. But ill-shapen and mud-coloured as were our first studies, a glimmer of essential truth soon penetrated our understanding. Duran's theory was undeniably logical. Objects in nature relieve one against each other by the relative values of light and shade which accompany and are a part of each local colour. An outline, a contour, is, as we all know, a pure convention . . . an accepted convention. . . . It divides, however, the painter's final production into two different and contrary processes and . . . it establishes a habit of seeing falsely, which he is forced to correct when he takes up the study of colour.

Low also noted that it "took no little courage" to maintain faith in Carolus-Duran's stress on form and color rather than line, on paint rather than pencil, but, after a time, "the atelier was able to vindicate the logic of our master's theories by works, which, if not masterpieces, were equal to the average productions of other studios."[21]

In his teaching as in his work, Carolus-Duran repudiated the academic pantheon, esteeming Spanish painting above all. "Velasquez, Velasquez, Velasquez, ceaselessly study Velasquez," he always reminded his students.[22] But he did not insist that they emulate his personal taste. Rather, he urged them to interpret nature according to their own lights, to express their own artistic personalities, and to elect to follow their favorite artistic traditions. "We should search a guide among the masters who responds most fully to our temperament," Carolus proposed, and he insisted that his students meditate on the meanings of their mentors' works, not simply imitate them.[23] So great was Carolus-Duran's concern for his pupils' individuality, Low reported, that he would "recommend diametrically opposite courses to different men, as he judged might be useful to one or the other."[24]

Carolus often taught by demonstration, working from the model as his students looked on. To paint a head, he began by drawing it on the canvas in charcoal and fixing it. He then laid in the darkest passages followed by the *demi-teint général* (the brown half-tone prepara-

tion onto which he placed the exact colors and tones of the shadows), and finally the highlights. "The process, including drawing and a little interval while the fixatif was drying, took thirty-five minutes," an English student in the mid-1880s recalled. Carolus's stress on the *demi-teint général* and his recommendation that the "highlights" need not differ much from it helped his students produce works that were "brighter and far higher in key than the usual productions of an art studio," as the same pupil noted. He also urged students to capture "the envelope of a figure" and the dynamic relationship between the model's contours and what surrounds them.[25]

Carolus encouraged his students to paint subject pictures by assigning themes for compositional sketches to be done outside the atelier and brought in for criticism, recalled American pupil James Eliot Gregory. The master also recommended that they copy in the Louvre, stopped by to see them there, offered advice, and showed them his favorite masterpieces.[26] Low noted that Carolus-Duran even called on his pupils in their studios, especially when they were preparing pictures for the Salon.[27] Another former student remembered being welcomed "in the master's own studio, which was open to the visits of his pupils on a Thursday morning, I think once a month."[28]

Carolus-Duran appeared in the atelier on Tuesday and Friday mornings each week and accepted no fees for his instruction, according to the English pupil of the mid-1880s. The same student noted, "The pupils pay the rent of the studio, choose and pose the models, and manage all their own affairs; the patron have nothing to do with the financial side of the studio except that he has sometimes come generously to its rescue and kept it afloat when in difficulties."[29] Gregory added that Carolus-Duran also contributed "too often from his own pocket to . . . smooth the path of some improvident pupil."[30] Although he was detached from the financial affairs of the atelier, the *patron* retained control. According to the English pupil, "M. Duran gives the permission to each pupil to enter the atelier, all regulations concerning its workings must be submitted to him, and he retains the right to forbid the studio to any pupil he ceases to approve of." The same writer noted that Carolus-Duran was unusually liberal in admitting foreigners to the atelier, which was "often half full of Americans, English, and other aliens," and was "equally pleased to teach few pupils as many, if they work hard and are in earnest."[31]

Carolus-Duran's enthusiasm for teaching was reciprocated by his pupils, who reveled in the reflected glory of his growing reputation.

Hinckley's request in 1872 that Carolus-Duran open a teaching studio
had followed closely upon his being named a Chevalier of the Legion
of Honor, a tribute that would have caught the attention of admiring
— and aspiring — art students.[32] Recounting the favorable reception of
his master's works in the early 1870s, especially the French govern-
ment's purchase of *The Woman with a Glove*, Gregory noted: "It is
difficult to overestimate the impetus that a master's successes impart
to the progress of his pupils. My first studio year in Paris had been
passed in the shadow of an elderly painter [Henri Lehmann, Pils's suc-
cessor at the Ecole des beaux-arts], who was comfortably dozing on
the laurels of thirty years before. The change from that sleepy environ-
ment to the vivid enthusiasm and dash of Carolus-Duran's studio was
like stepping out of a musty cloister into the warmth and movement
of a market-place."[33] In the same spirit, Carolus-Duran's students in
the late 1870s would have been proud of the display in the French sec-
tion of the 1878 Exposition universelle of ten of his paintings, includ-
ing *The Woman with a Glove* and other portraits that had appeared in
the Salons between 1869 and 1876.

Carolus-Duran's youth, his good looks, and his engaging manner
must also have appealed to young art students. A portrayal of him as
the consummate *flâneur* appeared in *Art Age* in June 1885: "Everybody
familiar with the artistic haunts of Paris knows Carolus Duran, with
his bushy black curls thickly streaked with gray, his costume always at
the height of the mode, his hat always a little in advance of it, his
flowing wristbands and gold bracelets soldered upon his wrists, and
his general air of a Fortuny cavalier toned down to walk the Boule-
vards." The same article remarked that Carolus had, in fact, tempered
his even more extravagant self-presentation of the 1870s: "Old
Parisians . . . were familiar with the sight of the young Carolus draw-
ing his blouse tightly about his figure and writhing to see himself from
all points of view in large restaurant mirrors as he exclaimed, 'The
torso of an Apollo!'"[34] Moreover, Carolus-Duran had achieved repute
not only as a painter, but as a horseman, fencer, bicyclist, and musi-
cian.[35] This stylish versatility may also have enticed those envisioning
careers that were personally as well as financially rewarding.

Aside from the appeal of its *patron*, attractions of Carolus-Duran's
atelier appear to have been its small size (about thirty students), its
location in a "roomy one-storied structure in the rue Notre-Dame des
Champs," and its low fees of ten francs per month.[36] Its democratic
procedures were also unusual: a pupil's place in the studio each week

depended simply on the order of his arrival on Mondays. Hazing was prohibited. According to Low: "Our revolutionary atelier was, in point of fact, one of the quietest places of study in Paris."[37]

Most unusual was the absence of French students, at least in the early years of the atelier. Beckwith suggested that this resulted from their reluctance to affiliate themselves with a master whose works were controversial: "M. Carolus was an artist whose work was hotly disputed by the critics, and generally condemned without stint by the painters of the Institute. He had thrown a formidable and dazzling gauntlet into the ring in the shape of a series of masterly portraits, and he was a competitor in the field for popular favor calculated to arouse bitter antagonists as well as enthusiastic adherents."[38] His departures from orthodox academic techniques and teaching methods seem to have troubled the British and Americans less. Despite their presence, Low recorded that "the official language of the school remained French . . . a placard announcing a fine of ten centimes for each word of a foreign tongue being conspicuous on the walls."[39]

Before he enrolled under Carolus-Duran, Sargent's commitment to a career as a portraitist is not documented. Yet his preserved juvenilia reveal a command of human physiognomy and an interest in gesture. Without substantial financial resources, he may have grasped the necessity for and wisdom of working on commission, rather than on speculation, and may have recognized in portraiture a subject that suited both his artistic temperament and his need to make a living.

Among leading Parisian teachers, only Carolus and Bonnat commanded significant reputations as portraitists and emphasized portraiture in their teaching. Both painters were indebted to the Spanish baroque tradition, especially the expressive brushwork of Velázquez and the dramatic chiaroscuro of Jusepe de Ribera. Those predilections may have struck a responsive chord in Sargent, who had toured Spain with his parents in the spring of 1868.[40]

In electing to study with Carolus rather than Bonnat, Sargent was guided by Walter Palmer's advice, impressed by Carolus-Duran's painting style, and comfortable with the atelier's composition and conduct. He might also have found in this teacher and his works a reassuring balance between conservative and avant-garde tendencies. Carolus must have appeared unusually able to enlist realist elements in the service of patron-pleasing portraiture. Like Carolus, Sargent might have realized the virtue of subordinating an interest in subject pictures to the painting of portraits without abandoning the expressive freedom that subject pictures permitted. Moreover, in choosing between

Carolus-Duran and Bonnat, Sargent might have reasonably preferred the teacher who espoused a personal assimilation of tradition. Finally, Sargent would probably have gravitated to the outgoing and stylish Carolus-Duran, who was voluble and communicative, rather than the notoriously dour Bonnat.

Sargent quickly moved close to Carolus, and news of his talents spread within the American art students' community in Paris. Edwin Blashfield, who began his own second period of Parisian study in 1874, recalled:

> My temporary home had become Paris, my comrades the group of Montmartre American men who belonged to the Atelier Bonnat. Now and then some momentary visitor from the Rive Gauche, Carroll Beckwith, perhaps, or Frank Fowler, would tell us of their wonderful fellow pupil under Carolus Duran, a Boston boy named Sargent, a painter who was the envy of the whole studio and perhaps a bit the envy of Carolus, himself, who had, however, to admire generously. There was not any story of his painting an angel as did Da Vinci for Verrocchio in the latter's picture, nor was he as yet a Michelangelo so overtopping his master Ghirlandaio, but all the same we watched his growth and wondered whether Carolus were teaching him or he were stimulating Carolus.[41]

Similarly, J. Alden Weir, a student of Gérôme's, wrote to his mother in October 1874: "I met this last week a young Mr. Sargent about eighteen years old and one of the most talented fellows I have ever come across; his drawings are like the old masters, and his color is equally fine. He was born abroad and has not yet seen his country. He speaks as well in French, German, Italian as he does English, has a fine ear for music, etc. Such men wake one up, and as his principles are equal to his talents, I hope to have his friendship."[42]

Weir encountered Sargent when they were undergoing the *concours des places* at the Ecole des beaux-arts — "the great and terrible examination for Yvon's school in the Beaux-Arts," as Sargent described it to Heath Wilson — which had begun on 26 September 1874. Their durable friendship must have been stimulated by the fact that Weir and Sargent were the only two Americans admitted to matriculation on 27 October, Weir placing thirty-first out of the 70 students admitted (162 had entered the competition), and Sargent thirty-seventh.[43] Like many other students who pursued their principal instruction outside the Ecole, Sargent may have been determined to secure the

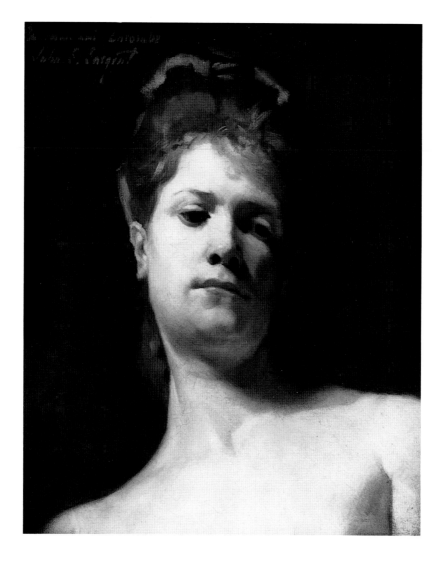

11. John Singer Sargent, *Blonde Model*, ca. 1877. Oil on canvas, 17 15/16 x 14 15/16 in.
Sterling and Francine Clark Art Institute, Williamstown, Massachusetts.

Ecole's imprimatur by some means, or may have been expected and
encouraged by his teacher — a dissident from beaux-arts practices — to
"round out" his technical skills through matriculation.

Thus, when Carolus-Duran's atelier reopened in October 1874
and Sargent began his first full year of instruction there, he was also a
matriculant in the Ecole and could spend two hours each afternoon
from four until six drawing there under the direction of Adolphe Yvon.
Sargent also appears to have visited Bonnat's atelier in the evenings,
working in the company of Walter Gay and other Americans.[44] Again
in the spring of 1875, Sargent would undergo the *concours des places* for
matriculation in the Ecole, placing thirty-ninth out of 197 competitors
when the semester began on 16 March 1875. His name is absent from

the semiannual rosters of the Ecole's matriculants until the spring of 1877, when, on 20 March 1877, he was ranked second among the 179 competitors, the highest place achieved by any American in the period.

Sargent's studies under Carolus and his early success as a portraitist — manifest, for example, by the acceptance of his portrait of Fanny Watts (cat. 1) into the 1877 Salon — validated his choice of portraiture as a specialty. Ultimately, Carolus-Duran and Sargent received commissions from affluent and well-connected French and American patrons.[45] As a result of his training under an artist who had assimilated the English baroque style, Sargent would also be well equipped to flourish in England, providing portraits for aristocratic settings that were filled with canvases by Van Dyck, Reynolds, and their British stylistic heirs.

Despite his gifts as a draftsman, and his success in the Ecole des beaux-arts, almost every easel painting by Sargent — from his atelier exercises to his most ambitious late portraits and outdoor genre works — discloses a conspicuous affiliation with the painterly, anti-academic manner of Carolus-Duran.[46] Sargent's *Blonde Model* (fig. 11) seems to provide a demonstration lesson of Carolus-Duran's method, as it was described by R. A. M. Stevenson, an English painter (and later a writer), who also entered the atelier in 1874:

> No preparation in colour or monochrome was allowed, but the main planes of the face must be laid directly on the unprepared canvas with a broad brush. These few surfaces — three or four in the forehead, as many in the nose, and so forth — must be studied in shape and place, and particularly in the relative value of light that their various inclinations produce. They were painted quite broadly in even tones of flesh tint, and stood side by side like pieces of a mosaic, without fusion of their adjacent edges. No brushing of the edge of the hair into the face was permitted, no conventional bounding of eyes and features with lines that might deceive the student by their expression into the belief that false structure was truthful . . . you must make a tone for each step of a gradation. Thus, you might never attempt to realize a tone or a passage by some hazardous uncontrollable process.[47]

In addition to his method, Sargent absorbed his teacher's admiration for Velázquez, whose fluent paint handling and interest in monochromatic palette and ambiguous space underlay Carolus-Duran's lessons. A stylish "Spanishness" appears in Sargent's portrait of Carolus-Duran (cat. 4), one of the first portraits that he exhibited publicly

and his second major Salon success, after *Oyster Gatherers of Cancale* (cat. 3), which was shown in the Salon of 1878.[48]

The origins of the portrait of Carolus-Duran may be traced to the fall of 1877, shortly after Sargent resumed studies in the atelier for the fourth full year. Along with several colleagues, he had been enlisted in Carolus-Duran's project to provide a ceiling decoration, *Gloria Mariae Medicis,* for the Palais du Luxembourg. Sargent and Beckwith painted each other's portraits into the mural, and Sargent painted in Carolus-Duran's portrait, along with two allegorical figures on either side of Marie de Médici and one of the heads in the lower part of the composition.[49] According to one authority, the portrait of Carolus in the mural "so pleased the sitter that he decided to sit to his pupil for a formal easel portrait."[50] In the easel portrait, begun about July 1878 and completed in the spring of 1879, Sargent exploited the planar, tonal style evident in *Blonde Model.*

Sargent's astute characterization of his teacher may be verified by comparing the portrait to Nadar's photograph of about a decade later (fig. 12).[51] The painting also revealed Sargent's command of the lessons of Carolus-Duran — and those of Velázquez. What could be better as a graduation piece to display Sargent's mastery of his teacher's technique than an image of the teacher himself? What could be more appropriate as a parting gift than the portrait, which Sargent inscribed "à mon cher maître M. Carolus-Duran, son élève affectionné/John S. Sargent. 1879"? What device could more clearly announce the debut of Sargent's professional career as a portraitist — and his rivalry with Carolus-Duran? The painting was a "masterpiece" in the traditional sense, attesting to a craftsman's skill and his qualifications for entry into the professional guild. It proclaimed Sargent's ability to the public and entitled him to call himself a master; it was both a valedictory and a gauntlet thrown down. According to Blashfield, the portrait "took us all by storm." Sargent's father wrote in the summer of 1879: "He sent to the Salon a portrait of his teacher Carolus-Duran. . . . There was always a little crowd around it, and one heard constantly remarks in favor of its excellence." It appeared on the cover of *L'Illustration* in honor of both the painter and the sitter.[52]

Commissions from French patrons for similar works followed, including portraits of the successful playwright Edouard Pailleron (1879; Musée Nationale, Versailles, France), of his wife (cat. 9), and of young Robert de Cévrieux (1879; Museum of Fine Arts, Boston), which was another stylistic "first cousin" to Carolus-Duran's portrait of his daughter (see fig. 6).[53] Sargent's *Lady with the Rose (Charlotte Louise*

12. Paul Nadar, *Portrait de Carolus-Duran,* 1888. © Arch. Phot. Paris soit © CNMHS.

Burckhardt) (cat. 22) suggests in its monochromatic economy, direct gaze, graceful pose, sumptuous textiles — and even its inclusion of flowers — the influence of Carolus-Duran's *Helena Modjeska Chlapowski* (fig. 13), a life-size portrait of the famous Polish-born actress. The actress later recalled that during one of her fourteen sittings with Carolus-Duran, Sargent made an oil sketch for the large portrait of his teacher. "In an hour or so he made a sketch which looked to me like a finished portrait in its wonderful likeness," she noted.[54] Even as late as 1896, the leading lady of Sargent's *Mrs. Carl Meyer and Her Children* (collection of Sir Anthony Meyer, Bt) echoes Carolus-Duran's sinuous disposition of the figure in his *Mlle de Lancey.*

Sargent's interest in the art of Velázquez was reinforced by his visit to Spain in the winter of 1879–1880, when he made about two dozen copies of the baroque master's works in the Prado before journeying to Toledo, Granada, and Seville.[55] Sargent demonstrated his debt to the Spanish master in his portrait of the renowned Parisian surgeon, *Dr. Pozzi at Home* (cat. 21), his first life-size, full-length male portrait, which replaces the usual gray-on-gray color scheme of Velázquez with a dazzling red-on-red. Monochromatic experiments in the manner of Velázquez appeared regularly in Sargent's oeuvre, from the pearly Venetian genre scenes of the early 1880s, to the black-against-black of *Madame X (Virginie Avegno Gautreau)* (cat. 26), to the white-gray-black triad of *Mr. and Mrs. Isaac Newton Phelps Stokes* (1897; Metropolitan Museum of Art, New York).

Direct homages to Velázquez occur often in Sargent's oeuvre, beginning with *The Daughters of Edward D. Boit* (see fig. 17), which appears to be an intentional commentary on Velázquez's *Las Meninas,* which Sargent had copied during his 1879–1880 Spanish sojourn. His later portrait of Beatrice Goelet (1890; Robert Goelet, New York) recalls the Infanta Marguerita from Velázquez's masterpiece, and the marvelous portrait of the Honorable Victoria Stanley (1899; private collection) is a more spontaneous, insouciant variant of both.

Beyond emulating Carolus-Duran's debt to Velázquez, Sargent also adopted his teacher's belief in the efficacy of establishing a personal dialogue with the past, choosing mentors other than the great Spaniard if their lessons seemed apt. Thus, the rapid paint handling in Sargent's *Vernon Lee* (see fig. 20) suggests the influence of Frans Hals. The color scheme of the portrait of Dr. Pozzi, as well as the mannered pose and graceful hands, reflects Sargent's susceptibility to Van Dyck, whose portrait of Cardinal Guido Bentivoglio (1623; Pitti Palace, Florence) he had known since his youth in Florence. Like Carolus-Duran,

13. Carolus-Duran, *Helena Modjeska Chlapowski,* 1878. Oil on canvas, 75 x 41 3/4 in. Courtesy of the Museum of American Art of the Pennsylvania Academy of the Fine Arts, Philadelphia. Gift of Paris Haldeman.

Sargent rivaled Van Dyck and his English baroque successors, produc-
ing canvases, such as *Mrs. Henry White* (see fig. 18), that read as up-
dated Van Dycks. Indeed, in his successful late career as purveyor of
portraits to the English aristocracy, Sargent seems to have carried on a
necessary and self-conscious dialogue with tradition, producing pen-
dants to family portrait heirlooms.[56]

Sargent also followed Carolus-Duran in adopting concurrent in-
terests in portraiture and genre painting, shared his affection for the
painterly realism of certain contemporaries, and may have been intro-
duced to avant-garde notions and individuals by Carolus. When Sar-
gent sketched *Rehearsal of the Pasdeloup Orchestra at the Cirque d'Hiver*
(1876; Museum of Fine Arts, Boston), he was probably responding to
the example of Degas's theater scenes such as *The Orchestra of the
Opéra* (ca. 1870; Musée d'Orsay, Paris). For *In the Luxembourg Gar-
dens* (1879; Philadelphia Museum of Art, John G. Johnson Collec-
tion), with its rapid brushstrokes, brilliant palette, and interest in a
casual incident in a paradigmatic modern urban space, a public park,
Sargent took his example from Monet, Manet, Degas, Pierre-Auguste
Renoir, and Gustave Caillebotte. The asymmetrical setting and scat-
tered focus among the sitters in *The Daughters of Edward D. Boit* also
suggest the influence of Manet and Degas; the thinly painted surfaces
and hazy forms of *Venise par temps gris* (ca. 1882; National Trust, Eng-
land) imply the influence of James McNeill Whistler.

Although Sargent's portraits owed much to the manner of his
teacher, they are usually more spirited and more convincing in their
characterizations than those of Carolus.[57] Summarizing the influence
of Carolus-Duran upon Sargent, Blashfield remarked: "The younger
man's canvases always bore a reminder of the master, but the reminder
became so faint as to be negligible, for Sargent sublimated the texture
of Carolus's handling into something more felt and distinguished."[58]
It is difficult to disagree with Blashfield when we measure the candor,

14. Carolus-Duran, *Mme G. Feydeau and Her Children*, 1897.
Oil on canvas, 75 x 50 5/16 in. National Museum of
Western Art, Tokyo.

naturalism, and psychological nuance in similar portraits by both artists: even Carolus-Duran's praiseworthy *Lucy Lee-Robbins* is outshone by the brio of Sargent's vivacious *Mrs. Edward Darley Boit* (see fig. 35) or the ravishing *Lady Agnew* (ca. 1892–1893; National Gallery of Scotland, Edinburgh), with her direct, yet demure gaze and relaxed pose. In Carolus-Duran's awkwardly reserved portrait *Mme G. Feydeau and Her Children* (fig. 14), his daughter, Marie-Anne, now grown, and his grandchildren remain aloof from the viewer who might be more susceptible to Sargent's insouciant and psychologically provocative *Mrs. Carl Meyer and Her Children* of the prior year.

Carolus-Duran's stylistic influence upon Sargent is easier to assess than his personal influence, and the documentation that would support the claim that he "served as a role model for the lifestyle Sargent adopted" is elusive.[59] At the least, the two artists appear to have formed a cordial relationship early in their association, Sargent becoming less of a student and more of an apprentice to Carolus. In January 1875, Sargent and two other American students — Hinckley and Stephen Hills Parker — accompanied Carolus-Duran to Nice. When illness forced Hinckley and Parker to leave, Sargent recounted that "Carolus Duran took one of their vacant beds in my room" and spent three additional days with him in Nice before the two returned to Paris.[60] The writer of a brief notice on Sargent that appeared in *Art Amateur* in 1880 remarked: "The friendship existing between this young artist and his instructor, M. Carolus Duran, is of somewhat unusual intimacy. M. Duran, in his summer vacations, goes to his birthplace at Lille, where he is received by the citizens with ovations and an indigestible frequency of dinners. On these occasions he loves to have his young American disciple in company, introducing him to his relatives and making him a participant in his honors."[61] Carolus little envisioned the extent to which his young disciple would outstrip him in accomplishments, awards, and reputation.

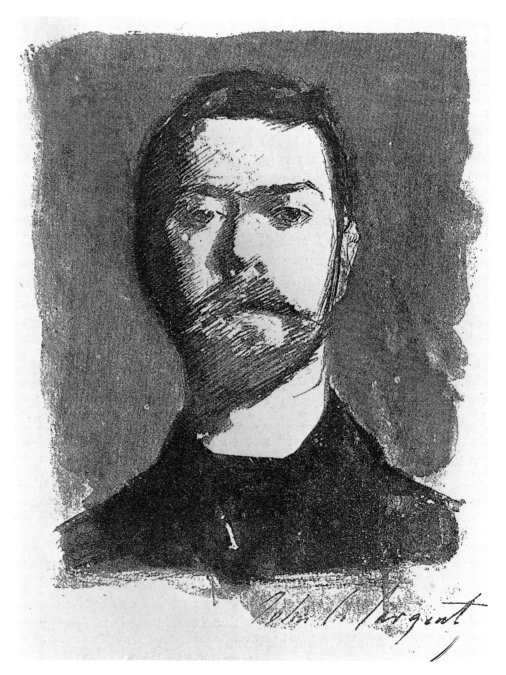

15. John Singer Sargent, *Self-portrait,* ca. 1886. Reproduced from an uniden-
tified clipping, Photograph Collection of the Sterling and Francine Clark
Art Institute, Williamstown, Massachusetts.

Sargent and His Critics

MARC SIMPSON

The first decade of John Singer Sargent's career offered to the acute perceptions of Henry James the "slightly 'uncanny' spectacle of a talent which on the very threshold of its career has nothing more to learn."[1] The writer chose his words carefully, selecting his adjective to convey the almost magical way that observation, technique, and maturity seemed to combine in the young American painter. James continued by noting that "perception with him is already by itself a kind of execution. . . . It is as if painting were pure tact of vision, a simple manner of feeling."[2] In effect, according to James, Sargent had only to think of how an object should be painted — to look and consider the world before him — and that internal vision would appear on the canvas with no lapse in painterly technique to compromise it. But why did a wordsmith as skilled and deliberate as James put the word *uncanny* in quotation marks? The only reasonable response is that the quotation marks establish a subjunctive, counter-to-fact use — parallel to the later "it is as if painting were." James, a close friend of the painter from 1884 on, knew, as we do through hindsight, that, although Sargent was a gifted draftsman and painter, he labored over his work. He plotted his major canvases at length, often scraped away days if not weeks of effort, sometimes made second versions of a finished composition when the traces of the campaign appeared too evident. He strove hard, successfully, to make the result seem effortless.[3]

The same inflected sense of *uncanny* applies to Sargent's swift attainment of an international reputation. Just as his skills were not supernatural gifts but hard-won achievements, his early exhibition history and the critical responses to it demonstrate that he moved with deliberation and nearly uniform good judgment among the many options of the art world. He was ultimately successful — a painter of aristocrats and plutocrats, honored in his day as the greatest portraitist of the era.[4] The foundations of this fame were laid not simply by chance or good fortune. From the beginning, Sargent was determinedly, cannily focused on the creation of a notable career.

Making a Reputation

In the 1870s and 1880s, as now, many components played a role in the
creation of an artist's reputation: studio visits by patrons and collec-
tors; word-of-mouth praise among them and the painter's colleagues;
circulation among members of society likely to commission portraits
or purchase pictures; representation by a commercial gallery (entities
only just beginning to operate in the manner and on a scale akin to
their modern successors). But far and away the most important ele-
ment of becoming known was putting work before the public in exhi-
bitions and then having that work written about by one or more of
the many well-known art critics of the era.

Maneuvering within these arenas was somewhat more compli-
cated than had been the case just a decade earlier, when a painter's al-
legiance was generally confined to limited social strata and political
entities. During the latter part of the nineteenth century, however, the
international art world as we now know it arose. Relatively speedy and
inexpensive modes of travel and surer means of communication
bridged distances. World's fairs brought together multitudes of objects
from diverse countries and cultures for the education and delectation
of middle- and upper-class visitors. Publishing companies established
a plethora of specialized art periodicals, many of which provided inter-
national digests of gossip and news; some of these publishers created
links to similar periodicals in other countries or themselves offered si-
multaneous, if not necessarily identical, editions in several cities. The
development of inexpensive reproductive techniques allowed for the
widespread dissemination of images, both in periodicals and as single
sheets suitable for framing. European commercial dealers established
galleries on both sides of the English Channel and, eventually, the At-
lantic Ocean, first to promote the urge to collect paintings and prints
and then to satisfy the new demand. The concurrent rise of public
museums throughout Europe and America stimulated a broad interest
in the arts, as did a proliferation of academies devoted to both profes-
sional and amateur art training. The collecting of art, once limited to
the extremely wealthy, became an activity in which many middle- and
upper-middle-class individuals felt able — indeed, compelled — to par-
ticipate.[5]

Artists of ambition thus began to think not of local, or even na-
tional, but of international fame. Sargent was the ideal candidate for
this new kind of renown — born in Florence of American parents,
schooled in Italy and Germany, trained in Italy and France, at home

in (to the degree that such a phrase could have meaning for his no-madic upbringing) a society dominated by British and American expa-triates, and fluent in several tongues.[6] And indeed, he sought and achieved recognition in Paris, New York, and London before 1887. He also took part in exhibitions of contemporary painting in Boston, Philadelphia, Brussels, Dublin, and Geneva, although these venues seem to have been diversionary forays compared to his sustained efforts in the three larger cities.

Sargent began his campaign for public recognition in 1877. Given his training in Paris, it is not surprising that he chose the annual Salon, held in the Palais de l'Industrie from May through June, for his debut.[7] In terms of international attention and respect, this was the preeminent art event of each year, where thousands of paintings were submitted by artists from across Europe and the Americas, judged, ex-hibited, and ranked by juries composed of the most respected French artists of the day. Many would-be exhibitors were refused. Hundreds of thousands of people visited the galleries over the six- to eight-week-long exhibitions. Critical responses to the works formed front-page articles in many of the day's newspapers and periodicals.[8]

Sargent submitted at least one painting to the Salon each year from 1877, when he was just twenty-one, through 1886; during this pe-riod it was his principal exhibition site. In each of these years (except for 1878), he showed portraits, generally at life scale, most often in a full-length format. These works, in all but one instance featuring young women or children, commanded considerable wall space, pro-vided a clear focus that could attract attention and empathy, and ad-vertised his most marketable skill.[9] In 1881, 1883, 1885, and 1886 the submissions included a group portrait showing from two to four indi-viduals, demonstrating Sargent's prowess at more complicated compo-sitional structures and narrative interactions. Although the painting of likenesses was a key public enterprise for Sargent, as with most of the major French portraitists of the age, he simultaneously sought to indi-cate his versatility to the Salon audience by submitting subject paint-ings each year from 1878 to 1882. These works, of medium to large scale, showed figures inspired by his travels to such exotic locales as Brittany, Capri, Tangier, Venice, and Spain. He was singularly suc-cessful at the Salon, winning an honorable mention in 1879 for *Carolus-Duran* (his sole submission of a portrait showing an adult male) (cat. 4), a second-class medal in 1881 for *Mme Ramón Subercaseaux* (fig. 16), and immense renown.

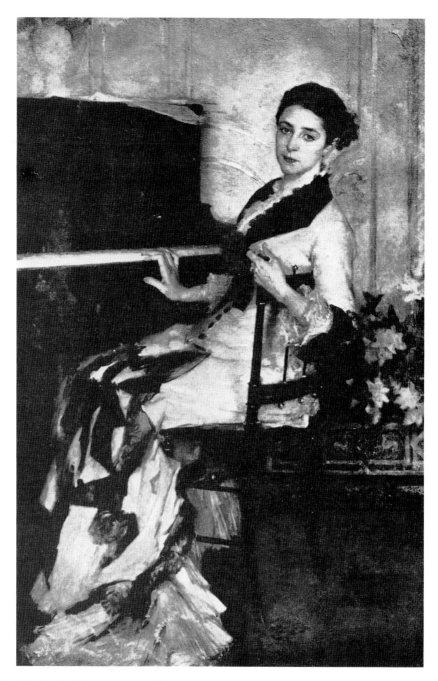

16. *Mme Ramón Subercaseaux,* 1880. Oil on canvas, 65 x 43 1/4 in.
Private collection.

Paris was also home to a number of smaller, independent exhibi-
tion societies during the first decade of Sargent's professional life.[10]
Some were organized and run by the artists themselves, but more had
a fairly constant relation with a social club or a particular commercial
gallery. These smaller exhibitions of the 1870s and 1880s (one writer of
the time called them *salonnets*) have been little studied, with the nota-
ble exception of the Société des indépendants (or impressionists),

whose exhibitions Sargent attended but in which he was never asked to participate.[11] They were all, however, important parts of the fashionable art world of the time, considered indispensable to "l'intellectualité de notre Parisianisme."[12] Among the most famous of the salonnets during the years of Sargent's early maturity were those organized by three private clubs: Le Cercle de l'Union artistique, also called the Cercle de la place Vendôme, or the Mirlitons; Le Cercle artistique et littéraire de la rue Volney; and Le Cercle des Arts libéraux. Opening their annual shows in February and March, each of these featured a relatively small, reasonably stable group of artists — all of whom were successful at the Salon — and generally included between 150 and 200 works. Sargent exhibited at both the Cercle des Arts libéraux and the Mirlitons during the early 1880s. We know from reviews that he showed principally his Venetian genre scenes there (although we can only speculate about which ones) as well as portraits.[13]

The Galerie Georges Petit on the rue de Sèze — which opened in February 1882 — was one of the most luxurious of the day.[14] Among the many special events organized there were the exhibitions of the Société internationale de peintres et sculpteurs, whose inaugural exhibition was in December 1882. This group was sometimes called "les jeunes," to distinguish it and its winter exhibition from the Expositions internationale de peinture, a series begun in late spring 1882, also at the Galerie Georges Petit.[15] Sargent showed once with each group during this period. Among the twenty-two artists in the first show of the Société internationale de peintres et sculpteurs — all young and well regarded, including Jules Bastien-Lepage, Jean Béraud, Giovanni Boldini, Jean-Charles Cazin, Ernest-Ange Duez, Albert Edelfelt, R. de Egusquiza, Max Liebermann, William Stott, and Jan Van Beers — Sargent was a major exhibitor. He showed seven paintings, comprising a mix of informal individual portraits (none larger than head and bust), the experimental *Daughters of Edward D. Boit* (fig. 17), which shattered proprieties of portrait format and emphases, and four Venetian genre scenes. The artist clearly thought of it as a site for innovative, potentially controversial work. It was not until 1885 that he participated in the Exposition internationale de peinture — Béraud, Cazin, Edelfelt, Egusquiza, Liebermann, and Van Beers from the earlier group also showed, as did Claude Monet, Alfred Stevens, and Albert Besnard, joining such stalwarts as Léon Bonnat. Sargent contributed four works, ranging from the major full-length portrait of Mrs. Henry White (fig. 18) to the informal *Dinner Table at Night (The Glass of Claret)* (cat. 29). Sargent was friends with a number of

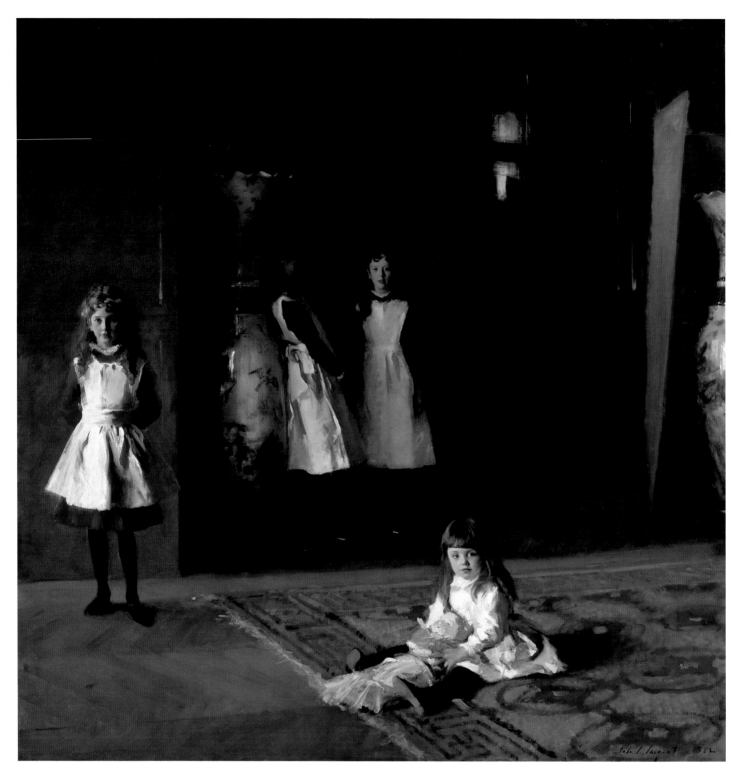

17. John Singer Sargent, *The Daughters of Edward D. Boit*, 1882. Oil on canvas, 87 x 87 in. Gift of Mary Louisa Boit, Florence D. Boit, Jane Hubbard Boit, and Julia Overing Boit, in memory of their father, Edward Darley Boit. Courtesy, Museum of Fine Arts, Boston.

his young co-exhibitors in these two groups, sketching their portraits or giving them paintings.[16]

In New York, Sargent also aligned himself with a group of younger men, the Society of American Artists, several of whom were friends from student days in Carolus-Duran's atelier. The group was formed in 1877 in direct response to the perceived slights and exclusions of the major American artists' organization, the National Academy of Design. The society's artists were generally European-trained and cosmopolitan in outlook, as opposed to the older artists of the academy, many of whom had trained in the United States or whose works, at the least, gloried in native subjects. "This exhibition means revolution," wrote one of New York's leading art critics on seeing the society's first annual exhibit in March 1878.[17] Sargent showed in the first four exhibitions of the society, from 1878 to 1881 and again in 1883 and 1886, as well as serving as a Parisian representative of its selection committee.[18] Yet the society was clearly a secondary venue for him; in the first two years he sent penultimate versions of genre scenes whose final renditions he was to send to the Salon that same season: the small, loosely brushed study of *Fishing for Oysters at Cancale* (cat. 2), and what seems to be the earlier, more heavily worked version of *A Capriote* (cat. 6). In 1880 and 1883 he sent works that had been seen at the Salon the year before. In 1881 he exhibited two small heads, including the splendid but tiny *Head of Ana-Capri Girl* (cat. 5); in 1886, two portraits, at least one of which — that of Mr. and Mrs. John White Field (cat. 23) — was several years old. Only once during this first decade of activity, in 1879, did he have a work shown at the better established National Academy of Design. In spite of the welcome attention that *Neapolitan Children Bathing* (cat. 8) received at the academy, he did not submit there again until 1888.

It seems possible that one reason Sargent did not exhibit at the Society of American Artists in 1882 was his focus on England that year (barring, that is, his primary devotion to Paris). In the spring and summer Sargent stormed the ramparts of the British capital, showing works at three London venues. He sent three small, relatively informal canvases — two Venetian scenes and a study of a young man — to the high temple of English aestheticism, the "greenery-yallery" Grosvenor Gallery (as Gilbert and Sullivan put it in their lampooning operetta *Patience*).[19] Three major canvases from previous Salons were on view at the Fine Art Society, a commercial firm founded in 1876 that championed especially the work of English Aesthetic and Arts and Crafts workers. This was also the first time that Sargent submitted a painting

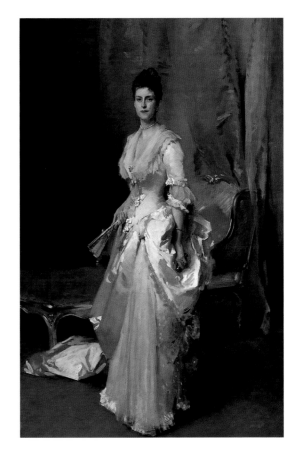

18. John Singer Sargent, *Mrs. Henry White*, 1883. Oil on canvas, 87 x 55 in. In the collection of The Corcoran Gallery of Art, Washington, D.C. Gift of John Campbell White.

— the dazzling, never-before-seen full-length *Dr. Pozzi at Home* (cat. 21) — to the Royal Academy, London's answer in pedigree and prestige, if not international clout, to the Paris Salon. In spite of some very favorable responses to the work, Sargent waited until 1884 to show at the academy again; thereafter, however, his submissions, all portraits during this period except for *Carnation, Lily, Lily, Rose* of 1887 (cat. 35), played significant roles in the institution's annual summer exhibition. He also continued to show portraits, by invitation, at the Grosvenor (1884 to 1886), and was from 1886 an exhibitor at the New English Art Club — England's institutional home for, among others, painters of impressionist tendencies.

Sargent's participation in these and other exhibitions through 1887 demonstrates his efforts to appeal to audiences of diverse tastes. He used the principal exhibition venues of the city in which he was living (the Paris Salon until 1886, London's Royal Academy thereafter), to debut his most impressive portraits and largest genre scenes. His more experimental works, comprising portrait studies and informal genre scenes, were included in group exhibitions most frequently housed in upscale galleries, such as the Georges Petit or the Grosvenor, known for their elegant appointments. When he showed in other cities in Europe and America, it was within the context of contemporary if not revolutionary art. What he did not do from the mid-1870s to the mid-1880s, so far as we know, was to show at any of the major state- or exposition-related exhibitions in other European or American centers — Brussels, Chicago, Ghent, Louisville, Manchester, Milan, Munich, Rome, San Francisco, or Vienna. At the opposite extreme, he did not seem ever to need alternative exhibition facilities — restaurants, cafés, windows of art-supply shops, and the like — as various friends and colleagues did.[20] He was, that is to say, focused in terms of both locale and status. And although he left relatively little in the way of writings about his paintings or practice, among the few bits to survive are indications that his choice of venue was deliberate. In 1885 he wrote to Henry James, "certainly neither my R.A. nor my Grosvenor are calculated to bring me into much favor. But this year I felt bound to collect as many good things as possible in Paris."[21]

Sargent frequently arranged for a noted painting to make appearances in several cities. His portrait of Carolus-Duran, for example, won him an honorable mention at the Salon of 1879; the next year he sent the painting to New York; in the summer of 1882 he included it, somewhat eccentrically, in an exhibition in London billed as consisting of English and American works from that spring's Salon, and to

which he did, in fact, also send his two Salon paintings from that season. It was again seen in Paris in 1883 at the *Portraits du siècle* exhibition at the Ecole des beaux-arts. Both of the 1882 Salon paintings, meanwhile, after being in London, were forwarded to New York and Boston within the year.

A truly successful work was currency in the purchase of a reputation; the more it was seen, the more it was worth. It could not readily be used up. Art critics, by and large, encouraged the wide circulation of a given painting, noting when and where it had been exhibited before (taking pride in being able to add their own cities to the list) and, on a more figurative level, alluding frequently to works previously seen. They expected their readers to keep a given artist's productions in mind over the span of a decade or more, revisiting triumphs of past years, holding up certain works as exempla to be met or as milestones on the way to the present achievement. The more an artist's work was noticed, the better it was for the artist's fame.

In this regard, Sargent's early career is especially notable for the immediacy of its success. Writers for some of Paris's most prestigious journals traveled through the crowded rooms of the 1877 Salon, packed with almost 2,200 paintings, and selected for favorable notice the very first effort he put before the public: *Fanny Watts* (cat. 1). They singled out the painting as new and pleasantly unsettling.[22] The portrait's bright-colored background drew the eye, and the internal tension of the pose (elaborately nonchalant, striving for casualness but twisted instead more like a coiled spring) compelled attention. Critics at both the Salon and the following year's Exposition universelle, where Sargent again exhibited the painting, praised its projection of brio and coquetterie, pronouncing it a reveille to the frigid series of female portraits that lined the walls.[23] Attractiveness of subject, vitality of handling, and especially informality of pose were all to become leitmotivs of the early favorable reviews.

For the Salon of 1878, Sargent turned from portraiture, submitting instead a large scene of French country life, *Oyster Gatherers of Cancale* (cat. 3). As his portrait of Fanny Watts was simultaneously on display at the Exposition universelle, which opened just three weeks before the Salon, this choice should probably be seen as a conscious demonstration of versatility. A critic for the *Gazette des beaux-arts* praised the genre painting, especially its brightness and high tone, which seemed to generate light from within the picture. Even more, simply as pure painting, he applauded the vigor and dynamism with which the materials were used: paint visibly stroked and dabbed across

the surface, readable as a depicted object only when seen from a distance.[24] A smaller, even more dynamic version of the work was Sargent's submission to the inaugural exhibition of the Society of American Artists in New York in 1878 (cat. 2). The critics there praised the painting's "silvery hue," "magical" rendition of atmosphere, and in retrospect asserted it to be "the most certain and manifold artistic success of the season" for both public and connoisseurs alike.[25]

Thus, at the end of his first two years of effort, Sargent had exhibited three paintings in four venues — two Salons, a world's fair, and America's most exciting exhibition society — aiming at European-American culture's most challenging artistic arenas. In each he found favor. Discerning critics noted his works with near-universal approval, in Paris in a small but choice group of journals, and in New York in an extensive number of prominent magazines and newspapers. Sargent thereafter rarely exhibited at the major expositions without garnering a comparable quantity of notices — although the critical stance was to become more varied and vehement. On an economic level, he sold both available works from the exhibitions of these first years — one to a family acquaintance and the other to an older American painter. All of these factors contributed to the nurturing of reputation, to the sense of professional promise healthily rooted and sending forth shoots.

Questions of Nationality in an International Context

Henry James opened his discussion of Sargent by raising the rhetorical question of the artist's nationality: "Is Mr. Sargent in very fact an American painter?" With typical wit, he first responded trivially: "The proper answer to such a question is doubtless that we shall be well advised to claim him, and the reason of this is simply that we have an excellent opportunity." Ultimately he answered the question more paradoxically, deciding that Sargent's "great symptom of an American origin" was "that in the line of his art he might easily be mistaken for a Frenchman." This led to the insight that "when to-day we look for 'American art' we find it mainly in Paris. When we find it out of Paris, we at least find a great deal of Paris in it."[26]

James's point of view concerning the unimportance or blurring of nationalities, a decidedly self-referential stance, was not universal.[27] In an age fascinated by the possibility of classification by type, size, shape — the taxonomy of the world — the issue of national identity was of great moment in the 1880s art press, uneasily holding in check the

competing forces of cosmopolitanism.[28] Thus critics often used a
given artist to exemplify a specifically national school of art, be it
French, German, American, or such hybrids as Franco-American.[29]
Phrases as gleefully chauvinistic as "our national genius in the art of
portraiture" proliferated.[30]

Art writers of the 1880s used notions of nationality in a variety of
ways. On the simplest level, critics of the Salons often organized their
reviews on the basis of the artists' geographical origin, heading one in
an extended series of critiques, for example, "Le Salon de 1880: Les
Etrangers."[31] The world's fairs that abounded from the middle of the
nineteenth century onward — with exhibitions of art and industry or-
ganized by country, often supplemented with separate national pavil-
ions — encouraged this form of critical compartmentalization.

But nationalistic classification also encouraged a hybrid of patrio-
tism and xenophobia to enter the art arena. Paris was the "capital of
the nineteenth century," as Walter Benjamin memorably phrased it,
for art as well as urban planning. "We are flattered, as Frenchmen, to
see foreigners coming to ask of us the secrets of Art," wrote a critic for
L'Art.[32] This was a seemingly universal truth: it was in France that
painters learned to be great artists. One commentator on the Salon be-
gan a section of his review with the pointed sentence: "Here come the
legions of foreigners, too numerous but very brilliant, thanks to us."[33]
Another critic noted, when protesting the use of the word *interna-*
tionale on the occasion of the first exhibition of the Société interna-
tionale de peintres et sculpteurs, "all, to an equal degree, *sucked art*
from French breasts."[34]

Pride of position, however, easily became fear of loss. Foreigners
swarmed, rivalries simmered. Critics couched success in the art world
in martial language, with artists becoming soldiers on a cultural bat-
tlefield: "The borders of art are nearly fallen; rivalry has seized all the
races; each, with equal ardor, trains itself to draw, to paint, to study
nature, to observe life. If foreigners modestly enroll in our schools, it is
to learn from us how better to struggle against us, with the secret hope
of vanquishing us one day."[35]

For many writers, the specter of a guest who would thus turn on
the host, of a child who would conspire to outshine the benign suc-
corer, was a specially horrid perfidy. Americans in particular sparked
thoughts of treachery in the French critical mind, leading to articula-
tions of an intense patriotic rivalry. To a degree, this reflected larger
social concerns.[36] The society columnist for *L'Illustration* perceived
that in Paris itself, Americans were challenging the French for su-

premacy in the realms of sport, art, finance, and society — even the celebration of Bastille Day: "Beware this people that grow ever larger. . . . *Uncle Sam* threatens with his gnarled, industrious hands our commerce, our agriculture, and our stables. It is a stealthy war, but they come to hoist their victory flag over our land."[37] The writer enumerated among the perceived threats: "They have painters who seize our medals, such as M. Sargent, and pretty women who eclipse ours, like Mme Gauthereau," a prescient linkage years before Sargent began his portrait of the famed beauty.

Numerous French writers found Sargent to be a convenient target for xenophobic darts. Prompted by his entry at the Salon of 1883, one characterized the unsentimental presentation of the daughters of Edward D. Boit in nationalistic terms: "These portraits have something false and impertinent in the American fashion, cold and cruel."[38] But the French critical voice did not speak in unison: "Must one count M. Sargent among the foreigners? He was born in America [*sic*], but he learned to paint in Paris, under the guidance of M. Carolus Duran. He does honor to the city and to his professor."[39] Or again: "We French should regret that the Paris public may not seize the significance of this talent [Sargent's], which answers so perfectly to the qualities of our race."[40]

Critics of other nationalities, too, were willing to grant Sargent, or his paintings, French citizenship. The Belgian correspondent for *Le Figaro* noted that he included Sargent in his discussion of French painters since, although American by birth, "he belongs by his masters and his manner to the young French school."[41] Writing of the portrait of Carolus-Duran, one American opined that it was "French work through and through. French no less in technique, which is twin to that of more than one Parisian we know of, than in its feeling and its meaning as a work of art."[42] Another American, who seemingly hated both the subject and the handling of Sargent's portrait of Madame Pailleron (cat. 9), summarized her scorn for the work by calling it "of the French, Frenchy."[43] Even Sargent, writing in 1885 to an artist friend in Australia, said that the British considered his portraits to be "beastly French,"[44] an observation confirmed during the next several years as London critics condemned "a certain Parisian *clique* of stylists, at the new English Art Club" and mentioning him by name, or complained of him as "the arch-apostle" of the "'dab-and-spot' school."[45] This was perhaps most direct when the British correspondent of *Le Figaro* used as a subhead in one of his bulletins: "Les artistes français: MM. Bouguereau, Sargent et Rodin."[46]

With Sargent's move to London in 1886, however, the question of his status as an "honorary" French citizen was largely put to rest. British critics, at least to 1887, did not claim him for the sceptered isle, nor did American critics expatriate him there. Perhaps the bonds of language and literary culture that linked England to America let such issues lie in abeyance.[47] Henry James certainly felt that such distinctions were useless: "I can't look at the English and American worlds, or feel about them, any more, save as a big Anglo-Saxon total, destined to such an amount of melting together that an insistence on their differences becomes more and more idle and pedantic."[48] And while questions of Sargent's actual citizenship did arise later, as when he was elected an associate in the Royal Academy in 1893 and when he declined a knighthood in 1907, the native Florentine remained American.[49] It was the Albany-born Henry James who, in 1915, became a subject of the British king.

Sargent and His Contemporaries

The groupings that the critics made — the living artists to whom they compared or contrasted Sargent — help illuminate his place in the art world during his early career. The contemporary artist most frequently mentioned in this context was his teacher, Carolus-Duran.[50] Many exhibition catalogues listed artists' masters as part of their identifying apparatus, along with birthplace, birth date, title of work, and so on; critics generally saw this information as worthy of repetition. Many reviewers also liked to give a bit of biographical background in their notices, to provide a pedigree or imprimatur for the younger artist: "The friendship existing between this young artist and his instructor, M. Carolus Duran, is of somewhat unusual intimacy. . . . [H]e loves to have his young American disciple in company, introducing him to his relatives and making him a participant in his honors."[51] Thus from 1878, with Sargent's first American exhibition, through at least 1886, French, British, and American writers frequently found a way to mention the fact that the American had studied with the Frenchman.

But more often, and this does not seem a common strategy in the reviews of other teacher-student pairs, critics set them against one another. The preponderance of English-speaking writers favored Sargent. Very early in the artist's career one wrote that Sargent "reads everything, and in the studio is treated as a comrade by M. Carolus-Duran, who is indeed something less than the equal of his precocious pupil."[52] More bluntly, another critic wrote, the American "paints better than his professor."[53] Year in and year out, Carolus-Duran was sav-

aged and Sargent was praised by a significant number of American and, to a lesser extent, English critics: "Mr. Sargent's 'Portraits d'Enfants' is a delightful picture, full of freshness and life. . . . M. Carolus Duran's work is, if possible, more vulgar than usual this year."[54] Even in the face of the scandal of Sargent's portrayal of Madame Gautreau, the critic for the *American Architect and Building News* wrote, "Mr. Sargent is in a fair way to eclipse his master, M. Carolus-Duran, if the world does not spoil him and make him careless."[55] Nor did nationality of the critic determine allegiance. A number of French-language writers weighed in on the American's side, as when *L'Art* reviewed the Cercle des Arts libéraux exhibition of 1881 and found Sargent's Venetian studies particularly revelatory of "eminently distinctive and distinguished qualities," which thus did "singular harm to his master," who had decided to show, "under the pretext of sketches, daubs as mediocre as those which he has called *Vision* and *La Gloire*."[56]

The syndrome was most obvious, paradoxically, in the responses to Sargent's portrait of Carolus-Duran. In spite of its overt witness of mutual respect and affection — on the one hand, in the master's sitting for the pupil and, on the other, in Sargent's dedication to "cher maître" in the prominent inscription along the top of the canvas — the painting prompted an outpouring of poisonous comments. When it was at the Salon in 1879, the critic for the *New-York Times* praised it with a backhanded compliment for Carolus-Duran's chief Salon entry, which won that year's highest honor, and launched a personal jab at the Frenchman: "[Carolus-Duran's *Portrait de vicomtesse de V.* is] free from his usual vulgarity but it is not so good as his own portrait by our own promising young countryman Mr. Sargent, whose only fault is that he has made the copy look more refined than the original."[57] The same strategy of praising the painter while decrying the sitter proliferated when the painting went to the United States in 1880 for the Society of American Artists exhibition: "One must not speak of the subject of a portrait, but so much may be allowed to say that if the fatal word 'vulgar' rises to the lips, it is not Mr. Sargent who provokes it."[58] When the painting was shown in England in 1882, with Sargent attaching to it the almost adulatory title *Portrait of My Master, Carolus Duran*, a comparable snideness toward the sitter surfaced, one writer calling the work "excellently apprehended and painted," but noting that the figure was "made to look a little like a brilliant dentist."[59]

This by no means unanimous but nonetheless sizable group of public voices seems to be seeking to induce, *avant la lettre*, an Oedipal conflict. Even with the best will in the world, these comparisons could

result in tension between the two painters, as some journalists rather gleefully recognized. The editor of the *Art Amateur*, who was generally hostile to Sargent, cackled: "John S. Sargent is, or was, the favorite pupil of Carolus Duran. The accomplished Frenchman used to be very proud of him. But if our Sargent continues, as he is doing, to win from the critics abundant praise, while his master receives nothing but blame — well, I'm afraid 'he'll get himself disliked.'"[60] Whether this bounty of divisive critical responses bore fruit, as predicted, or their relationship simply evolved in different directions, we do not know. By 1885, however, Sargent wrote to a mutual friend: "Carolus goes on painting magnificently. I hardly ever see him. I have quite fallen away from him."[61] The American still admired the Frenchman's painting, but the close personal friendship, which had earlier been described as "of somewhat unusual intimacy," had irreparably unraveled.

By virtue of his citizenship and the circumstances of where he showed his work, Sargent was naturally discussed with other American painters. In the American press, his name frequently appeared with those of other young Americans trained in France (as Abbott Handerson Thayer), or such friends from student days as J. Carroll Beckwith, Wyatt Eaton, and J. Alden Weir. These references occur especially in discussions of the Society of American Artists, where the francophile painters were seen as a significant new force on the contemporary art scene.[62] Critics of all nationalities concerned with American progress in the international arena spoke of him in company with William Dannat, Herbert Denman, Elizabeth Gardner, Henry Mosler, Charles Sprague Pearce, William Picknell, Julius Stewart, and other now lesser-known lights who had notable successes in one or another year's Salon.[63] The two Americans with whom he seems most trenchantly compared, however, were William Merritt Chase and James McNeill Whistler.

In the early 1880s, Chase and Sargent were seen as leaders of two competing branches of American modern painting: Chase representing the Munich school of bravura brushwork, dark tonalities, and seemingly arbitrary coloring; Sargent exemplifying a lighter, more academic French technique. Responses to the Society of American Artists exhibition of 1880 (and the altered, reduced version at Boston's St. Botolph Club) were the first to standardize the men as embodying this polarity. Writers proclaimed Sargent's *Carolus-Duran* and Chase's portrait of General James Watson Webb (1880; Shelburne Museum, Shelburne, Vermont) to be the dominant works on view — "almost enough in themselves for an exhibition" — and used them to charac-

terize their respective movements.[64] The pairing continued through-out the period, notably in reviews of the Paris Salon of 1882 and the first exhibition of Les XX in Brussels.[65] For the latter exhibition, each painter responded to the invitation to participate by sending (presum-ably independently and without knowledge of the other's actions) a life-size portrait painted almost entirely in red tones: Sargent's *Dr. Pozzi at Home* and Chase's *Study of a Young Girl* (ca. 1883; National Academy of Design, New York). Comparisons proved inevitable: "John Sargent shows opposite Chase. And the danger comes in that he exhibits not only a portrait, but a red portrait," noted one Belgian writer, praising Chase at Sargent's expense.[66]

Another American painter included in that first exhibition of Les XX was Whistler, who also showed large, monochromatic portraits — not, however, red. The same Belgian critic who so disliked Sargent's *Dr. Pozzi at Home* observed that Whistler's works were, simply, "per-fection realized."[67] Comparisons between the two men were rarely so one-sided.[68] Especially in the European press from the mid-1880s on-ward, Sargent and Whistler (who was the senior by more than twenty years) were together considered the two foremost American painters, admired for their successful enterprise in the capitals of European cul-ture no less than their advanced picture-making talents: "The two great American painters today are MM. Whistler and Sargent," wrote one French critic in 1886.[69] Indeed, Sargent solidified the association when, in 1886, he moved into a studio in London's Tite Street that had earlier been occupied — and painted yellow — by Whistler.[70]

Other contemporary artists were occasionally noted in connection to Sargent. These references, prompted purely by the look of his art rather than biographical connections, help reveal how Sargent's paint-ings were perceived in this first decade of his career. The writings on the earliest exhibited genre works — the multiple versions of the Can-calaise oyster gatherers and the Capriote standing against an olive tree, and the single rendition of the Neapolitan children bathing — com-pare them to such contemporary Italian and Spanish painters as Gio-vanni Boldini, Mariano Fortuny, and, especially, Francesco Paolo Michetti. When, for instance, in 1879 the art critic for the *Aldine* saw the Salon version of *Among the Olive Trees, Capri* (cat. 7), it was the work of the now little-known Michetti that came to his mind, so much so that he called Sargent's image "rather an imitation" of the Italian's work; other critics claimed the same insight concerning the version shown at the Society of American Artists that year.[71] The critic for the *Nation* went so far — in what is perhaps a rhetorical rather

than reportorial gesture — as to quote Sargent himself saying that his *Neapolitan Children Bathing* at the National Academy, also in 1879, was "too much like Michetti."[72]

It does not seem surprising that Sargent, born and raised in Italy, should be sensitive to contemporary Italian art, especially as so much of it could be seen in Paris.[73] Nor is it unexpected, given the popularity of painters such as Ernest Meissonier, Adolf von Menzel, and a host of others of various nationalities who were working in a related manner — emphasizing small scale, flashing sunlight, and a selective focus that abetted an easy reading of the scene's anecdote — that the young Sargent should experiment in the mode. What is noteworthy is that, for all intents and purposes, only American critics of the late 1870s (not their French or British colleagues and few later writers of any nationality) highlighted a connection. Modern Italian art evidently had a far more prominent profile in the United States than is now acknowledged; indeed, a writer of the time called it "conspicuous as it everywhere is."[74] It also suggests that for the first two years of exhibitions in the United States, Sargent capitalized on that national predilection, through both the handling and the subject of what he chose to show. It is equally noteworthy that from 1880 through at least 1887, these same American critics failed to trace any Italian parallels to Sargent's paintings. This change in their allusions concretizes the painter's move away from the exhibition of small-scale, sunlit genre scenes. Sargent's career is not a flowing continuum but contains angles and stoppages; after 1879 he chose to be known for works of a different style than the international glare-aesthetic.

Understandably, given his place of residence and the predominance of the Salon in his exhibition strategy, the majority of links to Sargent's works suggested by critics were to French painters. In some instances, the writers praised Sargent by saying that his work was either superior to or nearly identical with that of a well-known academic artist; Léon Bonnat, Alexandre Cabanel, Ernest Hébert, and Charles Chaplin were all probably perplexed to find themselves linked to the young American.[75] And certain of Sargent's paintings were on occasion associated with works by his less-academic contemporaries — *Mme Edouard Pailleron* with the lightened palette and high horizon of Bastien-Lepage, or *El Jaleo* (fig. 19) with the drama of the still-lamented Henri Regnault.[76] By being discussed together in reviews, his friends Cazin and Duez, too, and the painter-sculptor Paul Dubois were often linked to him — young artists possessing a challenging but not revolutionary stance to tradition.

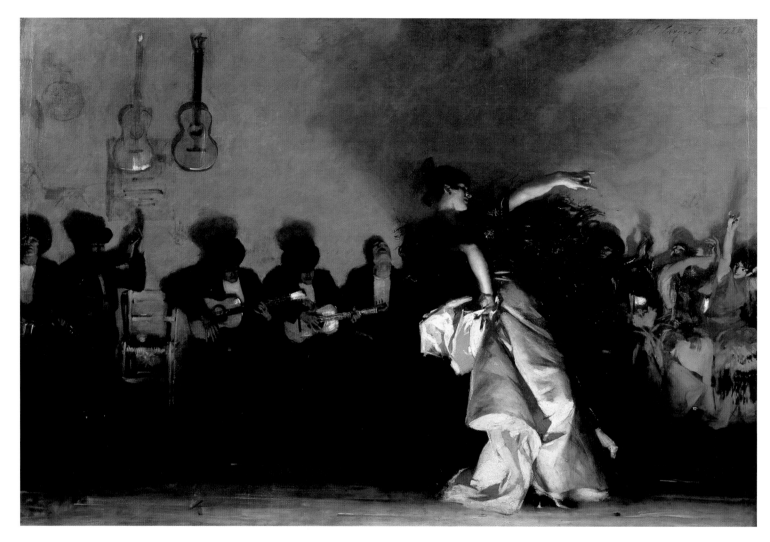

19. John Singer Sargent, *El Jaleo*, 1882. Oil on canvas, 94 1/2 x 137 in. Isabella Stewart Gardner Museum, Boston.

But far and away the most frequent affiliation among living French artists (excepting Carolus-Duran) posited for Sargent was with Edouard Manet. Sargent and Manet were first juxtaposed in critiques of the Salon of 1881, when they each received a second-class medal — two portraitists in the midst of a gaggle of history painters.[77] Reviews of their paintings happened to fall side by side in such key places as the *Gazette des beaux-arts*.[78] By the next year, the linkage between them was more prevalent and much stronger than mere contiguity, for they presented the Salon of 1882 with its two most notorious paintings: Manet's *Bar aux Folies-Bergère* (1882; Courtauld Institute, London) and Sargent's *El Jaleo*. They were consequently joined, either through contrast or comparison, by some of the most prominent re-

viewers. For a small number of the critics, both works were admirable.[79] For a larger group, both were to be regretted.[80] Writers for *La Revue des deux mondes* and *L'Art* took a third tack that surprises a viewer a century later, soundly condemning the Manet and, especially the latter, unable to say sufficient good about the Sargent: "Nothing resembles less a work of art than the scene borrowed from the Folies-Bergère, nothing is more a work of art than the *Danse de Gitanes*. All the secret resides in the magic of the execution."[81] A variant of this appeared in the American newspaper *Galignani,* whose critic disliked the "ghastly ghosts" of *El Jaleo* but forbore mean-spirited criticism of the work, asserting, "Mr. Sargent has so much genuine talent, however, that doubtless he will soon foreswear the vagaries of Manet, and paint nature instead of 'impressions.'"[82]

Manet's death in the spring of 1883 — followed by a retrospective exhibition at the Ecole des beaux-arts and studio sale in early 1884 — tempered only slightly the generally negative critical view of the man.[83] From his letters and his actions, we know that Sargent, to the contrary, thought extremely highly of the Frenchman's works. He called the memorial exhibition "The most interesting thing in Paris now. . . . It is altogether delightful."[84] At the auction of the artist's effects, Sargent acquired several works for his personal collection.[85] In later years, in tandem with Claude Monet, he spearheaded the effort to acquire Manet's *Olympia* (1863; Musée d'Orsay, Paris) for the French state.[86] And more than one of Sargent's early works testifies to his sympathy for and receptivity to the works of Manet.[87]

A reported link between the works of Manet and Sargent, then, would probably have pleased the American. A bright spot amid the debacle of the 1884 Salon might well have been simply this: at least two critics, one writing in English and the other in French, asserted that Sargent's notorious portrait *Madame X (Virginie Avegno Gautreau)* (cat. 26) was a direct response to Manet's work. The one declared that the "realistic cult" espoused by Manet had received such a boost by the memorial exhibition that "even a pupil of Carolus Duran" may have been affected: "Under this impulse — singularly powerful among painters, even to the point of producing here and there positive optical modifications in their way of looking at the object to be rendered — Mr. Sargent may have fancied he was reproducing exactly and literally 'les plus belles épaules, et le plus beau profile de Paris,' as they appeared to him, and not as, by convention, they appear to the numerous admirers of his model."[88] The writer in *L'Art moderne* went further, pronouncing a clear influence: "The portrait of Mme G***,

we are told in Paris, was three-quarters complete when the Manet retrospective opened. That had such an effect on M. Sargent that he repainted his canvas almost entirely, in a fundamentally different fashion. This is what would explain the artist's sudden reversal concerning clear tones, spread in liquid strokes across the grain of the support, through broad overlapping planes, he who previously had searched for his effects in the contrasts of light and shadow, in the oppositions of value."[89] Sargent had been at work on the portrait of Madame Gautreau for nearly two years before the Manet exhibition, intending it, indeed, for the Salon of 1883. And it was in February 1883 that he wrote of Gautreau as among those "fardées to the extent of being a uniform lavender or blotting-paper colour all over . . . [with] the most beautiful lines."[90] So decisions of flatness and artificiality were taken early in the portrait-making process. But if it is unlikely that the painting of Gautreau's face was a direct response to the Manet retrospective, it speaks volumes of the goodwill Sargent had stored with some critics that they would try to lay blame for what they perceived as his failure on the dead man's doorstep.

Writers also frequently associated Sargent with the impressionist movement. "From the time of his first successes at the Salon," observed Henry James, "he was hailed as a recruit of high value to the camp of the Impressionists, and to-day he is for many people most conveniently pigeon-holed under that head."[91] This "wonderfully elastic term" was applied by writers of the 1880s to vast, dark figural compositions as readily as to informal sketches made *en plein air.*[92] It became an umbrella to shelter all the works that could not be classed as academic. In this light, the word was often used for Sargent's paintings simply to convey a sense of his daring: "M. Sargent is much more modern than the impressionists."[93] Several journals praised two now unidentified Venetian watercolors — the only works in that medium we know Sargent to have shown up through 1887 — as being "only impressionist sketches, but what light! what sparkle!"[94] At the other extreme of scale and formality, *The Daughters of Edward D. Boit*, too, when it was in the Salon of 1883, inspired a critic to claim for it "un impressionisme vrai."[95] Others applied the term in the sense more readily understood later, as when the sketchiness, light, and flashing brushwork seen in Sargent's portrait of Vernon Lee (fig. 20) prompted a writer for the *Gazette des beaux-arts* to proclaim: "M. Sargent there shows himself to be an impressionist of the first order."[96]

The work by Sargent that most often earned the appellation of "impressionist," however, especially with British and American writ-

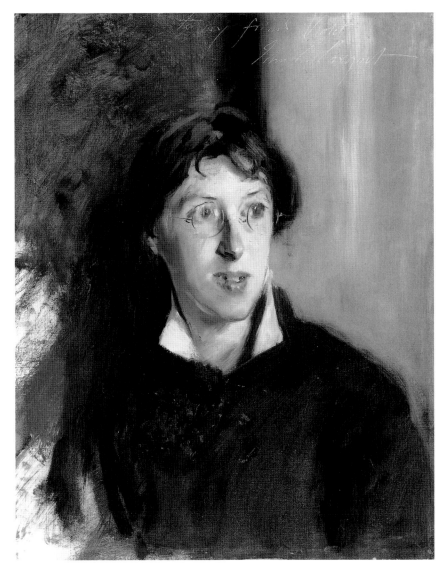

20. John Singer Sargent, *Vernon Lee*, 1881. Oil on canvas, 21 1/8 x 17 in. Tate Gallery.

ers, was *El Jaleo*. Many found the work to be, as one phrased it, "treated a good deal in the Impressionist style."[97] For some, in fact, the massive painting put Sargent at the head of the group: "If Mr. Sargent has joined the ranks of the French impressionists, it is their gain and his loss. That band of artistic ne'er-do-weels, whose existence has been but an ineffectual protest against a stupidity stronger in its way than their insight, has found a leader of some prowess in the painter of 'El Jaleo,' if he means seriously to take up their cause."[98]

As there was a time, however, after which critics stopped noting comparisons between Sargent and the nineteenth-century Hispano-Roman painters, so, too, there came a point about 1882 or 1883 when similarities to contemporary French painters stopped being of principal interest. After this, so far as the critics were concerned, Sargent found new inspiration: "He has learned much in museums."[99]

Sargent and the Old Masters

It is a common critical strategy to position a given work or painter by making reference to a better-known artist of the past. In part this helps explain a stylistic influence or shared subject matter to a reader who might not be able to see the picture under discussion. But, even more important, it establishes a pedigree for the new work, asserting that it is a worthy addition to the continuum of a valued tradition. Certain of Sargent's paintings seem to have begged for explication in this manner, although which artist from the past was summoned obviously depended much on the experiences of the critic. *Lady with the Rose (Charlotte Louise Burckhardt)* (cat. 22), for example, seethed with possible antecedents. At the Salon of 1882, it invoked unquenchable, if indiscriminate, thoughts of seventeenth-century Spanish and eighteenth-century French masters. Of these latter, Chardin, Fragonard, and especially Watteau were all nominated as forebears.[100] When the same work was shown in the United States, at the Society of American Artists exhibition in 1883, American critics, too, found that the work, "without suggesting discipleship, makes Watteau's name come spontaneously to the lips."[101] But perhaps only a writer from the United States could claim that Miss Burckhardt's stance recalled "the attitude of some of the Copley female portraits."[102]

Several later works seem to have prompted an associative response equally limited by the reviewer's background. It was a British writer who, in 1886, found a "Gainsborough-like life and suppressed vivacity" in the portrait of Mrs. Albert Vickers (cat. 28), an observation no Frenchman made when the painting was in the Salon the year before.[103] Likewise, a solitary Frenchman studied the grand double portrait of Louise Burckhardt and her mother (cat. 32), shown in Paris in 1886, and conjured Sébastien Bourdon, Pierre Mignard, Charles Le Brun, and Hyacinthe Rigaud to his mind.[104] On the other hand, writers of several nationalities looked at the sharp profile and near-shadowless flesh of *Madame X* and saw echoes of the work of Piero della Francesca (or, at the least, of fifteenth-century works then attributed to him but now given to Piero del Pollaiolo).[105]

As opposed to these occasional references to Watteau or Copley, Gainsborough or Chardin, reviews of Sargent's paintings in his first decade of exhibition activity overflow with allusions to three old masters: Francisco Goya, Frans Hals, and Diego Velázquez. One of the first of these was inspired by the Venetian scenes Sargent showed at the Cercle des Arts libéraux in the spring of 1881. When, later in the year, the Salon critic for the *Gazette des beaux-arts* looked at the por-

trait of the Pailleron children (cat. 20), he sought to distinguish between its society-portrait, please-the-customer character and what he called the "true M. Sargent, the one whom I saw at the Exposition des Arts libéraux, whose sketches prompted me to remember Goya's Spain."[106]

That might have been the end of it — a single subjective response dependent on the critic's own travel to Spain — had Sargent not exhibited *El Jaleo* in the Salon of 1882. This, one of the two most debated paintings of the year, generated an immense number of critical responses (both positive and negative) and was sold to an American collector outside the artist's circle of friends and family. In the summer it traveled to the Fine Art Society in London; then in the fall it was seen in New York, and later in Boston. It was, for the artist, a success in every way. When *El Jaleo* was at the Salon, the generally conservative critic for *Le Figaro* called it "one of the most original and strongest works of the present Salon," setting the tone by noting that it was conceivable only after the artist's study of Goya.[107] At each stop of its transatlantic progress (and for years afterward, as critics continually made reference to it), writers on the arts invoked the name of Goya. Mostly this was a matter of its topic — Spanish, bohemian, exotic — although the grotesquerie of certain of Sargent's background figures brought to mind the *Caprichios* and the *Disasters of War* for some, as did the dark tonality of the whole.[108] It became an unavoidable pairing — if one mentioned *El Jaleo*, one had also to mention Goya: "Goya! One has pronounced the name Goya; M. Sargent is his avenger; he comes to us to prove the rightness of the observations of this great painter of toreadors and fantastic hallucinations."[109]

One of the dangers in associating a modern with an old master, however, was the issue of originality — if too close, then the vaunted link turned instead to a condemnation. Many tried to attack *El Jaleo* in this fashion: "*La Danseuse espagnole*, of M. Sargent, is the most original work of the Salon — for those who do not know Goya."[110] But this was a feeble thrust. After 1882, except for retrospective references to *El Jaleo*, Goya was largely absent in the critical literature on Sargent. He had been invoked largely to explain the fury and wildness of that one picture; critics did not often feel the need to call on him thereafter.

Frans Hals, too, was tied to only a few specific works by Sargent during this period. Direct comparisons date from 1885 onward, principally in the writings of British and American critics looking at *The Misses Vickers* (fig. 21) and *Mrs. Edward Burckhardt and Her Daughter*

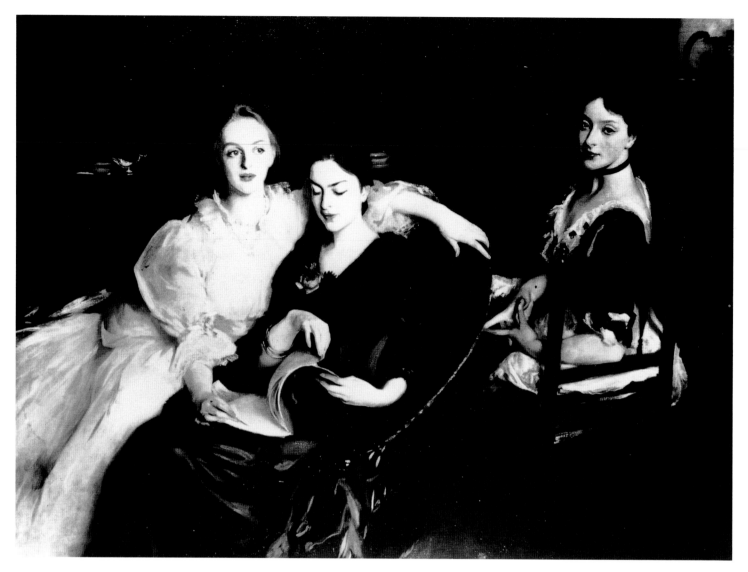

21. John Singer Sargent, *The Misses Vickers*, 1884. Oil on canvas, 54 1/4 x 72 in. Sheffield City Art Galleries.

Louise.[111] The bold painting of flesh and Sargent's habitual lack of half-tones — letting strokes of disparate colors lie side by side to shape a surface rather than joining colors through an even modulation of intermediate tones — prompted most of these comments. But Hals was called upon in several more general discussions of Sargent's works. The most extended of these appeared in an article devoted to the Dutch painter, one that claimed that in general aesthetics, color, drawing, and technique, Hals could be a nineteenth-century "modern."[112] The author then claimed that Manet and the "école franco-américaine" — including Sargent, Whistler, William Merritt Chase,[113] and others — shared "affinités indéniables" with him: "On all sides, the same nervous facture, superimposing touches of color without

blending them, proceeding by planes, fleeing indecision and gropings. But the manner of execution is not the sole point of comparison: in the bearing of the sitters, in the setting, in the lighting, in the general feel, there is between these modernists and Frans Hals a definite kinship."[114] The writer might have asserted this position even more strongly as regards Sargent (as, indeed, he did the next week), if he had had the good fortune in 1880 to see Sargent in Haarlem, copying paintings by Hals and learning, as the American artist later said, "There is certainly no place like Haarlem to key one up."[115] From the time of this 1880 trip onward, Sargent's enthusiasm for Hals was evident: "it's hard to find anyone who knew more about oil-paint than Franz Hals," he is reported as saying.[116]

A New York critic, writing in 1886, linked Hals and Sargent on a more abstract level with one further artist: "The highest kind of painting is that which is the most intelligent, and the kind of intelligence which the painter needs is analytical and selective — the intelligence which produced those two masters of diverse techniques, Velasquez and Franz Hals. Mr. Sargent has intelligence of this kind."[117] To be associated with those two of all previous masters would have most gratified the American. One of Sargent's repeated maxims on the art of painting was the simple, auto-revelatory dictum: "Begin with Franz Hals, copy and study Franz Hals, after that go to Madrid and copy Velasquez, leave Velasquez till you have got all you can out of Franz Hals."[118]

It was Velázquez whom Sargent judged to be the ultimate painter, a sentiment shared by his contemporaries Whistler and Chase among others, and one that he would have heard often from Carolus-Duran. We know that in late 1879 Sargent traveled to Spain specifically to see and make copies after the Spanish master's paintings, and that he kept those copies throughout his lifetime (as was also true of copies he made after Hals — fig. 22).[119] So he must have felt vindicated for the more than two years spent on his Spanish subject painting, *El Jaleo*, when in 1882 it prompted an outpouring of references to Velázquez in the critical press. Some of this flood, as had been the case with allusions to Goya, was simply a response to the Spanish subject matter, demonstrating little more than the pervasiveness of Velázquez's name during the 1880s.[120] But the other of his Salon paintings that year, *Lady with the Rose*, too, seemed to some "un ressouvenir de Vélasquez."[121] "Sargent, for his day, is likely to prove as great a master of realities as Velasquez was for his," said a Boston critic when standing before the work.[122] This signals an appreciation of the manner, rather than simply the matter, of Sargent's painting.

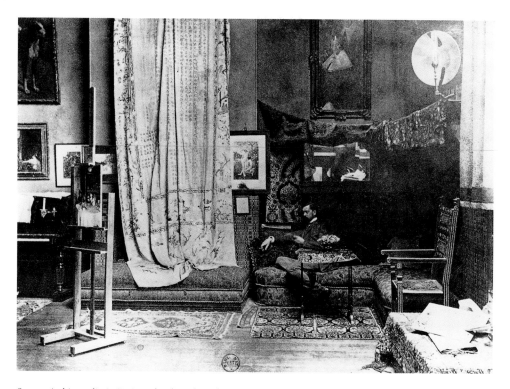

22. Sargent in his studio in Paris, 41 boulevard Berthier, ca. 1883–84. Photographs of Artists in Their
Paris Studios, Archives of American Art, Smithsonian Institution.

Once begun, the invocations of Velázquez continued to flow,
some appearing in each of the later years concerned in this chapter.
Sargent's works shown at the Société internationale de peintres et
sculpteurs in the winter of 1882–1883 inspired one writer, rightly, to
see the Venetian scenes as "all eloquent reminiscences of the Museo
del Prado" and to urge a similarity between *The Daughters of Edward
D. Boit* and *Las Meninas* (1656; Museo del Prado, Madrid) in the
"concentrated devotion of mind and hand to the development of its
inherent artistic potentialities."[123] Even in the midst of a negative re-
sponse to *Madame X* in the Salon of 1884, the same writer paused to
observe, "as Mr. Sargent's best work often does, the handling recalls
Velazquez."[124]

"But it is clear," the critic qualified, "that, although it may be said
of Sargent much more truly than it was said of Fortuny, that he is Ve-
lasquez come to life again, he owes only to his recent study of that
master what there is of general truth and general point of view in his
art, and not the mannerisms of which mere artistic sensitiveness be-
comes enamoured."[125] Whereas with Goya simple denials seem to have
settled the issue of imitation and originality, with Velázquez, perhaps
because the body of work merited a more extensive summoning of

parallels, this and similarly elaborate refutations appeared. One observer, for example, wrote of Sargent's paintings: "The pictures which have gained him this reputation may shortly be described as reflexes of Spain and its great master, Velasquez; not, let it be understood, a slavish following of his methods, but pictures painted by a talented artist whilst saturated with admiration for, and a study of, the man and the country — the student producing original work, but of necessity impregnated with the best qualities of his master."[126] The writer for the *New York World*, too, made comparable assertions: "Mr. Sargent, in spite of the strong personal sentiment he infuses into his work, is a realist *pur sang*— one, therefore, who must worship Velasquez as the greatest of all teachers. He could hardly remain uninfluenced either by his mode of vision, if I may so say, or by his manner of working. But he is strong enough to be influenced for good without hurt to the individuality of his own eyes and brush. . . . Mr. Sargent would probably be the first to write himself a scholar of Velasquez, but his critics should add that he is one whom his master would have delighted to honor."[127] All of Sargent's works, wrote Claude Phillips in 1887, belong "to the school which acknowledges Velasquez as its head."[128] It was Velázquez, Henry James reported, who was the "god" of Sargent's "idolatry" and his "patron saint." Indeed, the most convincing link that James could find to bind together all of Sargent's diverse works was his playful hypothesis that the painter approached each new project by asking himself "just how the great Spaniard would have treated the theme."[129] Because in the 1870s and 1880s Velázquez was simultaneously revered old master, modernist beacon, and timeless seer, James, for all his command of language, could find no higher praise.[130]

Of course, not everyone agreed with those who claimed Sargent as the modern Velázquez. A writer for the *Art Amateur* observed in 1882: "[T]his year not a few contended that in Sargent was plainly seen our Velazquez of the future"; he continued with his own verdict, "Whatever Sargent may be, he will never be an American Velazquez."[131] For the critic of the *Athenaeum*, writing of *The Daughters of Edward D. Boit* when it was in the Salon of 1883, the aspiration but not the achievement was there: "Mr. Sargent would fain paint like Velazquez without Velazquez's pains."[132]

Sargent and Modernity

The thread that ties together the more meaningful references to Velázquez, Hals, and Manet is the notion of Sargent's modernity — his being at the cutting edge of aesthetic taste. One can characterize

this generally as the cult of the painter rather than the draftsman. Mastery of the loaded brush, an easy acceptance of the physical character of paint, and a sense of the process of painting left visible on the canvas were the lodestars of the era. When Sargent wrote to Vernon Lee in 1884, "some day you must assert that the only *painters* were Velasquez, Frans Hals, Rembrandt and Van der Meer of Delft, a tremendous man," he consciously set forth his belief in the power and legitimacy of color over line, of observation over academic exempla.[133] And in this he was in touch with his time — exhibition critics likened few painters to Raphael, for instance, during the 1870s and 1880s.[134]

The characterizations — in either English or French — most often used to describe Sargent and his works to the public, too, cluster around concepts of painterly innovation and technical advancement. Whether used positively or negatively, *amazing, audacious, bold, brilliant, courageous, curious, daring, new, novel, original, personal, revolutionary, singular, startling, striking, uncommon, unconventional, unique,* and *weird* recur continually from 1877 to 1887. To focus, for example, on one of the less frequently used words, *audacity,* writers were prepared to be surprised by both Sargent's subjects and his technique. The word was applied to his choice of subject in genre painting, his choice of sitter's pose in portraits, his lighting effects, his palette, his paint handling, as well as to his approach to picture making in general.[135] The American painter Benjamin Champney summarized Sargent's entire career by saying, in the midst of a text otherwise written in English, "Il a de l'audace, toujours de l'audace!"[136]

A smaller collection of words centered on the notion of Sargent's being a fashionable painter, possessed of up-to-the-minute style in both what he painted and how he painted it. As with *audacity, chic* could be seen as a positive or a negative trait. Thus *A Capriote* was praised for "the — what an English equivalent should be found for as soon as convenient — *chic* of the whole."[137] *El Jaleo* was condemned, on the other hand, as being "of great size, and not an inch of it but is touched with trickiness and *chic*"; or, as another critic sniffed dismissively, the work was "simply a vagarie of the artist, very *chic* and all that."[138] Responses to several of Sargent's three-quarter- and full-length paintings of fashionable women unsurprisingly called forth the word *chic*: *Lady with the Rose* was favorably characterized as "*tres chic,* or perhaps in the newer Paris slang it would be called '*petchult.*'"[139] *Edith, Lady Playfair (Edith Russell)* (cat. 27), according to a British critic, possessed "truly Parisian qualities of *chic* and winning attractive-

ness."[140] Noting that Sargent had been generously treated by the hanging committee of the 1886 Royal Academy, the critic for the *Art Journal* grudgingly conceded that "there is a certain *chic* about his portraits, and at a distance the general effect is not unpleasing," before concluding that "his colouring and composition are both eccentric."[141] The portrait of Dr. Samuel Pozzi, when it appeared in Brussels amid the avant-garde exhibition of Les XX, sparked one Belgian writer to catalogue a long list of perceived flaws, summarizing them all by declaring, "tout est chic et parisianisme."[142]

Another cluster of words that continually recurs describes the artist's technique — *brilliant, distinguished, exquisite, facile, glistening, insolent, slap-dash, slovenly, willful, witty*. Yet another draws together those words concerned with the decadence of his themes and treatments — *bizarre, diabolic, exotic, fantastic, mysterious, mystifying, poisonous, psychedelic, sinister, strange*. This latter would include references to the works that contain something out of the ordinary, such as *Fumée d'ambre gris* (cat. 10) or *El Jaleo*. But it would also encompass the review of *Lady with the Rose* that startlingly and perversely located the heart of the painting in the "rose of yellow white, greenish at the core, a tone of absinthe washed of all fresh and pure origins and poured out on this proffered and perfidious flower, which exhales poisoned perfumes. This rose is a feast for the eyes. Why aren't the hands of the woman black?"[143]

One further characterizing cluster, if such can be allowed for a single unit, would consist of a solitary word. If Sargent has an epithet in the critical writing of his early maturity, one Homeric adjective that describes him and his work, it would be *clever*. The word appears more often than any other description, penned by friend and foe alike. So *El Jaleo* becomes for one writer "preposterously clever — far too clever, in fact, for a work of art."[144] Another judges it, at least in terms of craftsmanship, "insolently clever."[145] Sargent's Venetian studies at the Grosvenor Gallery in 1882 are "extremely clever, and we use the word extremely as indicating at once a danger and a merit."[146] The examples proliferate.

But this terse gathering is sufficient to suggest the general expectation that informs the vast majority of critical writing about Sargent's work in the decade from 1877 to 1887: new and innovative subjects (or, at the least, traditional subjects viewed from a different sensibility), treated in a fashion that emphasized an awareness of the artist's technique. Sargent's ability to produce works that continually ex-

ceeded these critical expectations — for good or ill — is what allowed another crop of words to recur throughout the decade: *chef-d'oeuvre, tour de force, triomphateur, incontestably supreme.* These homages testify to his success in achieving an immense public reputation.

Sargent and Pictorial Criticism

If one picture is worth a thousand words, then some of Sargent's most prolix commentators were the caricaturists and editors who included pictures of his exhibited works among the illustrations in journals and newspapers. There were, broadly speaking, three ways an artist could have work reproduced in a critical text during the 1870s and early 1880s: parodies, copies by another hand, or one's own summary version of the work — usually a line drawing. Sargent clearly realized that every opportunity for pictorial reproduction in the journals and newspapers of the day was a signal honor — even the parodies — for each reproduction in the age before widespread photographic images carried immense weight, providing more space and legibility than almost any verbal assessment could muster. He abetted the process to every possible degree.

The caricatures, of course, were beyond his control. Both of Sargent's Salon paintings of 1879 brought forth barbs from the caricaturist "Stop" (L. P. G. B. Morel-Retz) who drew for *Le Journal amusant.* Prompted by the sitter's good looks and savoir-faire, Stop probably found it quite easy to convert Sargent's portrait of his master into "Portrait de M. Carolus Duran, dans le rôle du marquis de Méphisto" (fig. 23). It was a somewhat more complicated transformation to see in *A Capriote* the combination of Mediterranean mythology and Ovidian metamorphoses necessary to conjure forth "Mademoiselle Laocoon, à Capri (Italie)" (fig. 24). The next year "Paf" (Jules Renard), who drew for *Le Charivari,* turned his attention to *Fumée d'ambre gris,* perceiving in the work not an exotic woman of North Africa swathed in an immense quantity of white but, instead, the "Champignon du Sérail. Espérons qu'il n'est pas vénéneux" (The mushroom of the seraglio. We hope it is not poisonous) (fig. 25). Even so popular a work as *Lady with the Rose* prompted the humorist from *La Caricature* to mimicry, with a drawing that emphasized its coquettish aspects and became a call to arms in the fashion wars with the subtitle: "Double noir. Gare la crinoline! Aux armes, citoyennes!" (fig. 26). Once seen, these caricatures are like an inane melody that plays incessantly in the head: see *Fumée d'ambre gris* and, in spite of one's best efforts, one cannot help but think of mushrooms. And yet even to be caricatured, when such a

23. Stop (L. P. G. B. Morel-Retz), "Portrait de M. Carolus Duran, dans le rôle du marquis de Méphisto," *Le Journal amusant*, 5 July 1879, 5. Getty Research Institute, Resource Collections.

24. Stop (L. P. G. B. Morel-Retz), "Mademoiselle Laocoon, à Capri (Italie)," *Le Journal amusant*, 28 June 1879, 7. Getty Research Institute, Resource Collections.

25. Paf (Jules Renard), "Champignon du Sérail. Espérons qu'il n'est pas vénéneux," "Le Salon pour rire — par Paf (Troisième Promenade)," *Le Charivari*, 12 May 1880, 3.

26. "Double noir. Gare la crinoline! Aux armes, citoyennes!" *La Caricature*, 27 April 1882. Special Collections Library, University of Michigan.

minuscule percentage of the objects exhibited in a year were picked out for any kind of notice, must have been gratifying.

Numerous times during the decade, works by Sargent were copied by others for reproduction, most often through the medium of wood engraving, although heliogravure, aquatint, and other means were sometimes used. These resulted in images of varying degrees of fidelity to Sargent's design, from the jangly "Mme R. S." of the *1881 Catalogue illustré du Salon* (fig. 27) to the wholly benign "Capri Peasant" in *Scribner's Monthly* (fig. 28).[147] In some instances Sargent assisted the other artist by providing copies to work from — he reclaimed the detailed watercolor of *Fumée d'ambre gris* that he had earlier sent to his family for just this reason.[148]

Not surprisingly, the best reproductions were from drawings the painter made specially for the purpose. Most often in this situation Sargent would make pen-and-ink works of considerable verve, in which he summarized the principal forms, suggested tonal change through almost random pen scratchings, and omitted immense quantities of detail that another hand might have been more tentative about deleting. The resulting drawings convey the spirit of the paintings while being themselves admirable works of art. As early as 1878 — the second year he exhibited — the *Gazette des beaux-arts* devoted nearly a whole page to his dynamic reduction of *Oyster Gatherers of Cancale* (fig. 29). The next year, a Sargent drawing formed the basis for the reproduction of the portrait of Carolus-Duran in the *Salon de 1879: Catalogue illustré* and again in the *Gazette des beaux-arts* in 1883 (fig. 30). In 1880 another Sargent drawing was the basis for the reproduction of *Fumée d'ambre gris* (fig. 31). In 1882 he made three drawings after *El Jaleo*, apparently for the same purpose, although we know of only two of them being used (fig. 32).[149] It is thanks largely to two of Sargent's drawings, both reproduced at various points in the 1880s, that we can identify two of the Venetian paintings that were exhibited at the Société internationale in the winter of 1882–1883 (figs. 33, 34). So dynamic were the earliest of Sargent's drawings for reproduction (and the later ones follow in their mold), that one of the writers for the *Gazette des beaux-arts* looked back over the year from February 1880 and was moved to note that Sargent had, along with seven others (including Rodin), "a rare happiness of execution from the point of view of the requirements of reproduction; their talent as painters or sculptors finds itself doubled, certainly without their knowledge, by the art of the illustrator."[150]

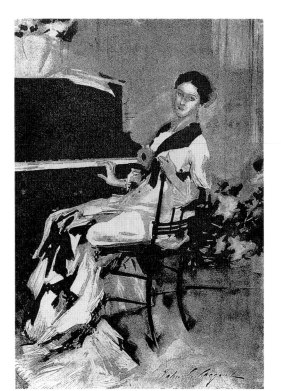

27. "Mme R. S.," *1881 Catalogue illustré du Salon*, ed. F.-G. Dumas (Paris: Salon, 1881), 451.

28. "Capri Peasant," *Scribner's Monthly* 22, no. 3 (July 1881): 321. Courtesy of Sawyer Library, Williams College.

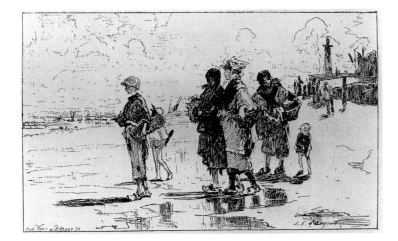

29. "En route pour la pêche," "Le Salon de 1878," *Gazette des beaux-arts* 18, no. 1 (July 1878): 179.

2697. SARGENT (J.-S.). *Portrait de M. Carolus Duran.*

30. "Carolus Duran," F.-G. Dumas, ed., *Salon de 1879: Catalogue illustré* (Paris: Ludovic Baschet, 1879), 161.

31. "Fumée d'ambre gris," F.-G. Dumas, ed., *Salon de 1880: Catalogue illustré* (Paris: H. Launette, 1882), 120.

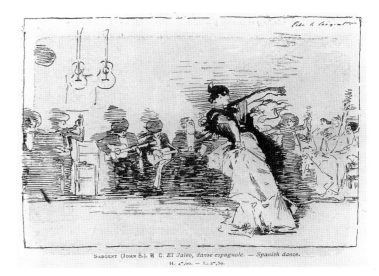

SARGENT (JOHN S.). H C. *El Jaléo, danse espagnole. — Spanish dance.*
H. 4m,00. — l. 2m,50.

32. "El Jaleo," F.-G. Dumas, ed., *Salon de 1882: Catalogue illustré* (Paris: Ludovic Baschet, 1882), 54.

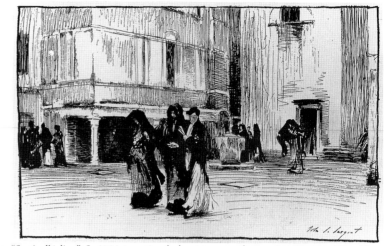

33. "Une Rue à Venise," Arthur Baignères, "Première Exposition de la Société Internationale de Peintres et Sculpteurs," *Gazette des beaux-arts* 27, no. 2 (February 1883): 192.

34. "Sortie d'église," *Société internationale de peintres et sculpteurs: Première exposition 1882* (Paris: A. Quantin, 1882), n.p.

Sargent Beyond the Threshold

The one conditional note that Henry James sounded in his *Harper's* essay of 1887 centered on Sargent's youth — the fact that he was on the threshold of his career and might not find a subject that would inspire the proper use of his great gifts. James, as was his wont, knew what steps the younger man should take to ensure his future: having settled in England, he ought to become the painter of that society's leading individuals. James had urged this course of action privately as early as 1884: "I want him to come here to live and work — there being such a field in London for a *real* painter of women, and such magnificent subjects, of both sexes. He is afraid but he inclines, I think, this way, and will probably end by coming. He has got all, and more than all — that Paris can give him — and he can *apply* it here, I believe, as nowhere."[151] James proclaimed it publicly: "There is no greater work of art than a great portrait — a truth to be constantly taken to heart by a painter holding in his hands the weapon that Mr. Sargent wields."[152]

At nearly the same time, R. A. M. Stevenson, another art writer of the day and Sargent's colleague from the atelier of Carolus-Duran, urged a wholly different course of action. After delivering one of the best descriptions and appreciations of Sargent's brushwork yet written, and prompted by the aesthetic power of *Carnation, Lily, Lily, Rose*, Stevenson wrote of his hope that Sargent would move away from the painting of specific people: "I have long wished to see him deal with romantic and fantastic figure subjects, for which I believe him to be still better organized than for portraiture."[153]

Sargent, who was in America when both these voices rang out in London, set for himself a course between James's almost holy quest of portraiture and Stevenson's path of fantasy. Although he would paint an immense number of genre scenes and landscapes in succeeding years, Sargent the oil painter chose to put himself before the public largely as a portraitist. Stevenson's desire to have Sargent focus on a fantastic subject found public satisfaction most notably in only one place — the mural decorations of the Boston Public Library. Commissioned in 1890, worked on well into the twentieth century, this grand pictorial recapitulation of the history of religion remains one of the painter's least appreciated works. Nor, however, could James claim victory. He wrote privately to a mutual friend: "I have accepted his limitations — which is always a comfort. But I think they are greater than I did of old. I don't know that I know all that he will do in the future — but I think I know pretty well what he *won't* do."[154]

Sargent demonstrated his chosen course with two American portraits sent to the Royal Academy exhibition of 1888: *Mrs. Edward Darley Boit* (fig. 35) and *Mrs. Henry G. Marquand* (fig. 36). James had the chance to see them in advance of the exhibition and wrote: "They are both full of talent & life & style & as he only could have painted them, but very different from each other. Mrs. M. will do him great good with the public — they will want to be painted like that — respectfully, honourably, dignement. It is a noble portrait of an old lady." James continued, however: "Our dear Iza [Mrs. Boit] won't do him good — though she is wonderful & of a living! But she not only speaks, she *winks*, & the public line will find her vulgar."[155] After six weeks of rumination, James returned to the subject: "His Mrs. Boit is admirable for *life* & impudence & talent, but seems to me a supreme example of his great vice — a want of respect for the face. Il s'en moque, of the face! . . . Abbey tells me that he (Sargent) considers his splendid portrait of Mrs. Marquand, which we all admire so unrestrictedly, as a humbug, a [illegible] & a sham, a base concession. She isn't drunk — quoi!"[156] Sargent's decision to show Mrs. Boit in a moment of action, winking or laughing or showing some other flashing and transient expression, seemed to James of questionable judgment. The painter's dismissal of the stately *Mrs. Henry G. Marquand* as humbug (only reported, but James believed it) showed what the writer considered an even more fundamental flaw in character: irreverence. Sargent did not treat the figure as paramount over and above the art of painting itself, did not feel the respect for the individual character that James saw as central to the highest achievement in portraiture.

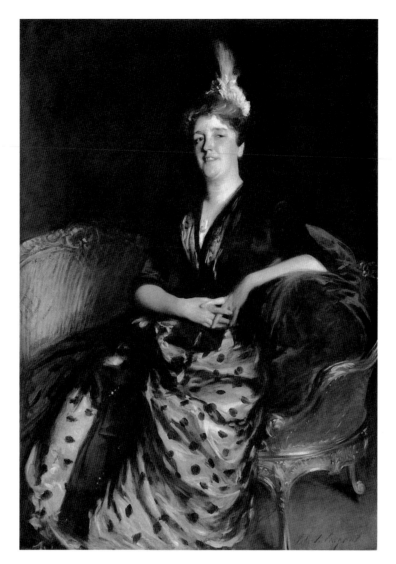

35. John Singer Sargent, *Mrs. Edward Darley Boit*, 1888. Oil on canvas, 60 1/4 x 42 3/4 in.
Gift of Miss Julia Overing Boit. Courtesy, Museum of Fine Arts, Boston.

Over the course of his career, as in his individual works, Sargent
tweaked the expected into the unprecedented. He did indeed become
the portraitist of many of the most famous and powerful Britons and
Americans at the turn of the century. But the pictures are such that
the art-making personality swamps the depicted one; rather than be-
ing known as a portrait of so-and-so, the works today are much more
likely, as one writer of the 1880s feared would be the case, to be "val-
ued as painting long after the names of their originals shall have been
forgotten."[157] And this privileging of the art over the subject is surely
what the painter intended. A litany of anecdotes concerning his atti-
tude toward portraiture in the ensuing decades, mocking individuals
and the very idea of portraiture alike, and the great energy with which

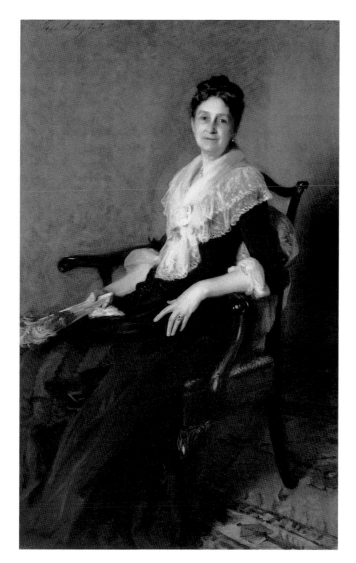

36. John Singer Sargent, *Mrs. Henry G. Marquand*, 1887. Oil on canvas, 66 1/2 x
42 in. The Art Museum, Princeton University. Gift of Eleanor Marquand
Delanoy, daughter of the sitter.

he undertook landscape and subject paintings whenever he was free
from commissions, testify to his impatience with face-painting — with
the profession he had chosen to earn his living and establish his fame.[158]

From 1877 through the first decade of his career, Sargent brought his
paintings to the attention of a broad public. He accomplished this —
in tandem with the art press in Paris, New York, and London —
through exhibiting works that struck the public and critics as fully ac-
complished but unsettling, as striving after new and startling effects.
In Paris his portraits, a class of painting that in other hands all too
readily reverted to formulas and repetitions, stood apart through their
novelty of pose and costume, striking color, and atypical viewer-

subject engagement. The critical reviews show that opinion makers within the art press appreciated Sargent's efforts, if not always favorably, then at least with notice. Further, in the years from 1878 to 1880 and again in 1882, Sargent exhibited genre scenes as well as portraits. Again, audacity in subject and fluency in handling drew the attention of the public and critics alike. With the last of these, *El Jaleo*, he became "the most talked-about painter in Paris."[159]

Yet while he wanted to startle, Sargent did not want to offend. In spite of his predilection for the extremely informal compositions and summary techniques of his Venetian oils, in Paris he reserved those (as well as his most dynamic and experimental portraits, such as *Vernon Lee*) for less decorous settings, where the general field inclined toward the daring — with Renoir at the Cercle des Arts libéraux in 1881, Monet at the Société internationale in 1885. In such venues "his true self," as one critic wrote, could come out.[160]

In New York, genre scenes dominated his early exhibition paintings. In 1878 he discovered that small-scale pictures showing sunstruck figures in atmospheric and loosely defined settings were popular. In 1879 he sent two more such works to New York, taking advantage of an American fascination with contemporary Italian paintings by making his subjects, of a comparable scale and style, demonstrably Italian. In the early 1880s Sargent seems to have thought of American public exhibitions principally as opportunities for drumming up portrait business. That is surely why a series of small and restrained paintings of heads — such as those of Edward Burckhardt (1880; private collec-

tion) and Beatrix and Eleanor Chapman (ca. 1881; the former destroyed, the latter in a private collection) — made public appearances. They are efficient, apparently good likenesses, and as nearly conventional as Sargent was ever to be. They are not works intended to build his reputation, but they would make his name known to Americans who traveled to France and who, as a souvenir, would have their portraits done by "the rising young man."[161]

In London, a more closed and inscrutable art world, Sargent tried many avenues simultaneously when he decided to approach the city in 1882. At the Royal Academy he showed a splashy picture that more than a century later still shocks. *Dr. Pozzi at Home* "has a little the air of a challenge to England . . . a mystification, a mystification and a half," as one critic observed.[162] Yet it also has ties to Van Dyck and the grand manner portraiture dear to the hearts of English patrons. At the same time, Sargent showed his much-spoken-of Salon paintings and his most experimental public works at high-profile commercial galleries. After this, with the notable exception of *Carnation, Lily, Lily, Rose* in 1887, portraiture in a variety of guises — from the formal presentation to the fleeting impression — became his path to that portion of the English market that shopped at the Royal Academy and the New English Art Club. All of this demonstrates a determined and sensible approach to the distinctions between the art worlds and the markets of his three principal arenas of activity. Sargent seems to have been, in the choices and decisions of his career no less than with his brush, exceptionally canny.

Catalogue

The catalogue entries are arranged chronologically and divided into three sections: Searching and Experimentation, 1877–1880; "Away for Venice," 1880–1882; and "Crispation de nerfs," 1880–1887. Preceding each catalogue section, an essay addresses a variety of issues related to the works in the exhibition, generally being most concerned with Sargent's movements and the biographies of his sitters. The format of each entry is

Title of work as it is now known, date
Medium, dimensions (in inches, height preceding width)
Current location
City and date of exhibition — Title of exhibition
Title of work shown (from catalogue or, when lacking, reviews)
Catalogue number of the work (with an indication, when known, of number of comparable works in exhibition, as well as notes concerning owner or price).

The entries are completed by a brief selection of comments drawn from the critical reviews of a given exhibition. These are given in the original language as printed and have not been altered. If a work was shown at any later exhibitions, data concerning these later shows and selected reviews follow in the same entry.

In some cases it is not possible to document which work was exhibited in a given venue. A question mark before an exhibition city and date indicates that critical responses, traditional histories, and other factors have yielded an informed guess; two question marks preceding the exhibition city and date indicate a greater level of uncertainty.

Searching and Experimentation 1877–1880

Fanny Watts (cat. 1) was, as Sargent's father called it, the painter's "first serious work, his, as yet, 'opus magnum.'"[1] The portrait of his childhood friend Frances Sherborne Ridley Watts (1858–1927) testifies to a young man's hard-won technical accomplishments: the carefully modeled hands — tours de force of anatomical rendering and fore-shortening — document intense academic study; lace at wrists and throat and the glistening jewelry demonstrate dashing brushwork and the ability to summarize complex visual phenomena; the pose and color scheme reveal the awareness of earlier masters back to at least Van Dyck, while the sitter's columnar neck and long jaw admit an acquaintance with the more contemporary English Pre-Raphaelites. More specifically, Sargent drew heavily on the model of his own much-admired teacher, Carolus-Duran, whose Salon painting of 1874 — *Portrait de Madame Pourtalès* (1873; location unknown), a work Sargent saw and admired — uses the same format of pose, spirit, and attention-getting color.[2] (Carolus-Duran was renowned for the sometimes startling colors of his portraits' drapery-rich backgrounds.) In spite of adherence to these models, Sargent's work stands apart from them. He posed Fanny Watts in an elaborately nonchalant fashion, but her twisted torso, striving for casualness and immediacy, instead suggests tension and reserve. He chose a strong, glaring light to illumine her face, opting to emphasize pictorial pattern over physiological structure, but he did not extend the same sensibility to the entire canvas, so the overall effect is one of dislocation. It is the first manifestation of the internal tension that Sargent would use in many of his most notable works. Sargent believed in the strategy and this particular portrait to a sufficient degree that he borrowed the work from the sitter the next year for inclusion in the American art section of the Paris Exposition universelle of 1878.

Many of the best-known painters of the era had a diversified practice — whether renowned for history, genre, or even decorative painting, they also made portraits that were prominent components of the annual fairs. During the first years of his career, Sargent, too, put forward a variety of both portraits and genre paintings. Prominent

among the latter were brightly colored canvases showing attractive young women set in exotic locales. The earliest of these is *Oyster Gatherers of Cancale* (cat. 3), which testifies to Sargent's modish preoccupation with studying the figure in the open air. He had spent at least part of July and August 1877 in the Breton village, where, according to his sister, he "had a good deal of rainy and cloudy weather" as well as "great difficulty in finding people to pose"; when he succeeded in finding models, through either persuasion or pay, "the crowd around him is so great, that he cannot work."[3] In spite of these difficulties, Sargent succeeded in making a series of informal figure studies (Museum of Fine Arts, Boston; ex coll. Mr. and Mrs. John D. Rockefeller 3rd; and Daniel J. Terra Collection) and dashingly painted site views (Nelson-Atkins Museum of Art) that he took back to his Paris studio to synthesize into a finished composition over the winter.

Sargent was happy with the results, or so his father reported to a relative in America: "John writes encouragingly about his work. . . . He has also finished a picture for the Annual Exhibition in Paris, which his master & friends think is very well done. He seems to be doing very satisfactorily — which is a great comfort to us — and to have well chosen his vocation."[4] Carolus-Duran and Sargent's fellow students were not alone in their appreciation. In the days when paintings were hung on walls from floor to ceiling, and hence could be "skied" or made nearly unviewable by the height of their placement, *Oyster Gatherers of Cancale* was given a good spot by the Salon's hanging committee. The critic for the *Gazette des beaux-arts* could see the work well enough to praise its technique as well as its effect; he also selected it as one of the few works to be reproduced, via a drawing by the artist, in the journal.[5] This was a singular accolade. Simply by giving over so much space to the work, the *Gazette des beaux-arts* proclaimed it to be a newsworthy event. On top of everything else, the work was sold to an American friend of the Sargent family.[6]

Nor was this the only public manifestation of the Brittany trip. Six weeks before the Salon opened, a smaller canvas of the same composition, probably the penultimate version in Sargent's careful and academic development of the theme, was included in the inaugural exhibition of the Society of American Artists, becoming the first of his paintings to be exhibited in the United States. *Fishing for Oysters at Cancale* (cat. 2) shows an even freer brushwork than the Salon painting, along with slight variations in some of the figures. Sargent's father noted with pride: "A picture, or rather a sketch, which he sent to the New Art Exhibition in New York, was very much thought of, apparently,

by two artists who drew lots as to who should purchase it for $200, the price he had put on it."[7] More than anything else, the painting captures the sense of being outdoors: it is "a good sketch . . . very luminous," as a fellow artist wrote from Paris to J. Alden Weir.[8] Two years after its first showing, in one of the earliest attempts to chronicle the era's younger generation of American painters, William C. Brownell praised the poetry of Sargent's brush and chose the "charming 'Oyster Gatherers'" as one of only eleven woodblock-engraved plates in the first installment of his tale.[9]

If the works shown in 1878 advanced Sargent's career a step, those in the next year catapulted him forward. A note from Emily Sargent, the elder of the painter's two younger sisters, to her childhood friend Vernon Lee, sets the stage: "The Salon was not as good as usual this year. Duran's plafond for the Luxembourg, on which John has been working, looks fine, but of course the perspective is extraordinary. . . . Duran made an excellent portrait of John in it, & John made one of him which so delighted Duran, that he told John he would sit for his portrait, & John has begun it but expects to go to Capri in a few days, so will not be able to finish it now."[10] The "plafond" was the large canvas *Gloria Mariae Medicis* (Musée du Louvre), intended to decorate the ceiling of one of the vast galleries in the Palais du Luxembourg. For the whole winter before it was shown in the Salon of 1878, Carolus-Duran had honored his best pupils — including Sargent and fellow American J. Carroll Beckwith — by inviting their assistance on it, re-creating a Renaissance workshop environment in nineteenth-century Paris.[11] The play of adding one another's portraits among the ancillary figures led to the idea of Sargent's painting a more formal portrait of his teacher.[12] The sittings for that work were interrupted over the summer of 1878 by Sargent's travel to southern Italy — first a week in Naples in early August, and then an extended stay on the island of Capri. Sargent submitted results from each of the campaigns, the Parisian portrait and a group of Italian genre scenes, to the exhibitions of 1879.

At the Salon, *Carolus-Duran* (cat. 4) was a sensation, an *épatant* performance according to one colleague.[13] Its talking likeness, the informal pose, and the appeal of the sitter all contributed to making the work a great popular success, written of by a bounty of critics, reproduced in the press by Sargent's own drawing, and prompting a caricaturist's wit. The portrait also won for Sargent his first official recognition: an honorable mention that brought him considerable attention and placed him among the *exemptés* (able to submit work

without jury approval) for the coming year. All of this was probably abetted by the fact that Carolus-Duran (1838–1917) was himself news-worthy, having been awarded that year the Salon's *prix d'honneur* — the highest possible accolade. Over the next several years Sargent sub-mitted the work for exhibition in his most important markets — New York and Boston in 1880, London in 1882, Paris again in 1883 — and critics through-out the decade made reference to it as a benchmark of achievement.

In the same Salon of 1879, Sargent also showed a memento of his Italian trip, *Among the Olive Trees, Capri* (cat. 7). Capri seems to have been especially fruitful for the painter, prompting some of his earliest views of architecture and of the dance — themes to which he would return frequently in later years.[14] The Salon painting features a model named Rosina Ferrara (ca. 1861–1928),[15] her back to the picture plane, leaning against the gnarled trunk of an olive tree and turning her head to show the viewer her profile (a profile study of the model, un-adorned and without trace of background, would be one of Sargent's submissions to the Society of American Artists in 1881; cat. 5). It is a curious stance, simultaneously vulnerable and confident: if observed from the front, her pose would seem supremely easy and controlling, but Sargent shows her from the back, giving the viewer (whom she does not necessarily see, although the turned head is perhaps a sign that she is aware of us) greater knowledge of and hence power over her. At the same time, it seems clear that she is at home in this grove, whereas we are visitors. Again, the artist forbids the viewer an easy, uninflected response to the work. Sargent has brushed in the land-scape surrounding the Capriote with considerable freedom, effectively creating an impression of a warm, overcast day but keeping a softened focus throughout the work so that the model's face retains our atten-tion. Its fluid ease, however, is a controlled effect. As he had done the year before, Sargent sent his penultimate version of the composition to the Society of American Artists in New York (cat. 6). A Parisian friend wrote of it that Sargent made "some remarkable studies in Capri last summer, far better than anything he ever painted you saw a specimen in the N.Y. Young mens Exhn."[16] This time, however, the New York and Paris canvases were almost exactly the same size, the latter being nearly a fair-copy version, with only slight differences in the placement of foreground weeds, a clearer rendition of the figure's face, and an overall hotter tonality. The apparently effortless painting he showed in Paris; New York could see the record of his labor.

On his way to Capri in 1878, Sargent also spent about a week in Naples, which he described as "simply superb and I spent a delightful week there. Of course it was very hot, and one generally feels used up. It is a fact that in Naples they eke out their wine with spirits and drugs, so that a glass of wine and water at a meal will make a man feel drunk. I had to take bad beer in order not to feel good-for-nothing. I could not sleep at night. In the afternoon I would smoke a cigarette in an armchair or on my bed and at five o'clock wake up suddenly from a deep sleep of several hours. Then lie awake all night and quarrel with mosquitoes, fleas and all imaginable beasts. I am frightfully bitten from head to foot. Otherwise Italy is all that one can dream for beauty and charm."[17]

If Sargent was occupied with naps in the afternoon and Neapolitan fleas in the evenings, during the mornings he seems to have made good use of Naples's coastline, sketching children playing and at ease on the beach (Tate Gallery; private collections). One exhibition picture grew from these studies: *Neapolitan Children Bathing* (cat. 8). This, in 1879, was the first, and for many years the only painting by Sargent to be seen at the National Academy of Design in New York, the nation's preeminent art society.

Public and critics could not have been more enthusiastic about the small work, which shows four boys on a light-struck beach, with another swimming in the brilliant blue sea behind them. The painting is just ten by sixteen inches — tiny by comparison with many works exhibited at the academy — and very freely brushed, with forms no more than suggested and strong cast shadows created from an unmodulated, almost hallucinogenic blue-purple, as if the viewers of the painting were themselves out on a beach, squinting in response to the glare of hot sun reflected from sand and water. Yet even conservative reviewers exclaimed repeatedly over the painting's color and sense of actual daylight, its "out-of-doors, sunshiny" nature, which made it stand out from among the more than six hundred other works in the exhibition.[18]

With both the *Capriote* and *Neapolitan Children Bathing*, many American writers felt the need to assert a variety of presumed ancestors for the works' Italian color and French light. But these comparisons were not intended invidiously — nearly every writer who made them also professed a wonder at Sargent's inventive composition and truthful vision. He seemed to them simply a master of current art practice, adept at a variety of styles and manners. For an artist who was only

twenty-three years old, the year 1879 had provided an astonishing degree of success in both Paris and New York.

For the Salon of 1880 Sargent again submitted a portrait and an exotic genre scene. The portrait (cat. 9) was of Madame Edouard Pailleron, née Marie Buloz (1840–1913). Her parents were the publishers of the *Revue des deux mondes*, one of Paris's most respected journals; her husband was a successful dramatist and writer whose portrait Sargent had painted early in 1879 (Musée National du Château de Versailles) but apparently not exhibited. (It would not be seen widely until it served as a cover for *L'Illustration* in December 1882.) Expressly so that he could do the portrait of Madame Pailleron, the couple invited Sargent to the Buloz family country home in Savoie, at Ronjoux, late in the summer of 1879. The painter's mother and his sister Emily were at nearby Aix-les-Bains taking the waters. Emily reported in a letter of 3 September to Vernon Lee: "John came to see us the evening we arrived, & stayed with us from Saturday to Monday morning, when we returned with him to Ronjoux & had a charming breakfast with the people he is staying with. They are very clever, & have lots of literary & artistic friends, besides a delightful country place, so John's time passes very agreeably. He works at the lady's portrait every propitious afternoon."[19] It was important that the weather be favorable, as Sargent was painting Madame Pailleron on the grounds of the estate. He posed her as if she were strolling about the lawn, dressed in black satin with lace sleeves, tulle ruffles at neck and wrists, a bright red nosegay pinned to her shoulder. She lifts a flounce of her skirt, perhaps to keep it from brushing against the fallen leaves or the autumn crocuses that are scattered across the light-struck grasses; the gesture reveals the edge of her petticoat. It is an artificial stance, unnatural to the same degree that her dress seems out of place in that setting and light. The level, nonengaging nature of Madame Pailleron's expression as she stares at the viewer combines with the discomfiting pose to lend the portrait an air of tension and unease — not unlike the tone of *Fanny Watts*. Sargent is playing with contrasts and disjunctions to draw and sustain attention, mixing and matching phrases from the advanced painterly vocabularies of his time. In the case of *Mme Edouard Pailleron*, it is almost as if he plucked the figure of the mother from Renoir's *Mme Charpentier and Her Children* (1878; Metropolitan Museum of Art), which had been seen and favorably reviewed in the Salon of 1879, and settled her into a landscape painted by Jules Bastien-Lepage, with its typical light tonality, flattening patterns, and high horizon.[20] And, of course, the works of James Tissot

and Alfred Stevens must be seen as part of the context of fashionable painting that Sargent would have had in his mind's eye. The work contains a clear message, a bold announcement of technical prowess, and a command of the entire repertoire of modern female portraiture.

Sargent's other Salon entry, *Fumée d'ambre gris* (cat. 10), evidenced an entirely different but no less striking kind of modernity. This scene of a North African woman infusing her robes and her senses with the aphrodisiacal perfume of ambergris had grown from the painter's months in Tangier during the winter of 1879–1880. He had gone to North Africa after a working tour of Spain, reaching Morocco sometime before 4 January 1880, when he was able to lament, "I have been doing so much jogtrotting on atrocious horses and mules that I can't sit down to write, and . . . the temperature in these tropical regions is such that one's fingers refuse to hold the pen." He allowed that this was a slight exaggeration and continued:

> We have rented a little Moorish house (which we don't yet know from any other house in the town, the little white tortuous streets are so exactly alike) and we expect to enjoy a month or two in it very much. The patio open to the sky affords a studio light, and has the horseshoe arches arabesques, tiles and other traditional Moorish ornaments. The roof is a white terrace, one of the thousand that form this odd town, sloping down to the sea. All that has been written and painted about these African towns does not exaggerate the interest of at any rate, a first visit. Of course the poetic strain that writers launch forth in when they touch upon a certain degree of latitude and longitude — is to a great extent conventional; but certainly the aspect of the place is striking, the costume grand and the Arabs often magnificent.[21]

The canny sophisticate, wary of precedents and the "poetic strain" that travelers are subject to, nonetheless himself fell victim to the romance of the place — he brought back "lots of pretty old rugs & properties" for his studio.[22] But in his major souvenir of Tangier, *Fumée d'ambre gris*, he holds the romance in check; and this is true also of the small oil preparatory for the work, and a watercolor and a drawing apparently made after it (private collection, Isabella Stewart Gardner Museum, and Clark Art Institute, respectively). Although the work is ostensibly about the exotic figure of the swathed woman, set amid bits of characteristic architecture and decorative objects that give local color and testify to Sargent's actual presence on site (the signature specifies the site as "Tanger," although he probably worked on

the canvas itself in Paris),[23] he undercuts the interest in the things portrayed by his tour-de-force presentation of them. By making the work a study of creams and whites, Sargent shifts the emphasis away from the choice of things to the process of showing them. He himself disparaged the painting's subject entirely when he wrote overmodestly "of a little picture I perpetrated in Tangiers" that "the only interest of the thing was the colour."[24] It thus truly becomes art for art's sake, a demonstration of Sargent's signal attachment to one of the touchstones of modernity. Vernon Lee confirmed the painter's interest in such issues when she described him in 1881: "John is extremely serious, a great maker of theories; he goes in for art for art's own sake, says that the subject of a picture is something not always in the way etc."[25]

Critics in both France and America responded warmly to *Fumée d'ambre gris*. Even before the Salon opened, by mid-March *L'Illustration* had indicated that it would include an engraving of the painting in its pages.[26] After it was more widely seen, literally not enough good could be said of the subject or the handling. By mid-May, the work had been sold to an as-yet-unknown admirer. His sister Emily wrote: "Mamma had a postal some evening ago from John saying that his Tangier Arabe woman that he painted there last winter, has been sold to a Frenchman living in Paris 3000 frs. only. I think it is too little. I am so glad to see it in the Salon now, otherwise we might not be able to."[27] Truer words were never spoken. In spite of repeated notices in the press that *Fumée d'ambre gris* was being sent to America for exhibition, the French owner seems to have spurned all Sargent's efforts to show the work; after the Salon of 1880, it was lost to public view for thirty years.[28]

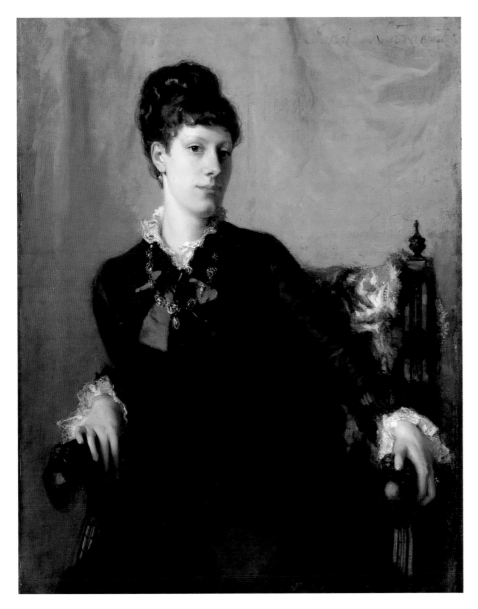

1. *Fanny Watts*, 1877

Oil on canvas, 41 5/8 x 32 7/8

Philadelphia Museum of Art

Mr. and Mrs. Wharton Sinkler Collection

Paris 1877 — Salon de 1877

Portrait de Mlle W . . .

1912 (of 2192 paintings)

Chose singulière, les portraits de femmes sont presque toujours inférieurs à ceux des hommes, et les portraits de jeunes femmes à ceux des vieilles femmes. . . .

　　Il y a des exceptions. . . . [Charles Chaplin, Emile Lévy, Michel Lévy] De l'entrain, de la liberté dans la longue dame de M. Sargent, jettent une autre note que réveille la froide série féminine.

　　Duranty, "Réflexions d'un Bourgeois sur le Salon de Peinture," *Gazette des beaux-arts* 15, no. 6 (June 1877): 560.

[U]n charmant portrait de jeune miss, par M. Sargent, d'une claire harmonie et auquel on ne peut reprocher que des mains fuselées.

　　Henry Houssaye, "Le Salon de 1877," *Revue des deux mondes* 21, no. 4 (15 June 1877): 839.

Paris 1878 — Exposition universelle internationale

Portrait d'une dame

Etats-Unis 88 (of 144 paintings and watercolors)

D'autre portraitistes, sans avoir la force de ceux-ci, méritent des éloges. . . . Le *Portrait d'une dame*, par M. Sargent, robe verte sur fond rose, assise et accoudée de trois quarts contre le bras de son fauteuil, a de la coquetterie et du brio.

　　Dubosc de Pesquidoux, *L'Art dans les deux mondes: Peinture et sculpture*, 2 vols. (Paris: E. Plon, 1881), 2: 536.

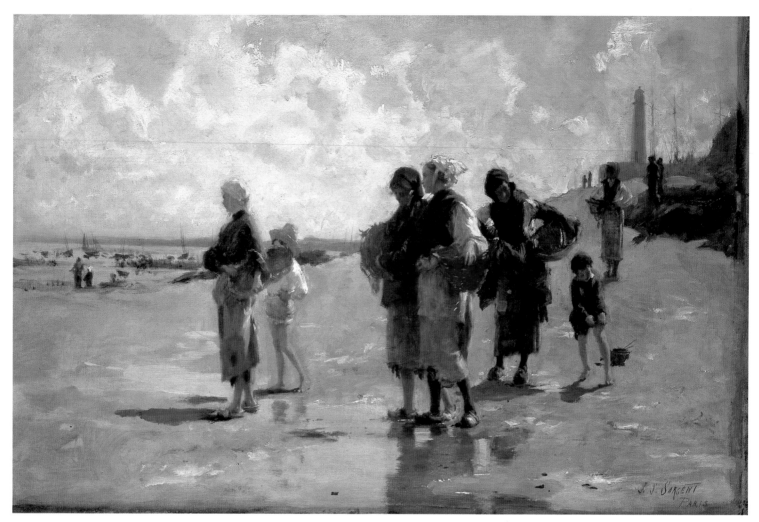

2. *Fishing for Oysters at Cancale*, 1878

Oil on canvas, 16 1/4 x 23 3/4

Courtesy, Museum of Fine Arts, Boston

Gift of Miss Mary Appleton

New York 1878 — Society of American Artists First Exhibition

Fishing for Oysters at Cancale

23 (of 124 works; price: $200)

[N]o word less than "exquisite" describes Sargent's Oyster Fishers at Cancale. We envy a mind, that can look thus at common life, the bliss of its daily existence. Where another would see but a group of rude fish-wives plodding heavily in the sand, he shows us a charming procession coming on with a movement almost rhythmical. The light is behind and throws their shadows forward in a dusty violet bloom. Small pools in front give back reflections. The close skirts show the action of the figures. The line of a descending hill in the background is cut by the straight sea horizon. All is as fresh and crisp as the gray and blue of the shifting sky. The light touches only in scattering points upon the forms, which are for the most part in shade. It is managed with a delicious skill. The difficult matter of the relief of white upon white is disposed of as if with an airy nonchalance. The white peasant caps are brought off the light sky with just a sufficient suggestion of detachment, here by a slight darkening of gray, there by a flicker of yellow in the light on an edge.

> Raymond Westbrook, "Open Letters from New York," *Atlantic Monthly* 41, no. 248 (June 1878): 785.

A picture the only one of its kind in the exhibition, and strongly recalling Boldoni and his colour, is 23, "Fishing for Oysters at Cancale," by John S. Sargent. The silvery hue of this painting is what first attracts the attention, and immediately the eye rests upon a group of women and children, half in silhouette, rambling among the quiet pools left by the retreating tide. Their shadows, dark and vapoury, are cast on the ground, while the reflection of their figures appears in the still water around their feet. A little way off the ripples of the blue sea roll up against the steep shore, and luminous clouds shimmer with sunlight.

> S. N. Carter, "First Exhibition of the American Art Association," *Art Journal* (New York) 4, no. 4 (April 1878): 126.

"Fishing for Oysters at Cancale," by Sargent, was one of the best studies of flashing daylight ever made by an American artist.

> "Fine Arts. The Lessons of a Late Exhibition," *Nation* 26, no. 667 (11 April 1878): 251.

Mr. John S. Sargent, perhaps, is the only member of the Society who, from the outset, almost gained the ear simultaneously of the public and of connoisseurs. His little marine, "Fishing for Oysters at Cancale," exhibited last year

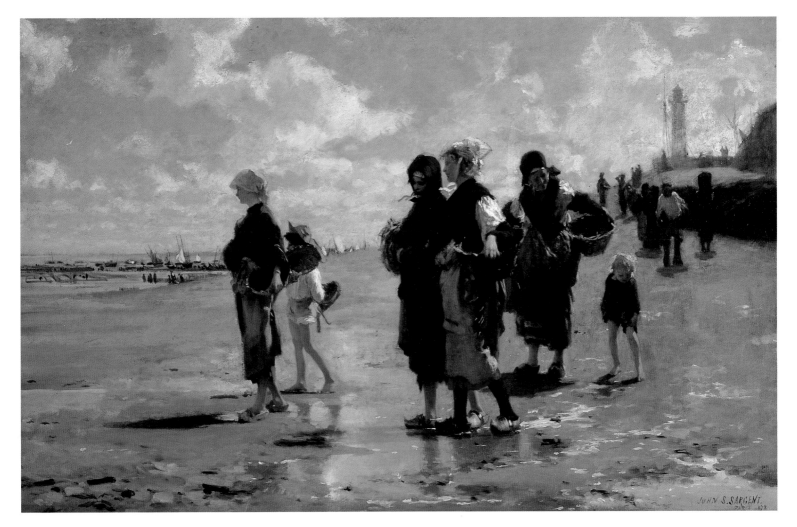

in the Kurtz Gallery, New York, was the most certain and manifold artistic success of the season.

"Sketches and Studies," *Art Journal* (New York) 6, no. 6 (June 1880): 174.

It was often remarked, during the first exhibition of the Society of American Artists in New York, that young Mr. Sargeant's magical "Fishing for Oysters at Cancale" had been bought by Mr. Samuel Colman. In fresh, translucent, humid atmospheric effects, this picture was the best there displayed; and when asked by a friend why he had purchased it, Mr. Colman replied, promptly: "Because I wanted to have it near me to key myself up with. I am afraid that I may fall below just such a standard, and I wish to have it hanging in my studio to reproach me whenever I do."

G. W. Sheldon, *American Painters* (1879; New York: Appleton, 1881), 72.

New York 1880 — Metropolitan Museum of Art — Inaugural Exhibition

Oyster Fishing at Cancale

3. *Oyster Gatherers of Cancale*, 1878

Oil on canvas, 31 x 48

In the collection of The Corcoran Gallery of Art, Washington, D.C.

Museum Purchase, Gallery Fund

Paris 1878 — Salon de 1878

En route pour la pêche

2008 (of 2330 paintings)

J'ai eu beaucoup de plaisir à voir le tableau de M. Sargent: *En route pour la pêche*. Cet artiste procède par touches franches et larges qui, examinées de près, semblent confuses, mais donnent, vues à distance, du relief et de l'éclat aux figures. On a la sensation du soleil éclairant les sables mouillés de la plage tachée çà et là par les reflets bleus du ciel dans les petites nappes d'eau.

Roger-Ballu, "Le Salon de 1878 (Deuxième et Dernier Article)," *Gazette des beaux-arts* 18, no. 1 (July 1878): 185.

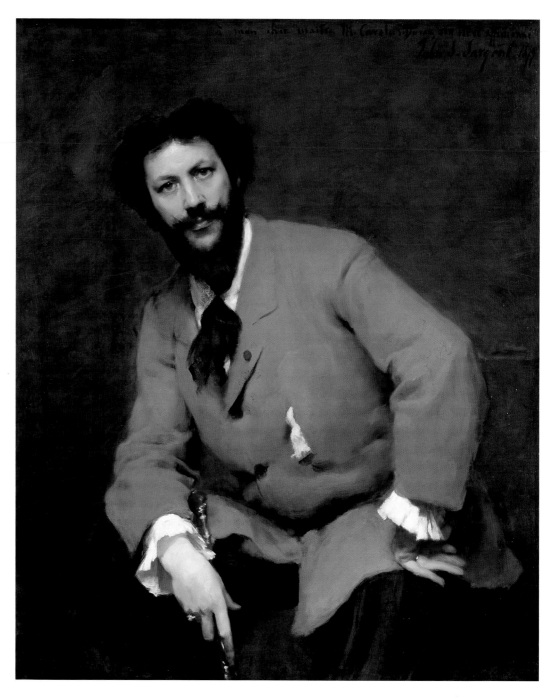

4. *Carolus-Duran*, 1879

Oil on canvas, 46 x 37 3/4

Sterling and Francine Clark Art Institute, Williamstown,
Massachusetts

Paris 1879 — Salon de 1879

Portrait de M. Carolus-Duran

2697 (of 3040 paintings)

If I have kept for the last Mr. John T. Sargent's portrait of his master, Carolus
Duran, it is that I may criticise him, not merely as an American, but as a
painter who has already fairly won a place in the foremost rank of young
French painters. . . . Without giving Mr. Sargent too much credit for the ad-
mirably spirited pose — it is quite in Duran's temperament himself to take
the most becoming pose — one cannot fail to admire his original and masterly
scheme of color. It was a happy idea to paint his sitter in a loose morning-
jacket, of soft pale yellow, against a cold gray background, but only the high-
est artistic sensibility would have thought to call out all the subtleties in this
gray harmony, and set it vibrating by a single gleam of turquoise blue from
the arm of the chair. The interest centres in the pale expressive head, — flat-
tened [flattered?], Duran's enemies say; a fair and generous expression of the
man when at his best and aglow with his noblest thoughts, cry his friends;
and a portrait is painted for a man and his friends, not for his enemies. A
quite unconscious idealization is a characteristic of Mr. Sargent's talent. Even

in his daily atelier studies he manages, without sacrificing their value as studies, to throw over the coarse vulgarity of the model a charm and elegance quite his own. It is a rare gift, this atmosphere of sentiment, which is too distinguished ever to be sentimental. But this would attract little attention from the prosaic French art-world were it not seconded by as distinguished technical qualities. Mr. Sargent, like a true colorist, models, rather than draws, but there is no suggestion of feebleness in drawing, and the only adverse criticism I have heard brought against this much-noticed portrait was a thinness in the painting. This, however, taking in view the rather sketchy scheme of the work, has little weight, and is quite lost sight of in the charm of the wonderful simplicity and freshness of the brush work, qualities which are at present so much the fashion here that many clever painters are sacrificing all else to them.

R., "The Last Paris Salon. II," *American Architect and Building News* 6, no. 199 (18 October 1879): 124–125.

John S. Sargent received "honorable mention" for his portrait of Carolus Duran, which was really one of the best portraits of the Salon. Mr. Sargent has the trick of making the "human face divine" more so, infusing a soul into his model where very little exists.

Outremer, "American Painters at the Salon of 1879," *Aldine* 9, no. 12 (1879): 370–371.

New York 1880 — Society of American Artists Third Annual Exhibition

Portrait of Carolus-Duran

(not included among the 162 numbered works in the catalogue)

We note also the arrival of a picture by Mr. John S. Sargent, a portrait of the artist Carolus Duran. . . . Nothing that the artist has sent home heretofore will have introduced him so effectually to his countrymen as this portrait, a work which must challenge admiration and from which criticism cannot escape if it would.

"Fine Art. Society of American Artists," *New-York Daily Tribune*, 25 March 1880, 5.

The new sensation since the opening of the exhibition is a most life-like and speaking portrait of the French painter, Carolus Duran . . . who is cordially liked or cordially detested by each member of the art colony of Paris. He is seen to be a typical Frenchman, even to the very curl of his mustache, and evidently dead in earnest. No one could imagine him humorous for a moment. Mr. Sargent has caught the very spirit of the man, and reproduced him bodily, with almost the same cleverness Duran himself shows.

"One Day in the Gallery. Society of American Artists," *New-York Times*, 26 March 1880, 5.

Mr. Sargent has contributed the portrait of Carolus Duran from last year's Salon, with a well-moulded colorless head, and hands treated on an entirely different principle of modelling, so that we seem to see a sculptured head with paper extremities; his inconsistency here shocks the sight in America, as it lost him a medal in France.

E. S., "Fine Arts. The Society of American Artists. — Modern American Tendency," *Nation* 30, no. 770 (1 April 1880): 258.

This portrait may be termed celebrated, for not only did it enter the Salon and create much talk among artists in Paris, but it has been reproduced in the fine books of art that describe the Salon, and had the somewhat doubtful honor of a piece of "chiseled" verse at the hands of one of the minor French poets of to-day. It must be a pleasure to an artist to examine the workmanship of this thoroughly workmanlike production. There is a fine certainty and breadth to the strokes, an audacity in pose, a vigor in expression of character,

which would make it remarkable anywhere. Mr. Sargent gives a somewhat effeminate effect to his "dear master Carolus" by showing the lace cuffs of his shirt, the broad stripe of his trousers, his jaunty cravat, and a colored handkerchief. To sober Americans this "master" may seem a little on the order of fops, but how thoroughly the pupil has learned his lesson! How admirably he has placed color by color, and brought harmony out of shades of gray and brown put cleverly side by side.

"The American Artists. Close of the Exhibition," *New-York Times*, 16 April 1880, 8.

In every particular Mr. Sargent's *Duran* is not only a grand rendering of a striking subject, but also as good an example as we can probably get of the present state of portraiture in France.

S. G. W. Benjamin, "Society of American Artists. Third Exhibition," *American Art Review* 1, no. 6 (April 1880): 261.

At the Society's rooms, to cease from generalities, the two canvases that attracted us first, were Mr. Chase's portrait of General Webb, and Mr. John Sargent's of Carolus Duran. They were apt to be noted together, not only for the excellence common to them both, but for their divergence from one another. . . . [Sargent's] is French work through and through. French no less in the technique, which is twin to that of more than one Parisian we know of, than in its feeling and its meaning as a work of art.

M. G. van Rensselaer, "Spring Exhibitions and Picture-Sales in New York. — I," *American Architect and Building News* 7, no. 227 (1 May 1880): 190.

Boston 1880 — St. Botolph Club Inaugural Exhibition

Portrait of Carolus Duran

27 (of 142 works)

The two famous portraits by William M. Chase and John S. Sargent (both young New York artists), facing each other in the midst of the gallery, are almost enough in themselves for an exhibition. . . . Both these portraits have the *insouciance* of pose that so shocks the old-fashioned portrait-painter who has to obey the directions of his sitter and the intelligent jury of relatives and friends usually called in to sit on his work. . . . [T]he young Parisian in the elegant negligence of a morning dress, with frilled shirt cuffs, gray lounging jacket and striped trousers, leans forward, his hands or arms lightly resting upon his knees, but with an instinctive grace and politeness even in this most unceremonious of postures. . . . Mr. Sargent's portrait is painted much more simply, even slackly, one thinks. . . . But it will be seen on carefully looking at Mr. Sargent's work that the face and head have been wrought out with the finest knowledge, feeling and care, supplemented with the finest skill, as was befitting so rare a subject, and that the whole head is as "solid" as it is dashing in effect.

"Art Notes," *Boston Evening Transcript*, 21 May 1880, 4.

London 1882 — Fine Art Society, British and American Artists from the Paris Salon

Portrait of My Master, Carolus Duran

8 (of 14 paintings)

Very much more satisfactory are Mr. Sargent's two portraits: one of M. Carolus-Duran — who, by the way, is made to look a little like a brilliant dentist — and one of a young lady. . . . Both are excellently apprehended and painted.

"Art Notes [August]," *Magazine of Art* (London) 5 (1882): xli.

Paris 1883 — Ecole des beaux-arts: Portraits du siècle

Portrait

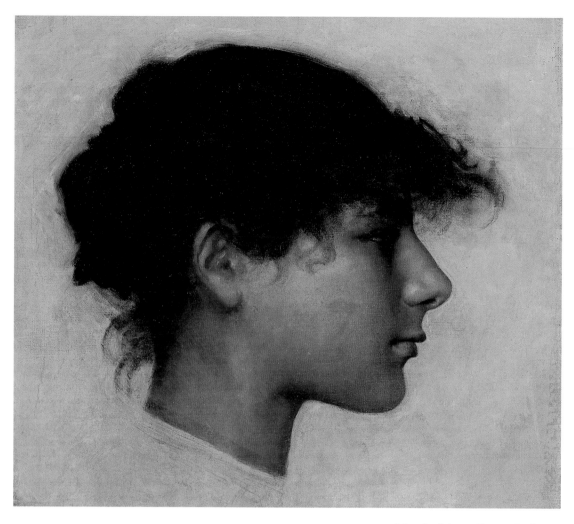

5. *Head of Ana-Capri Girl,* 1878

Oil on canvas, 9 x 10

Private collection

New York 1881 — Society of American Artists Fourth Annual
Exhibition

Capri Peasant — Study

73 (of 147 works)

The head of a Capri peasant-girl, by John S. Sargent, is firmly and neatly
painted, and is in itself an interesting profile. One regards it with the curiosity
of an ethnologist rather than the pleasure that one expects to get from a work
of art. Is this a type from that distinct race settled in Anacapri which is said to
have been introduced from Greece? It has the look of a Phenician, and may
be profitably compared with the busts at the Metropolitan Museum which
were found in Cyprus.
 "Some American Artists. Various Notable Pictures in the Exhibition,"
 New-York Times, 15 April 1881, 5.

Sargent's "Capri Girl" is modelled like a head on a Syracuse coin — the type
like the last of the Greek daughters, imprisoned in an island and preserved to
fade out among strangers; it is a small thing, but a masterpiece of care and in-
sight.
 Edward Strahan [Earl Shinn], "Exhibition of the Society of American
 Artists," *Art Amateur* 4, no. 6 (May 1881): 117.

6. *A Capriote*, 1878

Oil on canvas, 30 1/4 x 25

Courtesy, Museum of Fine Arts, Boston

Bequest of Helen Swift Neilson

New York 1879 — Society of American Artists Second Exhibition

A Capriote

37 (of 166 works; for sale)

Still another who has studied to good effect in Paris is Mr. Sargent, whose "Capriote," a damsel painted in very light hues, with the exception of her face and arms, is leaning on a gnarled tree in a bright-colored picture at the other end of the gallery. The weeds in the foreground are brought out cleverly, without the aid of any Preraphaelite exactness. The coloring strives after the joyous effects of the Fortuny school. It is certainly a very creditable performance.

 "American Art Methods: The Society of Artists," *New-York Times*, 10 March 1879, 5.

The pupils from France and the pupils from Germany are again drawn face to face in battle array. The Germanic painters . . . undoubtedly carry the day with the more impressionable part of the public. In opposition to them the work of the Parisians, based on structural analysis, and rejecting all color that is merely a superficial adornment and is not based on the conditions of the scene, inspire more confidence and beget a better hope for the future. Among the latter, John S. Sargent, whom many look very keenly at as the coming American painter, sends a little picture that does not belie the expectations raised by his radiant group of sea-side *Cancalais* in last year's exhibition. The present envoy is a graceful Capri girl (37), with her Greek pedigree delicately asserted in her posture and her beauty. The figure is set mosaic-wise, without any contrast of values, in an island landscape. The strangest and leanest of olive-trunks, pulling themselves this way and that in an apparent struggle to become grapevines, gad about over the whole panel with a decorative wilfulness and originality that would please a Japanese designer; on one of them, half-accepting its support, half-caught in its toils, the dark-skinned peasant leans. The color is rich, subdued, harmonious, and the drawing securely easy. The picture, which might be signed Hébert without much danger of detection, seems like a frank confession of the mood of creative joy out of which it proceeds. Few youths, indeed, have the chance of imbibing happiness through the cultivation of so many of the senses as Mr. Sargent, whose life has passed in choosing out the most favored countries to grow up in. . . . Mr. Sargent's "Capriote" is merely one of his cabinet pictures; but it has in it no touch that contradicts the impression of power and grace which his successive achievements have conveyed.

 "Fine Arts. Exhibition by the Society of American Artists," *Nation* 28, no. 716 (20 March 1879): 207.

Sargent justifies the good opinions he won for himself on his first appearance. A white-waisted, pink-skirted, brown girl of Capri meditates in an olive orchard, leaning against a crooked stem across which her arms are nonchalantly thrown back, disclosing a crease between the slender shoulder-blades. There are usually masters to whom the strongest of the new men can be traced. This one recalls Michetti, a charming, quaint bright-colorist whom some want of appreciation has kept thus far from being much imitated. This is not cited in depreciation, but to aid those knowing the greater to comprehend the less, if by chance there be any prevented from falling in with him. The resemblance extends to a striking of the same kind of note. It is in the olive orchard, the kind of a peasant girl, the — what an English equivalent should be found for as soon as convenient — *chic* of the whole.

 "The Two New York Exhibitions," *Atlantic Monthly* 43, no. 260 (June 1879): 781.

In Mr. John S. Sargent's "Capriote" picture there was the well-drawn figure of a woman, leaning against a small tree, in much the same fashion as Mr. Shirlaw's "goose herd" wound her arms about her staff; but the whole was so broadly painted it would hardly bear close inspection, and only at the proper distance was a picturesque effect produced. The stones, the trees, and the grass were given over to impressions, such as they may be assumed to have been under a strong light. So, too, the background of Mr. J. Alden Weir's "In the Park." . . . How much art or beauty there is in pictures treated in this manner each must decide for himself. It remains to be seen if the public will accept such productions as pictures possessing the requisite amount of thought and finish.

 J. B. F. W., "Society of American Artists," *Aldine* 9, no. 9 (1879): 278.

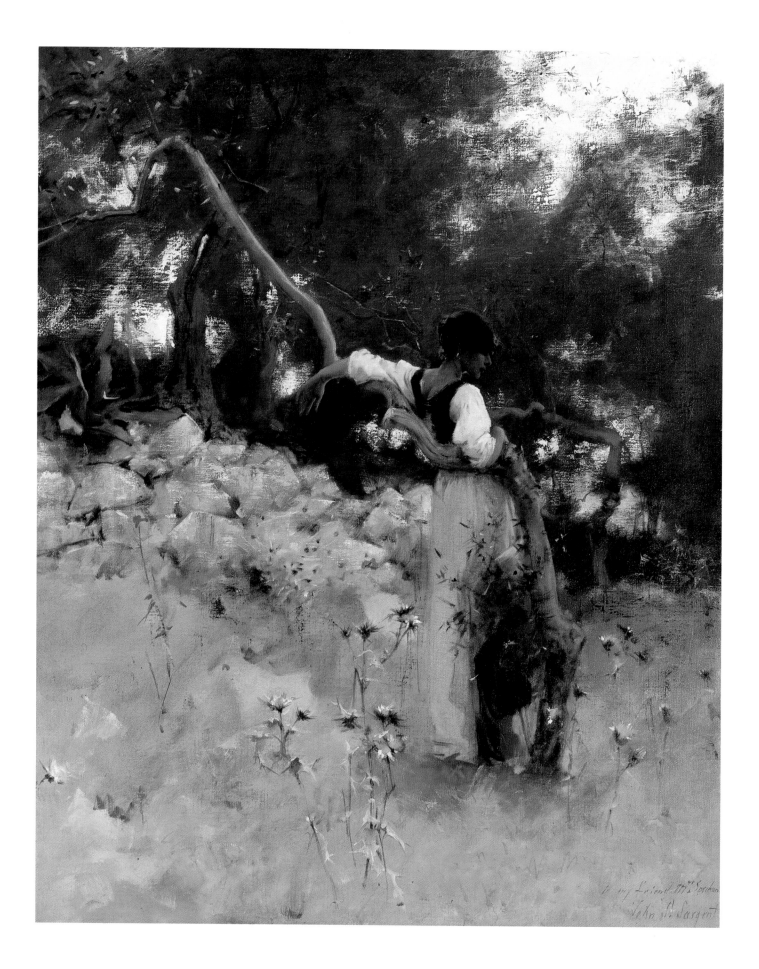

7. *Among the Olive Trees, Capri*, 1879

Oil on canvas, 30 1/2 x 25

Private collection

Paris 1879 — Salon de 1879

Dans les oliviers, à Capri (Italie)

2698 (of 3040 paintings)

M. Sargent expose en outre une superbe pochade, *Dans les oliviers à Capri (Italie)*, 2698.

> Charles Tardieu, "La Peinture au Salon de Paris, 1879. Itinéraire," *L'Art* 5, no. 17 (1879): 190.

M. John Sargent passe par Capri avant de revenir faire à Paris un très vivant et très élégant portrait de *M. Carolus Duran*. Il rapporte de la retraite de Tibère la vision d'une jeune fille des champs farouche et bronzée, qui lui est apparue *dans les oliviers*, au milieu de buissons et de broussailles éclairés de chatoiements d'émeraude et de reflets opalins.

> F.-C. de Syène [Arsène Houssaye], "Salon de 1879. II," *L'Artiste* 50, pt. 2 (July 1879): 9.

His other picture was rather an imitation of Michetti, and inferior to his bright, true pictures of the Normandy coast, with the fisherwomen descending the sands; but these deviations mark rather an excess of talent than the lack of it. A mind and eye continually on the *qui vive* sees so much that is beautiful and desires to accomplish all.

> Outremer, "American Painters at the Salon of 1879," *Aldine* 9, (1879): 371.

8. *Neapolitan Children Bathing*, 1879

Oil on canvas, 10 1/2 x 16 1/8

Sterling and Francine Clark Art Institute, Williamstown, Massachusetts

New York 1879 — National Academy of Design Fifty-fourth Annual Exhibition

Neapolitan Children Bathing

431 (of 615 works; owner: G. M. Williamson)

Mr. John S. Sargent's little seaside study is as brilliant and pure in color as is his exquisite Capriote maiden in the Kurtz Gallery. The feeling of luminous atmospheric glow expressed in this picture gives it a transparency and sparkle that is very remarkable, even among the dazzling productions of this young American exponent of the French school of light.

> "The Academy Exhibition," *Daily Graphic*, 29 March 1879, 207.

[Sargent's is] one of the most attractive pictures in the collection, an out of door study of some naked boys on a beach, with another seen swimming. It is a sparkling little work, full of air and sunlight and superb in its decorative Italian color. The figures are remarkable for good drawing and simple modelling, also for pure flesh tints. The pose of the two older boys lying on the sand is well taken, and what could be more inimitable than the fat little fellow, with his face turned to us, who timidly paws the air with a swimming stroke? As a remarkably clever bit of work note the painting of the semi-transparent air bags which the boy with his back to us has fastened to his shoulders as life preservers.

> "Fine Arts. Fifty-fourth Annual Exhibition of the National Academy of Design — Second Notice," *New York Herald*, 31 March 1879, 5.

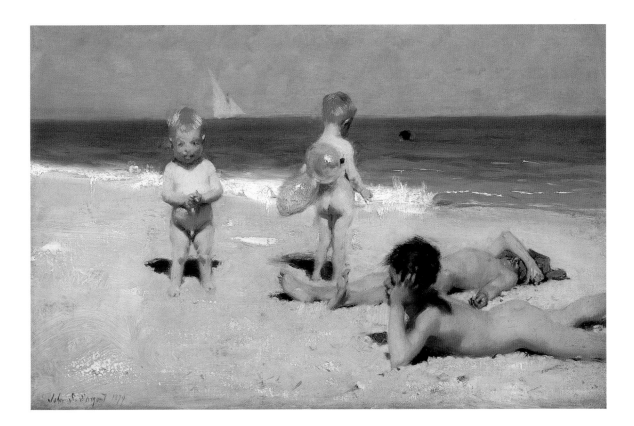

Mr. John Sargent's, "Little Wanton Boys," No. 431, West Room, will, of course, seem to the visitor who only knows the gray seas that welter round our inhospitable Northern coast grossly exaggerated. . . . In fact, however, the blue of this picture is not in the least exaggerated, as everybody knows who has passed even a few weeks of Summer at Naples. . . . To this school [Italian-Spanish artists, with their French and American imitators] belongs Mr. Sargent, and he does not merely promise to be one of its most brilliant men, he is already such. . . . Here is Tennyson's line translated for the eye — "By bays the peacock's neck in hue" — the luminous sapphire breaking into emerald and onyx lights, and these bronze and ivory cupids strewed like shells along the golden sands. The dark head of the swimmer sporting dolphin-like in the near blue; the bladders under the shoulders of the urchin who is about to venture on this sea of glory, bladders almost too well painted, for, though Veronese would hardly have made them better, he would have subordinated them, nor let them play so chief a part; the daring of the blue shadows, no more audacious, though, than Nature herself, who, alike on northern snows and tropic sands, thus pays with *lapis lazuli* for the light she takes away; lastly the beautiful bodies of these children, painted with skilful modelling and such purity of color — these things make up the charm of one of the prettiest pictures in the present exhibition.

It is not, however as a scientific statement that Mr. Sargent offers this picture to us, but as his impression of a beautiful combination of light, air and color, and if it not be worth showing us for this, its scientific accuracy would avail it nothing with artists or with lovers of art.

"Academy of Design. Fourth Article," *New-York Daily Tribune*, 26 April 1879, 5.

A most delightful little painting by J. S. Sargent (No. 431), "Neapolitan Children bathing," is an imitation, or, perhaps we should say, an adaptation, from some of the Spanish-Roman work. Three or four naked little boys, with big heads and legs slender, and bodies thin, are playing on the seashore with great transparent balls, very likely sunfish. The colour of this little painting is most exquisite as a palette of tints, with its azure sea, its white waves — as white and soft as down — combined with the lovely flesh-tints of the children; while the light colour which nearly everywhere fills the canvas is balanced and contrasted with almost positively purple, dark shadows under the little, soft bodies of the young boys who sprawl upon the sand, joyously and comically playing together.

"The Academy Exhibition," *Art Journal* (New York) 5, no. 5 (May 1879): 159.

Mr. John Sargent, a student at Paris, makes a very charming impression with an out-of-doors, sunshiny picture of children on a beach. Two of them are of the smallest size compatible with walking, and their large heads and tottering action give them a humorous likeness to old men. One has a makeshift life-saving apparatus formed of two bladders; another sprawls on the warm sand with all the naturalness and ungracefulness of a growing boy; a fourth has laid himself down, covered his face, and resolved on a sun-bath. Still another shows his head in the turquois water. The painting here is free and vivid, giving all that is necessary to the view, without much attention to details. The water is green where it breaks on the hot sand. It is a much better picture than the one shown at the Kurtz Gallery, although not so cautiously painted. It is very natural, home-like, and out-of-doorsy.

"The Academy Exhibition. Sales of Paintings," *New-York Times*, 2 May 1879, 5.

Before Sargent's other picture, at the Academy, Neapolitan Children Bathing, Michetti's very singular Springtime and Love, at the Paris Exposition, cannot fail to be remembered. This is not at all so full of figures, and they are boys instead of girls, but the same bluish and violet shadows are scattered about among them, and it is the same vivid blue sea against which the rosy flesh

tints are projected. Such groups are seen of a blazing July day from the window of a train to Castellamare. The chubby little fellows, and one particularly who has two bladders, shining with water and giving out shell-like reflections, attached to his shoulders, are made to look like young cupids.

"The Two New York Exhibitions," *Atlantic Monthly* 43, no. 260 (June 1879): 781.

One of the most delightful, golden, happy accidental hits in the exhibition is John S. Sargent's "Neapolitan Children Bathing" (431). It is a looser sketch than either of the three or four which he has so far sent to us from Paris. . . . Mr. Sargent is an artist proceeding from that nomadic life of certain American families in Europe, which sometimes produces mere waifs, and sometimes produces sons of uncommonly liberal education. In this case, at a very early age the young painter had the picture of every European capital imprinted on his mind, spoke all modern languages, and remembered his Latin and Greek derived from various professors between London and Florence. He is a thoroughly accomplished cosmopolitan. He comprehends music scientifically, reads all literatures with avidity, and paints better than his professor, Duran. Connected with his contribution to the academy there is a simple ballad-like story which may be worth the telling. . . . Mr. Sargent's visitor . . . was an elderly, modest man, and he was little. He called on the young painter-amateur in Paris just after the latter's "Cancalaises" had made some sensation at the Salon, and remarked that he had picked out the canvas as to his liking, and though not rich, would like a smaller but similar one if the artist could be tempted with a certain genteel price which was named. Sargent, who had never had an order in his life, and had never figured before the world as a professional, took care to express no surprise or joy. He said quietly he would furnish something or other for the money, and on the visitor's departure tore away to his friends, proclaimed the splendor of the order he had got, and spent most of the price in a crowded American orgy. When the picture was applied for, for this exhibition, the messenger was directed to one of those hopeless addresses far beyond the ends of the most endless streets of Brooklyn. . . . There, in a suburban wilderness, in a small house, he found the small Paris visitor hugging the solitary picture. Instead of being an art-patron with a collection, he was simply a man who had fallen in love with an artist's work and concluded to treat himself. So the "Children Bathing" went to a Brooklyn art-lover who had perhaps never bought a picture and never did again. And a young painter's vocation was settled; for Sargent determined to become a professional artist.

Edward Strahan [Earl Shinn], "The National Academy of Design," *Art Amateur* 1, no. 1 (June 1879): 4–5.

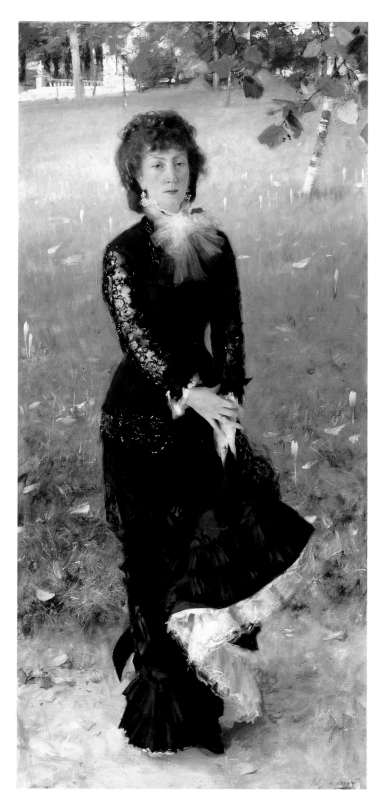

9. *Mme Edouard Pailleron*, 1879

Oil on canvas, 82 x 39 1/2

In the collection of The Corcoran Gallery of Art, Washington, D.C.

Museum Purchase and Gifts of Katherine McCook Knox, John A. Nevius, and Mr. and Mrs. Landsell K. Christie

Paris 1880 — Salon de 1880

Portrait de Mme E. P . . .

3428 (of 3957 paintings)

[A work by Collin conveys beautiful atmosphere] — moins intéressant cependant que la femme rousse de M. Sargent, errant aussi dans une prairie, au grand ébahissement des tulipes tendant vers elle leurs corolles curieuses. D'une saveur un peu étrange, ce dernier morceau m'a infiniment charmé; il fait penser à une poésie de Charles Baudelaire.

> Armand Silvestre, "Le Monde des Arts: Le Salon de 1880," *La Vie moderne*, 29 May 1880: 340.

Mr. John S. Sargent, who exhibited last year the portrait of his master, M. Carolus Duran, exhibits two pictures. His portrait of a lady strikes you queerly: the face is strongly but not pleasingly painted, no fault can be found with the drawing or treatment of the figure, which is very fine. The background is too much of a picture for the background of a portrait, it obtrudes itself too much; the figure stands at the foot of a sloping lawn covered with crocuses, the sentiment of color in the painting of the grass and crocuses is so beautiful that you see it before you do the portrait.

> "Special Correspondence: American Artists at the Paris Salon," *Art Interchange* 4, no. 12 (9 June 1880): 100.

M. John Sargent, dont la manière est plus jeune, n'est pas moins bien doué. M. Sargent est le peintre qui, l'année dernière, avait exposé un si bon portrait de son maître, M. Carolus Duran. On dirait qu'il a fait depuis lors de grands progrès. M. Sargent est beaucoup plus moderne que les impressionistes. Dans le portrait en pied d'une jeune dame qui se promène avec agitation au milieu des allées de son parc, le paysage du fond abonde en verdures fendres, en clartés à la Bastien-Lepage.

> Paul Mantz, "Le Salon: VII," *Le Temps*, 20 June 1880, 1.

Sargent's "Portrait of Mme. P." is of the French, Frenchy. One regrets that so much cleverness could give no lovelier picture to the exhibition than that of a modishly dressed and furiously red-headed woman, who looks as if her hair had not been touched for a week, and whose dim eyes are half closed, either from weakness or drowsiness, it matters not which.

> Margaret Bertha Wright, "American Pictures at Paris and London," *Art Amateur* 3, no. 2 (July 1880): 26.

Beaucoup de ces étrangers sont pour nous d'anciennes connaissances: la plupart ont étudié ou travaillé à Paris. . . . [L]'Américain Sargent, l'habile élève de Carolus Duran, avec son portrait de Mme E. Pailleron, debout dans un parc; le paysage est d'un beau ton, clair et frais, la robe d'un noir superbe; la tête et particulièrement la chevelure sont d'une peinture moins heureuse.

> Ph. de Chennevières, "Le Salon de 1880 (Troisième et Dernier Article)," *Gazette des beaux-arts* 22, no. 1 (July 1880): 61–62.

I think it will be generally admitted that the only really strong pictures exhibited by the American artists are John S. Sargent's portrait of Madame Pailleron (wife of the author of *L'Etincelle*) and his *Fumée d'Ambre Gris*. . . . Mr. Sargent is a surprise and a wonder to even his master, Carolus Duran, whose portrait, painted by Sargent, attracted great attention in the Salon of

last year and received an "honorable mention." He has painted this year a full-length in the open air, producing a very sunny, strong out-door effect. The hands attract much praise, but opinions vary as to the face.

> J. J. R., "Our Monthly Gossip: The Paris Salon of 1880," *Lippincott's Magazine* 26, no. 153 (September 1880): 384.

A côté de M. Watts, plaçons un Américain, élève de M. Carolus Duran, qui nous a donné l'an dernier un si bon portrait de son maître. Celui de Mme E. P. est meilleure encore, et, comme nous le lui avions prédit, voilà M. Sargent classé parmi les premiers portraitistes.

> A. Genevay, "Salon de 1880 (Huitième Article)," *Le Musée artistique et littéraire* 4 (1880): 14.

It is . . . to be regretted that Mr. John Sargent should have exhibited this year a work so unworthy of his growing reputation as his "Portrait of a Lady" — a red-haired, red-faced damsel in black, standing in the midst of a field that shows like a Brobdingnagian dish of green peas.

> Lucy H. Hooper, "The Paris Salon of 1880," *Art Journal* (New York) 6, no. 7 (July 1880): 222.

M. Sargent est un élève de Carolus Duran et il le prouve par son très remarquable *portrait de Mme E. P* . . . Le coup de soleil qui fait étinceler le gazon du fond, sur lequel se dessine la figure, est admirable d'effet.

> Maurice Du Seigneur, *L'Art et les artistes au Salon de 1880* (Paris: Paul Ollendorf, 1880), 104.

M. Sargent mérite, avec son portrait de Mme. P. . ., de prendre place à côté des artistes que je viens de nommer. C'est là un morceau de premier ordre et qui peut donner grande confiance dans l'avenir du jeune élève de M. Carolus Duran.

> X., "Le Salon de 1880," *La Nouvelle Revue* 4 (1880): 664.

I have kept two canvases for final mention, in view of their peculiar boldness of treatment — the one, by M. John Sargent, the picture of Mme. Pailleron in her park, with the sun lighting up the green slopes behind her, while she herself stands in clear half-light; the other, a very superior work, by M. Georges Bertrand, the portrait of Mme. A ——.

> Fourcaud, "Portraits," in Charles Carroll, ed., *The Salon*, 2 vols. (New York: Samuel L. Hall, 1881), 2:408.

10. *Fumée d'ambre gris*, 1880

Oil on canvas, 54 3/4 x 35 5/8

Sterling and Francine Clark Art Institute, Williamstown, Massachusetts

Paris 1880 — Salon de 1880

Fumée d'ambre gris

3429 (of 3957 paintings)

Avec *la Fumée d'Ambre gris*, M. John Sargent fait jouer tout le clavier des tons argentés autour d'une femme de l'Orient voilée d'une manière toute sculpturale.

> Frédéric de Syène [Arsène Houssaye], "Salon de 1880: Peintres Etrangers," *L'Artiste* 52, pt. 1 (May 1880): 367.

Mr. John S. Sargent, who exhibited last year the portrait of his master, M. Carolus Duran, exhibits two pictures. His portrait of a lady strikes you queerly. . . . His other picture of a Tangerian woman perfuming herself is marvelously strong; she is standing wrapped in a mass of soft cloth, spreading over her head another piece, and thereby catching the fumes from a small lamp on the ground before her. The cloth is a creamy color and the background is white also, though cooler in tone, it is a perfect piece of painting and may have a medal.

> "Special Correspondence: American Artists at the Paris Salon," *Art Interchange* 4, no. 12 (9 June 1880): 100.

Quant au tableau intitulé *Fumée d'ambre gris*, il est tout à fait imprévu et charmant. Combien les populations sont étranges! Voilà cinquante jours qu'elles sont en arrêt devant un vieillard déshabillé dont le ventre, pareil à une carte de géographie en relief, est sillonné de veines saillantes; le spectacle intéresse, bien qu'il soit repoussant; et devant le *Fumée d'ambre gris*, on ne rencontre jamais qu'un ou deux maniaques épris des choses fines. Une jeune femme de Maroc ou d'Alger vient d'allumer un brûle-parfum. Idole et prêtresse, elle s'offre un sacrifice à elle-même, car pendant que les fumées odorantes montent en spirales d'un gris doux, elle tient les bras étendus en ramenant son voile en avant comme la capote d'un cabriolet de l'ancien régime et elle fait si bien qu'elle concentre autour de son visage et retient un instant captives les vapeurs de l'encens brûlé. Naturellement, elle est vêtue d'une étoffe blanche tournant un peu vers le gris et que réchauffe discrètement la note plus vive d'une bordure orangée; le fond de la muraille est blanc, et la fumée qui monte est, comme il convient, couleur de fumée. Le petit visage d'un rose timide éclate au milieu de ces pâleurs ambiantes. Assurément, nous ne sommes pas en présence d'un chef-d'oeuvre immortel. Il s'agit d'une fantaisie mélodique, d'un jeu pareil à ceux qu'aimait le maître impeccable, Théophile Gautier. Seul, il aurait pu décrire le tableau singulier et délicat de M. John Sargent. Hélas! beaucoup d'entre nous ont perdu devant le *Job* de M. Bonnat des instants qu'ils auraient pu dépenser plus utilement devant la *Fumée d'ambre gris*. C'est le destin. Nous avons toutes les qualités du monde; mais nous sommes parfois bien malhabiles dans la gestion de nos heures.

> Paul Mantz, "Le Salon: VII," *Le Temps*, 20 June 1880, 1.

Sa *Fumée d'ambre gris* est une des toiles du Salon qui intrigue le plus le public peu au fait de ces raffinements de la volupté. Si "Theo" vivait encore, quelle belle matière à feuilletons lui aurait fournie cette toile. Cette Orientale qui se parfume et ravive ses ardeurs, car telle est, dit-on, la propriété de l'ambre gris, que l'aventurier Casanova prenait en poudre dans son chocolat, est une figure d'un effet bizarre et nouveau. C'est une fort jolie toile pour un boudoir secret,

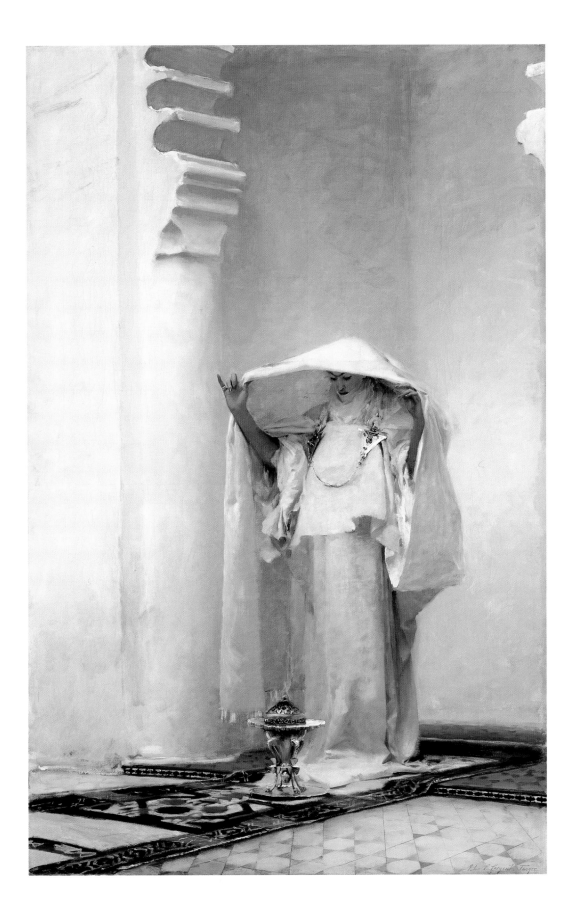

et, parmi nos épicuriennes beautés, M. Sargent aura-t-il la gloire d'avoir intro-
duit un usage qui deviendrait cher aux raffinées?

A. Genevay, "Salon de 1880 (Huitième Article)," *Le Musée artistique et
littéraire* 4 (1880): 14–15.

Fumée d'Ambre Gris represents a woman of Tangiers engaged in perfuming
her clothing with the fumes from a lamp in which ambergris is burning. The
white robes of the woman set off against a pearly-gray background, the rising
smoke, the curiously-tinted finger-nails of the woman, and the rich rug on
which the lamp stands, combine to make a very notable and curious picture.

J. J. R., "Our Monthly Gossip: The Paris Salon of 1880," *Lippincott's
Magazine* 26, no. 153 (September 1880): 384.

Un brillant débutant sort de l'atelier Carolus Duran, autre centre où s'ap-
prend naturellement l'irrespect pour les abat-jours verts. M. John S. Sargent
s'est révélé, l'an dernier, par un spirituel portrait de son maître, le sympa-
thique et sincère Carolus Duran, pour qui l'*Enfant rouge* de cette année est un
morceau complet. Il nous donne une jeune femme, *Mme E. P.*, marchant
dans un parc, d'une belle allure, et encore une fantaisie claire: *Fumée d'ambre
gris;* une mauresque voluptueuse, debout sur un tapis de prière, dans une salle
peinte à la chaux, penche la tête et tend ses voiles pour ne rien perdre de la
fumée qui monte d'un brasero couvert et l'enivre comme une nonne à l'autel.
C'est une association de tons fins qui dénote un rare tempérament de col-
oriste et un artiste de goût.

Ph. Burty, "Le Salon de 1880: Les Etrangers," *L'Art* 6, no. 21 (1880):
299.

Mr. Sargent's picture, "Ambergris Smoke," shows a curious blending of tech-
nical skill with the whimsical taste of the dilettante. An Eastern woman,
magnificent in her ample drapery of white woollen, sits watching a censer
placed at her feet, from which the pungent fumes of burning ambergris are
curling up to her nostrils. The high light of the room, of the woman's white
figure, and of the smoke, make up altogether a singularly striking and effec-
tive ensemble. Such variations on one tone are not, to be sure, among the

most difficult achievements of the art; but it takes knowledge, and a good deal
of it, to juggle with them as deftly as M. Sargent.

René Delorme, "Genre," in Charles Carroll, ed., *The Salon*, 2 vols.
(New York: Samuel L. Hall, 1881), 1:157–158.

Dans son autre tableau intitulé: *Fumée d'ambre gris*, l'artiste a eu l'audace de
faire une innovation dans l'art des camaïeux. La tonalité générale de la com-
position est toute blanche; sur le fond de mur blanc d'un harem, apparaît la
forme blanche d'une femme qui fait brûler, à ses pieds, de l'ambre dans une
cassolette. Il faut être vraiment fort, pour obtenir, avec une si grande simplic-
ité de procédé, une oeuvre aussi réellement intéressante que l'est celle de M.
Sargent.

Maurice Du Seigneur, *L'Art et les artistes au Salon de 1880* (Paris: Paul
Ollendorf, 1880), 104–105.

"El Jaleo" sins, in my opinion, in the direction of ugliness, and . . . a want of
serenity.

This is not the defect of the charming, dusky, white-robed person
who, in the Tangerine subject exhibited at the Salon of 1880 (the fruit of an
excursion to the African coast at the time of the artist's visit to Spain), stands
on a rug, under a great white Moorish arch, and from out of the shadows of
the large drapery, raised pentwise [tentwise?] by her hands, which covers her
head, looks down, with painted eyes and brows showing above a bandaged
mouth, at the fumes of a beautiful censer or chafing-dish placed on the car-
pet. I know not who this stately Mohammedan may be, nor in what mysteri-
ous domestic or religious rite she may be engaged; but in her muffled
contemplation and her pearl-colored robes, under her plastered arcade, which
shines in the Eastern light, she is beautiful and memorable. The picture is ex-
quisite, a radiant effect of white upon white, of similar but discriminated
tones.

Henry James, "John S. Sargent," *Harper's New Monthly Magazine* 75,
no. 449 (October 1887): 688.

"Away for Venice" 1880–1882

"Well," wrote Sargent to his friend Vernon Lee from Paris in the fall of 1874, "we have decided to spend the winter here. I am sorry to leave Italy — that is to say, Venice, but on the other hand I am persuaded that Paris is the place to learn painting in. When I can paint, *then* away for Venice!"[29] In France he did indeed learn both how to paint and how to manage a painter's career. True to his word, however, as soon as he had mastered the lessons of Paris, he turned to the Italian city.[30]

He was in Venice in early 1878 — Mary Cassatt makes reference to a Mr. Sargent, who, in the context of her discussion of the newly organized Society of American Artists, must be he — but nothing is known about where he lived, how he occupied his time, or the duration of his stay.[31] Two years later, in mid-September 1880, Sargent was again in the city. This time he registered at the Hotel d'Italie (now the Bauer-Grunwald) on the Campo San Moisè, joining his family who was spending a season there. "He expects to remain on here indefinitely, as long as he finds he can work with advantage, & has taken a Studio in the Palazzo Rezzonico, Canal Grande, an immense house where several artists are installed, & where one of his Paris friends has also taken a room to work in," wrote his sister Emily.[32] By 27 September he himself wrote to Vernon Lee's mother, declining an invitation to visit that family in Florence: "Much as I would like to see you and your son again and renew my old bonne camaraderie with Violet [Vernon Lee] I am forced to consider that there may be only a few more weeks of pleasant season here and I must make the most of them. . . . I must do something for the Salon and have determined to stay as late as possible in Venice."[33] After his family departed in search of more temperate winter climes, he moved to lodgings at 290 piazza San Marco, All'Orologio — at the throbbing heart of the tourists' city, the urban space that was, as Napoleon phrased it, the "finest drawing room of Europe." To Vernon Lee he wrote in late October: "There is plenty of work to be done here and the only thing I fear is the ennui of living almost alone in a wet and changed Venice."[34] The stay, in spite of potential boredom and dampness, lasted, according to some sources, as late as mid-March 1881.[35]

In the summer of 1882, Sargent returned for another extended visit, residing this time with his cousins and friends the Daniel Sargent Curtises in the Palazzo Barbaro on the Grand Canal — "a vast & luxurious & exquisite place, full of beautiful furniture & pictures, & at the same time absolutely unostentatious."[36] He was well settled by mid-August, when again Vernon Lee's mother invited him to Tuscany. Once more he declined, citing the press of work: "The time is nearing when, if my work were done, I might avail myself of your kind invitation to Siena. But I am afraid I shall only see you in Florence later on, for I am really bound to stay another month or better two in this place so as not to return to Paris with empty hands. The last month has been so warm that I have hardly done anything but make projects for work."[37] He stayed on in Venice through much of the fall.[38]

Although Sargent made some portraits of patrons or acquaintances while in Venice during these years, the majority of his works showed groups of Venetians going about their daily routines, engaged in conversation or nondescript activities in the campi and palazzi of the city.[39] These paintings are an extraordinary group. Rather than the vistas made famous by Canaletto or the fair-skinned beauties of Titian, Sargent sought out darkened alleyways and cool, vast interiors, filling them with working-class women and cloaked, slightly sinister men. These Venetians lounge and chat and go about their daily business, exemplars of the everyday. The women, and Sargent concentrated on the women, seem illustrations to Henry James's nearly contemporaneous *Princess Casamassima:* "The Venetian girl-face is wonderfully sweet and the effect is charming when its pale, sad oval (they all look underfed), is framed in the old faded shawl. They also have very fascinating hair, which never has done curling, and they slip along together, in couples or threes, interlinked by the arms and never meeting one's eye . . . dressed in thin, cheap cotton gowns, whose limp folds make the same delightful line that everything else in Italy makes."[40] On rare occasions they establish eye contact with the viewer in a distinctly challenging fashion.[41]

The English painter Henry Woods, who lived in Venice during the 1870s and 1880s, recorded in his diary for the autumn of 1880: "Sat with Sargent for a while at Florian's." On going back to Sargent's studio, he responded to the work: "His colour is black, but very strong painting."[42] The American collector and connoisseur Martin Brimmer visited the Curtises at the Palazzo Barbaro in 1882, and he wrote to a friend: "Young Sargent has been staying with them & is an attractive man. The only picture of his I have seen is a portrait of Thornton

Lothrop, in which I thought the head a masterly piece of painting. He had besides some half-finished pictures of Venice. They are very clever, but a good deal inspired by the desire of finding what no one else has sought here — unpicturesque subjects, absence of color, absence of sunlight. It seems hardly worthwhile to travel so far for these. But he has some qualities to an unusual degree — a sense of values & faculty for making his personages move."[43]

The blackness or absence of color noted by Woods and Brimmer reflected the fact that, by the time of the sojourns of 1880 and 1882, Sargent had fully absorbed the inspiration of Spain and Holland (experienced directly during his travels of 1879 and 1880) and added to his Parisian technique the spatial conceptions and tonal sympathies of Velázquez and the coloration and brushwork of Hals. And at least some of the paintings, moreover, were winter scenes, a season that prompted Sargent to write: "you will perhaps see how curious Venice looks with snow clinging to the roofs and balconies, with a dull sky, and the canals of a dull opaque green, not unlike pea soup, *con rispetto*, and very different from the julienne of the Grand Canal in summer."[44] The results were views of the city wildly unlike those of his contemporaries. When most genre painters of the day went to Venice, and many of all nationalities did, they focused on brightness and good cheer.[45] A British critic observed in 1883: "One of the characteristics of the Genre of the moment is that a whole group of the very best masters of it practise it in Venice. . . . Why has Venice been their choice? I suppose it may be because the painter of Genre delights to be picturesque as well as to be true, and picturesqueness may be hand in hand with truth in all these studies of the working folk of Venice as they labour and as they enjoy."[46] Citing works by Eugene de Blaas, Girolamo Favretto, Luke Fildes, Horace Fisher, William Logsdail, Cecil Van Haanen, and Henry Woods (all on exhibition in London in the early 1880s), a variety of critics began to speak of "this new school that has Venice for its center," or "the artists who have endeavoured to put modern Venetian life upon canvas" with an "extreme of gaiety and brilliancy of colour."[47] Only James McNeill Whistler, whom Sargent may have met at the beginning of his 1880 sojourn (Whistler was there until the middle of November) worked with comparably tenebrous subjects and muted tonalities while in the city.[48] Thus several professional critics, on seeing Sargent's Venetian genre works in London or Paris in the first half of the 1880s, responded with a sense of disjunction between their conception of colorful Venice and Sargent's more dour presentation. Five to ten years

later, however, when the works were shown in the United States, they gathered almost uniformly enthusiastic responses.[49]

Sargent wrote of wanting to make a significant Salon painting from his Venetian observations, but he never did so (although he did exhibit two watercolors, each called *Vue de Venise*, in the Salon of 1881). However, he showed the Venetian oils elsewhere, and often, throughout the decade. He finished a number of works on Venetian themes from his 1880 stay and showed at least two oils at the Cercle des Arts libéraux in Paris in April 1881 and two from the same campaign at London's Grosvenor Gallery in May 1882. At the first exhibition of the Société internationale de peintres et sculpteurs ("les jeunes") in December 1882, four of Sargent's seven paintings were of Venice, as was a work at the Cercle de l'Union artistique in February 1883. In America, when Sargent was honored with his first solo exhibition, held in Boston in 1888, he chose to have at least three Venetian works included, and he submitted two of those for his second showing at the National Academy of Design, which took place later that year.

Unfortunately for the present exhibition's purposes, only a handful of these recorded showings can now be positively identified with a known work. Certainly *Sortie de l'église, Campo San Canciano, Venice* and *Street in Venice* (cats. 17 and 18, respectively) were at the Société internationale, since a drawing after the first was included in the catalogue and drawings after both were in the *Gazette des beaux-arts*. To judge from retrospective descriptions and a reproduction in the *Art Amateur*, the same *Street in Venice* was part of the 1888 solo show in Boston, along with *Venetian Bead Stringers* (cat. 14) and the shockingly informal *Sulphur Match* (cat. 16). The first two were the National Academy of Design paintings.

But of the London and other Paris showings, the critical responses located to date are too general to be useful. The exception might be Henry James's criticism of the Grosvenor Gallery exhibition of the summer of 1882. At the time he wrote of "a certain papery texture" and "a charming little gray Venetian interior, with figures."[50] In retrospect James recounted: "There stands out in particular, as a pure gem, a small picture exhibited at the Grosvenor, representing a small group of Venetian girls of the lower class. . . . The girls are vaguely engaged in some very humble household work; they are counting turnips or stringing onions, and these small vegetables, enchantingly painted, look as valuable as magnified pearls."[51] No painting fits so well these two interlocking descriptions as *Venetian Women in the Palazzo Rezzonico* (cat. 13), which would thus date from Sargent's 1880 stay in the city.[52]

Complicating the consideration of which works were shown when is the fact that Sargent dated only one of the Venetian genre paintings — *The Sulphur Match* is inscribed 1882. Otherwise, scholars have settled on a consensus for them of about 1880–1882. But if *Venetian Women in the Palazzo Rezzonico* indeed serves as a touchstone of the 1880 stay, and *Sortie de l'église, Street in Venice*, and *The Sulphur Match* can function as standards of 1882, it might be possible to distinguish some groupings. The rounded faces and delicately detailed physiognomy of the foremost woman in *Venetian Women in the Palazzo Rezzonico*, the dramatic asymmetrical arrangement of the figures, as well as the painting's stillness find echoes in *A Street in Venice* (cat. 11), *Venetian Bead Stringers, Venetian Glass Workers* (cat. 12), and, somewhat less easily, *The Bead Stringers of Venice* (National Gallery of Ireland), which Sargent apparently mutilated before giving to his friend Valentine Lawless, Lord Cloncurry. On the other hand, *The Sulphur Match, Sortie de l'église*, and *Street in Venice* — the 1882 works — all have principal figures who are more schematically and quickly characterized; faces are sketched in without delicate gradations or particular care in rendering features; the central woman — recognizable in most instances as the dark-haired Gigia Viani — is elongated in form; the major figures, roughly centered on the canvas, are either in motion or imminently so. *A Venetian Interior* (Museum of Art, Carnegie Institute), *Venetian Street* (cat. 19), and *Venetian Water Carriers* (Worcester Art Museum) seem to share both a handling and a conception with the paintings of 1882. Three of the multiple-figure works now known fall outside either group. The Clark Art Institute's *A Venetian Interior* (cat. 15), which shows the same interior space as the Albright-Knox and Carnegie Institute paintings (although each registers a different hanging of pictures on the wall), is quickly and dramatically painted, with bold touches of color to suggest form and physiognomy, à la 1882; yet the distinctive features of the principal figures, none of whom is Viani, seem to have more in common with the works of 1880. Likewise, *Campo behind the Scuolo San Rocco* (private collection) and *Venetian Courtyard* (Collection of Mrs. John Hay Whitney), each startlingly composed and dashingly figured, elude the readily recognized characters of the 1880 and 1882 clusters. I am inclined to think of them as from the beginning of the later trip, but other works or documents might come to light and clarify the groupings, and there is no accounting here for the quite likely possibility that Sargent painted some genre works during his stay of 1878 and yet others during his frequent later trips to Venice.

What is clear from the paintings, no matter their chronology, is that while in Venice Sargent explored color harmonies and compositional strategies with much greater freedom than before. The seemingly random arrangement of figures, eccentric croppings, and light-filled voids, combined with a technique that revels in evidence of brushwork and paint that is sometimes paint more than the representation of an object, all work to make these an Italian, working-class equivalent of Degas's ballet scenes. Sargent, however, bravely, perversely, sought modernity not in Paris — in the midst of the embodiment of advancing civilization — but among the monuments of faded and bygone glory. Sargent's Venetian genre scenes are among the handsomest paintings of the era. Yet as wonderful as they are in themselves, they also foretell the future of his achievements; a work such as *The Daughters of Edward D. Boit* (see fig. 17) seems, in everything except geography, the culmination of his Venetian studies.

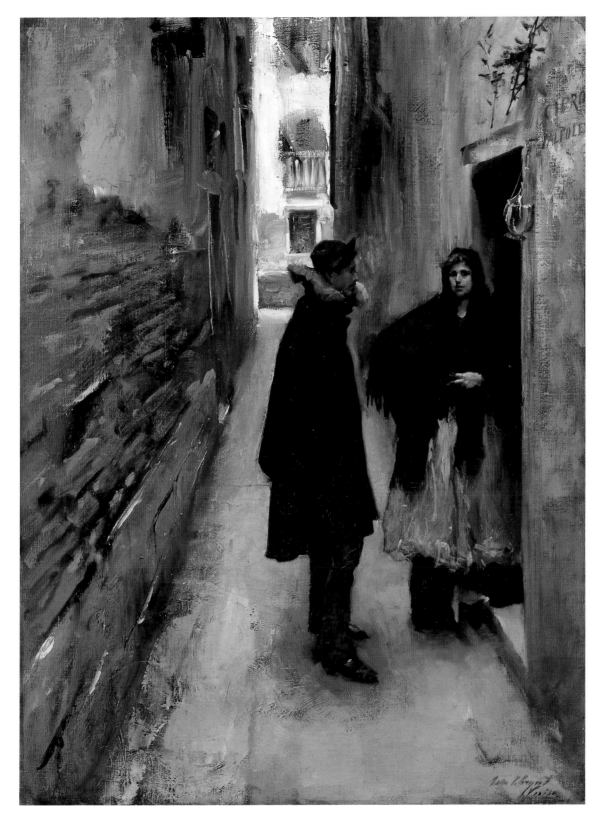

11. *A Street in Venice*, ca. 1880

Oil on canvas, 29 1/2 x 20 5/8

Sterling and Francine Clark Art Institute, Williamstown, Massachusetts

??Paris 1881 — Cercle des Arts libéraux

Etude fait à Venise

For critical reviews see cat. 12.

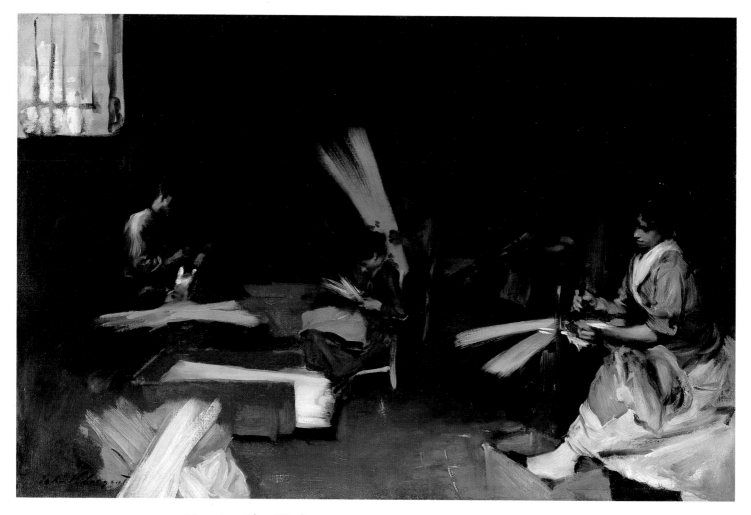

12. *Venetian Glass Workers*, ca. 1880

Oil on canvas, 22 1/4 x 33 3/4

The Art Institute of Chicago

Mr. and Mrs. Martin A. Ryerson Collection, 1933.1217.

??Paris 1881 — Cercle des Arts libéraux

Etude fait à Venise

Le vrai M. Sargent, celui dont j'ai vu à l'Exposition des Arts libéraux des es-
quisses qui m'ont ramené au souvenir que l'Espagne m'a laissé de Goya, se
retrouve davantage dans la jeune femme au piano.
 J. Buisson, "Le Salon de 1881," *Gazette des beaux-arts* 24, no. 1 (July
 1881): 44.

Nous y avons été tout particulièrement frappé des qualités eminemment per-
sonnelles et distinguées que révèlent les études faites à Venise par M. John S.
Sargent.
 "Expositions," *L'Art* 7, no. 25 (1881): 290.

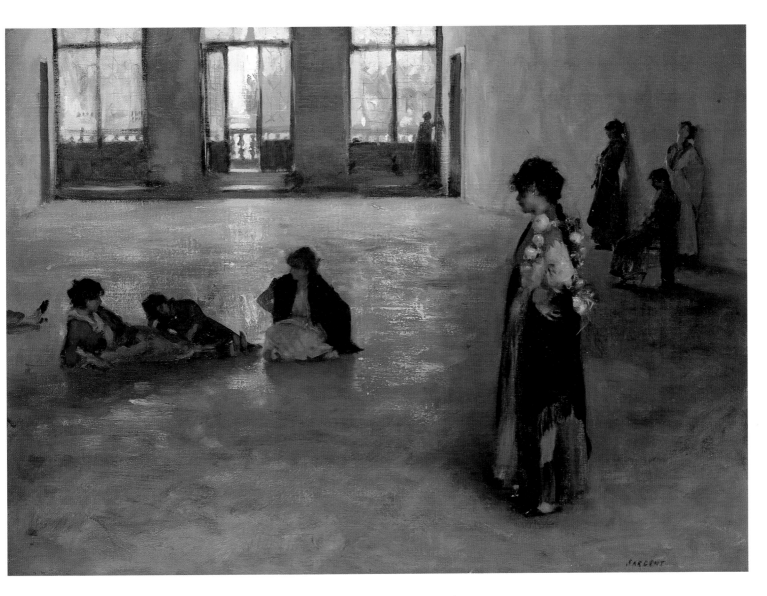

13. *Venetian Women in the Palazzo Rezzonico,* ca. 1880

Oil on canvas, 17 3/4 x 25

Mr. and Mrs. Peter G. Terian

?London 1882 — Grosvenor Gallery

Venetian Interior

135 (of 386 works; East Gallery)

or

Venetian Interior

346 (of 386 works; Fourth Room)

Mr. Sargent, whose only defect is a certain papery texture, contributes a charming little gray Venetian interior, with figures.

[Henry James], "London Pictures and London Plays," *Atlantic Monthly* 50, no. 298 (August 1882): 259.

There stands out in particular, as a pure gem, a small picture exhibited at the Grosvenor, representing a small group of Venetian girls of the lower class, sitting in gossip together one summer's day in the big, dim hall of a shabby old palazzo. The shutters let in a chink of light; the scagliola pavement gleams faintly in it; the whole place is bathed in a kind of transparent shade; the tone of the picture is dark and cool. The girls are vaguely engaged in some very humble household work; they are counting turnips or stringing onions, and these small vegetables, enchantingly painted, look as valuable as magnified pearls. The figures are extraordinarily natural and vivid; wonderfully light and fine is the touch by which the painter evokes all the small familiar Venetian realities (he has handled them with a vigor altogether peculiar in various other studies which I have not space to enumerate), and keeps the whole thing free from that element of humbug which has ever attended most attempts to reproduce the Italian picturesque.

Henry James, "John S. Sargent," *Harper's New Monthly Magazine* 75, no. 449 (October 1887): 689.

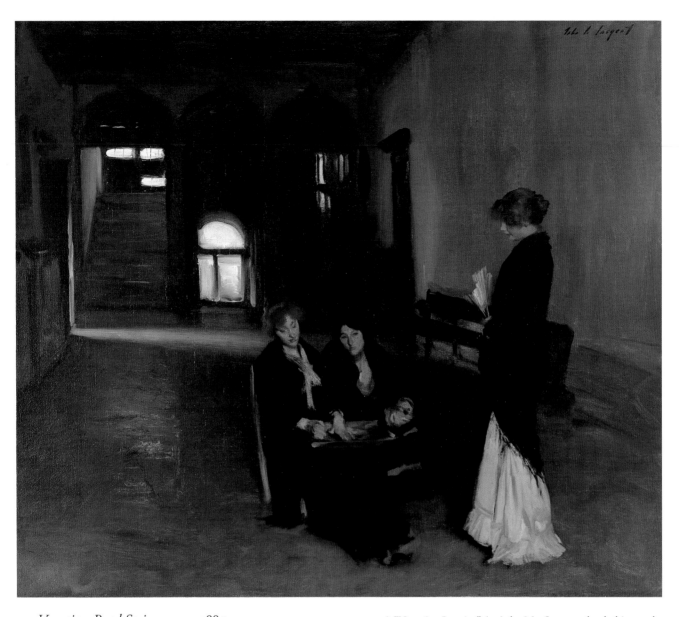

14. *Venetian Bead Stringers*, ca. 1880

Oil on canvas, 26 3/8 x 30 3/4

Albright-Knox Art Gallery, Buffalo, New York

Friends of the Albright-Knox Art Gallery, 1916

??London 1882 — Grosvenor Gallery

Venetian Interior

135 (of 386 works, East Gallery)

or

Venetian Interior

346 (of 386 works; Fourth Room)

A "Venetian Interior" (135), by Mr. Sargent, the dashing and accomplished painter of a picture which we have noticed in the Royal Academy, is one of three or four small pictures which he exhibits at the Grosvenor Gallery. His work here is extremely clever, and we use the word extremely as indicating at once a danger and a merit. The danger is of falling too much into the tricks of a particular school, of which the influence will be recognized by all students of modern French art. But it is probable that a painter strong enough to execute the portrait which Mr. Sargent exhibits in the Royal Academy will also be strong enough to avoid any charge of mere imitation in any serious work which he may undertake.

"The Picture Galleries. — IV," *Saturday Review* 53, no. 1387 (27 May 1882): 663.

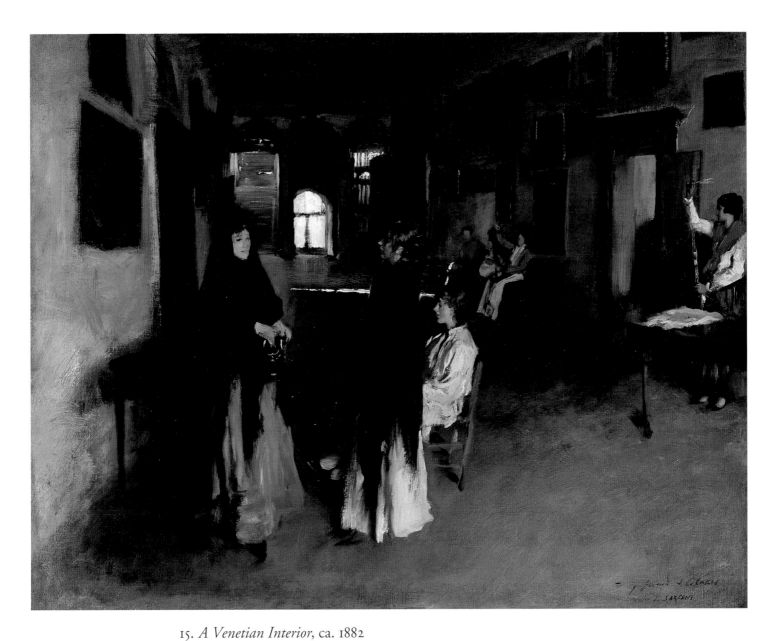

15. *A Venetian Interior*, ca. 1882

Oil on canvas, 19 1/8 x 24

Sterling and Francine Clark Art Institute, Williamstown,
Massachusetts

??Paris 1882 — Société internationale de peintres et sculpteurs

Intérieur vénitien

96 (of 126 works)

or

Autre intérieur vénetien

97 (of 126 works)

For critical reviews see cat. 16

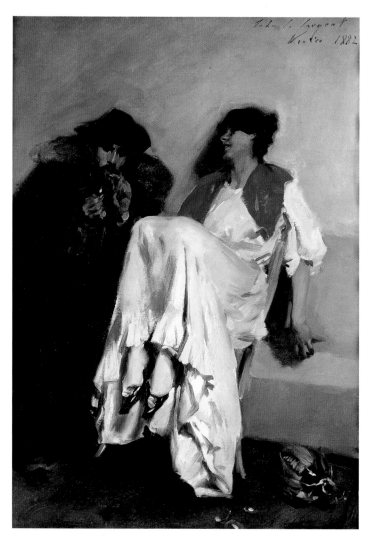

16. *The Sulphur Match*, 1882

Oil on canvas, 23 x 16 1/4

Hugh and Marie Halff

??Paris 1882 — Société internationale de peintres et sculpteurs

Intérieur vénitien

96 (of 126 works)

or

Autre intérieur vénitien

97 (of 126 works)

J'aurais voulu dire . . . beaucoup de mal des informes pochades de M. Sargent. Que de peine se donne cet artiste pour nous faire croire qu'il peint en se jouant! Je ne connais rien d'agaçant comme les laborieux chercheurs d'impromptus. L'espace me manque.

> G. Dargenty [Arthur d'Echérac], "Exposition Internationale des Peintres & des Sculpteurs," *L'Art* 9, no. 32 (14 January 1883): 40.

Faut-il compter M. Sargent parmi les étrangers? Il est né en Amérique, mais il a appris à peindre à Paris, sous la direction de M. Carolus Duran. Il fait honneur à la ville et au professeur. Aujourd'hui il est bien connu, et à toutes les dernières expositions des Champs-Elysées on l'a admiré. Ce qui frappe tout d'abord, c'est de voir à quel point son métier l'amuse. Par une juste conséquence il amuse les autres. On suit sur la toile le travail du pinceau; les coups de brosse laissent leur trace et le couteau à palette ne garde jamais l'anonyme. Que ses tableaux soient grands ou petits, ils sont exécutés avec la même flamme. . . .

M. Sargent complète son exposition par des vues de Venise d'un format moins développé que sa famille de potiches. Ne nous montons pas la tête sur Venise; nous n'y verrons ni grand Canal ni place Saint-Marc; tout cela est banal et usé. M. Sargent nous conduit dans d'obscurs carrefours et dans des salles basses toutes noires que transperce un rayon de soleil. Où se cachent les belles de Titien? Ce ne sont certes pas leurs descendantes que nous apercevons à peine sous leur chevelure inculte, drapées dans un vieux châle noir comme si elles grelottaient la fièvre. A quoi bon aller en Italie pour y recueillir de pareilles impressions? Avec un bien moindre déplacement on trouve, à la Villette et à Belleville, des rues d'aussi triste apparence et des femmes d'aussi mauvaise mine.

> Arthur Baignères, "Première Exposition de la Société internationale de peintres et sculpteurs," *Gazette des beaux-arts* 27, no. 2 (February 1883): 189–190.

Hélas! il n'était pas réservé à M. Sargent de relever la situation et de réparer la faute de ses collègues. M. Sargent tient les tristes promesses que faisait concevoir son *Jaleo*.

> "Chronique des lettres et des arts," *L'Artiste* 53, pt. 1 (February 1883): 143.

Je suis peut-être injuste pour M. J. Sargent; mais ses *Intérieurs vénitiens* exposés au printemps dans les cercles me rappelaient les préaux de la Salpêtrière plus que les chambres tièdes de la tranquille Venise.

> Philippe Burty, *Salon de 1883* (Paris: Ludovic Baschet, 1883), 103.

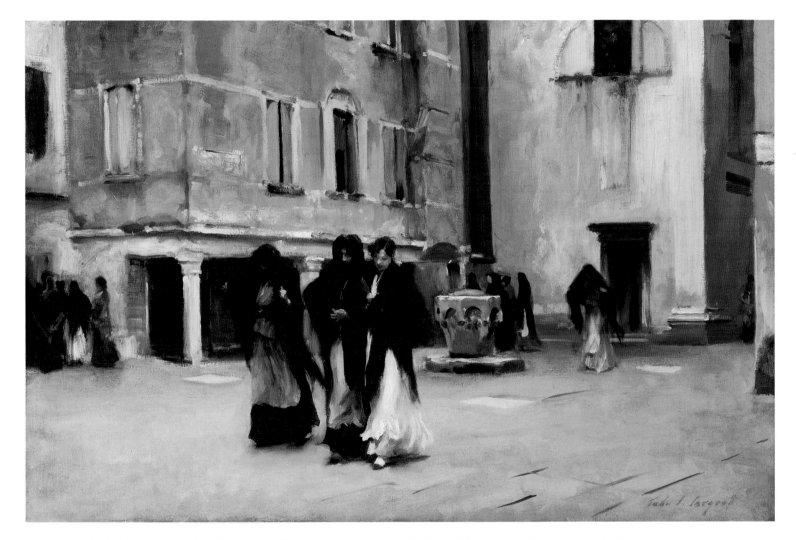

17. *Sortie de l'église, Campo San Canciano, Venice*, ca. 1882

Oil on canvas, 22 x 32 1/2

Hugh and Marie Halff

Paris 1882 — Société internationale de peintres et sculpteurs

Sortie d'église

98 (of 126 works)

M. Sargent est, nous le savons, un maître contesté. . . .

. . . Après avoir vu l'Espagne, il a voulu voir Venise, et il en rapporte des peintures qui, pour n'être pas toutes achevées, sont déjà instructives. Ce sont des coins de rue, de petites places rectangulaires qu'agrément un de ces puits dont la silhouette est si pittoresque. Ces études, d'une exécution fort sommaire, s'animent de quelques figurines d'un dessin approximatif. Curieux des lignes élégantes, M. Sargent allonge ses personnages et ils ne sont plus à l'échelle. Dans la *Sortie de l'Eglise*, les trois Vénitiennes qui reviennent en causant apparaissent démesurées. Toute cette fantaisie devra être revue et remise en bon order.

. . . Ce que M. Sargent voulait faire, il l'a fait. Et nous sommes vraiment enchanté que ce peintre subtil ait vu Madrid et Venise. Ce double voyage lui a montré clairement ce qu'il avait soupçonné par une sorte de vague intuition. Il ne sait pas grouper ses figures, il compose au hasard, mais il a le don des colorations fines et il a beaucoup appris dans les musées.

Paul Mantz, "Exposition de la Société Internationale," *Le Temps*, 31 December 1882, 3.

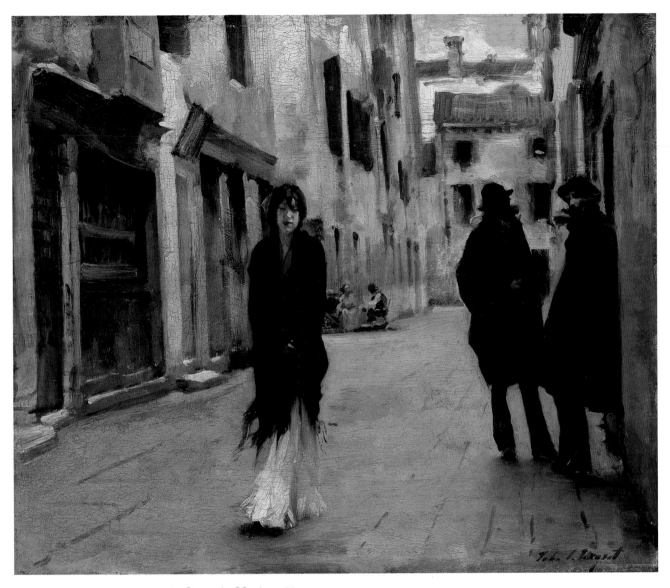

18. *Street in Venice*, 1882

Oil on wood, 17 3/4 x 21 1/4

National Gallery of Art, Washington, D.C.

Gift of the Avalon Foundation

Paris 1882 — Société internationale de peintres et sculpteurs

Une Rue à Venise

99 (of 126 works)

Mr. Sargent was born in Florence of American parentage, but he has passed very little indeed of his life in the United States. But whether there is anything racy in his work or not, his individuality is at any rate the most marked thing about him. . . . His "Children's Portraits" was exhibited last winter in the exhibition of the International Society of Painters, along with . . . a number of Venetian studies and sketches, Venetian women talking at the corners of streets or at the depths of long corridors and what-not — all eloquent reminiscences of the Museo del Prado.

 W. C. Brownell, "American Pictures at the Salon," *Magazine of Art* (London) 6 (1883): 497–498.

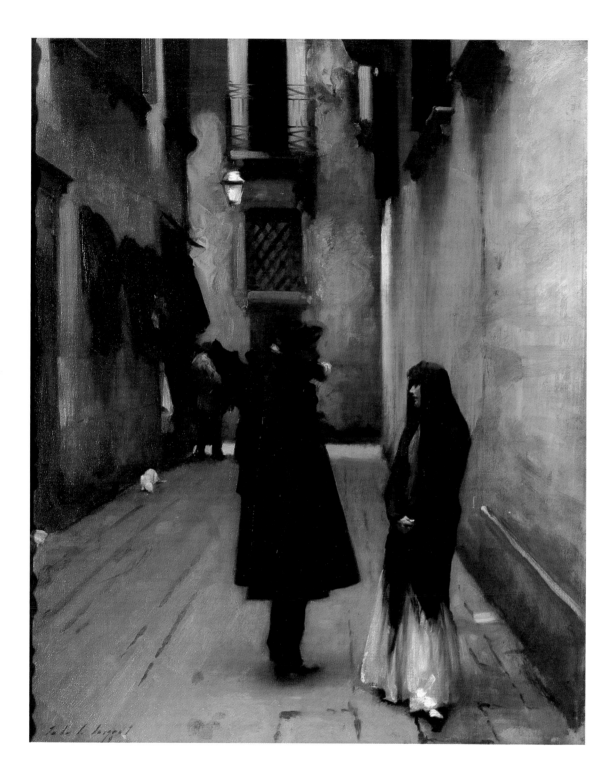

19. *Venetian Street*, ca. 1882

Oil on canvas, 29 x 23 3/4

Collection of Rita and Daniel Fraad

?Paris 1883 — Cercle de l'Union artistique

Conversation vénitienne

135 (of 173 works; owner: M. le docteur Pozzi)

On y remarque ensuite d'excellents . . . toiles intéressantes de MM. Stewart et Sargent, etc., etc.

 "Concours et expositions: Exposition du Cercle de l'Union artistique," *La Chronique des arts et de la curiosité* 6, no. 6 (10 February 1883): 41.

Nous citerons le portrait de M. de Camondo par Carolus Duran . . . la *Conversation vénitienne*, par John Sargent, et la dernière oeuvre de Gustave Doré, un cadre de glace en bronze doré.

 Maurice Du Seigneur, "Les Expositions particulières depuis une année, 1882–1883," *L'Artiste* 53, pt. 2 (August 1883): 125.

"Crispation de nerfs" 1880–1887

In spite of the noteworthy presentation and successful sale of such important genre pictures as *Oyster Gatherers of Cancale*, *Fumée d'ambre gris*, and *El Jaleo*, the painter, his family, his teacher, and writers of the contemporary art scene saw portraiture as the practical and obvious path for the young man to follow. It was of Sargent the portrait painter that one Parisian critic wrote in 1879: "If Mr. Sargent returns to Philadelphia, his native land, he will be able to find there few portraitists able to outshine him; but if he remains among us, he can be assured of his future and his fortune."[53] Sargent's father picked up on this immediately, writing in September to relatives in the United States: "The portrait which he sent to the Salon in the Spring gained him some 6 or 7 commissions for portraits, from French people, and a Paris art-journal published that his fortune is assured as well as his reputation if he chooses to remain in Paris."[54] The letter continued, "But I dare say I told you all this before: I am getting old & garrulous & forgetful." Indeed, five weeks earlier, on 15 August, he had written to much the same effect. The earlier letter, however, contained more specific news about the progress of Sargent's career: "But as the proof of the pudding is in the eating, so the best, or one of the best evidences of a portrait's success is the receiving by the artist of commissions to execute others. And John received six such evidences from French-people. He was very busy during the two months we were in Paris, in executing these commissions, and is now about going to the vicinity of Chambery to paint the portrait of the wife of a gentleman whose portrait he was finishing when we left him [the Paillerons]."[55]

As Sargent *père* truly observed, the portrait of Carolus-Duran led to the portrait of Madame Pailleron. That work, when it was seen in the Salon of 1880, led to at least two others — the lovely portrayal of Madame Ramón Subercaseaux (see fig. 16) and the extraordinary double portrait of the Pailleron children (cat. 20); both of these were then shown in the Salon of 1881. With significant works springing from past performances, the career of the young painter seemed solidly in place; he was becoming known not for momentary sensations, but for a chain of commissions growing from one another to the extent that Sargent had time and energy.

The double portrait of Edouard (b. 1865) and Marie-Louise (1870–1950) Pailleron — completing the family group begun in 1879 with the portrait of their father — did not come easily: the impatient children reportedly had to endure eighty-three sittings before the artist was satisfied.[56] Knowing this, it is perhaps too easy to read a certain hostility into the faces of the youthful sitters. One critic of the day observed it, but this was not the common response when the work was in the Salon of 1881.[57] While there, the striking portrayal prompted lengthy critical responses, most of which focused on the girl's figure and her marvelous self-possession. Principally favorable, more conservative critics tempered their remarks with distrust of Sargent's loose and brushy treatment. More progressive writers disliked the way in which the painting edged away from being a picture and instead became a society portrait — the sitters' status and an apparent desire on their (or their parents') part to make a good impression on the future seeming to be more crucial than purely pictorial concerns.[58] But even within the relatively restrictive framework of society portraiture, observers found that Sargent's portrait stood out from those around it, that it had "the exceedingly rare gift of attracting you . . . of fascinating you and of interesting you" as much as if not more than a history painting.[59] This was no small claim, given history painting's advantages of narrative, exotic settings, and eye-catching costumes (or lack thereof) to compel curiosity and then attention. Simply through color, form, implied movement, and psychological direct-ness, Sargent was able to supply notable drama to the portrayals of his contemporaries.

There was, in fact, some real-life drama in the Salon of 1881, generated by the portrait of the Pailleron children and its relationship to Sargent's second Salon work, *Mme Ramón Subercaseaux*. This painting, which had been commissioned by Ramón Subercaseaux, a Chilean diplomat and amateur painter, was done in the Subercaseaux apartment on the avenue du Bois de Boulogne.[60] It shows Madame Subercaseaux (b. 1860) turning from her piano, one arm over the back of her Aesthetic-style chair, while a background of flowers and elegant paneling provides a gracious setting. The few comments published about the work were pithy and positive, one writer calling it "quite simply a masterpiece."[61] The Salon jury evidently agreed, for its members awarded Sargent a second-class medal for the work; along with two portraits by Manet, the three were the only portraits amid a bevy of history paintings to win the award. And yet, in spite of the honor accorded the portrait, reviewers tended to give considerably more space to *Edouard and Marie-Louise Pailleron*. Even *Le Livre d'Or du*

Salon de peinture et de sculpture, which was supposed to feature the best works of each year — all the medal winners among them — included notice of the Pailleron rather than the Subercaseaux painting. According to the memoirs of Ramón Subercaseaux, the very placard announcing the award was removed after one day. The reason? If Subercaseaux is to be believed, the well-connected Edouard Pailleron (soon to be elected to the Académie Française) was outraged that the portrait of a foreign-born woman would win a medal when the portrait of his children by the same artist was snubbed. He lobbied among his friends in the Salon administration to change the award. Subercaseaux, in response, protested to the painter Jules-Charles Cazin — a friend of Sargent's and a figure of some authority — and the prize was reinstated.[62] Sargent made no mention of the affair when he announced his good news to a friend (and mocked his nearly illegible handwriting): "Just a few frantic arabesques to acknowledge the receipt of your pleasant letters and communicate my plans. In the first place I have got a 2ième *medaille* at the Salon and am *hors concours* and a great swell. I accept your congratulations. It is for that portrait of a Chilian lady (Mme. R. S.) that I was painting last summer Avenue du Bois de Boulogne."[63] But the disparate weight of published comment regarding the two paintings demonstrates the politics of the Parisian art scene, with Sargent in the middle of forces somewhat beyond his control.

The Salon of 1882 was a different matter entirely, with Sargent apparently in command. As he had done in 1879 and 1880, the painter submitted a portrait as well as a genre scene for exhibition. This year, however, both works were enormous — *Lady with the Rose (Charlotte Louise Burckhardt)* (cat. 22) is seven feet high, *El Jaleo* (see fig. 19), almost eleven and a half feet wide. The bounding up in scale was probably related in part to the fact that Sargent was, as he had noted to his friend, *hors concours* — able to show at the Salon without approval by the jury. By the simple measure of wall space, Sargent — justified by the steady accumulation of commissions, honors, and notices — was clearly announcing his arrival as a major figure in the Parisian (and, so far as he and his patrons were concerned, international) art scene. The paintings were of the scale of the vast history paintings of the academy, but they did not share either an academic subject or technique, and this departure generated a buzz of excitement among viewers and critics. Sargent became "one of the lions of the Salon this year."[64] He was just twenty-six.

Lions, of course, are hunted and, by some, hated; the same is true of metaphoric kings of the jungle. The warring factions were about

evenly matched on the subject of *El Jaleo:* many decried the sketchiness of the background figures, the low moral character of the scene, and the stance of the central figure; a somewhat smaller but equally vociferous group praised the truthfulness and sincerity of the presentation.[65] As regards *Lady with the Rose,* however, critics were nearly uniform in their enthusiasm — although they often tinged it with irony. The work inspired a great deal of attention in the press, with writers vying to perceive artistic pedigree (Watteau and Velázquez were most frequently cited), to characterize facial expression, and to define the combination of obvious brushwork and effective illusion that achieved such a chef d'oeuvre. Even more than the works of previous years, this portrait stood out from its competitors, winning attention and repeatedly drawing viewers back to it. Numerous critics proclaimed that it established exactly the mode that young women would want to be portrayed in and predicted that a rush of commissions would overwhelm the painter. Sargent clearly sought to encourage such an eventuality. After the Salon closed he sent the painting to London, and the next spring it was his sole (and extremely well received) submission to the Society of American Artists annual exhibition.

The work shows Charlotte Louise Burckhardt (1862–1892), a Swiss-American woman who lived in Paris and with whom Sargent was, for a brief while during the summer of 1881, romantically linked. The two young people were apparently great friends, attending dinners and concerts and even making chaperoned trips overnight to the countryside together; nonetheless, they did not become formally engaged.[66] Their relationship evidently remained close, however, for a year later Vernon Lee, who conceded that "the girl is handsome," wrote of Sargent's being "the victim of fresh matrimonial cabals on the part of Mrs. Burckhardt"; as late as 1885 Lee reported Henry James as speculating that Sargent "*may* marry Miss Burckhardt."[67]

In the painting, which developed at Sargent's request rather than as a commission, Louise Burckhardt presents an engaging, almost impudent, vision. Her pose, with provocative outstretched arm, derives directly from Velázquez's *Calabazas* (ca. 1628–1629; Cleveland Museum of Art).[68] That precedent, combined with the old-fashioned costume and relatively restrained color scheme, prompted many to consider the portrait, to quote Vernon Lee, "simply superb & like an old master."[69] Writers over the next decade made frequent, glowing reference to the work.

Not all of Sargent's portraits of the time, of course, were large-scale works intended to create a stir at the Salon or evoke prestigious

antecedents. Informal head-and-bust depictions of friends and col-
leagues were a means of practice, homage, or readily achieved hospital-
ity presents.[70] For some patrons, economy or taste dictated the
commissioning of smaller paintings, which on occasion the painter
would exhibit as further advertisement of his ability and success with
this more unassuming work. The double portrait (cat. 23) of John W.
and Eliza Field (1815–1887 and 1820–1902, respectively), whom Vernon
Lee met at a dinner at Leslie Stephens's and described as "two oldish
Americans, who are having their portraits done by John, and who
talked sixteen to the dozen," is exemplary of this category of object.[71]
In 1886, years after the painting was completed, Sargent asked the
owners to send it to the Society of American Artists exhibition. Critics
often passed by these works, but once in a while they would rain a cas-
cade of enthusiastic responses on them for their intimacy and ap-
proachability. The portraits of Vernon Lee (see fig. 20) and Madame
Allouard-Jouan (cat. 24), when they were shown at the Société inter-
nationale in 1882, proved to be memorable in spite of their modest
scale. Moreover, Sargent could use these works to tell the public about
himself: by exhibiting portraits of fellow artists, for example, Sargent
demonstrated his informal affiliation and sympathy with those artists
in the minds of exhibition visitors. This would explain the presence of
the rugged, up-close depiction of his friend Auguste Rodin (cat. 25;
1840–1917) at the Exposition internationale in 1885, and the small
profile head of Claude Monet (1887; National Academy of Design,
New York; 1840–1926) at London's New Gallery in May 1888. Thus
portraits of varying scale and ambition served a variety of purposes
with the public, in addition to being a means of earning a livelihood.

If Sargent was the lion of the Salon in 1882, as some critics
claimed, he was not satisfied to be caged in France. Instead, that sum-
mer he set out to storm London, the world's metropolis. He appar-
ently did not go there in person, but his paintings made a considerable
impression. In the space of the few summer months, two Venetian in-
teriors and a study of a man with brown drapery were at the
Grosvenor Gallery; his *Carolus-Duran, Lady with the Rose*, and *El Jaleo*
were all at the Fine Art Society; and, at the nation's most prestigious
contemporary art venue, the Royal Academy of Art's annual summer
exhibition, he showed a work under the disarming title *Portrait*. Be-
hind this innocent moniker, in fact, loomed one of Sargent's most
startling paintings, *Dr. Pozzi at Home* (cat. 21). One week after Ver-
non Lee found *Lady with the Rose* to be like an old master, she saw
and was able to characterize "John's red picture" as "tho' less fine than

his Paris portrait, magnificent, of an insolent kind of magnificence, more or less kicking other people's pictures into bits."[72] She could have spoken of old-master precedents here, too: Van Dyck's Genoese portraiture provides one model for the physical elongation and fineness of Pozzi's head and hands as well as his self-assured bearing; the dominant reds in Van Dyck's *Cardinal Bentivoglio* (1622 or 1623; Pitti Palace, Florence) or *Agostino Pallavicini* (1621 or 1622; J. Paul Getty Museum, Malibu) present the same kinds of coloristic challenges that Sargent addressed in the portrait of Pozzi. But in the end she was probably right to ignore these and focus instead on the sheer insolence of the work — as daring and mystifying a portrait of the 1880s as was made.

Dr. Samuel-Jean Pozzi (1846–1918) was himself a daring figure in Paris. A close friend of the Bonaparte princesse Mathilde as well as of prince Edmonde de Polignac and comte Robert de Montesquiou, Pozzi was a surgeon whose gynecological operations were a site for spectatorship by fashionable society. He was reputed to be — and the portrait, from the tips of his extraordinarily long fingers to his sequined slippers supports this — a sensualist of considerable achievement: lover of, among others, Madame Pierre Gautreau; founder and leader of the League of the Rose, a circle of friends meeting in the home of Misia Sert's parents, where sexual experiences were confessed and acted out; eventual victim of passion, shot by a lover's jealous husband.[73] Sargent and Pozzi were friends — in addition to the portrait, Pozzi eventually owned a watercolor after *Fumée d'ambre gris* (*Incensing the Veil*, ca. 1880), *Mme Gautreau Drinking a Toast* (ca. 1883) (both Isabella Stewart Gardner Museum), and a Venetian genre scene that the doctor lent to an exhibition in 1883. Sargent called him, in a letter to Henry James, both a friend and a "very brilliant creature!"[74] This relationship considerably expands our sense of Sargent's social milieu, shaking the image of stolid Edwardian propriety surrounding him in later years.

Portraitists of the later nineteenth century were often categorized as painters of either men (as was the case with Léon Bonnat and Thomas Eakins) or women (Carolus-Duran, for example). Although Sargent would eventually be counted in both groups, during these early years he was most frequently viewed as an exemplary painter of women. To a degree this follows from his choice of works to exhibit; in the first decade of his career, with few exceptions, the portraits he showed were of women and children. But it also derives from what critics perceived as Sargent's particular sympathy with the portrayal of

young women, their manner and dress, their aspirations, their presentation of themselves. For the Salon of 1883, Sargent had determined to solidify this facet of his reputation with pendant portraits that would demonstrate the range of his sensibility.

The plan was to exhibit two full-length portraits of well-known beauties living in Paris: Margaret (Daisy) Stuyvesant Rutherfurd White (1857–1916), the wife of an American diplomat, and Virginie Avegno Gautreau (1859–1915), the Louisiana-born wife of a Parisian banker. Mrs. Henry White was to stare out of the canvas at the viewer in full face, wearing great swathes of cream-colored silk (which in the painting is shot through with wonderfully vivid streaks of mauve and turquoise), discreet gold, and lustrous pearls, ready with fan and opera glasses for a formal evening. Madame Pierre Gautreau (cat. 26), on the other hand, showed only her profile — a figure to be admired but not engaged — and wore a daringly low-cut sheath of black satin, held up, barely (a prominent critic noted, "One more struggle and the lady will be free") by one bejeweled strap. (Sargent later reinforced the bodice by sliding the second, fallen, strap back onto her shoulder.)[75] The opportunity for the young portraitist to present these two contrasting types of women, each socially prominent, must have seemed ideal.

The genesis of the portrait of Mrs. White (see fig. 18) records another step in the successful development of Sargent's career. Both Mr. and Mrs. White had their portraits painted in Paris in the early 1880s: Mr. White chose the Frenchman Bonnat to portray him — a solid choice in keeping with his diplomat's conservative nature (1880; Corcoran Gallery of Art, Washington, D.C.); Mrs. White, on the other hand, after seeing *Lady with the Rose*, opted for Sargent — as a number of critics had prophesied, one successful work effectively led to others.[76] The work on Mrs. White's portrait in late 1882 was interrupted by her ill health — the effects of typhoid — and after only a few sittings she retreated to Cannes. When Sargent went to visit his family in nearby Nice over the winter holiday of 1883, he resumed work on her portrait. "I have been here over two weeks," he wrote from Nice, "paying my people the usual winter visit and going on with my Salon portrait for the original who was obliged to leave Paris before the portrait was half done fortunately went to Cannes."[77] Progress was not smooth; even now we can see pentimenti where Sargent changed his mind about the end of the chaise longue, the position of the arm and fan, the direction of the gown's sumptuous train, and the incline of Mrs. White's head.[78] In each case, the change seems to be in the direction of a more static, self-contained presentation.

The portrait of Madame Gautreau was a different matter entirely.
As early as 1881 Sargent and Virginie Gautreau had been linked in the
popular press by an article decrying the American intrusion on French
markets and culture; amid complaints of American beef and race-
horses the columnist noted of Americans, "They have painters who
carry off our medals, such as M. Sargent, and pretty women who
eclipse our own, such as Mme Gautreau."[79] About this time Sargent
apparently met Madame Gautreau — known as a professional beauty
(even Gallic sources used the English term) and occupying a specific
and highly visible role in Parisian society. Her portrait, however, was
not a commission; it was Sargent who sought to paint her. He wrote
to a friend, hoping for assistance: "I have a great desire to paint her
portrait and have reason to think she would allow it and is waiting for
someone to propose this homage to her beauty. If you are 'bien avec
elle' and will see her in Paris you might tell her that I am a man of
prodigious talent."[80] The painter clearly saw a picture of her as promo-
tional — a stroke of advertising and achievement that would further
his reputation and increase his clientele. By mid-February 1883 the sit-
tings were under way. Sargent had earlier written from Nice: "In a few
days I shall be back in Paris, tackling my other 'envoi,' the portrait of
a great beauty. Do you object to people who are fardées to the extent
of being a uniform lavender or blotting paper colour all over? If so you
would not care for my sitter. But she has the most beautiful lines and
if the lavender or chlorate-of-potash-lozenge colour be pretty in itself I
shall be more than pleased. However I have only three weeks to do it
in and may fail."[81]

Sadly, but not unexpectedly, three weeks were not enough for ei-
ther of his *envois.* Sargent wrote to Mrs. White on 15 March:

> Just one illegible line. This is the evening of the postal sending in
> day & I have sent nothing in. Neither you nor Mme Gautreau
> were finished. I have been brushing away at both of you for the
> last three weeks in a horrid state of anxiety. Your background has
> undergone several changes & is not good yet.
> Well the question is settled and I am beaten.
> Your frame is charming.
> One consolation has been that I know you do not care a bit
> whether your portrait is exhibited or not. Is not that true? May I
> send it to the academy? . . .
> P.S. I send the Boit children to the Salon.[82]

He did, finally, in 1884 send the portrait of Mrs. White to the Royal
Academy. Because Mr. White had in the meantime been posted as the

United States legation's second secretary to London, circumstances typically conspired to good effect, giving Sargent a major portrait of a recently ensconced luminary. He borrowed the work from Mrs. White again during the spring of 1885 so that it could at last be seen in Paris, at the Exposition internationale at the Galerie Georges Petit.

If the portrait of Mrs. White did not proceed smoothly, the portrayal of Madame Gautreau seems to have been even more problematic. A significant number of pencil drawings testify to Sargent's experimentation with many poses. Even when one was finally decided on and the canvas begun, there were multiple adjustments and scraping-downs as Sargent worked to encapsulate what he was to call "the unpaintable beauty and hopeless laziness of Madame G."[83] He noted to a friend, with a mixture of indulgence and self-pity: "Madame Gautreau is at the piano driving all my ideas away."[84] The painter continued to labor on it as he wrote: "My portrait! it is much changed and far more advanced than when you last saw it. One day I was dissatisfied with it and dashed a tone of light rose over the former gloomy background. I turned the picture upside down, retired to the other end of the studio and looked at it under my arm. Vast improvement. The *élancée* figure of the model shows to much greater advantage. The picture is framed and on a great easel, and Carolus has been to see it and said: 'Vous pouvez l'envoyer au Salon avec confiance.' Encouraging, but false. I have made up my mind to be refused."[85] Contortions, changes, dismissed memory of his *hors concours* status: Sargent agonized over the painting. At one point in its development he even started afresh on a clean canvas — making a fair-copy version as he had earlier done with such genre scenes as *Among the Olive Trees, Capri.* He evidently ran out of time, however, and left this second canvas unfinished (Tate Gallery, London).[86]

If Sargent's goal with the *Portrait de Mme ****, the title under which Madame Gautreau was thinly disguised at the Salon of 1884, was notice, he received it in abundance. Ralph Curtis, with whose family Sargent had stayed in Venice in 1882, reported to his parents on his experience of the Salon's opening day:

> Yesterday the birthday or funeral of the painter Scamps [Sargent]. . . . In 15 mins. I saw no end of acquaintances and strangers, and heard every one say "où est le portrait Gautreau?" "Oh allez voir ça." . . . He was very nervous about what he feared, but his fears were far exceeded by the facts of yesterday. There was a grande tapage before it all day. In a few minutes I found him dodging behind doors to avoid friends who looked

grave. By the corridors he took me to see it. I was disappointed in the colour. She looks decomposed. All the women jeer. Ah, voilà "la belle!" "Oh, quelle horreur!" etc. Then a painter exclaims "superbe de style," "magnifique d'audace!" "quel dessin!" Then the blageur club man — "C'est une copie!" "Comment une copie?" "Mais oui — la peinture d'après un autre morceau de peinture s'appelle une copie." I heard that. All the a.m. it was one series of bons mots, mauvaises plaisanteries and fierce discussions. John, poor boy, was navré. . . . In the p.m. the tide turned as I kept saying it would. It was discovered to be the knowing thing to say "étrangement épatant!" I went home with him, and remained there while he went to see the Boits. Mde. Gautreau and mère came to his studio "bathed in tears." I stayed them off but the mother returned and caught him and made a fearful scene saying "Ma fille est perdue — tout Paris se moque d'elle. Mon genre sera forcé de se battre. Elle mourira de chagrin" etc. John replied it was against all laws to retire a picture. He had painted her exactly as she was dressed, that nothing could be said of the canvas worse than had been said in print of her appearance dans le monde etc. etc. Defending his cause made him feel much better. Still we talked it over till 1 o'clock here last night and I fear he has never had such a blow. He says he wants to get out of Paris for a time. He goes to Eng. in 3 weeks.[87]

Visiting the painter a month later — he was still in Paris — Vernon Lee found that *Madame X* was necessarily part of the conversation, and the painter was feeling sanguine enough about the episode to share some of the more personal details: "John was very nice. His picture of Mme Gotreau is a solemn fiasco in the eyes of the world: you see it surrounded by shoals of astonished and jibing women. When it was first seen, the outcry was such that Mme Gotreau went into *crises* and her Mother rushed to John & said 'Vous avez perdu ma fille!' — Still, he is prouder of it than of the Jaléo, & I think it is, though bizarre & even unpleasant, a very grand work. He is tending entirely towards a return to 15th century ideas."[88] That the same words are attributed to Madame Avegno by both Curtis and Vernon Lee would seem to indicate that Sargent had formed it into a repeated and repeatable tale. Key here is the sense of Sargent's pride in the work, in spite of the astonishment of the masses.

As in 1882, popular and critical attention once more made Sargent the center of Salon attention. And again, as had been true of *El Jaleo*, *Madame X* generated a sharply divided critical response. It was the

most exciting picture of the year for critics for such important journals
as the *Gazette des beaux-arts, L'Art, American Architect and Building
News,* and *L'Artiste.*[89] For the well-respected painter and quasi-cult
figure Marie Bashkirtseff, it was, simply, "perfect painting, masterly,
true."[90] Even many of those who condemned the work, including the
writers for *L'Art moderne,* the *Magazine of Art,* and the *New-York
Daily Tribune,* still had praise for the artist. But for Sargent it marks a
shift in his unfailing confidence. As both a business venture and a nec-
essary link in the chain of his public reputation, the portrait of
Madame Gautreau was a stumble. Sargent felt the constraint, in Sep-
tember 1885 telling Vernon Lee that "his picture of Mme Gauthereau
has had much the same effect in checking his success that *Miss
B.*[rown] has had with me." Lee, reporting this to her mother, added,
"And I think this has made him much more serious. I liked him
greatly." Henry James, too, spoke to Vernon Lee about the work. She
reported, with a canny aside concerning her source: "James is very
friendly, with that curious mixture of (I should think) absolute social
& personal insincerity & extreme intellectual justice & plain-spoken-
ness. He seems to think that John is in a bad way. Since Mme Gau-
thereau & one or two other portraits, women are afraid of him lest he
should make them too eccentric looking."[91] The sentiment was wide-
spread enough to merit space in the pages of the satiric press in 1886.
In a humorous series of paired compliments and insults to be addressed
to a woman whose portrait was being done by various leading Parisian
painters — Bonnat, Cabanel, Carolus-Duran, Gervex, Duez, Dubois,
and others, Sargent being the only non-Frenchman on the list — the
compliment for Sargent's patron was: "Impossible to find another thing
to commend in such a great act of courage undertaken by the victim
after the success obtained by the portrait which no one has forgotten."[92]

In spite of his owning the canvas, Sargent did not put it before
the public again for nearly twenty years, first in London at the Carfax
Gallery in 1905, and then a decade later when he sent the painting to
the Panama-Pacific International Exhibition of 1915 in San Francisco.
After that fair, he sold the painting to the Metropolitan Museum of
Art, half-heartedly asserting in the offer of sale, "I suppose it is the best
thing I have done."[93] It was a curious loss of courage, one that his old
friend de Montesquiou never forgave:

> a sort of masterpiece, that impressive and unforgettable portrait
> of Madame Gauthereau, which appears in the artist's career as a
> culminating point, unique, accomplished from the beginning,
> and, since, pursued in vain, or left aside in favor of brilliant varia-

tions and facile effects, so perfectly lacking in what constituted the mystery, and almost the giddiness of that older canvas.

If ever Enigma merited the name of *Cruel* . . . it surely was that adventure of a painter, at the start of his career, seizing, from the grasp in which the strange beauty of the model held him, the occasion to produce a magisterial work. Then, the whole rest of the story turning to the inverse of all that one could have imagined: the lady furious, the public mocking, and the painter indignant, abandoning forever the country that witnessed his mortification. . . . If the young artist, at that solemn hour, had derived from his apparent failure, instead of a juvenile, almost childish spite, the pride that was appropriate, his career would have offered, I won't say an endless number of works equal to the one in question, but at least some other examples.[94]

As he had planned, Sargent traveled to England in the early summer of 1884. It was a working holiday, one arranged early in the year. Probably no later than February he wrote to Vernon Lee: "Will you be in England next summer? If so I shall see you there for I am to paint several portraits in the country & three ugly young women at Sheffield, dingy hole."[95] By May, however, after the fuss of the Salon, this plaintive tone of sacrifice had shifted to one of relief. As he wrote to Henry James: "It will be pleasant getting to London and especially leaving Paris. I am dreadfully tired of the people here and of my present work, a certain majestic portrait of an ugly woman. She is like a great frigate under full sail with homeward-bound streamers flying."[96] (Sargent's irreverence toward his sitters, verbal play rather than malice, runs throughout his correspondence.) But whatever Sargent's feelings at the time of his departure, it is clear that he was not running away. Long before any unpleasantness arose in Paris, he had committed himself for the entire season to making portraits in England, a pragmatic quest for an expanded market and a commitment to portraiture.

"John is just now in London, where he has some portraits to execute," wrote the artist's father on 17 June 1884.[97] Six months later he used the same phrase: "John is just now in London: he has spent the summer in England, & has been busy all the time."[98] Sargent himself, having planned and then cancelled a tour of Spain in the fall, was somewhat surprised at his extended stay. He wrote to Vernon Lee on 4 December: "You see I am still in England and have not quite got through my English work."[99] Among the earlier of these projects was the portrait of Edith, Lady Playfair (d. 1932; cat. 27), an American married to a distinguished British scientist and politician; Henry

James called her "little Lady Playfair."[100] Gold-colored silk and a vase of summer flowers complement the sitter's warm-toned flesh and project her figure forward from the dark background. It seems a restrained, almost natural image, without the overt mannerisms seen in the portraits of Mrs. White and Madame Gautreau. In this wholesomeness, it must have seemed an appropriate adjunct, as it stood unfinished on the easel, to a splendidly high-toned tea party that Sargent, his studio neighbor Edwin Austin Abbey, and Vernon Lee organized for 3 July (among the guests were Henry James, Theo Watts, Walter Pater with his sisters, and two daughters of Matthew Arnold, along with various English painters and members of high society).[101] It was surely, as well, as an ambassador radiating restraint and good taste that Sargent sent the portrait to the Royal Academy exhibition of 1885; it was seen in Boston in the fall.

The "three ugly young women" Sargent referred to in his February note were three of the daughters of Colonel Thomas E. and Frances Douglas Vickers — Mabel Frances, Clara Mildred, and Florence Evelyn — whom Sargent grouped into one large composition known as *The Misses Vickers* (see fig. 21), which he sent to the Salon of 1885 and the Royal Academy of 1886.[102] Among the other "portraits in the country" were portrayals of another branch of the family, Mr. and Mrs. Albert Vickers and their children, who lived near Petworth in Sussex. Sargent reportedly liked Edith Vickers (d. 1909) a great deal, both as hostess and as client. "I dined with the plastic John," wrote Henry James in October (as often happened, Sargent's trip stretched out much longer than he had anticipated), "who was in town from Petworth where he is painting the portrait of a lady whose merits as a model require all his airy manipulation to be expressed (in speech). I trust it is a happy effort and will bring him fame and shekels here."[103]

In the portrait, Sargent posed Mrs. Vickers in a restrained, vaguely eighteenth-century dress of dove gray with lacings up the bodice (cat. 28). Her hair is simply set, she wears no jewels, and for her sole prop she holds a giant magnolia bloom. Carved wainscoting provides the background. He has chosen, that is to say, an almost entirely fresh manner of presentation: rural rather than urban in feel, somber rather than modish, reflective rather than self-conscious. This portrait, like that of her nieces, was shown in the Salon of 1885 and the Royal Academy of 1886 — Sargent was obviously extremely proud of it. Some writers picked up on the air of self-conscious nostalgia in the portrait and likened it to the neurasthenic heroines of Edgar Allan Poe — a reasonably fashionable association in Paris of the late nineteenth century.[104]

That the Poe-like image was not necessarily a true reflection of Mrs. Vickers herself is suggested by a wholly different image of Edith Vickers he painted, posed and presented as a distinctly up-to-date individual, in an informal view of her and her husband sitting in their dining room after dinner. The only sources of light in that work, now called *A Dinner Table at Night (The Glass of Claret)* (cat. 29), are the lamps that cast their brightness onto the red walls and white linens of the room. This is an extremely modern composition, recalling the café scenes of Degas in its point of view, sketchiness of still-life elements, and the visual wit of Albert Vickers's truncated, marginalized figure, seemingly mesmerized by smoke rising from a cigarette we can only surmise. Sargent evidently felt it to be French in feeling, for he borrowed the work from Mrs. Vickers as one of four that he showed in the spring of 1885 at the Exposition internationale at the Galerie Georges Petit. There he preemptively called it *Le verre de Porto (Esquisse)*, defusing critical concern of its sketchy quality by boldly declaring it. Perhaps this is, as well, the *Study* (which criticism tells us was a lamplight scene) that Sargent submitted to the first exhibition of the New English Art Club in the spring of 1886, a venue that was perceived as being an outlet for ideas modern and French in the midst of the staid British art world.

A Dinner Table at Night established a mode of informal genre portrait, an updated version of the eighteenth-century conversation piece, to which Sargent would repeatedly turn. He painted the Besnard family clustered around a table in a red-walled dining room in 1885 (Minneapolis Institute of Arts); he scattered the Curtises across a salon of the Palazzo Barbaro when he painted them in 1899, a work he felt strongly enough about to convert into his Royal Academy diploma work (Royal Academy of Arts). It was with his portrayal of Mr. and Mrs. Robert Louis Stevenson, however, a painting of 1885 that he exhibited at the New English Art Club in 1887 and subtitled *A Sketch*, that he reached the acme of the format (cat. 30). The lean Scottish author (1850–1894), whom Sargent called "the most intense creature I had ever met," paces through the red-walled room, twirling his mustache, caught in a moment of extreme informality.[105] Off to the right, barefoot, draped in a glittering shawl, Fanny Stevenson sits and stares away from both her husband and the viewer.[106] The emotional gulf is concretized by the open doorway between them, leading to a staircase. The writer recounted the experience of serving as a model: "Sargent was down again and painted a portrait of me walking about in my own dining-room in my own velveteen jacket, and twist-

ing as I go my own moustache; at one corner a glimpse of my wife in an Indian dress and seated in a chair. . . . I am at one extreme corner; my wife in this wild dress, and looking like a ghost at the extreme other end. . . . All this is touched in lovely, with that witty touch of Sargent's; but of course it looks dam queer as a whole."[107] Splendidly vivid and lively, yet deeply puzzling, such a work shows Sargent challenging the conventions of portraiture and the expectations of the British public.

Two years later Sargent painted another portrait of Stevenson (cat. 31), a commission from the American banker Charles Fairchild intended as a present for his wife, an ardent admirer of the author. The work was painted in the last week of April. Mrs. Stevenson noted the beginning of the project: "Mr. Sargent came last night to do the portrait. It begins well, and one hand that is finished expresses about all of Louis. God grant the head may follow suit."[108] In the completed work, the hands — with their incredibly elongated fingers and graceful movements — indeed seem to capture the spirit of the writer. He sits in a wicker chair that is itself centered on a fur rug; Sargent makes much of the competing textures. But it is Stevenson's head — serene, amused, appraising — that dominates the small canvas. Mrs. Stevenson's final verdict was glowing, and one senses regret that this later work was to go away while she was left with the double portrait: "Mr. Sargent has just been here, and has painted a really good portrait of Louis. I understand that the standing figure where I play the part of an East Indian ghost is to be published by the Pall Mall. I stipulated that the ghost be left out. It seems a pity that it should not have been this new one, though for some inscrutable reason, conscientious probably, Mr. Sargent prefers the first. The last one is at Mr. Sargent's studio."[109] The work had its public debut five months later in Boston, where it was received with great favor.

While undertaking work on the scale and informality of the Vickers and Stevenson works, Sargent continued his ties to his friends in Paris. In 1885 he painted what proved to be the culmination of his early series of experimental full-length portraits of women. He turned to a familiar model, Louise Burckhardt. This time, however, he paired her with her formidable mother, who is seated in black near the picture plane (cat. 32). It is the first time that Sargent had shown a portrait of two adults portrayed full-length at life scale. The complications of the experiment include not simply the narrative — or lack thereof — of the two figures. Sargent shows them in their Paris apartment, an *enfilade* of red-carpeted rooms, sunlight streaming in from side win-

dows; the light creates a vivid pattern of color and space that animates the entire surface of the large canvas. Its scale and color scheme of red, black, and gray ensure a dominant and impressive work, reminiscent of eighteenth-century French portraiture, while the emotional remove between mother and daughter strikes a particularly modern note. The work was greeted by divided opinion when it was seen in the Salon of 1886 — some could not say enough good of it, including such gifted critics as Theodore Child, Alfred de Lostalot, and Paul Labrosse. Paul Leroi (Léon Gauchez), on the other hand, who had mounted a determined defense of Sargent in 1882, found the picture "perfectly heartbreaking; and I have no words strong enough to reprove the artist who thus compromises one of the most brilliant careers that ever opened to a painter."[110]

The year 1887 broke the pattern of exhibitions that Sargent had developed over the decade of his early career. For the first time since 1877, he did not submit anything to the Salon.[111] Nor did he arrange to have even one of his works seen in New York. Instead, he focused on England. Two pictures were shown at the New English Art Club. One, the dashingly vivid canvas of Mr. and Mrs. Robert Louis Stevenson, shows Sargent at his most witty. The other, the large-scale *Mrs. Cecil Wade (Frances Frew Wade)* (cat. 33), showing the twenty-three-year-old wife of a London stockbroker,[112] seems almost a summary of his recent portrait work — a demonstration of all he had achieved, and could yet accomplish, in the portrayal of stylish women. Mrs. Wade's distinct profile, set off by dark background and untroubled by excessive modeling, brings to mind his sharp-edged depiction of Madame Gautreau. Mrs. Wade's white satin gown, beaded and puffed — reportedly the dress she wore when she was presented to Queen Victoria[113] — echoes the vast quantities of white stuffs featured in the portrait of Mrs. Henry White. Moreover, Mrs. Wade sits at an oblique angle to the viewer, akin to the orientation of Mrs. Burckhardt in the 1885 Burckhardt double portrait; both works also have a background animated by light falling into a revelatory interior space (which in turn alludes to the hallway of *The Daughters of Edward D. Boit* and the even earlier rooms of the Venetian scenes). In all this *Mrs. Cecil Wade* remains very much a Parisian painting, which may be one of the reasons why Sargent decided to send it not to the Royal Academy, or even the Grosvenor Gallery, but to the Francophile New English Art Club.

For the Royal Academy, Sargent prepared two works. The first of these was a pleasingly straightforward portrayal of Emily Kitson Playfair (1841–1916), who was the wife of a renowned obstetrician, Dr.

William Playfair, and sister-in-law to Edith, Lady Playfair. The portrait (cat. 34) places its emphasis on Mrs. Playfair's friendly face (few women of the era, when they were being painted, smiled so that their teeth showed), but gives due respect to the bejeweled yellow gown and green, fur-trimmed cloak whose glintings and textures enliven the lower two-thirds of the canvas. It is a picture of a wealthy, fashion-conscious matron apparently about to go out for the evening. Nothing in the subject or its handling detracts from a stance of respectful observation. Even the open fan she holds, a complex problem of depiction that Sargent handles with easy mastery, falls into place without drawing attention to the painter's choices or to the act of painting. Critics, by and large, were pleased at this demonstration of what they perceived as Sargent's maturity, several calling it his most successful portrait to date. Sargent, too, approved of the work to the extent of borrowing it for the Salon of 1888, where both painting and artist were again favorably received.

But Sargent's major picture of 1887 was *Carnation, Lily, Lily, Rose* (cat. 35), the first large subject picture he had attempted since *El Jaleo* and the masterpiece of his early English career. It shows two girls standing in a darkening garden, with a multitude of flowers hovering in the dusky air. The girls do not wonder at the luminous blossoms marking their space, for they are otherwise intent on their task of delicately lighting oriental paper lanterns that, when lit, mimic the mysterious glowing of the flowers. The two girls are Dolly (1878–1949, on the left) and Polly (1874–1946) Barnard, daughters of the illustrator Frederick Barnard. Sargent met the Barnard family and began painting this picture in 1885 in the Worcestershire village of Broadway.[114]

But the identity of the children is of secondary interest in the work; *Carnation, Lily, Lily, Rose* is a painting of light and mood rather than of specific individuals. In August 1885, Sargent had been boating near Pangbourne, a quiet Berkshire village on the Thames; there "he saw the effect of the Chinese lanterns hung among the trees and the bed of lilies."[115] Later, at Broadway, he sought to recapture the twilight effect — "a most paradisiac sight [that] makes one rave with pleasure," as he wrote to Robert Louis Stevenson — experimenting with a variety of models in various configurations.[116] By early September he wrote (somewhat disingenuously, given the calculations involved in plotting the work's composition): "I am trying to paint a charming thing I saw the other evening. Two little girls in a garden at dark lighting paper lanterns hung among the flowers from rose-tree to rose-tree. I shall be a long time about it if I don't give up in despair."[117] Close to the end of the month Sargent again wrote:

I am still here and likely to be for some time, for I am launched into my garden picture, and have two good little models and a garden that answers the purpose although there are hardly any flowers and I have to scour the cottage gardens and transplant and make shift. . . . It is in [Frank D. Millet's] garden that I work. The two little girls are the children of a painter friend. Fearful difficult subject. Impossible brilliant colours of flowers, and lamps and brightest green lawn background. Paints are not bright enough, & then the effect only lasts ten minutes.[118]

That last phrase — "the effect only lasts ten minutes" — is key to understanding the work. Sargent has committed to producing a massive painting conceived and executed in the outdoors, making a true record of the scene's light, mood, and atmosphere: a goal he held in common during these years with his friend Claude Monet. (This was perceived as a distinctly modern procedure leading to a very different result than the more traditional process of making studies outdoors but painting the final version in the studio, as, for example, Sargent had done with *Oyster Gatherers of Cancale*.) He imposed his aspiration, as "a matter of excited interest," on nearly all of the painters, illustrators, writers, and their respective families who formed what the writer Edmund Gosse called "our little artist-colony" at Broadway. Gosse continued:

Everything used to be placed in readiness, the easel, the canvas, the flowers, the demure little girls in their white dresses, before we began our daily afternoon lawn tennis, in which Sargent took his share. But at the exact moment, which of course came a minute or two earlier each evening, the game was stopped, and the painter was accompanied to the scene of his labours. Instantly, he took up his place at a distance from the canvas, and at a certain notation of the light ran forward over the lawn with the action of a wag-tail, planting at the same time, rapid dabs of paint on the picture, and then retiring again, only, with equal suddenness, to repeat the wag-tail action. All this occupied but two or three minutes, the light rapidly declining, and then, while he left the young ladies to remove his machinery, Sargent would join us again, so long as the twilight permitted, in a last turn at lawn tennis.[119]

Work on the canvas extended over two seasons, took place in two gardens (over the winter the Millet family relocated within the village; Sargent sent fifty Auralian lily bulbs to them in April 1886, asking that

twenty be put in pots for him to carry on with his work later that summer), and was probably completed only in Sargent's London studio.[120] Yet in spite of dislocations of time and distance, the painter was able to capture a transient moment that seems wholly integral and true.

In many ways this is Sargent's homage to England. There are echoes in *Carnation, Lily, Lily, Rose* of works by British artists as diverse as Thomas Gainsborough and John Everett Millais. The subject, too, seems aimed at a peculiarly Victorian sentimentality and sensibility: pretty children in white frocks standing among flowers, intent on innocent, aesthetic activity. Even the title, based on a line from "The Wreath," an early nineteenth-century art song by Joseph Mazzinghi, evokes British pastoral mythology. As Vernon Lee phrased it, the painting is "*too* lovely, really beautiful as distinguished from merely wonderfully done."[121] Yet the painting itself, by dint of Sargent's formal choices — his feel for complementary shapes, chromatic nuance, and variegated brushwork — defies the prettiness or storytelling that marks much popular English art of the era. The nearly square format of the painting, which was not decided on until midway through the project, accentuates the work's decorative nature, as does the disjunction between the picture's internal viewpoint (looking down on the children) and the physical experience of viewers in galleries generally having to look up at it: Sargent imposes a formal distance that keeps sentimentality at bay.[122] The combination was a striking success. Even before the opening of the Royal Academy exhibition, the work had been selected as a Chantrey Bequest purchase for the nation. It has remained one of Sargent's most admired works.[123]

Sargent's definitive relocation to London in 1886 was a calculated move. He had contemplated such a transfer for at least a year, writing in 1885 to an atelier friend an exceedingly clear-eyed evaluation of his career's state: "Since the last three or four years I have been more or less up and down of prosperity: just now I am rather out of favour as a portrait painter in Paris, although my last Salon, two portraits done in England rather retrieved me. I have been coming to England for the last two or three summers and should not wonder if I someday have a studio in London. There is perhaps more chance for me there as a portrait painter, although it might be a long struggle for my painting to be accepted. It is thought beastly French."[124] Within the year, and certainly by May 1886, the decision was made. The artist's father announced it to the family in America, casting the choice in wholly

pragmatic terms: "[John] spent last winter in London, and is about moving his traps from Paris to London, where he expects to reside instead of in Paris, and where he thinks he will find more work to do than in the latter place. He seems to have a good many friends in London, & appears to be very favorably known there. London is a world in itself, with its 4 1/2 millions of people."[125] From his exhibition record, it could be construed that, having moved his home and studio to London in 1886 and being fully aware of English aesthetic prejudices, Sargent spent the next year devoting himself to his new land, demonstrating especially with his Royal Academy exhibition paintings — all portrayals of British folk — his commitment to London.

But whatever the nationality of the sitter, or the studio mannerisms and color harmonies that he might shift, there are some constants that run through Sargent's works of these years. Vernon Lee, an acute observer, picked up on one of these. After walking through the Salon of 1885 with Sargent and seeing his paintings of the Vickers family, she wrote to her mother: "I fear John is getting rather into the way of painting people too *tense*. They look as if they were in a state of *crispation de nerfs*."[126] It is easy to see what she means. In the larger of his Salon paintings of the year, the entwined hands and arms of the Misses Vickers present a worrying knot of flesh; in the other, Mrs. Vickers, for all the placidity of her pose and her downward drooping magnolia, turns a wary face to the viewer. But Sargent was not just beginning to find this nervousness in 1885; his predilection for it, in addition to the painterly style that critics noted as being unique and distinctive, is what unites nearly all the many portrayals of his contemporaries. This pervasive energy tinged with unease is evident in even his earliest exhibited works: Fanny Watts twists uncomfortably in her chair; Carolus-Duran leans forward, one hand loosely lying on his stick while the other is pinioned on his thigh; Madame Pailleron draws up her skirt and brings her arms forward almost as if to protect her body from a blow. The manifestations become more obvious in later works: Madame Subercaseaux twists over her chair; the Pailleron children brace their hands uncomfortably against the tedium of posing; Dr. Pozzi, almost like a highly strung thoroughbred, lifts his head and sniffs the air. Miss Burckhardt holds out her rose to the side, a gesture without obvious meaning and yet one demanding considerable effort to maintain, prompting an empathetic wonder at the fortitude involved in posing, arm extended, for hours on end. Madame Gautreau lifts her head to the right, throwing back the opposing shoulder and arm, giving a glorious sweep to the tensed muscle of her neck and creating a curve that flows from the reddened ear at the cen-

ter of the canvas to her shoulder. And while one hand lightly grasps skirt and fan, the other is splayed over the edge of a table, her arm torqued as if she were about to spin the table like a roulette wheel. Repeatedly, the majority of his sitters clutch their hands, twist in their chairs, or pace the room. They are in motion, or they contort themselves so that, like tightly coiled springs, they seem ready to explode. Their faces record wariness or concern.

To a certain degree this energy is necessarily a reflection of the artist's spirit: all portraiture, after all, is self-portraiture. Memoirs of those who observed him report that Sargent darted about while he painted, rushing back and forth as he matched tones on his palette from a distance, then charged his canvas to place a stroke before retreating again to a more distant vantage point. Vernon Lee wrote that the three hours Sargent spent painting her glittering portrait were immensely enjoyable, "John talking the whole time & strumming the piano between whiles."[127] While Sargent was working outdoors on *Carnation, Lily, Lily, Rose*, Edmund Gosse described his constant motion by comparing him to a wag-tail, an aptly named English bird.[128]

But there was also a tenseness common to the age, at least to some observers, and Sargent's recording of it was yet one more sign of his modernity. The French critic Louis de Fourcaud, in response to the Salon of 1881, recognized this state:

> In the works of all modern portrait painters, worthy of the name, we find all the symptoms of evolution in social condition — the anxious onlooking toward the future, so apparent in our eagerness for innovation, offset by a mindfulness of the past nourished by exacting tradition, and over all, and through all, a tinge of *melancholy*, a lack of intellectual poise, the more noticeable for the mask of assurance in which it is often disguised. It is a rare thing to find a brain that is calm and at rest, or features either. When we feel the charm of a really serene face, it is almost always on the features of a very young or a very old person, where life has not yet cast its shadow of anxious unrest, or where old age has spread its veil of calm. All between are the slaves of nervous overstrain, and wear its scars; the lack of equilibrium in our souls writes its story in our drawn and agitated features.[129]

One of the reasons Sargent's early portraits are so compelling today is that, beneath the elaborate clothing and quaint hairstyles, they reveal people beset with the very insecurities and concerns that so consume our own era.

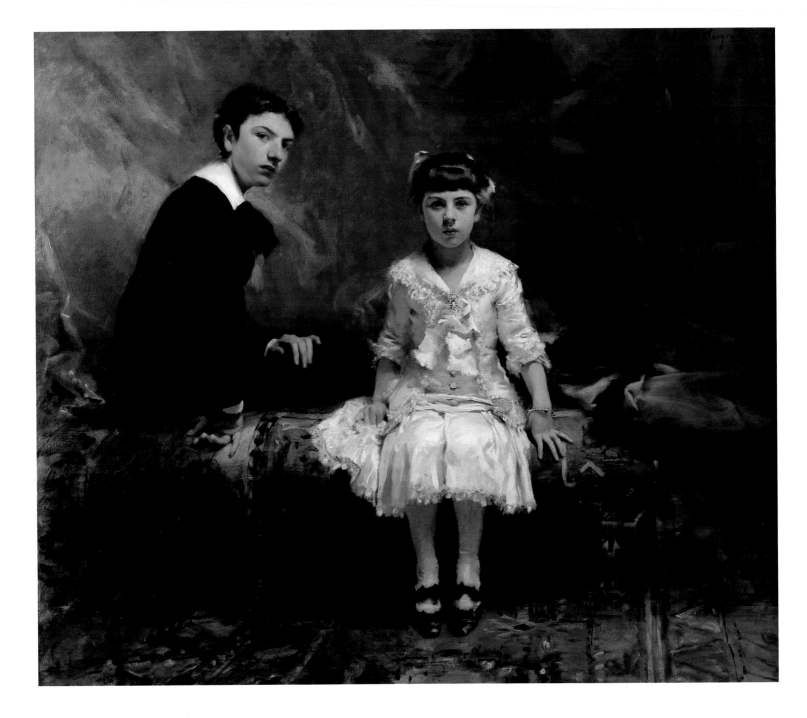

20. *Edouard and Marie-Louise Pailleron*, 1881

Oil on canvas, 60 x 69

Des Moines Art Center

Purchased with funds from the Edith M. Usry Bequest, in memory of her parents, Mr. and Mrs. George Franklin Usry, the Dr. and Mrs. Peder T. Madsen Fund, and the Anna K. Meredith Endowment Fund, 1976.61

Paris 1881 — Salon de 1881

Portrait de M. E. P . . . et de Mlle L. P . . .

2109 (of 2448 paintings)

Des deux cadres de cet artiste, je préfère celui où sont réunies les effigies en pied de M. E. P . . . et de Mlle L. P . . . , le frère et la soeur, assis tous deux sur le même divan, le frère à gauche, le corps de profil, la soeur, charmante fillette, de face, habillée de blanc. Là, tout est d'une belle couleur, suffisamment dessiné et peint avec aplomb, d'une large brosse. Cependant, le peintre a le tort de se contenter trop aisément. Aussi est-il inférieur à ce qu'il pourrait être.

> Olivier Merson, "Salon de 1881: IV," *Le Monde illustré* 25 (28 May 1881): 362.

Notons encore le portrait d'un frère et d'une soeur par M. Sargent, élève de M. Carolus Duran, qui a l'habileté, l'éclat, l'abondance un peu fastueuse de son maître et des facultés de coloriste analogues. . . . Les portraits des enfants de M. D . . . me donnaient l'impression contraire d'un homme qui court le risque, malgré des dons évidents, de s'engager dans une voie au bout de laquelle il rencontrerait M. Dubufe.

> J. Buisson, "Le Salon de 1881 (Deuxième Article): Le Portrait," *Gazette des beaux-arts* 24, no. 1 (July 1881): 44.

La banalité est le pire défaut des portraitistes; ils peuvent peindre à merveille, dessiner avec conscience, mais souvent ils sont gauches dans l'agencement de leur modèle; on sent, dans leurs tableaux, la pose forcée de l'atelier, le *ne bougeons plus les yeux*, ou bien le *relevez la tête ainsi*.

Les portraits de M. Sargent ne mériteront jamais ces reproches, ils ont le don bien rare de vous attirer quand vous passez à côté d'eux, de vous fasciner et de vous intéresser, plus que ne pourrait le faire aucune composition historique. Ils ont la vie, le mouvement, l'allure dégagée, la couleur franche. M. Carolus Duran doit être fier d'avoir formé un tel élève. Les portraits de M. E. P . . . et de sa soeur, sur la même toile, sont charmants de physionomie, d'une tonalité claire et brillante. Ils sont bien de la même famille que l'étincelant portrait de Mme E . . . P . . . exposé au Salon de 1880.

> Maurice Du Seigneur, *L'Art et les artistes au Salon de 1881* (Paris: Paul Ollendorf, 1881), 203–204.

Je dois citer avec éloge [. . . Laugée, Saintpierre], les enfants de mon ami Pailleron, esquissés vivement, mais seulement esquissés, et assez mal mis en toile par M. Sargent.

> Edmond About, *Le Décaméron du Salon de peinture* (Paris: Librairie des Bibliophiles, 1881), 106.

L'année dernière, je crois, j'ai signalé le beau portrait de M. Carolus Durand, par M. Sargent; nous avons à signaler aujourd'hui celui de *Madame E. P. et Mademoiselle L. P.*, par le même artiste. Les deux personnages sont dans le même cadre; c'est évidemment un tableau de famille, et la grande personne est sacrifiée à la fillette. Elle est vue en face, toute vêtue de blanc, assise sur un canapé; elle a pris si au sérieux sa pose que ses mains sont crispées par la tension de la volonté la tient immobile; son regard est comme fatigué par la lumière qui frappe la rétine. Très gentille, très vivante et sérieuse comme il convient à un brave petit modèle, la tête, dans sa pâleur matte, est soigneusement et finement modelée; quant au costume, il est traité avec une habileté et rendu avec un effet qui dénoncent l'école où le peintre a été nourri. Mais qu'il prenne garde de n'aller pas trop loin dans ce sens et, au détriment du principal, de donner trop de valeur aux accessoires. Pendant quelques années, M. Carolus Duran a été dans cette voie, qui a mené à mal tant de portraitistes. La toile de M. Sargent est très bonne elle serait même excellente sans la tenture vin de Bordeaux, qui en forme le fond et qui n'est point heureuse. M. Sargent a beaucoup de talent.

> A. Genevay, "Salon de 1881 (Troisième article)," *Le Musée artistique et littéraire* 5, no. 21 (1881): 324.

London 1883 — Fine Art Society

Then to the Fine Arts Gallery, to see John's portrait of the Pailleron children. It is a splendid work (I have a photo, but too large & stiff to send, of it) which, so completely healthy and wholesome, does one good to see after all this scrofulous English art. Oscar Wilde, who is lecturing here at 10/6 the seat, calls John's art vicious & meretricious.

> Vernon Lee to her mother, 11 July 1883, quoted in *Vernon Lee's Letters*, edited by her executor [Irene Cooper Willis] (London: privately printed, 1937), 126.

21. *Dr. Pozzi at Home*, 1881

Oil on canvas, 80 1/2 x 43 7/8

The Armand Hammer Collection, UCLA at the Armand Hammer Museum of Art and Cultural Center, Los Angeles, California

London 1882 — Exhibition of the Royal Academy: The One Hundred and Fourteenth

A Portrait

239 (of 861 paintings)

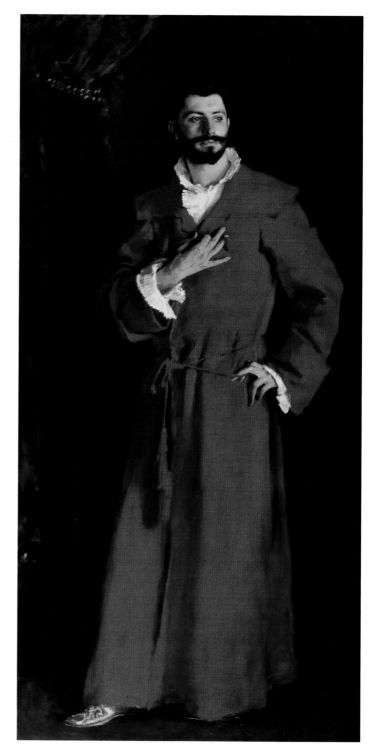

Another picture remarkable for technical skill is Mr. Sargent's "A Portrait" (239), which is a daring study in reds.
　　"The Picture Galleries," *Saturday Review* 53, no. 1383 (29 April 1882): 531.

M. Sargent, peintre américain, expose un géant sur fond rouge, vêtu en rouge, chaussé de pantoufles rouges; placé très haut, le géant de M. Sargent paraît encore trop grand; jugez de ce que ce serait s'il était à la cimaise.
　　T. Johnson, "Correspondance anglais," *Le Figaro*, 3 May 1882, 3.

John Sargent touche aussi à la frise. Il est vrai que la toile qu'il expose — un jeune homme en robe de chambre rouge sur fond cramoisi — a un peu l'air d'un defi à l'Angleterre, qui a mal pris la chose et se sera dit: à mystificateur, mystificateur et demi.
　　"L'Exposition de l'Académie royale des beaux-arts à Londres," *L'Art moderne* (Brussels) 2, no. 23 (4 June 1882): 180.

His work has been almost exclusively in portraiture, and it has been his fortune to paint more women than men; therefore he has had but a limited opportunity to reproduce that generalized grand air with which his view of certain figures of gentlemen invests the model, which is conspicuous in the portrait of Carolus Duran, and of which his splendid "Docteur Pozzi," the distinguished Paris surgeon (a work not sent to the Salon), is an admirable example. . . .
　　. . . I have alluded to his superb "Docteur Pozzi," to whose very handsome, still youthful head and slightly artificial posture he has given so fine a French cast that he might be excused if he should, even on remoter pretexts, find himself reverting to it. This gentleman stands up in his brilliant red dressing-gown with the *prestance* of certain figures of Vandyck.
　　Henry James, "John S. Sargent," *Harper's New Monthly Magazine* 75, no. 449 (October 1887): 684, 689.

Brussels 1884 — Les XX

Portrait

One of 112 works

JOHN SARGENT fait face à Chase. Et le hasard veut que ce soit également un portrait et un portrait rouge qu'il expose. Mais le rouge de Sargent est tapageur, il ameute, il crie, il est colère, il aboie; le rouge de Chase chante, gazouille, il est tout en sourdine.
　　Le portrait de Sargent a de l'allure, de la crânerie, le modèle est campé, il conquiert d'emblée l'attention.
　　A la réflexion pourtant, il faut en découdre. Il y a en tout ceci beaucoup de chic, cet art manque de solidité, de dessous, il vise à étonner, à «épater»; il est théâtral, il est poseur, il finit par lasser; il renferme, comme un verre à champagne trop précipitamment rempli, plus de mousse que de vin d'or.
　　Emile Verhaeren, "Chronique d'art: Exposition des Vingtistes à Bruxelles," *La Libre Revue* 16 (February 1884): 233.

Tout autre est l'envoi de *Sargent*. Son homme en rouge, en rouge groseille sur fond lie de vin, doit faire venir l'eau ou plutôt le sirop à la bouche de M. Herbo. Cela est criard, cela sent le convenu, cela semble compris à travers Carolus Duran. Peu de sincérité, de vérité. Quelque crânerie certes, mais au résumé manque de dessous; tout est chic et parisianisme.
　　Emile Verhaeren, "Chronique Artistique: Exposition des XX (Second article)," *La Jeune Belgique* 3, no. 4 (15 March 1884): 244.

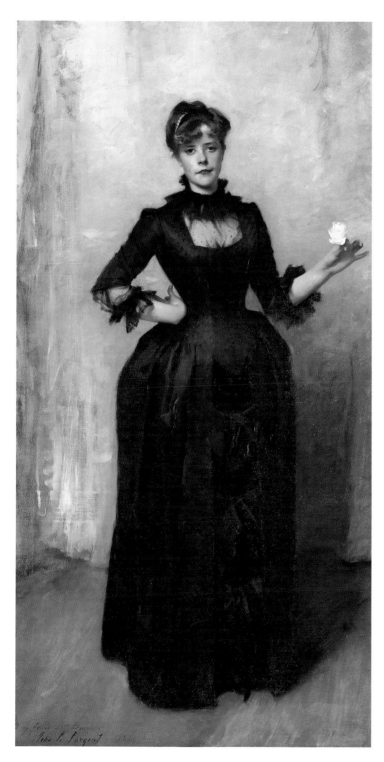

22. *Lady with the Rose (Charlotte Louise Burckhardt)*, 1882

Oil on canvas, 84 x 44 3/4

The Metropolitan Museum of Art

Bequest of Mrs. Valerie B. Hadden, 1932

Paris 1882 — Salon de 1882

Portrait de Mlle ***

2398 (of 2722 paintings)

Il semble que chaque année voie s'accroître le nombre des portraits envoyés à l'Exposition des Champs-Elysées. . . . Moins heureux, il est vrais, le critique obligé de chercher, au milieu de toutes ces figures banales, celles où transparaît une note d'art, où le peintre se révèle ayant senti ou pensé!

 Un seul nom nouveau surgit de cette multitude, c'est celui de M. Sargent. . . . Une grande jeune fille en noir dont la tête se détache en pleine lumière, le costume traité avec soin, mais ne servant qu'à faire ressortir encore l'éclat tranquille de la physionomie, des traits fins étudiés de très près et rendus avec une precision élégante, un dessin correct, un modelé souple et délicat, telle est l'oeuvre qui a frappé dès le premier jour les artistes et le public en face de laquelle on ne sait ce qu'on doit le plus admirer, de l'extrême simplicité des moyens employés ou de l'intensité de l'effet obtenu; le portrait de M. Sargent est une des toiles les plus personnelles de tout le Salon, et on devine, rien qu'à le regarder, qu'il a aussi le mérite d'être ressemblant.

 Jules Comte, "Les Salons de 1882, III: La Peinture," *L'Illustration* 79, no. 2047 (20 May 1882): 335.

The drawing is firm, the color fresh and pure, and the whole effect enchanting. It is considered Sargent's best work; one of the French critics calling it a chef d'oeuvre. Mr. Sargent has had third and second medal, and it goes without saying that he should now have the first.

 C. M. Hilliard, *Boston Weekly Transcript*, 6 June 1882 (Burckhardt Scrapbook, John Singer Sargent Catalogue Raisonné Archive).

Mlle ***, telle du moins que l'a représentée M. Sargent, paraît d'allure plus décidée. . . . La bouche ébauche un sourire moquer. Voici qui n'est pas simple! Toutefois, en jugeant au point de vue du métier du peintre, il faut louer le piquant de l'attitude, la finesse de la couleur et l'exécution très enlevée.

 Henry Houssaye, "Le Salon de 1882 II. Les Portraits, Les Tableaux de Genre, Les Paysages," *Revue des deux mondes* 51, no. 4 (15 June 1882): 852.

L'ensemble, fait avec rien, comme on dit, est d'une originalité qui s'impose. C'est une des oeuvres du Salon qu'on vient *revoir* à chaque visite et qui consolent de tous les portraits fades, prétentieux, bêtes ou médiocres qui y pullulent et dont nous ne parlerons pas.

 André Michel, *Le Parlement*, 18 June 1882 (Burckhardt Scrapbook, John Singer Sargent Catalogue Raisonné Archive).

The young girl in this year's picture was dressed in mourning in the very latest mode, with exactly the colossal bouffant tournure that fashion put upon all lady visitors to the Salon of 1882. Artists contend that Fashion is Philistine. . . . Yet the artist had managed to give it such an indescribable quaintness of air and pose, and had treated it so thoroughly in the artistic spirit, that — in spite of its purplish, metallic flesh — one was instantly reminded of Velazquez, and could not but imagine how exquisitely quaint and strange it will seem to those who shall see it a hundred years hence.

 "American Art in the Paris Salon," *Art Amateur* 7, no. 3 (August 1882): 46.

Il va se produire inévitablement en faveur de M. Sargent une de ces vogues fashionables que son portrait de jeune fille suffit à justifier. Toute jolie femme rêve, à l'heure qu'il est, d'être peinte par lui. S'il ne succombe pas aux tentations d'un tel triomphe, s'il sait le dominer, guidé par le seul culte de l'art, il ne versera pas dans les habiletés du *fa presto*, et nous le verrons, sans cesse grandissant, atteindre les plus hauts sommets. Organisation d'élite, il dépend de lui de la faire valoir sous ses plus nobles aspects.

L'originalité durable, celle qui ne crée pas seulement pour le présent, mais ambitionne légitimement la sanction de l'avenir, s'appuie sur l'étude, le savoir et le goût, c'est celle de M. John Sargent. De là son grand succès.

> Paul Leroi [Léon Gauchez], "Salon de 1882," *L'Art* 8, no. 30 (July–September 1882): 139.

The contrast between the sombre blacks and the fresh hue of the lady's complexion gives such a ripe richness to the whole that we prophesy that there will be a rush of commissions from the fair sex when Mr. Sargent takes up his abode, as he proposes, in London.

> "The Salon. From an Englishman's Point of View," *Art Journal* (London) 44, no. 7 (July 1882): 218.

Le chef-d'oeuvre, le bijou du genre est, à notre avis, le portrait de Mlle ***, par M. John Sargent. . . . [T]out est parfait, étudié, compris.

> Maurice Du Seigneur, *L'Art et les Artistes au Salon de 1882* (Paris: L'Artiste, 1882), 51–52.

The most brilliant of all Mr. Sargent's productions is the portrait of a young lady. . . .

. . . I know not why this representation of a young girl in black, engaged in the casual gesture of holding up a flower, should make so ineffaceable an impression, and tempt one to become almost lyrical in its praise; but I well remember that, encountering the picture unexpectedly in New York a year or two after it had been exhibited in Paris, it seemed to me to have acquired an extraordinary general value, to stand for more artistic truth than it would be easy to declare, to be a masterpiece of color as well as of composition, to possess much in common with a Velasquez of the first order, and to have translated the appearance of things into the language of painting with equal facility and brilliancy.

> Henry James, "John S. Sargent," *Harper's New Monthly Magazine* 75, no. 449 (October 1887): 684, 686.

London 1882 — Fine Art Society, British and American Artists from the Paris Salon

A Portrait

10 (of 14 paintings)

New York 1883 — Society of American Artists Sixth Annual Exhibition

Portrait of a Lady

103 (of 148 works)

His full-length likeness of a young girl in a black silk dress . . . is a delightful piece of painting, better in every way (although not so difficult a task) than his "El Jaléo," with Spanish dancers and musicians. It is quiet, yet has great animation, and that alone is a triumph in a portrait. . . . [P]erhaps one is going to weary of the animated gesture in the bright-looking young lady in black. . . . It lends just so much more interest to the exhibition; the portrait is indeed painted with an eye to exhibiting just as was "El Jaléo."

> "The Society of Artists. The First View of Its Spring Exhibition," *New-York Times*, 25 March 1883, 14.

If this portrait [J. Alden Weir's portrait of Richard Grant White] be dubbed "Dignity," its neighbor by Mr. Sargent might aptly be termed "Impudence," if the dimpled, coquettish maiden who peeps out at us from the canvas will forgive the name. . . . It would be unfair to inquire too closely how much Mr. Sargent owes to his Paris associations, for this picture shows two things — firm and masterly painting and beauty of expression — which are due to the artist alone.

> "The Society of American Artists," *New-York Daily Tribune*, 25 March 1883, 5.

I am not sure that this lady's grandchildren will not begin to weary a little of her attitude and action, as she stands straight up in her Watteau dress and holds out, sideways, a rose without a stem. But for a week or two we are all content to see her stand so; her jaunty little head with its hair in "sweet disorder," and an old time mingling of freedom and refinement in her dress and manners.

> Clarence Cook, "The Society of American Artists' Exhibition," *Art Amateur* 8, no. 6 (May 1883): 124.

There are strong qualities along with much bad taste in Mr. Sargent's "Portrait of a Lady," No. 103. The strong qualities are those of drawing and color values. The bad taste is displayed in the ungraceful pose and the ugly costume, which sadly deforms the figure. We have no doubt the picture is truthful in these points; but it is a pity that an artist should devote so much skill to giving enduring form to the monstrosities of a fashionable Parisian costume. The fashion in which the lady's hair is arranged is also very ungraceful and unfit for a painter.

> C. H. Moore, "Fine Arts. The Sixth Annual Exhibition of the Society of American Artists," *Nation* 36, no. 928 (12 April 1883): 328.

Boston 1883 — Society of American Artists Sixth Annual Exhibition (at the Museum of Fine Arts)

Portrait of a Lady

100 (of 144 works)

The small Velasquez exhibited with the modern work, suggests an explanation of the almost wearisome undertone of many of the portraits. Our younger painters have of late years spent much time in Spain, and the style of the great master of Spanish art is much in vogue. It is a natural reaction and protest against the gaudy, tawdry color of some of the prominent French painters of the present day. There is a danger of overdoing this sobriety of color. . . . In the Sargent portrait the tone of drapery and background is soft and subdued, but the flesh is *alive*. Through the well-modelled arms it takes no great stretch of the imagination to fancy that there might run veins, and that those veins might contain blood. The face is full of vitality, the eyes might almost sparkle, the curved red lips smile.

> "The Exhibition at the Art Museum," *Boston Evening Transcript*, 10 May 1883, 6.

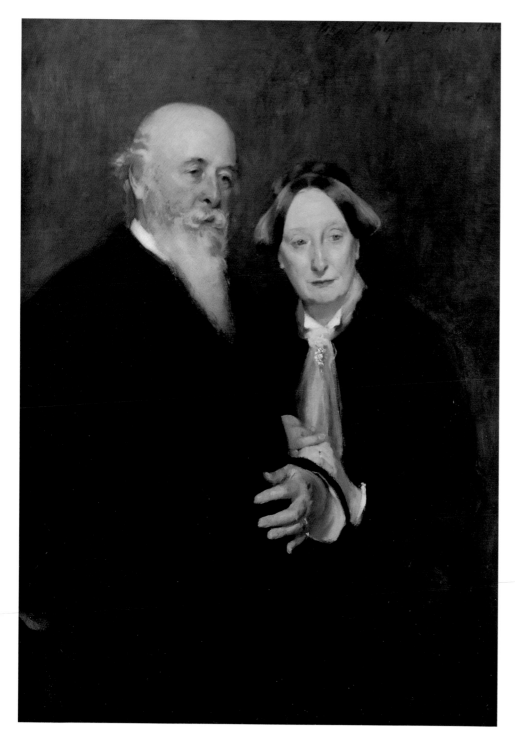

23. *Mr. and Mrs. John White Field,* 1882

Oil on canvas, 44 x 33

Courtesy of the Museum of American Art of the Pennsylvania Academy of the Fine Arts, Philadelphia

Gift of Mr. and Mrs. John White Field

New York 1886 — Society of American Artists Ninth Annual Exhibition

Portrait

96 (of 121 works; owner: John W. Field, Washington)

In Mr. John S. Sargent's picture of an aged couple, the man's head is as good as the woman's is bad, and the hands of both persons are wretchedly treated.
 "Society of American Artists," *New-York Times,* 13 May 1886, 5.

Perhaps the most interesting painting in the collection are the two portraits contributed by John S. Sargent. . . . The quality of Mr. Sargent's painting has improved; his delicate appreciation of tones is more remarkable than ever, and his friends have good reason to expect great things from him.
 "The American Artists' Exhibition," *Art Amateur* 15, no. 2 (July 1886): 25.

24. *Mme Allouard-Jouan,* ca. 1882

Oil on canvas, 29 3/8 x 22 1/4

Ville de Paris Musée du Petit Palais

Paris 1882 — Société internationale de peintres et sculpteurs

Portrait de Mme A. J.

100 (of 126 works)

L'exposition actuelle mérite cependant d'être vue; n'y eût-il que les poétiques paysages de M. Cazin et les portraits de M. Sargent, elle serait fort intéressante.

> "Concours et Expositions," *La Chronique des arts et de la curiosité* 5, no. 40 (23 December 1882): 306.

M. Sargent a deux portraits, l'un de femme en noir qui est tout à fait éclatant, enlevé de main de maître.

> Arthur Baignères, "Première Exposition de la Société Internationale de Peintres et Sculpteurs," *Gazette des beaux-arts* 27, no. 2 (February 1883): 190.

There was a beautiful and sympathetic portrait of a lady — a patrician whose blue blood Fortuny could not have better rendered.

> W. C. Brownell, "American Pictures at the Salon," *Magazine of Art* (London) 6 (1883): 497.

I should like to commemorate the portrait of a lady of a certain age, and of an equally certain interest of appearance — a lady in black, with black hair, a black hat, and a vast feather, which was displayed at that entertaining little annual exhibition of the "Mirlitons," in the Place Vendôme [probably misremembered for the Société internationale at Galerie Georges Petit]. With the exquisite modelling of its face (no one better than Mr. Sargent understands the beauty that resides in exceeding fineness), this head remains in my mind as a masterly rendering of the look of experience — such experience as may be attributed to a woman slightly faded and eminently sensitive and distinguished. Subject and treatment in this valuable piece are of equal interest, and in the latter there is an element of positive sympathy which is not always in a high degree the sign of Mr. Sargent's work.

> Henry James, "John S. Sargent," *Harper's New Monthly Magazine* 75, no. 449 (October 1887): 689–690.

25. *Auguste Rodin*, 1884

Oil on canvas, 28 3/4 x 20 7/8

Musée Rodin, Paris

Paris 1885 — Exposition internationale de peinture

Portrait de M. Rodin

98 (of 114 works)

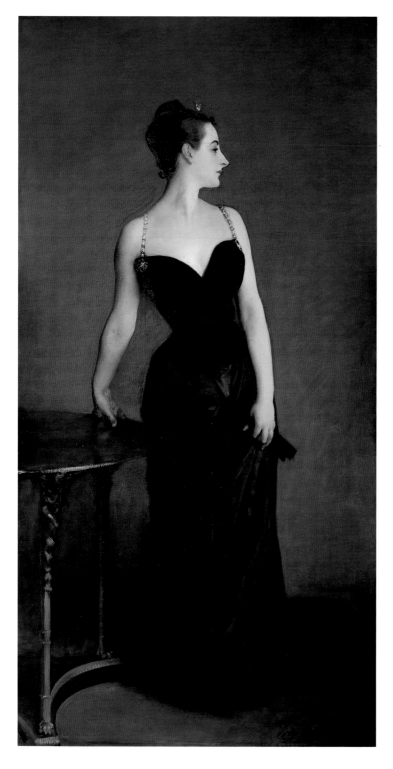

26. *Madame X (Virginie Avegno Gautreau)*, 1884

Oil on canvas, 82 1/8 x 43 1/4

The Metropolitan Museum of Art

Arthur Hoppock Hearn Fund, 1916

Paris 1884 — Salon de 1884

Portrait de Mme ***

2150 (of 2488 paintings)

Un peintre américain d'infiniment de talent, M. Sargent, s'est trompé cette fois de tout au tout; le portrait de celle qu'on appelle la belle Mme Gautherot est absolument manqué; comme dessin il rappelle imparfaitement le profil si fin de la belle mondaine. Au point de vue de la coloration particulière du teint de madame Gautherot, je me rends très bien compte de la difficulté qu'il présentait à l'artiste, mais enfin il pouvait du moins se rattraper sur la grâce de la composition. C'est une revanche à prendre.

Albert Wolff, "Le Salon de 1884," *Le Figaro*, 30 April 1884, 1.

[J]e voulais prendre décidément parti dans la grande querelle qui divise les salons de Paris: le portrait de «la belle Mme Gautreau», par Sargent, est-il ressemblant, oui ou non?

Etrange, je le veux bien, singulier, je n'en disconviens pas, presque macabre; j'écrirai le mot, si l'on y tient, mais, pour ressemblant, il est ressemblant. . . .

La toilette aussi est ressemblante. . . . M. Sargent, avant de peindre son modèle, l'avait fait photographier grandeur nature, comme on dit. Il faut que les amies de la belle Mme Gautreau en prennent leur parti, voilà la *professional beauty* qui fait tourner ou retourner toutes les têtes. Je serais femme que je trouverais dangereux d'être couramment nommée dans les gazettes «la belle Mme Gautreau». . . . [I]l y a les femmes, et les femmes ont des lorgnettes. Les femmes passent leur vie à lorgner. . . .

. . . Voilà toute l'histoire d'un portrait qui fait si grand tapage depuis quinze jours chez les mondaines et chez les couturiers. Seulement, à mon avis, le talent de Sargent est intact, et c'est l'*autrement* qui bien pourrait être la vérité.

Jules Claretie, "La Vie à Paris," *Le Temps*, 16 May 1884, 3.

M. John Sargent a pu s'en apercevoir. La foule, quelque peu féroce, qui, au jour du vernissage, s'ameutait devant son portrait de femme, a dû lui être une leçon et lui apprendre combien il est dangereux de n'être pas résolument vulgaire. Cette foule, à laquelle nous avons eu l'indiscrétion de nous mêler, était bien curieuse à entendre. Les femmes, les anges de vertu ou les coquettes avérées, dissertaient sur la toilette de Mme *** et blâmaient les échancrures de son corsage; les peintres, exagérant l'insuccès d'un camarade redoutable, prenaient des airs contrits qui étaient les plus drôles du monde. Tout ce bruit est aujourd'hui fort calmé: l'oeuvre de l'artiste américain rest étrange et intéressante.

Il est des choses qu'on ne saurait pardonner à M. Sargent. Le modèle est debout, appuyant la main sur un guéridon. Cette main où conrent des violets roses est d'un dessin exécrable, d'une coloration qu'on n'acceptera jamais; une heure de travail suffirait pour réparer cette faute. Tout le reste, tout ce qui importe, est singulier, mais légitime. . . . M. Sargent a peint ce qu'il a vu. Il a de plus donné au profil cette étrangeté troublante que Piero della Francesca, qui, lui aussi, fut un ennemi des ombres, a donnée à la jeune dame inconnue qu'on admire à Milan dans la collection Poldi-Pezzoli. Si le portrait de M. Sargent est une erreur si caractérisée, pourquoi ne peut-on quitter le Salon sans aller le revoir encore? Pour nous, nous ne pouvons parvenir à être

furieux contre l'artiste, qui s'est révélé jadis par des oeuvres d'une curiosité si rare. Nous lui pardonnons de grand coeur son caprice blanc.

Paul Mantz, "Le Salon: IV," *Le Temps*, 23 May 1884, 2.

Négligeons le *Portrait de Mme Gautereau*. Le poitrine, que la robe ouverte en coeur laisse voir jusqu'aux limites permises, et même peut-être au delà, les épaules, les bras, sont néanmoins d'un bon peintre. Reste le visage, de profile. Voilà le malheur, ce profil. . . . Mais patience, M. Sargent ne se trompera pas toujours; il est homme à prendre avant peu une revanche éclatante.

Olivier Merson, "Le Salon de 1884: III," *Le Monde illustré* 28, no. 1417 (24 May 1884): 327.

Nous allions oublier le grand succès du Salon, car il y a succès et succès: le portrait de Mme ***, par M. Sargent. Le profil est pointu, l'oeil microscopique, la bouche imperceptible, le teint blafard, le cou cordé, le bras droit désarticulé, la main désossée; le corsage décolleté ne tient pas au buste et semble fuir le contact de la chair. Le talent du peintre se retrouve seulement dans les reflets miroitans de la jupe de satin noir. Faire d'une jeune femme, justement renommée pour sa beauté, une sorte de portrait-charge, voilà à quoi mènent le parti-pris de l'exécution lâchée et les éloges donnés sans mesure.

Henry Houssaye, "Le Salon de 1884," *Revue des deux mondes* 63, no. 3 (1 June 1884): 589.

As has been usually the case of late years, the Salon is rich in portraits, many, too many, being full-length and life-size. . . . Mr. Sargent, though those who know Madame Gauthereau declare that he has not done justice to her beauty, has at least produced a most interesting work of art.

"Impressions of the Salon (from a Correspondent)," *Times* (London), 3 June 1884, 8.

Mr. Sargent's portrait of a lady is the most disquieting object that eyes ever looked upon. The hideous colour and the fantastic drawing which Mr. Sargent has brought together in this strange work fairly puzzle the will.

"The Paris Salon," *Saturday Review* 57, no. 1493 (7 June 1884): 745.

A *succès de scandale* has been attained by Mr. Sargent's much-discussed "Portrait de Madame . . . ," which represents a lady standing with one arm resting on a table, in an evening dress of black satin, which displays the sculpturesque beauty of her form with a liberality remarkable, and remarked, even in modern Paris. The painter has deliberately rendered, with extraordinary skill and almost cynical audacity, the effect of enamelled flesh and of hair which owes its gold to art. The intention, no doubt, was to produce a work of absolutely novel effect — one calculated to excite, by its *chic* and daring, the admiration of the *ateliers* and the astonishment of the public; and in this the painter has probably succeeded beyond his desire.

Claude Phillips, "The Salon. II," *Academy* 25, no. 632 (14 June 1884): 427.

Of Mr. Sargent's portrait of Mme . . . , one can say nothing but praise . . . vigorous, well-drawn, and full of life. Mr. Sargent is in a fair way to eclipse his master, M. Carolus-Duran, if the world does not spoil him and make him careless.

Penguin, "The Paris Salon," *American Architect and Building News* 15, no. 443 (21 June 1884): 296.

Les avis se partagent et l'on se passionne au sujet du grand portrait en pied de Mme G . . . par M. John Sargent. . . . On noircirait dix pages à noter les singuliers propos interrompus qu'on entend devant cette toile.

Pour moi, je suis tout conquis à une oeuvre si peu vulgaire, où je discerne toute sorte d'intentions curieuses et d'étranges raffinements. Je n'ai pas, en général, le goût des complications, mais pour rendre un type particulier, dans lequel se fondent mille singularités compliquées, un peu de complication

est bien de mise. Je voudrais pouvoir écrire ici la physiologie de la Parisienne d'origine étrangère, élevée dès son enfance pour être une idole et citée constamment dans les journaux mondains à titre de beauté reconnue ou, selon l'expression anglaise, de *professional beauty*. . . .

Considérez maintenant la peinture de l'artiste américain. Il a éminemment exprimé l'idole, et c'est là ce qu'il faut voir. La pureté des lignes de son modèle a dû le frapper d'abord, et son parti a été pris aussitôt de faire de ce portrait quelque chose comme un grand dessin en camaïeu. . . .

En résumé, je n'affirme point — cela va de soi — que le peintre se soit livré à de profondes spéculations touchant les conditions psychologiques de son modèle: il se peut fort bien qu'il ait été dominé par des préoccupations exclusivement plastiques: mais j'affirme que le dessin a été son objectif capital en ce portrait . . . et qu'il est résulté de sa longue persévérance à observer et à fixer la manière d'être de l'idole, une oeuvre non seulement de raffinement, mais encore de portée.

L. de Fourcaud, "Le Salon de 1884. (Deuxième Article)," *Gazette des beaux-arts* 29, no. 6 (June 1884): 482–484.

De toutes les femmes déshabillées, la seule intéressante est de M. Sargent. Intéressante par sa laideur au fin profil qui rappelle un peu Della Francesca, intéressante par son décolletage encore à chaînettes d'argent, qui est indécent et donne l'impression d'une robe qui va tomber; intéressante enfin par le blanc de perle qui bleuit sur l'épiderme, cadavérique et clownesque à la fois. Et la faute de dessin que tout le monde a vue dans les bras n'y est pas: c'est le bleuissement du blanc de perle qui fausse le raccourci à l'oeil. L'auteur du *Jaleo*, des petites filles si aristocratiques dans une antichambre, se continue dignement par cet envoi de la plus grande originalité.

Joséphin Peladan, "Salon de 1884," *L'Artiste* 54, pt. 1 (June 1884): 441.

Surely, no picture in the whole Salon can come more aptly under the head of "eccentric" than the American Sargent's portrait of Madame Gautherau. It is depressing to look at this picture and, remembering what this clever, although always sensationalist, pupil of Carolus Duran has done in the past, to realize how he abandons true art and runs after the strange gods of notoriety and coarse sensationalism. This portrait is simply offensive in its insolent ugliness and defiance of every rule of art. . . . The drawing is bad, the color atrocious, the artistic ideal low, the whole purpose of the picture being, not an artistic and sensational "tour de force" still within the limits of true art, as Sargent's Salon pictures have hitherto been, but a wilful exaggeration of every one of his vicious eccentricities, simply for the purpose of being talked about and provoking argument.

"Eccentricities of French Art," *Art Amateur* 11, no. 3 (August 1884): 52.

Mr. Sargent's portrait, on the other hand, was certainly a mistake. For a time it was a sensation, but its character was really too pronounced for enduring success of sensation even, and before long proved fatiguing. Mr. Sargent is absolutely and integrally an artist; and the reason of his failure this year is probably to be found in his fundamental incapacity for painting portraits *à la mode*. Despite their popularity his portraits all have the grand air, a distinction due to the way in which they are conceived, as well as to the manner of their presentation. . . . This year the painter's subject did not lend itself to considerations from the art point of view. A successful, or in current phrase a "professional," beauty, the lady herself was superficially a work of art, and for the proper, or at least the satisfactory and complimentary, treatment of the artificial surfaces she exposed, a method quite different from Mr. Sargent's naturalistic method was needed. . . . From any point of view the individuality of the sitter is quite lost, which is bad portraiture; the general aspect is displeasing, which is bad art; and the face is essentially and visibly unreal, which is bad naturalism.

W. C. Brownell, "The American Salon," *Magazine of Art* (London) 7 (1884): 493–494.

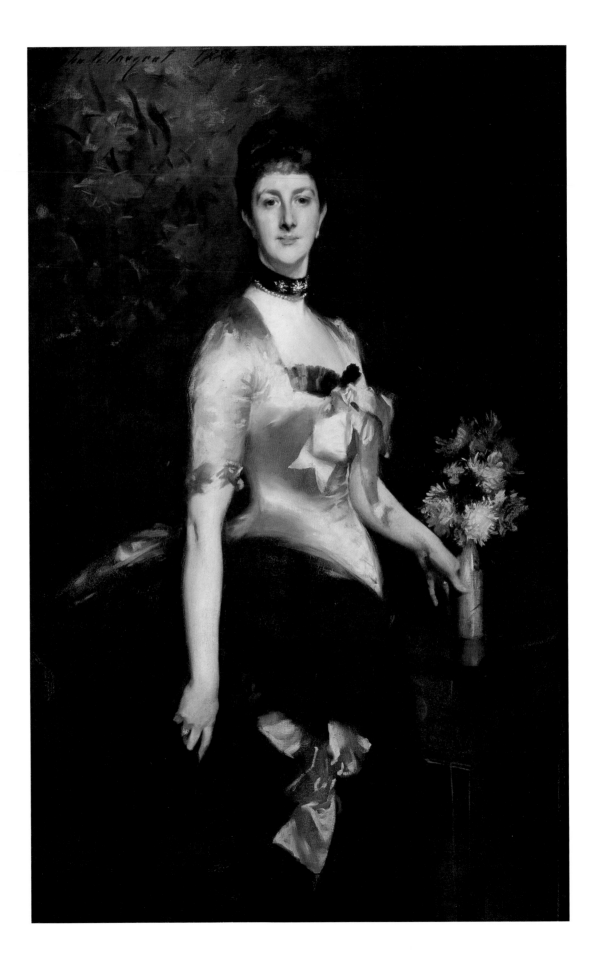

27. *Edith, Lady Playfair (Edith Russell)*, 1884

Oil on canvas, 59 x 38

Courtesy, Museum of Fine Arts, Boston

Bequest of Edith, Lady Playfair

London 1885 — Exhibition of the Royal Academy: The One Hundred and Seventeenth

Lady Playfair

586 (of 1160 paintings)

Mr. John Sargent's portrait of "Lady Playfair" (586), though clever, is conceived in the very worst spirit of contemporary French art. Its technical ability may be generally admitted, although the modelling of the arms is the reverse of graceful; but the failure of the attempt to portray a "grande dame" is painfully conspicuous.

 "The Royal Academy. Third Notice," *Illustrated London News* 86, no. 2405 (23 May 1885): 533.

[Sargent's *Lady Playfair* (586)] some portions of which are harsh, while the local colours of other parts are admirably disposed. The lady wears black lace over an orange satin bodice and skirt, while her carnations are harshly modelled, with crude greys and half tones, and the air of the figure is almost vulgar in its demonstrativeness. Beauty, choiceness, and delicacy of form, modelling, local colouring, light and shade, and even the character of the subject, have one and all been sacrificed to the attainment of a Velazquez-like, but very crude manner of colouring and painting. Mr. Sargent has left off exactly where the refining power of a genuine master would begin to display itself. His great tact, and natural, if only half-cultivated feeling for genuine but limited harmonies of tone and colour, are leading him astray to a lamentable extent, so that, instead of producing masterpieces, he but narrowly escapes perpetrating almost vulgar *tours de force*, where the very harmonies are almost garish. Nature has done much for Mr. Sargent, who is one of the few true followers of Mr. Whistler, but he has wasted not a little of her gifts.

 "Fine Arts: The Royal Academy," *Athenaeum* 3009 (27 June 1885): 828.

Mr. John Sargent's portrait of Lady Playfair (586) is decidedly *tapageur*, and neither graceful nor dignified.

 "The Royal Academy," *Art Journal* (London) 47, no. 6 (June 1885): 190.

I wish that a good word could be said for our gifted countryman, J. S. Sargent. His portraits in the Paris Salon showed such a falling off — especially in the bad drawing of the hands of his sitters — that I sought out with more than common interest his work in the Royal Academy. It is no less mannered and uninteresting. His "Lady Playfair" is as unsympathetically posed and as streakily painted as his "Mme. V." at the Salon.

 Montezuma [Montague Marks], "My Note Book," *Art Amateur* 13, no. 3 (August 1885): 44.

Mr. Sargent's brilliant "Lady Playfair" — so vivacious in pose, so charming in expression, so frankly realistic in intention, so sparkling and delightful in effect, in colour broad yet subtle, in handling masterly through every touch.

 W. E. H., "Current Art. — I," *Magazine of Art* (London) 8 (1885): 347.

Two of Mr. Sargent's recent productions have been portraits of American ladies whom it must have been a delight to paint; I allude to those of Lady Playfair and Mrs. Henry White, both of which were seen in the Royal Academy of 1885 [*Mrs. Henry White* was in the Royal Academy exhibition of 1884], and the former subsequently in Boston, where it abides. These things possess, largely, the quality which makes Mr. Sargent so happy as a painter of women — a quality which can best be expressed by a reference to what it is not, to the curiously literal, prosaic, Philistine treatment to which, in the commonplace work that looks down at us from the walls of almost all exhibitions, delicate feminine elements have evidently so often been sacrificed. Mr. Sargent handles these elements with a special feeling for them, and they borrow something of nobleness from his brush. This nobleness is not absent from the two portraits I just mentioned, that of Lady Playfair and that of Mrs. Henry White; it looks out at us from the erect head and frank animation of the one, and the silvery sheen and shimmer of white satin and white lace which form the setting of the slim tallness of the other.

 Henry James, "John S. Sargent," *Harper's New Monthly Magazine* 75, no. 449 (October 1887): 691.

Boston 1885 — Williams & Everett Gallery

Portrait

As for Sargent's portrait, so much has already been said that further notice is perhaps not desirable, but it should be remembered by those who are carried away by its sheer force and dashing bravado that men can be *taught* to do this sort of thing, that all this fascinating and masterly vigor is the result of education, and that a man might learn (given sufficient earnestness and power of application) to do all these things, who would make quite as good a lawyer or banker, but that a man must be born a Tintoretto or a Turner, or even a Velasquez or a Rembrandt. There are qualities in this picture of Sargent's which would do credit to Rubens or Velasquez, but with those men this bold, fiery dash and breadth was the result of ungovernable impulse. Moreover, it may be questioned whether Velasquez, the first of the portrait painters, would have painted a portrait wherein the head was not only unpleasant and calumniating, but even entirely secondary and as an adjunct; quite falling into insignificance beside a triumphantly painted yellow satin bodice, the chief value of which is that it is nearly as good a piece of copyism as the drop curtain in one of the Boston theatres.

 "Art Notes," *Boston Evening Transcript*, 25 September 1885, 4.

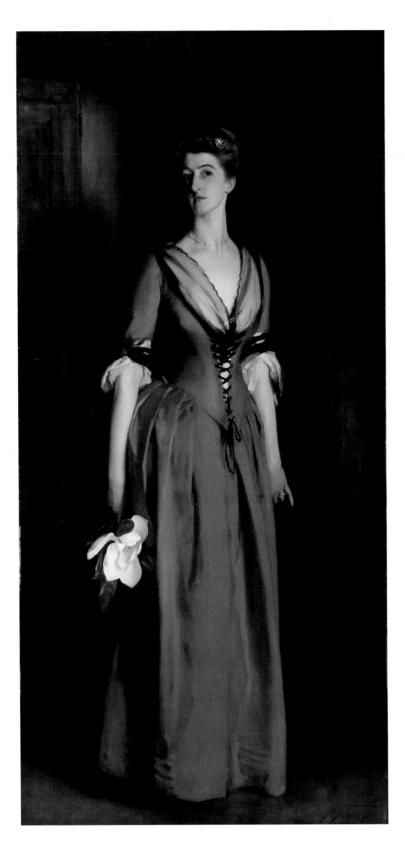

28. *Mrs. Albert Vickers*, 1884

Oil on canvas, 82 3/4 x 39 13/16

Virginia Museum of Fine Arts, Richmond

The Adolph D. and Wilkins C. Williams Fund

Paris 1885 — Salon de 1885

Portrait de Mme V . . .

2191 (of 2488 paintings)

Mr. Sargent is a pseudo-Velazquez whose sense of tone is exquisite, but not chastened by fine taste, whose perception of character is searching and faithful to nature, but almost devoid of the love for grace and natural dignity which enabled the great Spaniard to be always gentlemanlike. These defects of culture, grace, and dignity are obvious in the *Portrait de Madame V* — (2191), the otherwise fine picture of a gaunt and pallid lady, in a cool grey silk dress trimmed with black, placed against a brown ground. We see at once that the crudity of the carnations and the harsh definition of the local tints, tone, and shadows are due to the painter, not to the model. Improved in these respects, the picture would be delightful.

> "The Salon, Paris," *Athenaeum* 3005 (30 May 1885): 702.

M. John Sargent reste un singulier, bizarre et puissant tempérament. La Jeune Femme en gris, émaciée, alanguie, fantômateuse qu'il piète devant une armoire, tenant dans ses doigts allongés une blanche fleur de magnolia, a tout le caractère irréel et mystique des héroïnes de son compatriote Edgard Poë. N'est-ce point là la Ligeïa ou la Morella des *Contes extraordinaires?*

> Charles Ponsonailhe, "Salon de 1885: La Peinture (Suite): III," *L'Artiste* 55, pt. 1 (June 1885): 452.

[Sargent] est fort émancipé, il n'est pas orthodoxe, on le discute, et tous les jours il y a des querelles sous son balcon. Reconnaissons-le, d'ailleurs, M. Sargent a des grâces aventureuses et des séductions imprudentes. Il enlève sa peinture rapidement, dans une vue d'ensemble qui cherche la silhouette générale et indique à grands traits l'essentiel. Le portrait de Mme G . . . , exposé l'année dernière, fit le bonheur des ironiques. . . . Il y a encore des bizarreries, ou du moins de l'imprévu dans le portrait de Mme V . . . , debout et tenant à la main une fleur de magnolia.

> Paul Mantz, "Le Salon: V," *Le Temps,* 7 June 1885, 1.

Mr. Sargent is growing more and more eccentric and his painting more and more unpleasing. His portrait of Mme. V. represents a very thin, bony and hatchet-faced lady, standing bolt upright and looking very irritable. She wears an elephant-gray dress, the folds of which look as stiff as if they were made of tin; in her right hand she holds a magnolia; behind her is a background of dark-brown woodwork. The portrait is as hard and unsympathetic as it can be.

> T. C. [Theodore Child], "The Paris Salon," *Art Amateur* 13, no. 2 (July 1885): 24.

Mr. Sargent is one of the young and successful Americans whose work holds its own technically with the best work in Paris, and who is rapidly making a name elsewhere. . . . His other contribution, the "Portrait de Mme. V.," reminds one of his work last year in the Academy and Grosvenor. It is brushed with the same bold and summary manner, and has a similar somewhat slatey tone and key of colour. Mr. Sargent, like Mr. Whistler, is very skillfull in his treatment of those parts of the picture which he does not wish to make important; which are to play only a decorative part, to guide the eye elsewhere, and to support or increase the effect of the rest. His manner is somewhat different: Mr. Whistler swamps and omits; Mr. Sargent converts and utilizes. But

both possess this important and esoteric branch of art; and both must in consequence expect to be called sketchy by the ignorant.

R. A. M. Stevenson, "The American Salon," *Magazine of Art* (London) 8 (1885): 514.

Les oeuvres de M. Sargent sont facilement reconnaissables entre toutes; elles ont un cachet si distingué et si particulier qu'on ne peut, même de prime abord, les attribuer à d'autres. Cela tient à sa virtuosité et à sa virtualité qui résident surtout dans l'éclat et la délicatesse du pinceau, dans un modelé savant et sincère, dans une manière personnelle de grouper les figures, de varier les attitudes, de les imprégner de grâce, et enfin de les ennoblir par un rayon d'idéal, bien permis. . . . M. Sargent traite ses portraits en action à l'instar de l'école flamande, et, sans s'écarter de la réalité vivante, poétise la femme, dont il traduit merveilleusement la simplicité élégante, la suavité morale et extérieure, la langueur mystérieuse, les blancheurs et les fraîcheurs printanières. Son *Portrait de Madame V . . .*, tenant à la main une fleur de magnolia et en robe grise unie, est d'une exécution savante et d'une ressemblance parfaite quoique un peu raide d'allure, ce qui était probablement imposé par le scrupule de la similitude physique.

J. Noulens, *Artistes français et étrangers au Salon de 1885* (Paris: E. Dentu, 1885), 163–165.

London 1886 — Exhibition of the Royal Academy: The One Hundred and Eighteenth

Mrs. Vickers

195 (of 1111 paintings)

The discouraging state of things revealed by a consideration of the year's art is the cause that we hail with satisfaction the work of the very few among the younger painters whose productions bear evidence that they have chosen to see with their own eyes, to obey the promptings of their own personality, instead of appropriating ready-made the spectacles of others, to however high a pitch of perfection these may have been brought. It is for these reasons that the work of such a painter as Mr. J. S. Sargent commands respect, though we may be somewhat repelled by his persistent search rather for what is peculiar and personal than for what is beautiful in nature, by his desire, at the expense of all other qualities, to express in portraiture what he deems the essence of a physical personality, rather than to suggest the higher mental characteristics of the humanity he seeks to reproduce. Yet, though he has, in company with most of the younger generation, been strongly influenced by the art of Velasquez and of kindred masters, he has something new to say, and says it, if with a certain eccentricity, yet with fearless sincerity, thus standing out from the crowd, whatever may be our opinion as to the absolute value of his art, or the healthiness of its direction.

Claude Phillips, "The Royal Academy. I," *Academy* 29, no. 731 (8 May 1886): 333.

The three portraits by Mr. J. S. Sargent are among the most hotly discussed, the most variously appreciated of the year: they may be attacked, contemned, misunderstood, but it is impossible to pass them over. Their remarkable force and directness, deliberately obtained with the aid of notable suppressions and sacrifices, imperatively forbids this. . . . "Mrs. Vickers" (195) has for its subject a lady dressed in grey, who stands facing the spectator, holding, drooping from one hand, a magnolia blossom, her erect form being relieved against a background of dull-toned wainscoting. The prominence given to what almost amounts to a physical defect of the model — the abnormal length of the lady's neck — seems to us, from any point of view, an unnecessary eccentricity, seeing that the accentuation of this peculiarity is not indispensible in furtherance of the painter's chief aim — that of emphasising the distinctive personality of his subject. The picture has, in other respects, much merit, and notably a

Gainsborough-like life and suppressed vivacity which are qualities as precious as they are rare.

Claude Phillips, "The Royal Academy. II," *Academy* 29, no. 732 (15 May 1886): 352.

Mr. J. S. Sargent's portrait of "Mrs. Vickers" (195), where we have an example — and a good one — of the Franco-American school at its best.

"The Royal Academy. Third Notice," *Illustrated London News* 88, no. 2456 (15 May 1886): 508.

His full-length of "Mrs. Vickers" in the third gallery is a very much better work [than the *Misses Vickers*], more restrained in style, and in better keeping. The head is distinctly individual and full of vivacity, the pose of the figure spontaneous, and at the same time graceful.

"The Royal Academy: III," *Graphic* (London) (22 May 1886): 554.

Among the portraits in the Academy next in interest to this by M. Duran come several of John S. Sargent, his most distinguished pupil, who in style is more subdued and more refined than his master, without being less picturesque. It is this style, distinctively his own, which always makes his canvases interesting. His coloration is seldom satisfactory, being, as a rule, either violently keyed as in the picture of "Mrs. Harrison" . . . or disagreeably slaty as in that of "Mrs. Vickers." Not infrequently his drawing is faulty, and his mannerisms are so pronounced as to be aggressive. In technique, while resembling his master in simplicity and strength, his resources are more restricted. His flesh suggests imperfect circulation, either by its leaden hue telling of total absense of blood, or its high color in certain features suggestive of dyspepsia. . . . But if, as has been intimated, the technique of this artist is limited, it cannot be denied that the resources he possesses he employs with surprising mastery. As a single instance may be mentioned the deft, but simple treatment of the arm in the portrait of "Mrs. Vickers," as it hangs against her side and receives the reflected shadows from the dress. It is to be hoped that this picture, as well as the two others by Mr. Sargent in the Academy, will be seen in America before too long.

Montezuma [Montague Marks], "My Note Book," *Art Amateur* 15, no. 2 (July 1886): 24.

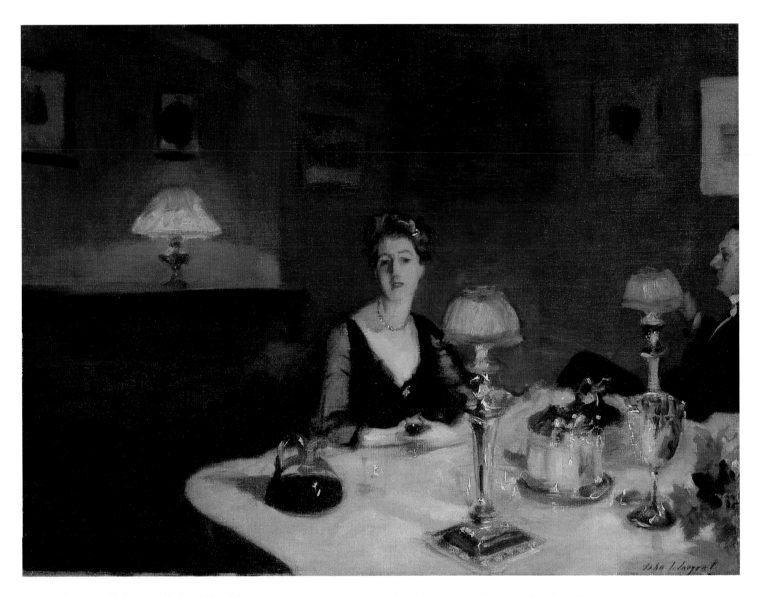

29. A Dinner Table at Night (The Glass of Claret), 1884

Oil on canvas, 20 1/4 x 26 1/4

Fine Arts Museums of San Francisco

Gift of the Atholl McBean Foundation

Paris 1885 — Exposition internationale de peinture

Le verre de Porto (Esquisse)

99 (of 114 works)

Plus habile encore, et c'est difficile, nous apparaît M. Sargent. . . . quelle mer-
veilleuse esquisse il expose sous ce titre: le *Verre de porto!* Une salle à manger
rouge, éclairée de lampes à abat-jour de même couleur; une table servie et
deux convives. C'est le dernier mot de la peinture enlevée et cependant défini-
tive: quand on se met au point de vue, l'illusion est complète.

> Alfred de Lostalot, "Exposition Internationale de peinture (Galerie
> Georges Petit)," *Gazette des beaux-arts* 31, no. 6 (June 1885): 531.

?London 1886 — New English Art Club

A Study

37 (of 58 works)

Mr. Sargent sends a small Impressionist "Study" and a "Portrait of Mrs.
Barnard."

> "The Marlborough Gallery," *Times* (London), 12 April 1886, 4.

For qualities of brilliancy, verve of execution, subtlety of colour, and large
truth of aspect, we prefer others; as, for instance, Mr. Sargent's lamplight
"Study" (37).

> "Minor Exhibitions," *Saturday Review* 61, no. 1590 (17 April 1886): 541.

Mr. Sargent [is represented] by an admirable "Study" in his wittiest vein of
painting and observation.

> "The Chronicle of Art: Art in May," *Magazine of Art* (London) 9 (May
> 1886): xxx.

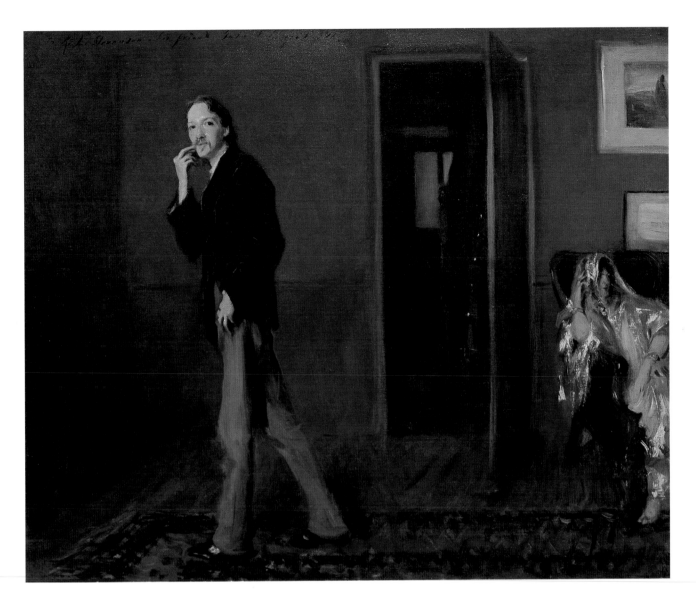

30. *Mr. and Mrs. Robert Louis Stevenson*, 1885

Oil on canvas, 20 1/2 x 24 1/2

Collection of Mrs. John Hay Whitney

London 1887 — New English Art Club

Portrait of Robert Louis Stevenson and Mrs. Stevenson. A Sketch
84

Mr. Sargent's . . . domestic episode described as portraits of Mr. R. L. Stevenson and his wife suggests that the former was stealthily quitting the room, leaving his companion to settle with the waiter.
 "Art Exhibitions," *Illustrated London News* 90, no. 2503 (9 April 1887): 406.

Mr. Sargent sends . . . a sketch, "R. L. Stevenson and Mrs. Stevenson" (84). For the sake of those who may not understand the meaning of "a sketch," we may point to the walking figure which it would have been impossible to render so instinct with life and gesture by closer and more explicit workmanship.
 "Picture Galleries," *Saturday Review* 63, no. 1641 (9 April 1887): 515.

A portrait of Mr. R. L. Stevenson and his wife, by the same painter, is humorous and interesting: one cannot help wondering what the author of *Kidnapped* is chuckling over.
 G. B. S. [George Bernard Shaw], "Picture Shows," *The World: A Journal for Men and Women*, no. 667 (13 April 1887): 20.

Almost grotesque as portraiture, his sketch of Mr. and Mrs. R. L. Stevenson is a piece of sparkling and well-manipulated colour.
 "Spring Exhibitions," *Art Journal* (London) 49, no. 5 (May 1887): 159.

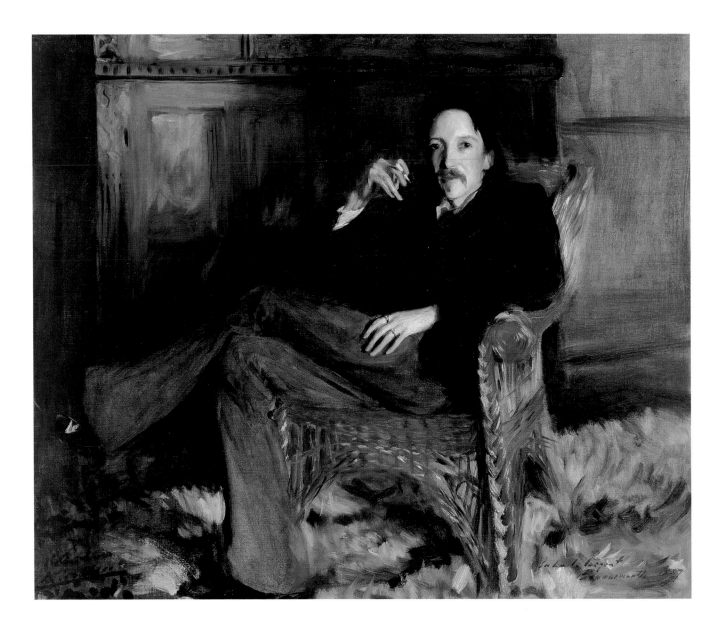

31. *Robert Louis Stevenson*, 1887

Oil on canvas, 20 1/16 x 24 5/16

The Taft Museum, Cincinnati, Ohio

Bequest of Charles Phelps and Anna Sinton Taft

Boston 1887 — St. Botolph Club — Loan Exhibition 1887

Portrait R. L. Stevenson

21 (of 58 paintings)

[The exhibition inaugurating the new clubhouse] comprised many precious and costly French, Spanish, and Italian paintings, together with a couple of new portraits by Sargent, one of which was an odd sketch of Robert Louis Stevenson, full of character and truth, say those who know him. It represented him sitting in a low wicker chair, with his long legs and his long fingers waving in the air, so to speak, and a quizzical smile on his speaking face, as though he enjoyed the artist's prank to the full. Fortunate is the possessor — a Boston banker — of this intimate memorial of a delightful acquaintanceship.

Greta, "Art in Boston," *Art Amateur* 18, no. 1 (December 1887): 3–4.

Nobody who saw his odd sketch of Mr. Robert Louis Stevenson, for example, with its eager glance and the quizzical smile just breaking on its thin lips, the long, thin, nervous fingers rolling a cigar and the still longer and thinner crossed legs, with one long foot tossing in the air, but must feel that he knows just how this new "wizard of the north" can run on and on in a stream of flashing and fertile talk.

Greta, "The Art Season in Boston," *Art Amateur* 19, no. 1 (June 1888): 5.

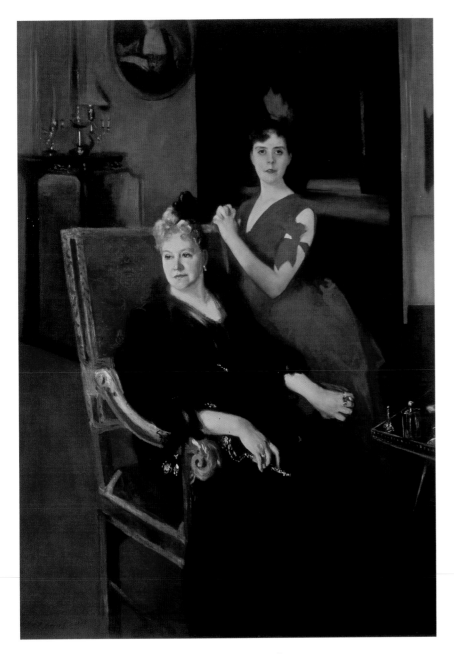

32. *Mrs. Edward Burckhardt and Her Daughter Louise*, 1885

Oil on canvas, 79 1/4 x 56 1/2

Private collection

Paris 1886 — Salon de 1886

Portraits de Mme et de Mlle B . . .

2128 (of 2488 paintings)

This picture is an attractive and yet a disagreeable exercise in such red and black as the attire of an elderly lady and her daughter affords. Mr. Sargent has painted the young lady before, and much better. The rawness of the flesh and the atrocious drawing of the features are characteristic of the artist. His forte is in tone; his colouring is original and vigorous, but not always agreeable — indeed at first sight it is almost invariably disagreeable, but a little study works wonders in our opinions on this matter. The shortcomings of this picture are due to the weakness or absence of half-tints and half-tones, to the lack of har-monizing elements of more than one kind, to the crude handling of the flesh, the ugliness of the faces, and the ungraceful attitudes of the figures. The senseless stare of the young lady is, we think, unique in portraiture, although something of the kind has been recognized in the subject-pictures of the ear-lier Impressionists, whose vagaries are not good examples for their follower.

"The Salon, Paris. (First Notice)," *Athenaeum* 3055 (15 May 1886): 653.

M. John Sargent, qui, en groupant dans le même cadre les portraits d'une dame et d'une jeune fille, a fait un véritable tableau très distingué par les types, très vivants par la couleur.

Paul Mantz, "Le Salon: IV," *Le Temps*, 30 May 1886, 2.

Mr. Sargent is a most gifted and skillfull painter; . . . his portrait group in the Paris Salon is equal in skill to any of the French work of the year — most deli-cate, simple and masterly painting.

Theodore Child, "Pictures in London and Paris," *Fortnightly Review* n.s. 39, no. 234 (1 June 1886): 794.

L'habileté prodigieuse de M. Sargent étonne moins qu'autrefois; il y a maintenant trop de prestidigateurs au Salon; nous commençons à être un peu las de leurs exercices. Fort heureusement, M. Sargent ne se contente pas d'être un habile homme; c'est un chercheur d'attitudes, un metteur en scène ennemi de la routine. Il aime les élégances rares, avec une nuance légère d'étrangeté; aussi ne va-t-il pas chercher ses modèles dans la petite bourgeoisie. Les *Portraits de Mme et de Mlle B . . .*, deux belles dames dans un seul cadre, produisent sur le public l'effet habituel; il s'en dégage une sorte de parfum exotique qui grise les passants. Certains pourtant s'éloignent en disant que c'est de la peinture malsaine, et vont en grande hâte respirer un peu d'air pur devant les toiles de M. Bouguereau.

Alfred de Lostalot, "Salon de 1886 (Premier article) La Peinture," *Gazette des beaux-arts* 33, no. 6 (June 1886): 460.

[Sargent] expose cette année deux portraits grandeur nature dans le même cadre, *Mme et Mlle B . . .* Bien que par sa naissance et son tempérament M. Sargent soit essentiellement l'homme de demain et de tous les progrès, il me permettra de lui dire qu'il a été, dans ce portrait de mère et fille, très vieux-jeu tant par la composition que par l'idée. Ce groupement faisait la joie au grand siècle de Sébastien Bourdon, de Mignard, de Le Brun, d'Hyacinthe Rigaud. . . . Il est vrai que M. Sargent rajeunit son tableau par l'exécution. Je goûte fort la libre facture sans repentirs ni retouches, simple, forte, juste de la femme âgée, assis en un grand fauteuil. J'admire la perspective des pièces fuyant derrière les personnages; leur tonalité rouge est bien observée, mais je fais mes réserves vis-à-vis de la jeune miss. Il y a ici l'abus des tons plats. . . . La tête ne me console pas. Etre aussi maigre est une infirmité et le peintre a tort de souligner les tons de cire du visage par ces lèvres saignantes qui rappellent le débridement d'une plaie, étant donné leur contraste brutal avec la blancheur des dents.

Tout cela n'empêche pas M. John Sargent d'être un artiste très original, très individuel et très doué. Ce sont ses audaces qui le perdent en l'entraînant trop loin.

Charles Ponsonailhe, "Salon de 1886: La Peinture," *L'Artiste* 56, pt. 1 (June 1886): 427.

Among the portraits, I should without hesitation give the highest place to John Sargent's picture of "Mrs. and Miss Burckhardt," which, in my opinion, is one of the most striking works in the present Salon. The ladies are represented in their home. . . . In the left-hand corner of the room are a screen, a silver candelabrum and the gray wall; at the back is an open doorway through which we see, in violently ascending perspective, a suite of saloons into which the sun strikes in broad rays from side windows which we do not see, making an alternation of deep shadows and luminous patches. All these saloons are carpeted with red, so that this portrait-picture may be regarded as an arrangement in red, black and gray. The plan of the picture, its elevation and perspective are uncommon, and remind one somewhat of the compositions of the Japanese draughtsmen, and yet it is not voluntarily or affectedly strange. The picture has an aspect of that rareness and distinction which are the characteristics of aristocracy; it is essentially "distingué," calm, dignified.

Theodore Child, "The Paris Salon," *Art Amateur* 15, no. 1 (June 1886): 3–4.

Mr. John S. Sargent . . . among other talents, has of late developed that of putting me into a bad temper. To remember his "Danse de Gitanes: El Jaleo" (1882), dashed off with a gallantry and a maëstria that would have set Goya beside himself with joy, and his portrait of a girl in black, that Watteau himself would have praised, and to see him hurling himself down headlong into mere sloppiness and commonplace, and strangling so many first-rate qualities,

as he does in his flabby "Portraits de Mme. et de Mlle. B.," is perfectly heartbreaking; and I have no words strong enough to reprove the artist who thus compromises one of the most brilliant careers that ever opened to a painter.

Paul Leroi [Léon Gauchez], "The American Salon," *Magazine of Art* (London) 9 (1886): 490.

Les deux grands peintres américains sont aujourd'hui MM. Whistler et Sargent. Whistler, un ancien toujours jeune, et Sargent, un jeune qui sait son métier comme un vieux. — Ils ont tous deux le secret de l'harmonie et l'audace des trouvailles, — tous deux une aptitude particulière à résumer, savamment et originalement, les caractères dramatiques ou familiers des êtres et des objets, at à faire saillir d'une forme jusque-là non aperçue, des signes d'élégance, de distinction ou de sévérité. . . .

Cette année, M. Sargent nous a montré une mère et sa fille dans leur milieu familial; la mère occupe, au premier plan, un fauteuil; la jeune fille se tient derrière, les mains appuyées sur le dossier. Je ne parlerai pas des objets inanimés que Sargent rend vivants et significatifs; depuis longtemps il est passé maître en cet art; lui seul, jusqu'ici, a su donner de la poésie à un piano! Je m'attacherai aux expressions des têtes; expressions caractéristiques au suprême degré de la société actuelle.

La mère est une femme âgée, bien conservée, portant sur son visage le souvenir de longs jours passés dans le luxe aimable. Elle a le grand air, seconde nature des personnes élevées dans la discipline mondaine. Le peintre en a trouvé la formule sans rien emprunter aux noblesses de convention qui sont la joie des maquignons et des singes de l'art.

Les yeux sont vivants et personnels. Ils veulent rester, malgré la venue des ans, l'ornement intelligent d'un visage qui fut, sans doute, fort agréable, et garde à l'heure actuelle un air de bonté et de savante coquetterie.

La jeune fille a déjà été peinte par Sargent; de face, en pied et tenant une rose de la main gauche. Elle était de trois ou quatre ans plus jeune. Elle avait le visage plus rond et les traits, dont le charme est si pénétrant, n'existaient alors qu'à l'état d'ébauche; elle était représentée dans une pose d'affabilité gracieuse allant bien à sa nature de toute jeune fille. Aujourd'hui c'est presque la femme; elle se tient droite, sérieuse, énigmatique derrière sa mère. Elle va la remplacer dans sa vie de femme du monde; elle va continuer son influence et soutenir à son tour la réputation d'esprit et de beauté de la maison. Cette beauté, elle la porte plus aristocratique peut-être, plus altière et comme affinée, une fois encore, par le luxe croissant ou la vie plus délicatement intellectuelle d'une génération nouvelle. La bouche est typique de distinction. Qu'on me pardonne d'appuyer ainsi, mais je tiens à mettre en lumière le côté considérablement intelligent de cette oeuvre, avant d'en marquer en quelques mots le charme pictural.

Cette intelligence prodiguée, par tempérament et amour de son art, règne en souveraine dans les oeuvres du peintre qui nous occupe; la disposition supérieure de son esprit lui permet d'allier la légéreté de la facture à la profondeur du sentiment; alliance excessivement rare chez les peintres de notre époque.

Un tableau de Sargent est fait de justesse et de décision, de sobriété et de recherche; la couleur en est calme et puissante, toujours très harmonieuse, sans aucune défaillance.

Regrettons, nous autres Français, que le public parisien ne saisisse pas la portée de ce talent, qui répond cependant si bien à nos qualités de race, et lui préfère, dans son élégante ignorance, les écoeurantes poncivités, fruits gâtés de la mode.

Paul Labrosse, "Notes sur l'art, II: Les Peintres américains au Salon de 1886," *Revue illustrée* 2, no. 18 (1 September 1886): 611–612, 614.

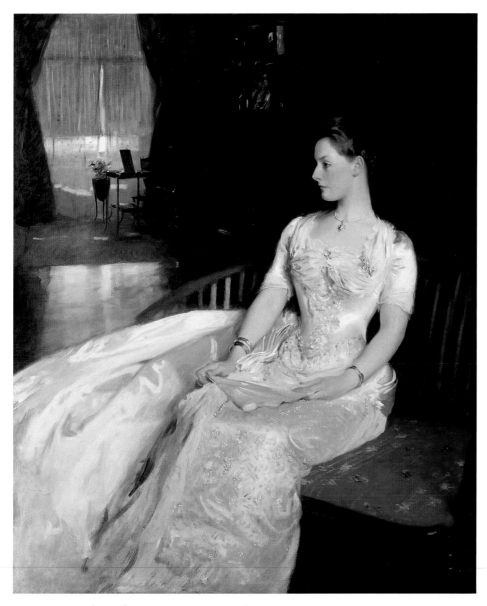

33. *Mrs. Cecil Wade (Frances Frew Wade)*, 1886

Oil on canvas, 66 x 54 1/4

The Nelson-Atkins Museum of Art, Kansas City, Missouri

Gift of the Enid and Crosby Kemper Foundation

London 1887 — New English Art Club

Portrait of a Lady

55

Mr. Sargent's "Portrait of a Lady" (55) in white satin suggests that her arms and face were made of cardboard.

> "Art Exhibitions," *Illustrated London News* 90, no. 2503 (9 April 1887): 406.

Mr. Sargent sends a brilliant and admirably handled likeness of a lady in white (55) against a charmingly painted interior.

> "Picture Galleries," *Saturday Review* 63, no. 1641 (9 April 1887): 515.

The trick of drawing and colouring badly as if you did it on purpose is easily acquired; and the market will be swamped with "new English art," and the public tired of it, in a year or two. Then there will be vain lamenting over lost ground to recover, bad habits to correct, and association of names and un-saleability to be lived down. The "new" fashion may be capital fun for Mr. Whistler, Mr. Sargent, and a few others who can swim on any tide; but for feebler folk it means at best a short life and a merry one.

. . . [J. J. Shannon's portrait of Mrs. Mark Lockwood] is clever; but cleverness is a drug, and rather a nauseating one, at the Dudley Gallery now. In a similar work by Mr. Sargent, the distant sunlit side of the room is capital; but the young lady's expression is pasty.

> G. B. S. [George Bernard Shaw], "Picture Shows," *The World: A Journal for Men and Women*, no. 667 (13 April 1887): 20.

Mr. J. S. Sargent's "Portrait of a Lady" should be seen from a distance; the painting is of a most dashing sort, and the wonderful rendering of the dress and background cannot fail to evoke admiration.

> "Spring Exhibitions," *Art Journal* (London) 49, no. 5 (May 1887): 159.

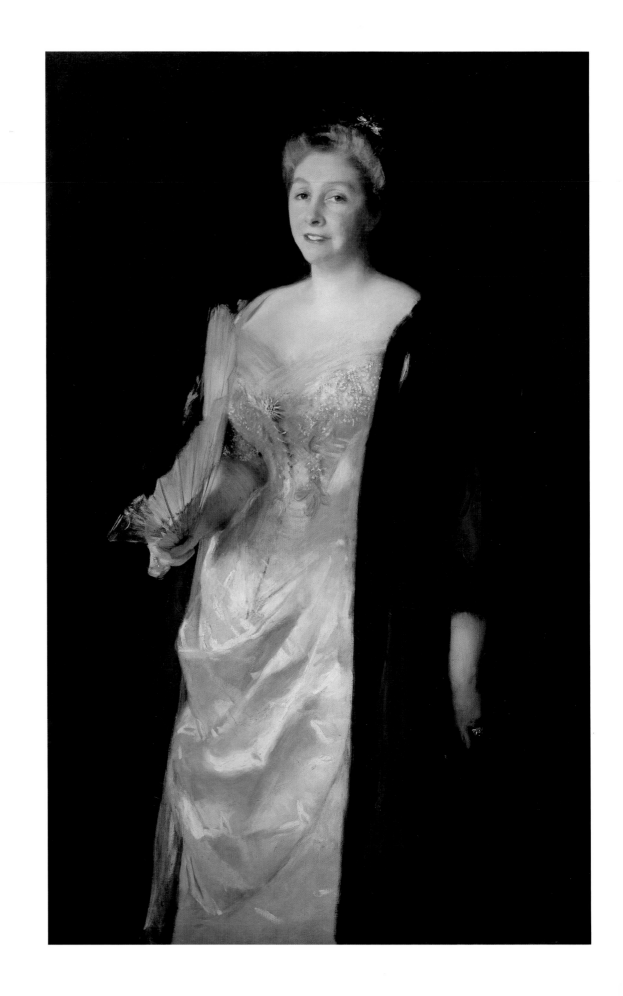

34. *Mrs. William Playfair*, 1887

Oil on canvas, 60 1/2 x 39

Collection of Mr. and Mrs. Harry Spiro

London 1887 — Exhibition of the Royal Academy: The One Hundred and Nineteenth

Mrs. William Playfair

197 (of 1052 paintings)

[A] long and close investigation reveals a more steadily growing charm in other work — especially in Mr. Sargent's "Mrs. W. Playfair" In Mr. Sargent's portrait every touch is the direct outcome of feeling; it assists in explaining some nicety of plane and texture. All distinctions of the kind are revealed as if by real light, and without any resort to false, trickily-effective reliefs, or a mannered system of colouring.

> "The Royal Academy. II," *Saturday Review* 63, no. 1646 (14 May 1887): 685.

Mr. J. S. Sargent's "Mrs William Playfair" (197) — a portrait belonging, like all the artist's works, to the school which acknowledges Velasquez as its head, and seeks above all the strong suggestion of physical, as distinguished from mental, vitality, and of an individuality deriving its characteristics as much from the idiosyncrasy of the painter as from the distinguishing peculiarities of the person presented — has certainly in its own style no superior, if, indeed, it has any equal, in the exhibition. The lighting of the vivacious head and of the massive proportions of the figure is consummate; the blood seems to circulate in the veins, and the lips to give forth breath, while a dextrous management of chiaroscuro successfully conquers certain difficulties created by the nature of the task attempted. There is, perhaps, in the complacency of the smile just the slightest approach to conventionality — a quality very unusual with the painter — though this ingredient is not present in a degree sufficient to mar the truth of the delineation. The colour, as might be expected, is forceful and original rather than of subtle transparency or harmony, the peculiar juxtaposition of the dark green mantle, which half covers the yellow-white satin of the lady's dress, with the wine-coloured background being something of a novelty.

> Claude Phillips, "Fine Art. The Royal Academy. III," *Academy* 31, no. 786 (28 May 1887): 383.

Before turning to landscape it would be well to say a few words more about the portraits. Our conviction that Mr. Sargent's "Mrs. William Playfair" is the finest piece of painting in the Academy becomes strengthened every time we see it. When we compare it with some good and serious work hard by we become more than ever conscious of its quiet power of fascination. The subtle manner in which the modelling reveals everything, the admirable relation of the figure to the background, the finesse and brilliancy of the flesh, and the true colouring in the shadows, are not approached even by the one or two excellent portraits we have already named in connexion with it.

> "The Royal Academy. IV," *Saturday Review* 63, no. 1649 (4 June 1887): 800.

A picture of the season is Mr. J. S. Sargent's *Mrs. W. Playfair* (197), a life-size, three-quarters-length figure, in three-quarters view, dressed in white satin, which has a silvery charm not improved by the green cloak, otherwise fine and good, that accompanies it. The brilliancy of these elements is supported by the brightness, clearness, and harmony of the flesh. This picture is more solid and finer in taste than usual with this able pupil of M. Carolus-Duran, a master who, in his turn, has not disdained to learn of his junior. It is to be hoped that Mr. Sargent may take Mrs. Playfair's portrait as his standard piece, and never paint with less taste, culture, and freedom from whim and self-assertion. It shows technical qualities which, so far as they go, are superior to those of the much discussed "Carnation, Lily, Lily, Rose," No. 359, which we have already criticized as a technical experiment of more audacity than good fortune.

> "Fine Arts: The Royal Academy. (Fourth Notice.)," *Athenaeum* 3111 (11 June 1887): 772.

Plus complète encore est la valeur du portrait de *Mrs William Playfair*, montrant sur un fond lie de vin une dame de proportions majestueuses, vêtue de satin d'un blanc jaunâtre, et drapée dans un manteau de velours vert-bouteille bordé de fourrures noires. Le peintre a su donner à son modèle une intensité de vie physique, un charme même — né de franchise et de bonne humeur — qui en font une de ses oeuvres les plus vraies et les plus entièrement satisfaisantes. La virtuosité de l'artiste s'affirme dans la remarquable adresse avec laquelle la tête et les formes sont éclairées, par la façon ingénieuse avec laquelle le clair-obscur intervient, pour vaincre certains difficultés inhérentes au sujet, et, à un degré moindre, dans le coloris, plutôt nouveau et piquant que véritablement transparent et harmonieux.

> Claude Phillips, "Correspondance d'Angleterre: Expositions d'Eté de la Royal Academy et de la Grosvenor Gallery," *Gazette des beaux-arts* 36, no. 1 (July 1887): 85.

Next to it hangs what some enthusiasts declare to be the best female portrait of the year, No. 197, "Mrs. William Playfair," while others almost as strenuously deny that it has any merit at all. What with this picture, and his other [*Carnation, Lily, Lily, Rose*] . . . Mr. Sargent is certainly the most discussed artist of the year.

> "The Royal Academy Exhibition," *Art Journal* (London) 49, no. 7 (July 1887): 247.

Mr. Sargent contributes also one of the most effective portraits in the Royal Academy, that of the wife of Dr. Playfair, an imposing-looking lady in an evening dress of cream satin, trimmed with pearls, with a dark green opera-cloak thrown over her shoulders — all set off strikingly against a dark red background.

> James S. Harding, "The Royal Academy Exhibition," *Art Amateur* 17, no. 2 (July 1887): 30.

When we come to "Mrs. Playfair" we come, in my opinion, to the best of Mr. Sargent's portraits. Anything more subtle and more true than the play of light over the surfaces of the flesh and dress it would be difficult to conceive. The nervous force of the hand half hidden, the aptness of folds and detail, and the soft shimmer of silks and satins, were but superficial beauties in a piece of finished modelling that might be studied from end to end without fear of finding a single instance of hardness, arbitrary colouring, or meaningless smoothness. Nothing eccentric in the handling shocked one's belief in the genuineness of the inspiration; nothing over-systematic froze one's delight in its spontaneity, appropriateness, and infinite variety. When this picture obtains the mellowing skin of age it will come as near to a Velasquez in the quality of its technique as the work of any man living. A portrait of this sort lays itself open to very little adverse criticism, even from those who do not sympathise with the painter's style. It is too complete in all the qualities which underlie painting — in drawing, modelling, composition, aerial truth of tone, decorative effect of colour, subordination of accessories, and the like. Its modest but unassailable attitude of strength does not quite belong to all the portraits which have come between it and the "Carolus Duran" or the "Young American Lady." The fact is that Mr. Sargent has not been standing still. He has made many a perilous excursion into new realms of difficulty, and it has sometimes cost him an effort to cover his retreat with honour. In "Mrs. Playfair" he shows that he has conquered the fresh country, and his sway over the broader empire of Art is now as easy and masterful as it was over the more confined. No one who looks at the pictures of the two epochs can fail to see in both the same finish, sureness, and complete realization of the intention, while some will doubtless recognise that the intention of the picture of last year is by far the nobler.

> R. A. M. Stevenson, "J. S. Sargent," *Art Journal* (London) 50 (March 1888): 69.

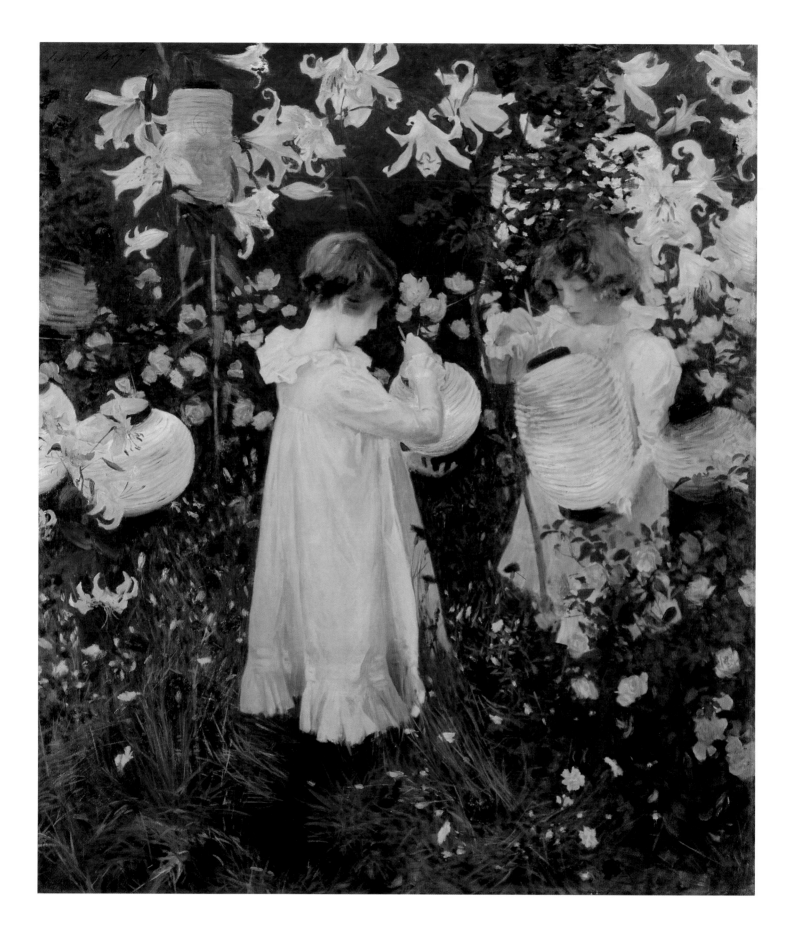

35. *Carnation, Lily, Lily, Rose*, 1887

Oil on canvas, 68 1/2 x 60 1/2

Tate Gallery, London

Presented by the Trustees of the Chantrey Bequest, 1887

London 1887 — Exhibition of the Royal Academy: The One Hundred and Nineteenth

"Carnation, lily, lily, rose"

359 (of 1052 paintings)

[John Everett Millais's *St. Bartholomew's Day*] is the great artistic failure of the year; the corresponding triumph is beyond doubt Mr. John Sargent's picture, entitled "Carnation, Lily, Lily, Rose," in which two fair-haired children are lighting Chinese-lanterns in a garden, surrounded by flowers. The time is that of a summer's evening; the attempt has been to show the conflict of lights between the fading day and the lanterns, and its effect upon the various coloured flowers, "carnation, lily, lily, and rose." Had Mr. Sargent only succeeded in rendering this effect truthfully as a study, he would have done a supremely difficult thing, and would have deserved high praise; but the artist has done far more than this. He has succeeded in painting a picture which, despite the apparent *bizarrerie* of its subject, despite the audacious originality with which he has treated it, is purely and simply beautiful as a picture. The introduction and painting of the children's figures, the disposition of the masses of flowers and leaves with which they are surrounded, the delicately bold colouring of the roses, lilies, and carnations, — in all these respects is this picture an exquisite work of art. And even now we have left its chief merit untold, and must leave it undescribed; for how is it possible to describe in words that subtle rendering of brilliance and shadow, that united mystery and revelation, which render this composition so admirable? Honour to the young artist who has succeeded in combining, as we at least have never yet seen combined in a picture of this "impressionist" school, truth of effect and beauty of colour, who has given us in the little world of his picture the subtle mingling of fact and fancy which exists in every great work of art, and renders its subject freshly beautiful while leaving its details true.

 Harry Quilter, "Art. The Royal Academy. [First Notice.]," *Spectator* 3070 (30 April 1887): 591.

Mr. Sargent's "Carnation, Lily, Lily, Rose" (359), two children lighting Chinese lanterns in a conservatory, is extremely curious, highly scientific and novel, if not wholly beautiful.

 "Fine Arts: The Royal Academy. (First Notice.)," *Athenaeum* 3105 (30 April 1887): 580.

Leaving the nude and the historic for works of pure fancy, we come upon a most courageous, and in some respects successful, experiment by Mr. John Sargent. Few with more right than Mr. Sargent might hope to carry out triumphantly such a novel and audacious scheme of treatment as that adopted in "Carnation, Lily, Lily, Rose" (359). . . . The children are exquisitely painted, and the flowers and the whole lower half of the picture marvellously beautiful; but we could spare much detail from the top, that we might enjoy the rest unembarrassed by a profusion of white spots.

 "The Royal Academy. I," *Saturday Review* 63, no. 1645 (7 May 1887): 650.

Mr. Sargent's "Carnation, Lily, Lily, Rose," continues to gain ground. It has been bought by the Chantrey Trustees, and we must congratulate them on their purchase. Every inch of this picture is delicately manipulated; most care-

ful art and an excellent feeling for decoration have been shown in the management of the flowers and other spots of colour.

 "The Royal Academy. II," *Saturday Review* 63, no. 1646 (14 May 1887): 685.

Mr. Sargent's *tour de force* . . . has specially in view the mastery he can show in depicting diffused light. Two little girls, in light dresses, have gone out in to the garden whilst it is still twilight to arrange for an evening's fête. . . . Amid all this imaginative work, Mr. Sargent's underlying realism peeps out now and again, and is marked in the accuracy of the effect of the yellow light on the hand of the child peeping into the lantern she is about to suspend.

 "The Royal Academy. (Third Notice.) Gallery IV," *Illustrated London News* 90, no. 2509 (21 May 1887): 584.

The *Carnation, Lily, Lily, Rose* (359), of Mr. Sargent, has been, we learn with regret, bought by the Council with the Chantrey Fund. Of the cleverness of this *tour de force* there can be no doubt. An inquiry, however, conducted on scientific principles, into the loyalty of this professed representation of a peculiar effect, would demonstrate its fallaciousness; the true relationship of the white dresses, the lanterns dimly shining in the hardly reduced daylight, the flesh, tresses, and ornaments of the figures, could readily be established to be other than Mr. Sargent has represented it. Unluckily, too, the meretricious elements of this picture are easy of imitation by beginners who hate studies of any sort, while the real cleverness of the attempt is a quality quite beyond their reach.

 "Fine Arts: The Royal Academy. (Third Notice.)," *Athenaeum* 3109 (28 May 1887): 708.

There can be little doubt this year at the Royal Academy of the success of that most worthy American representative, John L. Sargent. His marvellously clever and strangely-named picture, "Carnation-Lily, Lily-Rose," ever since "varnishing day" was the talk of all the studios, as it is now the talk of the town, for it has been bought for the Academy out of the Chantrey Bequest Fund — an exceptional honor for Burlington House to confer upon a foreigner. . . .

 . . . Enough has been said to indicate the daringness of Mr. Sargent's experiment with light and color. From the description would one not suppose that the result would be to sacrifice the portraits? No sacrifice of the kind is involved. The little girls are charmingly painted, and the charm is enhanced rather than diminished by the accessories.

 James S. Harding, "The Royal Academy Exhibition," *Art Amateur* 17, no. 2 (July 1887): 30.

[Bramley's work] is a good specimen of the "dab and spot" school, which has its arch-apostle in Mr. J. S. SARGENT, and its apotheosis in that artist's wonderful production, No. 359, "Carnation, Lily, Lily, Rose." As artists almost come to blows over this picture, a difference of opinion about it is at any rate allowable, and we can only hope that the British public, when it sees it in the Chantrey collection, may be of the same opinion as those who bought it.

 "The Royal Academy Exhibition, Gallery IV," *Art Journal* (London) 49, no. 7 (July 1887): 248.

M. J.-S. Sargent, dont le talent, fait de recherche et de sincérité confine souvent à l'excentrique, n'est pas de nature, à première vue, à devoir conquérir chez nous les suffrages, a cependant remporté cette année un succès éclatant avec deux toiles très remarquables. On dirait qu'après une période d'hésitation, il est rentré en pleine possession de lui-même, ayant acquis en plus une certaine largeur de style, une manière de voir plus calme, plus juste, et non moins personnelle qu'autrefois.

La première de ces toiles, intitulée *Carnation, lily, lily, rose*, est une étude de lumières diverses sur un sujet de fantaisie, en même temps poétique et moderne. . . . Nous voyons . . . deux toutes jeunes filles, enfants encore, qui le plus sérieusement du monde s'occupent à allumer de grosses lanternes japonaises, dont les reflets vivement colorés luttent avec la lumière du crépuscule. Cette complication de recherches, dont aucune n'affirme une importance prépondérante, ce combat de lumières et de coleurs, embarrassent d'abord quelque peu l'oeil, et nuisent à la première impression générale; mais peu à peu l'idée de l'artiste, sa conception en même temps hardie et émue se révèle et nous charme. C'est surtout dans ces deux ravissants types de jeunes filles qu'il déploie une tendresse à laquelle il ne nous a point accoutumés. Elle mériteraient peut-être de dominer plus complètement les autres éléments du tableau, dont l'exécution est, du reste, comme on pouvait s'y attendre, remarquable de tous points.

> Claude Phillips, "Correspondance d'Angleterre: Expositions d'Eté de la Royal Academy et de la Grosvenor Gallery," *Gazette des beaux-arts* 36, no. 1 (July 1887): 85.

"Carnation, Lily, Lily, Rose," was fantastic enough in some ways; indeed, one of its great merits lay in the strange unlikeness to anybody else's work. But it was primarily a decorative picture in spite of its conformity to actual truth.

> R. A. M. Stevenson, "J. S. Sargent," *Art Journal* (London) 50 (March 1888): 69.

"Carnation, Lily, Lily, Rose" is a rare vision which the artist may have seen some summer evening perhaps. . . . The impression given by the picture renders precisely what must have been the charm of the spectacle in nature, namely, for the eye, the intensity of the color heightened by the incipient conflict between lamp-light and daylight — the lamp-light only just beginning to make the paper lanterns glow more strongly than the flowers; and for the mind, the earnestness with which the children are working at this preparation for an illumination, unconsciously becoming a part of the scene, like so many moths or fire-flies. This picture is a work of exquisite beauty and refinement, one of those delicate dreams of color and dainty form that nature suggests and the artist realizes only in moments of peculiarly propitious inspiration.

> Theodore Child, "American Artists at the Paris Exhibition," *Harper's New Monthly Magazine* 79, no. 472 (September 1889): 504–506.

Liverpool 1887 — Walker Art Gallery, Seventeenth Autumn Exhibition of Pictures in Oil and Water-Colours

"Carnation lily, lily rose"

213

The principal picture, however, is Mr. John Sargent's "Carnation, Lily, Lily, Rose," which shows to the utmost advantage, and vindicates itself the more fully the longer it is studied.

> "The Autumn Exhibitions. The Walker Art Gallery, Liverpool," *Art Journal* (London) 49, no. 10 (October 1887): 350.

Notes

Sargent and Carolus-Duran

This chapter is based upon H. Barbara Weinberg, *The Lure of Paris: Nineteenth-Century American Painters and Their French Teachers* (New York: Abbeville Press, 1991), chapter 7.

1. Will H. Low, "The Primrose Way," typescript, "revised and edited from the original MS by Mary Fairchild Low, with the collaboration of Berthe Helene MacMonnies," 1935, Albany [New York] Institute of History and Art, 55–56.

2. Evan Charteris, *John Sargent* (New York: Charles Scribner's Sons, 1927), 15, indicates that Sargent entered the Accademia in the winter of 1870–1871. Stanley Olson, *John Singer Sargent: His Portrait* (New York: St. Martin's Press, 1986), 28, does not indicate when Sargent began his studies at the Accademia but notes that when the Sargent family returned to Florence in November 1873, Sargent "would have to make do [at the Accademia] for yet another year." Unless otherwise cited, this essay relies on biographical information from Olson.

3. Fitzwilliam Sargent to George Bemis, 23 April [1874], George Bemis Papers, Massachusetts Historical Society.

4. Sargent to Mrs. [Mary T.] Austin, Florence, 25 April 1874; quoted in Charteris, *John Sargent*, 19.

5. Typewritten transcription of Sargent's autograph letter, signed, to Heath Wilson, [Paris] 23 May 1874. The original, now destroyed, was in the possession of William H. Allen, Bookseller, Philadelphia, who kindly made the transcription available. Edited excerpts from this and from a subsequent letter, cited in note 10, are quoted in James Lomax and Richard Ormond, *John Singer Sargent and the Edwardian Age*, exh. cat. (Leeds, England: Leeds Art Gallery; London: National Portrait Gallery; Detroit: Detroit Institute of Arts, 1979), 18, without citations.

6. Olson, *Sargent: His Portrait*, 33. Also see 283n4, wherein Olson cites Palmer's diary, 20 May 1874 ("Went to talk to Sargent about studios") and thanks Maybelle Mann for the information.

7. Typewritten transcription of Sargent's autograph letter, signed, to Heath Wilson, [Paris] 23 May 1874 (courtesy of William H. Allen).

8. See Will H. Low, *A Painter's Progress* (New York: Charles Scribner's Sons, 1910; reprint, New York: Garland, 1977), 89; James Carroll Beckwith in William Coffin, "Sargent and His Painting, with Special Reference to His Decorations in the Boston Public Library," *Century Magazine* 52 (June 1896): 172.

9. Fitzwilliam Sargent to Winthrop Sargent, 30 May [1874], Archives of American Art, Smithsonian Institution, quoted in Olson, *Sargent: His Portrait*, 33.

10. Typewritten transcription of Sargent's autograph letter, signed, to Heath Wilson, Paris, 12 June 1874 (courtesy of William H. Allen).

11. Stanley Olson, "Chronology," in Patricia Hills et al., *John Singer Sargent*, exh. cat. (New York: Whitney Museum of American Art, in association with Harry N. Abrams, 1986), 277.

12. See H. Barbara Weinberg, *The Lure of Paris: Nineteenth-Century American Painters and Their French Teachers* (New York: Abbeville Press, 1991), chapter 1.

13. Sargent followed Robert Hinckley, Walter Launt Palmer, James Carroll Beckwith, Will H. Low (who all enrolled in 1873), and, probably, Hiram Reynolds Bloomer (who seems to have enrolled by 1874).

14. This account relies on the most accessible source of biographical information on Carolus-Duran is Gabriel P. Weisberg, "Charles-Emile Auguste Durand, Carolus-Duran," in *The Realist Tradition: French Painting and Drawing, 1830–1900*, exh. cat. (Cleveland: Cleveland Museum of Art, 1980), 279–280.

15. A recent account of some of the connections within this circle is Atsushi Miura, "Un double portrait par Carolus-Duran: Fantin-Latour et Oulevay," *Gazette des beaux-arts* 6e Période, 124 (1994): 25–34. In the company of Fantin-Latour and Legros, Carolus-Duran visited Manet's studio to congratulate him on the 1861 Salon exhibition of *The Spanish Singer* (1860; Metropolitan Museum of Art, New York); see Gary Tinterow and Henri Loyrette, *Origins of Impressionism*, exh. cat. (New York: Metropolitan Museum of Art, 1994), 343.

16. Carolus-Duran was predisposed to Spanish art by having had a paternal grandfather of Spanish descent, according to Arsène Alexandre, "Artistes contemporains — Carolus-Duran," *La Revue de l'art ancien et moderne* 14 (1903): 188.

17. Painted in oil on canvas, *Gloria Mariae Medicis* is preserved in the Louvre.

18. Carolus-Duran became one of the founding members of the Société nationale des beaux-arts, organizers of the "new Salon," in 1889, and in 1898 he served as its president.

19. Paul Mantz, "Salon de 1869," *Gazette des beaux-arts*, 1 June 1869, 503; quoted in Tinterow and Loyrette, *Origins of Impressionism*, 343.

20. Jules-Antoine Castagnary, *Salons (1857–1870)*, 2 vols. (Paris: Charpentier-Fasquelle, 1892), 1:364; quoted in Tinterow and Loyrette, *Origins of Impressionism*, 343.

21. Low, *A Painter's Progress*, 185–188 passim.

22. Charteris, *John Sargent*, 28.

23. Carolus-Duran quoted in H. [Robert Hinckley?], "A French Painter and His Pupils," *Century Magazine* 31 (January 1886): 373.

24. Will H. Low, *A Chronicle of Friendships, 1873–1900* (New York: Charles Scribner's Sons, 1908), 16.

25. "In the Studio of Carolus Duran," *Art Interchange*, 21 no. 3 (28 July 1888): 35 passim; the article, written by an English student who was enrolled in the atelier from October 1885 to May 1886, was reprinted from *Contemporary Review*. The account, with numerous quotations from Carolus-Duran's studio talk, was continued in *Art Interchange*, 21 no. 4 (11 August 1888): 54–55; and 21 no. 5 (25 August 1888): 70.

26. [James] Eliot Gregory, *The Ways of Men* (New York: Charles Scribner's Sons, 1900), 109–110.

27. Low, *A Chronicle of Friendships*, 17.

28. Hamilton Minchin, "Some Early Recollections of Sargent," *Contemporary Review* 127 (June 1925): 736.

29. "In the Studio of Carolus Duran," 35.

30. Gregory, *The Ways of Men*, 108.

31. "In the Studio of Carolus Duran," 35.

32. Subsequent honors included a medal of honor (1879), promotion to Commander of the Legion of Honor (1898) and Grand Officer (1900), election to the Institut de France (1904), and appointment as director of the French Academy in Rome (1905).

33. Gregory, *The Ways of Men*, 108.

34. *Art Age* 2, no. 23 (June 1885): 168.

35. "Carolus-Duran," *Art Amateur* 32 (February 1896): 80, notes Carolus-Duran's avocations.

36. Minchin, "Some Early Recollections of Sargent," 736, notes: "The studio had no furniture but about thirty easels and stools, a platform for the model, and a stove for the winter months." Gregory, *The Ways of Men*, 107, gives the atelier location on the rue Notre-Dame des Champs and fees of ten francs per month, and notes that the studio was originally established in a "modest workroom" on the boulevard du Montparnasse, which soon became too small for the students. J. Carroll Beckwith, "Carolus-Duran," in John C. Van Dyke, ed., *Modern French Masters* (New York: Century, 1896; reprint, New York: Garland, 1976), 73, gives the original address as 81 boulevard du Montparnasse.

37. Low, *A Chronicle of Friendships*, 12–13, 21.

38. Beckwith, "Carolus-Duran," 74. Beckwith's remark about "the painters of the Institute" refers to members of the Class of Fine Arts of the Institut de France, the extremely conservative representative body of artists and intellectuals founded in 1795. During certain periods, teachers at the Ecole des beaux-arts were drawn from the ranks of Institut members. For a brief account of the Institut and its administrative evolution, see Albert Boime, *The Academy and French Painting in the Nineteenth Century* (New York and London: Phaidon, 1971), 5–7.

39. Low, *A Chronicle of Friendships*, 21.

40. Fitzwilliam Sargent to George Bemis, Gibraltar, 11 April 1868, George Bemis Papers, Massachusetts Historical Society, notes the family's itinerary. Sargent's several trips to Spain are examined in M. Elizabeth Boone, "Vistas de España: American Views of Art and Life in Spain, 1865–1890" (Ph.D. diss., City University of New York, 1996), chapter 5.

41. Edwin H. Blashfield, "John Singer Sargent — Recollections," *North American Review* 221 (June 1925): 641–642. See also Edwin H. Blashfield, "John Singer Sargent," in *Commemorative Tributes to Cable, Sargent, Pennell* (New York: American Academy of Arts and Letters, 1927), 9–44.

42. Weir to Mother, Paris, 4 October 1874, quoted in Dorothy Weir Young, *The Life and Letters of J. Alden Weir* (New Haven: Yale University Press, 1960; reprint, New York: Kennedy Graphics and DaCapo, 1971), 50.

43. Typewritten transcription of Sargent's autograph letter to Heath Wilson, Paris, 12 June 1874 (courtesy of William H. Allen), adds: "[T]here are two annual examinations and if I do not try for this Sept. one, or fail to pass it, (which Heaven forbid!), I shall try for the next one in April. This examination, which on an average, 60 pass out of 250, is very severe." See also Sargent to Ben [del Castillo], Paris, 4 October 1874, during the course of the competition, in Charteris, *John Sargent*, 22. For Sargent's and Weir's success, see *Procès-verbaux originaux des jugements des concours des sections de peinture et de sculpture, 23 octobre 1874–22 octobre 1883* (AJ52: 78), Archives de l'Ecole nationale supérieure des beaux-arts, Archives nationales, Paris.

44. Charteris, *John Sargent*, 36; Gary A. Reynolds, *Walter Gay: A Retrospective*, exh. cat. (New York: Grey Art Gallery and Study Center, 1980), 22. Reynolds cites Walter Gay, *Memoirs of Walter Gay* (New York: privately printed, 1930), 11, and Warren Adelson, *John Singer Sargent, His Own Work*, exh. cat. (New York: Coe Kerr Gallery, 1980), unpaged.

45. For Carolus-Duran's American clientele, see *Art Collector* 9 (15 March 1899): 149.

46. Charles Merrill Mount, "Carolus-Duran and the Development of Sargent," *Art Quarterly* 26, no. 4 (1963): 385–417, suggests many analogies between the works of Sargent and his teacher.

47. R. A. M. Stevenson, *Velazquez* (1908), 107–108; in Richard Ormond, *John Singer Sargent, Paintings, Drawings, Watercolors* (New York: Harper and Row, 1970), 16. See also J. Boyd, "The Painting of the Head in Oil: A Pupil of Carolus-Duran Gives in Detail a Lesson for Beginners in Portraiture as Taught in That Master's Studio," *Art Amateur* 32 (February 1895): 88. For a discussion of *Blonde Model*, see Margaret C. Conrads, *American Paintings and Sculpture at The Sterling and Francine Clark Art Institute* (New York: Hudson Hills Press, 1990), 156–158.

48. For a discussion of the portrait, see Conrads, *American Paintings and Sculpture*, 166–172.

49. The ceiling decoration is discussed in Mount, "Carolus-Duran and the Development of Sargent," 386–387.

50. Ormond, *John Singer Sargent*, 16.

51. The comparison is proposed in Mount, "Carolus-Duran and the Development of Sargent," 387.

52. Blashfield, "John Singer Sargent," 14; Fitzwilliam Sargent to unspecified correspondent, St. Gervais, Savoy, 15 August 1879, in Charles [Merrill] Mount, "New Discoveries Illumine Sargent's Paris Career," *Art Quarterly* 20, no. 3 (Autumn 1957): 304; *L'Illustration Journal universel* 38, no. 75 (17 January 1880): 37.

53. Mount, "New Discoveries Illumine Sargent's Paris Career," 304–316, argues that Sargent's fortunes were not substantially improved by his success in the 1879 Salon.

54. *Polish-American Journal*, 23 November 1968, courtesy Pennsylvania Academy of the Fine Arts.

55. See Juan J. Luna, "John Singer Sargent y el Museo del Prado," *Historia 16* 13 (June 1988): 100–107.

56. Compare, for example, Reynolds's (1778) and Sargent's (1905) portrayals of the Marlborough family (both paintings property of the Duke of Marlborough, Blenheim, England); and Copley's (1786) and Sargent's (1900) portrayals of the Sitwell family (both paintings property of Trustees of the Sitwell Settled Estates, Renishaw, Derbyshire, England). Sargent's *Wyndham Sisters: Lady Elcho, Mrs. Adeane, and Mrs. Tennant* (1899; Metropolitan Museum of Art, New York) includes on the background wall a portrait of the sitters' mother by George Frederic Watts.

57. Gary A. Reynolds, "John Singer Sargent's Portraits: Building a Cosmopolitan Career," *Arts Magazine* 62, no. 3 (November 1987): 42–46, explores this issue.

58. Blashfield, "John Singer Sargent — Recollections," 642.

59. Conrads, *American Paintings and Sculpture*, 166.

60. John Singer Sargent to Ben del Castillo, Paris, 6 March 1875; quoted in Charteris, *John Sargent*, 37.

61. "John S. Sargent," *Art Amateur* 2, no. 6 (May 1880): 118.

Sargent and His Critics

1. Henry James, "John S. Sargent," *Harper's New Monthly Magazine* 75, no. 449 (October 1887): 684.

2. James, "John S. Sargent," 684.

3. As but one notable example, see the discussion of *Madame X* in Doreen Bolger Burke, *American Paintings in the Metropolitan Museum of Art III* (New York: Metropolitan Museum of Art, 1980), 229–235.

4. Royal Cortissoz, "The Field of Art," *Scribner's Magazine* 75, no. 3 (March 1924): 345. Subsequently, the literature devoted to Sargent is considerable. The first volume produced by the John Singer Sargent Catalogue Raisonné Project, under the direction of Richard Ormond, is scheduled to be published in 1997. The principal biographies of Sargent include William Howe Downes, *John S. Sargent: His Life and Work* (Boston: Little, Brown, 1925); Evan Charteris, *John Sargent* (New York: Charles Scribner's Sons, 1927), authorized by Sargent's family; Charles Merrill Mount, *John Singer Sargent, a Biography* (New York: W. W. Norton, 1955; second edition, 1969); Stanley Olson, *John Singer Sargent: His Portrait* (New York: St. Martin's Press, 1986). The major studies of his work, in addition to these, include John Dee McGinnis, "John Singer Sargent and the Ironic Tradition" (Ph.D. diss., Florida State University, 1968); Martha Kingsbury, "John Singer Sargent: Aspects of His Work" (Ph.D. diss., Harvard University, 1969); Richard Ormond, *John Singer Sargent: Paintings, Drawings, Watercolors* (New York: Harper & Row, 1970); Trevor J. Fairbrother, "John Singer Sargent and America" (Ph.D. diss., Boston University, 1981); Carter Ratcliff, *John Singer Sargent* (New York: Abbeville Press, 1982); Trevor J. Fairbrother, *John Singer Sargent* (New York: Harry N. Abrams in association with The National Museum of American Art, Smithsonian Institution, 1994). Monographic exhibitions of the past forty years that have been accompanied by significant publications include: David McKibbin, *Sargent's Boston* (Boston: Museum of Fine Arts, 1956); Donelson Hoopes, *The Private World of John Singer Sargent* (Washington, D.C.: Corcoran Gallery of Art, 1964); Natalie Spassky, *John Singer Sargent* (New York: Metropolitan Museum of Art, 1972); James Lomax and Richard Ormond, *John Singer Sargent and the Edwardian Age* (Leeds: Leeds Art Galleries and London National Portrait Gallery, 1979); Warren Adelson, *John Singer Sargent: His Own Work* (New York: Coe Kerr Gallery, 1980); James Hamilton, The Misses Vickers: *The Centenary of the Paintings by John Singer Sargent* (Sheffield: City Council Arts Department, 1984); Patricia Hills et al., *John Singer Sargent* (New York: Whitney Museum of American Art, 1986); Stanley Olson, Warren Adelson, and Richard Ormond, *Sargent at Broadway: The Impressionist Years* (New York: Coe Kerr Gallery, 1986); Denys Sutton, *John Singer Sargent (1856–1925)* (Tokyo: The Japan Association of Art Museums, 1989); Mary Crawford Volk, *John Singer Sargent's* El Jaleo (Washington, D.C.: National Gallery of Art, 1992). In addition, numerous articles, institutional collection catalogues, thematic exhibitions, and texts have added significantly to the picture of the man and his work. For a comprehensive listing to 1986, see Robert H. Getscher and Paul G. Marks, *James McNeill Whistler and John Singer Sargent: Two Annotated Bibliographies* (New York: Garland, 1986).

5. For a more fleshed-out review of the development of the art world at the end of the nineteenth century, see *The Expanding World of Art,*

1874–1902, selected and edited by Elizabeth Gilmore Holt (New Haven: Yale University Press, 1988); Harrison C. White and Cynthia A. White, *Canvases and Careers: Institutional Change in the French Painting World* (1965; Chicago: University of Chicago Press, 1993).

6. "Cosmopolitanism has been one of the keynotes of Sargent's life. 'An American, born in Italy, educated in Florence, who looks like a German, speaks like an Englishman, and paints like a Spaniard,' is a phrase that largely sums him up" (William Starkweather, "John Singer Sargent, Master Portrait Painter," *Mentor* 12, no. 9 [October 1924]: 4). For a detailed study of the context in which Sargent grew up, with a particular emphasis on his friendships and social contacts largely limited to Anglophonic expatriates living on the European continent, see Olson, *Sargent: His Portrait*, 29–32, 83–87.

7. The clearest recent discussions of the history of the Salon and its apparatus are in Lois Fink, *American Art at the Nineteenth-Century Paris Salons* (Washington, D.C.: National Museum of American Art, Smithsonian Institution, 1990); and H. Barbara Weinberg, *The Lure of Paris: Nineteenth-Century American Painters and Their French Teachers* (New York: Abbeville Press, 1991).

8. A writer for the American *Art Amateur* hinted at the Salon's international importance when he wrote of it, and not of some exhibition in New York or Boston: "Every year Americans visit the Salon with high hopes that some new genius has sprung to light among our countrymen" ("American Art in the Paris Salon," *Art Amateur* 7, no. 3 [August 1882]: 46).

9. The exception was one of his Salon entries of 1879, the portrait of the well-known painter and Sargent's own teacher Carolus-Duran. The portrait broke from the norms of official male portraiture through its informal pose and dress and earned the sitter opprobrium in some quarters as an effeminate fop.

10. The best basic review of Parisian exhibitions can be found by surveying the *Courrier de L'Art, La Chronique des arts et de la curiosité* (a supplement to the *Gazette des beaux-arts*), and *Le Musée artistique et littéraire* for the desired period. This paragraph grows largely from Maurice Du Seigneur, "Les Expositions particulières depuis une année, 1882–1883," *L'Artiste* 53, pt. 2 (August 1883): 119–132.

11. Sargent made at least one sketch (ca. 1877, Worcester Art Museum) after Edgar Degas's *L'Etoile* pastel over monotype (1876–1877; Musée d'Orsay, Paris). And it is clear that members of the group knew of him. His friendship with Claude Monet is said to date to 1876, although the earliest of their correspondence now known dates to the mid-1880s. Berthe Morisot wrote to her brother, who was trying in 1883 to organize an exhibition of contemporary French works by Fantin, Cazin, Lerolle, Monet, Renoir, Sisley, Degas, and Cassatt to travel to America. She asked: "Have you sent anything to Sargent, the American? We were at Nice together; he left suddenly for Paris when we were about to be introduced to each other. He is supposed to have spoken of me in the most flattering way. He is very successful and a pupil of Carolus Duran" (Morisot to Tiburce Morisot, 20 August 1883, in Denis Rouart, *The Correspondence of Berthe Morisot*, trans. Betty W. Hubbard [London: Lund Humphries, 1957], 118–119).

 For a discussion of the various names — Société anonyme, indépendants, impressionistes, intransigeants — used for the eight exhibitions now known as the Impressionist exhibitions, see *The New*

Painting: Impressionism, 1874–1886, exh. cat. (San Francisco: Fine Arts Museums of San Francisco, 1986).

12. Maurice Du Seigneur, "Les Expositions particulières [Août 1883–Décembre 1885]," *L'Artiste* 56, pt. 1 (February 1886): 133. Or, as another wrote, "Les expositions des cercles deviennent de jour en jour plus à la mode" ("A travers Paris," *Le Figaro*, 1 March 1884, 1). Of course, not everyone agreed that the exhibitions were worthwhile: "On s'exagère beaucoup l'attrait et l'intérêt. . . . [J']estime que, voulant tout exhiber sans cesse, on fatigue le public sans être utile aux artistes" (Fourcaud, "Beaux-Arts: Exposition au Cercle des Arts libéraux," *Le Gaulois*, 25 February 1883). Or again, of the Mirlitons, one wrote, "Au milieu de ce fatras mercantile quelque assez bons tableaux de Benjamin Constant, Paul Baudry, Ferdinand Cormon, John Sargent" (Félix Fénéon, "Les Expositions artistiques à Paris," *La Libre Revue* 16 [February 1884]).

13. Only a few catalogues for these exhibitions have come to light. Nonetheless, it is possible to surmise that Pierre-Auguste Renoir showed his massive and signally important *Un déjeuner à Bougival* (1880–1881; Phillips Collection, Washington, D.C.) at the Cercle des Arts libéraux in 1881, the year before it was one of the successes at the seventh impressionist exhibition. This early exhibition is not, so far as I know, recorded in the literature on Renoir. Given the importance of the painting and its pervasiveness in the literature of late nineteenth-century French art, that gap is testimony to the profound neglect of the *salonnets* by twentieth-century art historians (see Un Vieux Parisien [Antoine Genevay], "Exposition du Cercle des Arts Libéraux," *Le Musée artistique et littéraire* 5 [1881]: 330–331).

14. Albert Wolff announced the opening of the "Magnifique salle," "qui deviendra sûrement le centre du mouvement artistique contemporain," at a cost of three million francs ("Courrier de Paris," *Le Figaro*, 14 February 1882, 1). Another writer described its effect: "La galerie de Georges Petit a un certain air de comfort, un parfum d'élégance et de distinction qui disposent en faveur des oeuvres qui s'y montrent. Il ne semble pas qu'à des murs si bien préparés, sous de si éclatants candélabres, dans une salle où le velours des tapis mange le bruit et invite au silence, puissent venir s'accrocher des objets de médiocre valeur ou d'intérêt douteux" (G. Dargenty [Arthur Echérac], "Exposition Internationale des Peintres & des Sculpteurs," *L'Art* 9, no. 32 [14 January 1883]: 36).

15. Albert Wolff published a lengthy review of the exhibition "Les Quinze," *Le Figaro*, 15 May 1882, 1). The catalogues for the first six years of the society's exhibitions have been recently reproduced in facsimile: *Modern Art in Paris* (New York and London: Garland Press, 1981).

16. See, for example, Sargent's *Ernest-Ange Duez* (ca. 1884–1886; Montclair Art Museum, Montclair, N.J.) and his several depictions of Claude Monet (1885, Tate Gallery; 1887, National Academy of Design, New York). He made a gift of *A Venetian Interior* (cat. 15) to Jean-Charles Cazin.

17. C. C. [Clarence Cook], "A New Art Departure," *New-York Daily Tribune*, 9 March 1878, 5.

18. Montezuma [Montague Marks], "My Note Book," *Art Amateur* 14, no. 2 (January 1886): 28.

19. The Grosvenor had been founded as a commercial enterprise in 1877 and soon became a vehicle for the most advanced works of artists as diverse as Edward Burne-Jones and James McNeill Whistler. The fullest and most recent study of the gallery is Susan Casteras and Colleen Denney, eds., *The Grosvenor Gallery: A Palace of Art in Victorian England*

(New Haven: Yale University Press and the Yale Center for British Art, 1996).

20. To cite but one example of many, Monet recalled how he had been embarrassed at his first meeting with Sargent, which, at Monet's suggestion, took place at the Café Helder. Only when they were inside did Monet realize that he had paintings on exhibition in the café, and he then feared that Sargent would think that he had suggested the Helder simply to be surrounded by Monet's works (Monet interview with Evan Charteris, May 1926; recorded in Charteris, *John Sargent*, 130).

21. Sargent to Henry James, 29 June 1885; bMS Am 1094 (396), by permission of the Houghton Library, Harvard University.

22. Henry Houssaye, "Le Salon de 1877," *Revue des deux mondes* 21, no. 4 (15 June 1877): 839; Duranty, "Réflexions d'un Bourgeois sur le Salon de Peinture," *Gazette des beaux-arts* 15, no. 6 (June 1877): 560.

23. Duranty, "Réflexions d'un Bourgeois sur le Salon de Peinture," 560; Dubosc de Pesquidoux, *L'Art dans les deux mondes: Peinture et sculpture*, 2 vols. (Paris: E. Plon et Cie., 1881), 2:536.

24 Roger-Ballu, "Le Salon de 1878," *Gazette des beaux-arts* 18, no. 1 (July 1878): 185.

25. S. N. Carter, "First Exhibition of the American Art Association," *Art Journal* (New York) 4, no. 4 (April 1878): 126; C. C. [Clarence Cook], "American Artists," *New-York Daily Tribune*, 23 March 1878, 6; "Sketches and Studies," *Art Journal* (New York) 6, no. 6 (June 1880): 174.

26. James, "John S. Sargent," 683.

27. James wrote of his own objective of consciously blurring a sense of national style when he proclaimed his aspiration to the "highly civilized" goal of writing "in such a way that it would be impossible to an outsider to say whether I am, at a given moment, an American writing about England or an Englishman writing about America" (Henry James to William James, 29 October 1888, quoted in Leon Edel, ed., *Henry James Letters, 1883–1895* [Cambridge, Mass.: Belknap Press of Harvard University Press, 1980], 244). In 1884 a British journal writer noted somewhat acidly that James himself was "too Europeanized to be altogether satisfactory as a portrayer of the uncontaminated American; in fact, we doubt if Mr. James knows New York, or even Boston, as well as he knows Paris and London. As Colonel Higginson neatly put it, 'Mr. James is not a true cosmopolitan, because a true cosmopolitan is at home even in his own country'" ("England in America," *Saturday Review* 57, no. 1473 [19 January 1884]: 78).

28. This subject has been most recently dealt with, emphasizing in particular the nineteenth-century French fabrication of a Spanish school, by Janis Tomlinson in "Counter-Identity and the Formation of the National School," a paper presented at the 1996 College Art Association annual meeting,

29. The latter term was used, as one example of many, in the *Illustrated London News* to describe the portrait of *Mrs. Vickers* when it was shown at the Royal Academy in 1886, "where we have an example — and a good one — of the Franco-American school at its best" (*Illustrated London News* 88, no. 2456 [15 May 1886]: 508).

30. Du Seigneur, "Les Expositions particulières depuis une année, 1882–1883," 128. Unless otherwise noted, translations are the author's.

31. Ph. Burty, "Le Salon de 1880: Les Etrangers," *L'Art* 6, no. 21 (1880): 295–307.

32. Burty, "Le Salon de 1880: Les Etrangers," 300–302.

33. "Dialogue sur le Salon de 1883," *La Nouvelle Revue* 22 (May–June 1883): 714.

34. Dargenty, "Exposition Internationale des Peintres & des Sculpteurs," 36.

35. Charles Bigot, "Le Salon de 1883. Deuxième article," *Gazette des beaux-arts* 28, no. 1 (July 1883): 22–23.

36. Albert Boime was one of the first to explore this specifically as it connected to Sargent in his article "Sargent in Paris and London: A Portrait of the Artist as Dorian Gray," in Hills et al., *John Singer Sargent*, 75–109. Albert Wolff wrote a particularly nasty appraisal of American commerce and French art in "Courrier de Paris," *Le Figaro*, 10 March 1882, 1.

37. Perdican, "Courrier de Paris," *L'Illustration* 77, no. 1990 (18 June 1881): 412.

38. Ph. Burty, *Salon de 1883* (Paris: L. Baschet, 1883), 103–104.

39. Arthur Baignères, "Première Exposition de la Société Internationale de Peintres et Sculpteurs," *Gazette des beaux-arts* 27, no. 2 (February 1883): 187–192. In 1879 the same writer had praised Sargent's portrait of Carolus-Duran when it was shown at the Salon of 1879, listing it among a number of works by French painters, *before* closing his paragraph with a discussion of "les étrangers" (Arthur Baignères, "Le Salon de 1879. Deuxième Article," *Gazette des beaux-arts* 20, no. 1 [July 1879]: 54).

40. Paul Labrosse, "Notes sur l'art II: Les peintres américains au Salon de 1886," *Revue illustrée* 2, no. 18 (1 September 1886): 612; translated in an unidentified New York newspaper; Burckhardt Scrapbook, John Singer Sargent Catalogue Raisonné Archive.

41. Perkéo, "Lettre de Bruxelles," *Le Figaro*, 6 February 1884, 4.

42. M. G. van Rensselaer, "Spring Exhibitions and Picture-Sales in New York. — I," *American Architect and Building News* 7, no. 227 (1 May 1880): 190.

43. Margaret Bertha Wright, "American Pictures at Paris and London," *Art Amateur* 3, no. 2 (July 1880): 26. One New York writer later claimed, somewhat petulantly: "Sargent is practically a French painter. He doesn't live here, nor come here when he can help it" ("Painters and Pictures," *Daily Graphic*, 2 April 1888, 242).

44. Sargent to [Edwin] Russell, 10 September 1885, Tate Gallery, Archives.

45. "Art Chronicle," *Portfolio* 18, no. 8 (August 1887): 165; "The Royal Academy Exhibition. Gallery IV," *Art Journal* (London) 49, no. 7 (July 1887): 248.

46. T. Johnson, "Correspondance Anglaise," *Le Figaro*, 14 May 1884, 3.

47. For a discussion of the Anglomania that washed over America in the 1870s and 1880s, see Marc Simpson, "Windows on the Past: Edwin Austin Abbey and Francis Davis Millet in England," *American Art Journal* 22, no. 3 (1990): 64–89.

48. Henry James to William James, 29 October 1888, in *Henry James Letters, 1883–1895*, 244.

49. Sargent and James McNeill Whistler exchanged letters on the subject of the Royal Academy election, with Whistler asking, by invoking an echo of Gilbert & Sullivan: "Tell me one thing only — did you, / In face of great temptation, / Chuck up the t'other nation / To become an English-man!? — / However you are all right — for you have at last proved that a man is not judged by his Associates!" (James McNeill Whistler to John Singer Sargent, 20 January 1894, Boston Athenaeum, Sargent Papers). For information on the knighthood, see Olson, *Sargent: His Portrait*, 220–221.

50. The fullest recent discussion of Carolus-Duran's career is in Weinberg, *The Lure of Paris*, 189–219. For a more inflected reading of the Frenchman's career, see Olson, *Sargent: His Portrait*, 33–40.

51. "John S. Sargent," *Art Amateur* 2, no. 6 (May 1880): 118.

52. "Fine Arts. Exhibition by the Society of American Artists," *Nation* 28, no. 716 (20 March 1879): 207.

53. Edward Strahan [Earl Shinn], "The National Academy of Design," *Art Amateur* 1, no. 1 (June 1879): 4–5.

54. "The Paris Salon," *Saturday Review* 55, no. 1439 (26 May 1883): 664.

55. Penguin, "The Paris Salon," *American Architect and Building News* 15, no. 443 (21 June 1884): 296.

56. "Expositions," *L'Art* 7, no. 25 (1881): 290.

57. "Exhibition of the Salon. Work of the Paris Artists," *New-York Times*, 1 June 1879, 7.

58. "Fine Art. Society of American Artists," *New-York Daily Tribune*, 25 March 1880, 5.

59. "Art Notes [August]," *Magazine of Art* (London) 5 (1882): xli.

60. Montezuma [Montague Marks], "My Note Book," *Art Amateur* 9, no. 4 (September 1883): 69. It was a curious, messy situation, one that allowed the same writer, even when he was castigating Sargent, to drive the wedge yet deeper between the two men: "Mr. Sargent, it is understood, has profited by the decadence of his master, Carolus Duran, whose whimsical egotisms have driven to the studio of his clever pupil not a few of M. Duran's former friends and admirers in the beau monde. But Mr. Sargent must now look to his own laurels" (Montezuma [Montague Marks], "My Note Book," *Art Amateur* 13, no. 3 [August 1885]: 44).

61. Sargent to [Edwin] Russell, 10 September 1885, Tate Gallery, Archives. In 1915 Sargent wrote bluntly: "Carolus Duran hates me" (Sargent to Abbott Thayer, 12 November 1915, Archives of American Art, roll D201, frame 338).

62. See, among many others: J. B. F. W., "Society of American Artists," *Aldine* 9 (1879): 278; "The American Artists," *New-York Times*, 16 April 1880, 8; "The Society of American Artists," *New-York Daily Tribune*, 25 March 1883, 5; "The Exhibition of the Society of American Artists," *Art Journal* (London) 45, no. 7 (July 1883): 228.

63. Examples include Lucy H. Hooper, "The Paris Salon of 1879," *Art Journal* (New York) 5 (1879): 250; Outremer, "American Painters at the Salon," *Aldine* 9 (1879): 370; W. C. Brownell, "American Pictures at the Salon," *Magazine of Art* (London) 6 (1883): 495–497; Theodore Child, "American Pictures at the Salon," *Art Amateur* 14, no. 2 (May 1886): 123; "American Painting: Whistler, Dannat, Sargent," *Art Amateur* 29, no. 6 (November 1893): 134.

64. "Art Notes," *Boston Evening Transcript*, 21 May 1880, 4. For just a few of many possible examples, see "Spring Exhibitions and Picture-Sales in New York. I," *American Architect and Building News* 8, no. 227 (1 May 1880): 190; S. G. W. Benjamin, "Society of American Artists. Third Exhibition," *American Art Review* 1, div. 1 (1879–1880): 261; Greta, "Boston Correspondence," *Art Amateur* 3, no. 1 (June 1880): 7.

65. For the Salon, see, for example, Paul Leroi [Léon Gauchez], "Salon de 1882," *L'Art* 8, no. 30 (1882): 134.

66. Emile Verhaeren, "Chronique d'art," *La Libre Revue* 16 (February 1884): 233.

67. Emile Verhaeren, "Chronique Artistique: Exposition des XX (Second article)," *La Jeune Belgique* 3, no. 4 (15 March 1884): 244.

68. Although Sargent, too, and his close friends apparently felt the pressure of Whistler's success. Vernon Lee reported, on going with Sargent through the Salon of 1885: "[U]nfortunately his principal picture is hung by the side of Whistler's Lady Archibald Campbell, which beats John into fits" (Vernon Lee to her mother, 25 June 1885; in *Vernon Lee's Letters*, edited by her executor [Irene Cooper Willis] [London: privately printed, 1937], 171).

69. Paul Labrosse, "Notes sur l'art II: Les peintres américains au Salon de 1886," 611. See also, for example, R. A. M. Stevenson, "The American Salon," *Magazine of Art* (London) 8 (1885): 514. Others linked them, but unfavorably: "The influence of Mr. Sargent and (*pace* Velazquez) his model and guide, Mr. Whistler, is, as might be expected, visible on all sides" ("Society of British Artists," *Athenaeum* 3034 [19 December 1885]: 813).

70. "Sargent is fairly lodged in a yellow studio (yellowed by its ci-devant proprietor, Whistler) but is not, as yet I think overwhelmed by work — that is by lucrative orders" (Henry James to Henrietta Reubell, 12 November 1886; bMS Am [1068], by permission of the Houghton Library, Harvard University).

71. Outremer, "American Painters at the Salon of 1879," *Aldine* 9 (1879): 371; "The Two New York Exhibitions," *Atlantic Monthly* 43, no. 260 (June 1879): 781.

72. "Fine Arts. Exhibition of the Academy of Design. — II," *Nation* 28, no. 725 (22 May 1879): 359.

73. The first exhibition of the Société internationale des peintres et sculpteurs, for example, included works by Boldini, Gemito, Rossano, and Tofano.

74. Raymond Westbrook, "Open Letters from New York," *Atlantic Monthly* 41, no. 243 (January 1878): 96. Gretchen Sinnett, Williams College M.A. '96, has made significant progress in researching the prevalence of Italian painting in nineteenth-century New York and its critical ties to Sargent.

75. *New York Evening Post*, dateline 21 June 1880 (Burckhardt Scrapbook, John Singer Sargent Catalogue Raisonné Archive); *American Register*, 13 May 1882 (Burckhardt Scrapbook, John Singer Sargent Catalogue Raisonné Archive); "Fine Arts. Exhibition by the Society of American Artists," *Nation* 28, no. 716 (20 March 1879): 207; Ernest Hoschedé, *Impressions de mon voyage au Salon 1882* (Burckhardt Scrapbook, John Singer Sargent Catalogue Raisonné Archive).

76. Paul Mantz, "Le Salon: VII," *Le Temps*, 20 June 1880, 1; "American Art in the Paris Salon," *Art Amateur* 7, no. 3 (August 1882): 46.

77. Paul Baudry won the year's *medaille d'honneur*. No first-class medals were awarded; twelve artists received second-class medals, making them *hors concours* (able to submit thereafter without jury approval of their works). Ten of the painters were honored for history or genre scenes; only Sargent (who tied for fourth place with Julien Dupré) and Manet (who was at the bottom of the list) won for their portraits ("Expositions: Récompenses du Salon," *L'Art* 7, no. 25 [1881]: 245).

78. J. Buisson, "Le Salon de 1881," *Gazette des beaux-arts* 24, no. 1 (July 1881): 44.

79. Emile Bergerat, *Le Voltaire*, 10 May 1882; Burckhardt Scrapbook, John Singer Sargent Catalogue Raisonné Archive. See also Armand Silvestre, "Le Monde des Arts: Le Salon de 1882," *La Vie moderne* (3 June 1882): 342.

80. See, for example, J.-K. Huysmans, "Appendice (1882)," *L'Art moderne* (Paris: G. Charpentier, 1883), 272.

81. Paul Leroi [Léon Gauchez], "Salon de 1882," *L'Art* 8, no. 30 (1882): 138–139; see also Henry Houssaye, "Le Salon de 1882," *Revue des deux mondes* 51, no. 3 (1 June 1882): 583.

82. *Galignani*, 8 May 1882; Burckhardt Scrapbook, John Singer Sargent Catalogue Raisonné Archive.

83. See Du Seigneur, "Les Expositions particulières [Août 1883–Décembre 1885]," 135–136.

84. Sargent to "Interesting Mad One" [Miss Popert], 18 January 1884. Boston Athenaeum, Sargent Papers, box 1, folder 18.

85. Sargent acquired one of the large studies for *The Balcony* — a portrait of Fanny Claus — and perhaps two watercolors. The purchase of the oil for 580 francs was reported in "La Vente Manet," *Le Figaro*, 5 February 1884, 2.

86. Mount, *John Singer Sargent*, 129.

87. The most obvious pictorial response to Manet was Sargent's *Garden Study of the Vickers Children* (1884; Flint Art Institute). He also apparently modeled a number of his smaller, private works along lines followed by Manet. Compare, for example, Manet's *Swallows* (1873; Foundation E. G. Bührle Collection) to Sargent's *In the Orchard* (ca. 1886; private collection); or Sargent's *Pointy* (ca. 1881; Sotheby's, 12 April 1991) to any of a number of dogs' portraits by Manet (see Denis Rouart and Daniel Wildenstein, *Edouard Manet: Catalogue raisonné* [Lausanne–Paris: La Bibliothèque des Arts, 1925], 232–235, 253–255).

88. William C. Brownell, "The American Salon," *Magazine of Art* (London) 7 (1884): 494. Brownell goes on to praise many portions of the portrait but to castigate the painting of the head, which in its flatness "is not Manet; it is the reverse of naturalism."

89. "Le Salon de Paris: Quatrième article," *L'Art moderne* (Brussels) 4, no. 24 (15 June 1884): 194–195.

90. Sargent to Vernon Lee, 10 February 1883, Ormond family collection; published in Richard Ormond, "John Singer Sargent and Vernon Lee," *Colby Library Quarterly* 9, no. 3 (September 1970): 174.

91. James, "John S. Sargent," 684.

92. "Impressionisme," *Saturday Review* 57, no. 1474 (26 January 1884): 111–112. Up to 1887, however, the critics do not even mention Sargent and Claude Monet in the same breath, in spite of their friendship and their showing together at the Exposition internationale des peintres in 1885.

93. Paul Mantz, writing a favorable review of *Mme Edouard Pailleron* ("Le Salon: VII," *Le Temps*, 20 June 1880, 1).

94. Maurice Du Seigneur, *L'Art et les artistes au Salon de 1881* (Paris: Paul Ollendorf, 1881), 230.

95. *L'Art moderne* (Brussels) 3, no. 23 (10 June 1883): 184.

96. Baignères, "Première Exposition de la Société Internationale de Peintres et Sculpteurs," 190.

97. *Continental Gazette*, 1 April 1882; Burckhardt Scrapbook, John Singer Sargent Catalogue Raisonné Archive.

98. "The Fine Arts: Mr. Sargent's 'El Jaleo,'" *Critic* (New York) 2, no. 47 (21 October 1882): 286. The review of the painting, which is lengthy, was reprinted by the *Boston Evening Transcript*, 25 October 1882.

99. Paul Mantz, "Exposition de la Société Internationale," *Le Temps*, 31 December 1882, 3.

100. One writer claimed that it "rapelle Chardin, mais Chardin mitigé par Carolus Duran"; another discerned that "l'artiste descend . . . de Watteau ou de Fragonard par les femmes" (Henry Havard, *Le Siècle*, 27 May 1882; Em. Blémont [Emile Petitdidier], *Le Beaumarchais*, 7 April 1882; both from the Burckhardt Scrapbook, John Singer Sargent Catalogue Raisonné Archive). Years later, calling forth the painting solely in his mind's eye, a French critic wrote of the work as one "Watteau himself would have praised" (Paul Leroi [Léon Gauchez], "The American Salon," *Magazine of Art* [London] 9 [1886]: 490).

101. Clarence Cook, "The Society of American Artists' Exhibition," *Art Amateur* 8, no. 6 (May 1883): 124.

102. "Society of American Artists," unidentified clipping; Burckhardt Scrapbook, John Singer Sargent Catalogue Raisonné Archive.

103. Claude Phillips, "The Royal Academy. II," *Academy* 29, no. 732 (15 May 1886): 352.

104. Charles Ponsonailhe, "Salon de 1886: La Peinture," *L'Artiste* 56, pt. 1 (June 1886): 427.

105. See, for example, Vernon Lee to her mother, 8 June 1884, quoted in *Vernon Lee's Letters*, 143; Paul Mantz, "Le Salon: IV," *Le Temps*, 23 May 1884, 2; and Joséphin Peladan, "Salon de 1884," *L'Artiste* 54, pt. 1 (June 1884): 441. For the work mentioned by Mantz and now attributed to Piero del Pollaiolo, see *Museo Poldi Pezzoli: Dipinti* (Milan: Electa, 1982), cat. no. 186.

106. Buisson, "Le Salon de 1881," 44.

107. Albert Wolff, "Le Figaro — Salon," supplement to *Le Figaro* (May 1882).

108. Emile Hennequin, *Opinion nationale*, 12 May 1882 (Burckhardt Scrapbook, John Singer Sargent Catalogue Raisonné Archive); "Art and Artists," *Daily Graphic*, 14 October 1882, 736. Mary Crawford Volk has pointed out that Goya's "Black Paintings" were seen outside Spain for the first time when they were at the Exposition universelle in Paris in 1878. She rightly posits that, in addition to the vernacular culture of Sargent's work, the dark tonalities and incompleteness of the Goya works would have predisposed both Sargent and the Parisian critics to see *El Jaleo*, four years later, as distinctly Goyesque (*John Singer Sargent's* El Jaleo, 61–63).

109. Maurice Du Seigneur, "L'Art et les artistes au Salon de 1882," *L'Artiste* 52, pt. 1 (June 1882): 646. To what I imagine must have been Sargent's deep chagrin, some critics went so far as to claim the American's superiority over the Spaniard: "C'est du Goya, direz-vous, et vous direz mal. Que Goya n'ait point hanté l'esprit de l'artiste américain, je me garderai bien de l'affirmer, mais il suffit d'avoir vu les deux grands tableaux de Goya du *Museo del Prado*, pour se rendre compte de l'incontestable supériorité de M. Sargent qui est bien autrement dessinateur et coloriste plus audacieux, plus fin et plus puissant" (Paul Leroi [Léon Gauchez], "Salon de 1882," *L'Art* 8, no. 30 [1882]: 139).

110. Henry Houssaye, "Le Salon de 1882," *Revue des deux mondes* 51, no. 3 (1 June 1882): 583. The two fictional characters used by the clever critic for *La Nouvelle Revue* summarized the situation. L'Impressioniste, who valued the work highly, characterized it as "cette oeuvre tout originale, vibrante même dans les clairs comme dans les gris sombres." L'Académicien responded, "mais c'est un ressouvenir de Goya, et je m'étonne que vous puissiez en vanter l'originalité" ("Dialogue sur Quelques Tableaux du Salon de 1882," *La Nouvelle Revue* 16 [1882]: 702–703).

111. "The Salon," *Athenaeum* 3005 (30 May 1885): 703; Claude Phillips, "The Royal Academy. II," *Academy* 29, no. 732 (15 May 1886): 352.

112. "Le Modernisme de Frans Hals," *L'Art moderne* (Brussels) 3, no. 38 (23 September 1883): 302.

113. This was a misleading grouping, as Chase could not at this point be called "franco-" anything with justice.

114. "Le Modernisme de Frans Hals," 302. The article prompted an immediate, largely negative response from an anonymous French subscriber who, after denigrating Manet, asserted that Sargent saw Velázquez and Goya only through the eyes of Carolus-Duran. He continued: "Sargent, seul, je crois, a été à Madrid et est revenu très frappé. Ce qui ne l'empêche pas de dire que le Louvre est une collection de vieilles horreurs marron et noires" (Un abonné Français, "Frans Hals et Manet," *L'Art moderne* [Brussels] 3, no. 39 [30 September 1883]: 311–312).

115. "Nous savons aussi que Sargent est l'un des plus grands admirateurs de Frans Hals, avec lequel il a, notamment dans *El Jabo* [*sic*], exposé en 1882 à Paris, des affinités incontestables" ("Frans Hals et Manet," 311); Sargent to Julie Heyneman, quoted in Charteris, *John Sargent*, 140.

116. Sargent to William James, quoted in Charteris, *John Sargent*, 29.

117. Clipping from an unidentified New York newspaper; Burckhardt Scrapbook, John Singer Sargent Catalogue Raisonné Archive.

118. Sargent to Julie Heyneman, quoted in Charteris, *John Sargent*, 51.

119. For a list of the copies, see *Catalogue of Pictures and Water Colour Drawings by J. S. Sargent, R.A. and Works by Other Artists the Property of the Late John Singer Sargent* (London: Christie, Manson & Woods, 24 and 27 July 1925), cat. nos. 225–235.

120. Armand Silvestre, "Le Monde des Arts: Le Salon de 1882," *La Vie moderne*, 3 June 1882, 342; *Builder* (London), 20 May 1882 (Burckhardt Scrapbook, John Singer Sargent Catalogue Raisonné Archive).

121. *La Gironde*, 16 June 1882; Burckhardt Scrapbook, John Singer Sargent Catalogue Raisonné Archive.

122. "The Fine Arts," *Boston Daily Advertiser*, 2 February 1888, reporting a conversation overheard in 1883.

123. Brownell, "American Pictures at the Salon," 498.

124. Brownell, "The American Salon," 494.

125. Brownell, "American Pictures at the Salon," 498. He concluded, however, by finding a lack in Sargent: "In other words, the painter's ideal is merely conveyed to the beholder without being perfectly realised, and there is not that fulfilment of one of the oldest and least adequate definitions of a work of art, viz., the interpenetration of an object with its ideal. With Mr. Chase we have the object, with Mr. Sargent we have the ideal; with Velasquez, say, we have the identification of the two."

126. "The Salon. From an Englishman's Point of View," *Art Journal* (London) 44, no. 7 (July 1882): 218.

127. "American Artists in Paris," *World* (New York), dateline 28 June 1882; Burckhardt Scrapbook, John Singer Sargent Catalogue Raisonné Archive.

128. Claude Phillips, "The Royal Academy: III," *Academy* 31, no. 786 (28 May 1887): 383.

129. James, "John S. Sargent," 686.

130. Nicolai Cikovsky, Jr., provides a terse but substantive review of nineteenth-century attitudes toward Velázquez in his introduction to Volk, *John Singer Sargent's* El Jaleo, 17–19.

131. "American Art in the Paris Salon," *Art Amateur* 7, no. 3 (August 1882): 46. Curiously, however, he ended the review by speaking of the *Portrait de Mlle* *** and saying, "the artist had managed to give it such an indescribable quaintness of air and pose, and had treated it so thoroughly in the artistic spirit, that — in spite of its purplish, metallic flesh — one was instantly reminded of Velazquez."

132. "The Salon, Paris. (Fourth and Concluding Notice)," *Athenaeum* 2904 (23 June 1883): 803.

133. Sargent to Vernon Lee, undated [1884], Colby College.

134. One of the few places where Raphael's work was mentioned in connection to Sargent's noted that the attainment of the Italian painter's fluency and harmony "would overthrow realism, and is entirely incompatible with modern tendencies" (R. A. M. Stevenson, "J. S. Sargent," *Art Journal* [London] 50, no. 3 [March 1888]: 67).

135. "Le Salon de Paris: Quatrième article," *L'Art moderne* (Brussels) 4, no. 24 (15 June 1884): 194; André Michel, "Le Salon de 1884," *L'Art* 10, no. 37 (1884): 14; Du Seigneur, "L'Art et les artistes au Salon de 1882," 645; "The American Artists," *New-York Times*, 16 April 1880, 8; "The Royal Academy. [Fourth Notice]," *Athenaeum* 3111 [11 June 1887]: 772; "The Royal Academy. I," *Saturday Review* 63, no. 1645 (7 May 1887): 650; Maurice Du Seigneur, *L'Art et les artistes au Salon de 1880* (Paris: Paul Ollendorf, 1880), 104; *Galignani*, 8 May 1882; Carsency, *Le Contemporain*, 29 May 1882 — both, Burckhardt Scrapbook, John Singer Sargent Catalogue Raisonné Project; "Dialogue sur le Salon de 1883," *La Nouvelle Revue* 22 (May–June 1883): 714–715; *Athenaeum* 2950 (10 May 1884): 604; Charles Ponsonailhe, "Salon de 1886: La Peinture," *L'Artiste* 56, pt. 1 (June 1886): 427; "The Royal Academy. [Third Article]," *Times* (London), 22 May 1886, 3.

136. Benjamin Champney, *Sixty Years' Memories of Art and Artists* (Woburn, Mass.: News Print, 1900), 175–176.

137. "The Two New York Exhibitions," *Atlantic Monthly* 43 (June 1879): 781.

138. "America in Europe," *Magazine of Art* (London) 6 (1883): 6; "The Fine Arts. Sargent's 'El Jaleo,'" *Boston Daily Advertiser*, 3 November 1882, 5.

139. Unidentified clipping from the *New-York Daily Tribune*, March 1883; Burckhardt Scrapbook, John Singer Sargent Catalogue Raisonné Archive.

140. "The Picture Galleries. IV," *Saturday Review* 59, no. 1545 (6 June 1885): 756.

141. "Exhibition of the Royal Academy. Gallery I," *Art Journal* (London) 48, no. 6 (June 1886): 187.

142. Verhaeren, "Chronique Artistique: Exposition des XX (Second article)," 244.

143. *Phare de la Loire* (Nantes), 12 May 1882; Burckhardt Scrapbook, John Singer Sargent Catalogue Raisonné Archive.

144. "America in Europe," 6.

145. "Art Notes [August]," xli.

146. "The Picture Galleries. — IV," *Saturday Review* 53, 1387 (27 May 1882): 663.

147. I am grateful to Elaine Kilmurray for, among her many other generous sharings, bringing to my attention the reproduction of *Mme R. S.*

148. His sister gently complained: "He sent us a little watercolour sketch to give us an idea of the picture. . . . The 'Illustration' wants to engrave this one . . . apparently, so we had to return the watercolour as John said it would be very useful to the wood engraver" (Emily Sargent to Vernon Lee, 16 March 1880, Colby College).

149. Volk, *John Singer Sargent's* El Jaleo, cat. nos. 51–53. Volk's cat. no. 51 was in the *1882 Catalogue illustré du Salon* (Paris: L. Baschet, 1882), 54; her cat. no. 52 was published in Emmanuel Ducros, *Une Cigale au Salon de 1882* (Paris: L. Baschet, 1882), opp. 66.

150. Alfred de Lostalot, "Bibliographie: Salon Illustré de 1879," *Gazette des beaux-arts* 21, no. 2 (February 1880): 198. After 1883, Sargent rarely made drawings for the periodical press. In two instances where drawings by Sargent were used — referring to works shown in the Salon of 1884 and the Royal Academy of 1887 (*Gazette des beaux-arts* 29, no. 6 [June 1884]: 465; *Art Journal* [London] 50 [March 1888]: 68, respectively) — Sargent supplied drawings of details from a painting to stand for the whole. His talent as an illustrator came to the fore late in this period when he played the role literally, supplying seven designs to accompany the book *Spanish and Italian Folk Songs*, transcribed and translated by his friend Alma Strettell.

151. Henry James to Elizabeth Boott, 2 June 1884, quoted in *Henry James Letters, 1883–1895*, 42–43.

152. James, "John S. Sargent," 691.

153. Stevenson, "J. S. Sargent," 69.

154. Henry James to Henrietta Reubell, 24 May 1888; bMS Am 1094 (1078), by permission of the Houghton Library, Harvard University.

155. Henry James to Henrietta Reubell, 1 April 1888; bMS Am 1094 (1075), by permission of the Houghton Library, Harvard University. He reiterated the sentiments four days later: "'[V]ulgar' may not be really the word for the droll air he has given it. But if it isn't that, your subtlety must tell me what it is. Elle fait de l'oeil!" (Henry James to Henrietta Reubell, 5 April 1888; bMS Am 1094 [1076], by permission of the Houghton Library, Harvard University).

156. Henry James to Henrietta Reubell, 24 May 1888; bMS Am 1094 (1078), by permission of the Houghton Library, Harvard University.

157. Clarence Cook, *Art and Artists of Our Time*, 3 vols. (New York: Selmar Hess, 1888), 3:288. Cook went on to castigate the painter, especially for Sargent's awareness of and efforts to win over the public: "He is one of the most uncertain and disappointing of the younger men whose unquestioned talent has given them a commanding place in the public appreciation. Whatever he exhibits becomes at once a centre of interest, and is discussed with energy, often with heat, alike by artists and laymen: the former, in most cases, carried away by enthusiasm for the dash, the spontaneity, the sparkling life of the painter's handling; the latter amused, vexed, indignant, at the ugliness, the awkwardness, the fantastic defiance of convention, shown by the treatment of the subject. Whatever may be the final verdict on Mr. Sargent's merit as an artist, the possession of certain high qualities will never be denied him. He is undoubtedly a painter born, and yet, for an artist so strong in his technics, his pictures show a singular lack of individuality. At one time he was continually reminding us of Carolus Duran; but of late his admirers are insisting on his relationship to Velasquez. We wish we knew what Mr. Sargent really is, as a painter. He wears so many masks, and plays, with ill-concealed delight, so many tricks that it is impossible to guess what sort of pictures he would paint if he were working on a desolate island with no one to astonish, no one to confound, and no one to assure him that he was born to make Titian and Velasquez forgotten" (3:288–290).

158. Olson, *Sargent: His Portrait*, 227–228.

159. "The Salon. From an Englishman's Point of View," *Art Journal* (London) 44, no. 7 (July 1882): 218.

160. Buisson, "Le Salon de 1881," 44. Even away from the Salon, however, his breaking with formulas could prompt abuse: "Que de peine se donne cet artiste pour nous faire croire qu'il peint en se jouant! Je ne connais rien d'agaçant comme les laborieux chercheurs d'impromptus" (Dargenty, "Exposition Internationale des Peintres & des Sculpteurs," 40).

161. Olson, *Sargent: His Portrait*, 78–79. Henry James built his comic novel *The Reverberator* on this kind of situation (and in part on Sargent's life and activities).

162. "L'Exposition de l'Académie royale des beaux arts à Londres," *L'Art moderne* (Brussels) 2, no. 23 (4 June 1882): 180.

Catalogue

1. Fitzwilliam Sargent to his sister, 1 March 1877; quoted in Stanley Olson, *John Singer Sargent: His Portrait* (New York: St. Martin's Press, 1986), 56.

2. Sargent to Heath Wilson, 23 May 1874; see note 7 to "Sargent and Carolus-Duran," above. I would like to thank Bethany Taylor, Williams College M.A. '96, for bringing the striking parallel between the two portraits to my attention.

3. Emily Sargent to Vernon Lee, 29 July 1877, Colby College. Emily goes on to say that an "old French artist who has been going to Cancale for the last fifteen years, is at the same and only Hôtel there, and even he finds the same difficulty as John does, inspite of his age & experience." The French painter best known for scenes of Cancale during these years was Augustin Feyen-Perrin.

4. Fitzwilliam Sargent to Tom Sargent, 3 April 1878, Archives of American Art, Smithsonian Institution, roll D317, frames 553–554.

5. Roger-Ballu, "Le Salon de 1878," *Gazette des beaux-arts* 18, no. 1 (July 1878): 185, and reproduction 179.

6. Emily Sargent to Vernon Lee, 24 July 1878; quoted in Richard Ormond, "John Singer Sargent and Vernon Lee," *Colby Library Quarterly* 9, no. 3 (September 1970): 162.

7. Fitzwilliam Sargent to Tom Sargent, 3 April 1878, Archives of American Art, Smithsonian Institution, roll D317, frames 553–554. The winner of the lottery was Samuel Colman; see cat. 2.

8. Charles E. DuBois to J. Alden Weir, 2 March 1878, Archives of American Art, Smithsonian Institution, roll 71, frame 1085.

9. William C. Brownell, "The Younger Painters of America. First Paper," *Scribner's Monthly* 20, no. 1 (May 1880): 12, reproduction 7.

10. Emily Sargent to Vernon Lee, 24 July 1878; quoted in Ormond, "Sargent and Vernon Lee," 162.

11. The fullest discussion of the ceiling painting to date is Charles Merrill Mount, "Carolus-Duran and the Development of Sargent," *Art Quarterly* 26, no. 4 (1963): 386–387.

12. The actress Helena Modjeska observed one stage in the progress of the work. She later related: "One morning a tall, attractive young man came in and was introduced by Monsieur Duran as 'Mr. John Sarrrgent, of Amerrrica.' The young artist had brought with him a small canvas. . . . In an hour or so he made a sketch which looked to me like a finished portrait in its wonderful likeness. When he left the room, Carolus said,

'Il a du talent, ce garçon-la!' It was a sort of off-hand praise" (quoted in Olson, *Sargent: His Portrait*, 67).

13. Charles E. DuBois to J. Alden Weir, 14 May 1879, Archives of American Art, Smithsonian Institution, roll 71, frame 1067.

14. Gifford Eldredge (Williams College, M.A. '96) has studied Sargent's time on Capri to especially good effect. See also Marc Simpson, "Two Recently Discovered Paintings by John Singer Sargent," *Yale University Art Gallery Bulletin* 38, no. 1 (Fall 1980): 6–11.

15. Olson, *Sargent: His Portrait*, 69.

16. Charles E. DuBois to J. Alden Weir, 14 May 1879, Archives of American Art, Smithsonian Institution, roll 71, frame 1067.

17. Sargent to Ben del Castillo, ca. 10 August 1878, quoted in Evan Charteris, *John Sargent* (New York: Charles Scribner's Sons, 1927), 47.

18. "The Academy Exhibition," *New-York Times*, 2 May 1879, 5. Gretchen Sinnett, Williams College M.A. '96, has explored this work, its criticism, and its relation to contemporary European painting as fully as has any work in print; she presented her findings at the First Annual Williams College Graduate Program in the History of Art Symposium, May 1996.

19. Emily Sargent to Vernon Lee, 3 September 1879, Colby College.

20. Indeed, the connection with the Charpentier portrait becomes more likely given the fact that in 1879 Mme Charpentier's family had begun a journal of art and affairs, *La Vie moderne*, that, while illustrated and a weekly, nonetheless was competitively concerned with some of the same issues as the Bulozes' *Revue des deux mondes.*

21. Sargent to Ben del Castillo, 4 January 1880; quoted in Charteris, *John Sargent*, 50. The "we" here refers to at least one of Sargent's two traveling companions from the Spanish trip, Ferdinand-Sigismund Bach (1859–1952) and Charles-Edmond Daux (active 1878) (as identified by Olson, *Sargent: His Portrait*, 70).

22. Emily Sargent to Vernon Lee, undated [summer 1880], Colby College. Almost a decade later he wrote to Vernon Lee as she was planning her own trip to the region, advising her on what to do and where to go ([ca. September] 1888, Colby College).

23. "John returned to Paris about a month ago, leaving Tangiers in haste as the rains had begun, & he could not continue his picture of an Arab woman which he was painting in the patio of the little house his friend & he hired for a studio" (Emily Sargent to Vernon Lee, 16 March 1880, Colby College).

24. Sargent to Vernon Lee, 9 July 1880; quoted in Ormond, "Sargent and Vernon Lee," 163; dated by Olson, *Sargent: His Portrait*, 74.

25. Vernon Lee to her mother, 21 June 1881; quoted in *Vernon Lee's Letters*, edited by her executor [Irene Cooper Willis] (London: privately printed, 1937), 63.

26. After describing the scene, Emily Sargent noted: "It is very original & I like it extremely. If it is photographed you shall have one. The 'Illustration' wants to engrave this one & John's portrait of Mm Pailleron before they are sent to the Salon, apparently" (Emily Sargent to Vernon Lee, 16 March 1880, Colby College). *Fumée d'ambre gris* appeared in *L'Illustration*'s composite overview of the Salon on 22 May 1880.

27. Emily Sargent to Vernon Lee, 23 May 1880, Colby College.

28. "The Studio: American Art News," *Art Interchange* 5, no. 6 (15 September 1880): 52; "Pencil Sketches," *American Art Journal* 33, no. 23 (2 October 1880): 363; Montezuma [Montague Marks], "My Note Book," *Art Amateur* 3, no. 6 (November 1880): 113 — each promised that the work was on its way to Philadelphia, where it did not arrive.

29. Sargent to Vernon Lee, 4 September 1874; quoted in Ormond, "Sargent and Vernon Lee," 160. Fear of illness was another factor. He wrote of a trip projected for summer of 1874, but "our destination has been changed by reports of Cholera in Venice and of unique artistic training in Paris, so that we are bound for the latter place" (Sargent to Mrs. Austin, 25 April 1874, quoted in Charteris, *John Sargent*, 19).

30. The fullest discussions of Sargent in Venice are Linda Ayres, "Sargent in Venice," in Patricia Hills et al., *John Singer Sargent*, exh. cat. (New York: Whitney Museum of American Art, 1986), 49–73; Erica E. Hirshler, "'Gondola Days': American Painters in Venice," and Sargent catalogue entries, *The Lure of Italy: American Artists and the Italian Experience, 1760–1914*, exh. cat. (Boston: Museum of Fine Arts, 1992), 112–128, 398–409; Margaretta M. Lovell, Sargent biography and catalogue entries, *Venice: The American View, 1860–1920*, exh. cat. (San Francisco: Fine Arts Museums, 1984), 95–126; Margaretta M. Lovell, *A Visitable Past: Views of Venice by American Artists, 1860–1915* (Chicago: University of Chicago Press, 1989); Margaretta M. Lovell, "John S. Sargent's Venice," *Bollettino del Centro Interuniversitario di Ricerche sul Viaggio in Italia* 8, nos. 1–2 (1987): 61–94; Donna Seldin, *Americans in Venice, 1879–1913*, exh. cat. (New York: Coe Kerr Gallery, 1983).

31. "Your letter only reached me yesterday evening. Mr. Sargent forwarded it to me from Venice where it had followed him, that accounts for the delay. I thank you very much for all the kind things you say about my work" (Cassatt to J. Alden Weir, 10 March 1878; quoted in Nancy Mowll Mathews, ed., *Cassatt and Her Circle: Selected Letters* [New York: Abbeville Press, 1984], 137).

32. Emily Sargent to Vernon Lee, 22 September 1880, Colby College; quoted in Richard Ormond, *John Singer Sargent: Paintings, Drawings, Watercolors* (New York: Harper & Row, 1970), 95, n. 32.

33. Sargent to Mrs. Paget, 27 September 1880; quoted in Ormond, *John Singer Sargent*, 29.

34. Sargent to Vernon Lee, 22 October 1880; quoted in Olson, *Sargent: His Portrait*, 94.

35. L. V. Fildes, working from his father's diary, reports that the British genre painter arrived in Venice on 10 January 1881, met Sargent that first evening, and that they "were constantly meeting during the next two months" (*Luke Fildes, R.A.: A Victorian Painter* [London: Michael Joseph, 1968], 68–69).

36. Vernon Lee to her mother, 11 September 1885; reprinted in *Vernon Lee's Letters*, 202.

37. Sargent to Mrs. Paget, 16 August 1882; quoted in Ormond, *John Singer Sargent*, 29.

38. Charteris, *John Sargent*, 57.

39. The portraits include those of Mrs. Daniel Curtis (1882; Helen Foresman Spencer Museum of Art, University of Kansas), Gordon Greenough (1880; private collection, with a drawing in the Mead Art Gallery, Amherst College), Thornton Lothrop (1882; private collection), Ramón Subercaseaux in a gondola (1880; Dixon Gallery and Gardens, Memphis), and at least two of the Venetian model Gigia Viani (?1880, Fogg Art Museum; 1882, Cincinnati Art Museum).

40. Henry James, *Princess Casamassima* (1886), in *Henry James: Novels, 1886–1890* (New York: Library of America, 1989), 351–352.

41. Several scholars have lately speculated about the sexual impropriety implicit in these scenes, paralleling recent work done on, for example, Degas's paintings of ballet scenes. See Ayres, "Sargent in Venice"; Lovell, *Venice: The American View;* and Trevor Fairbrother, "Sargent's Genre Paintings and the Issues of Suppression and Privacy," *Studies in the History of Art* 37 (1990): 28–49.

42. Quoted in Fildes, *Luke Fildes, R.A.*, 67.

43. Brimmer to Sarah Wyman Whitman, 26 October 1882, Archives of American Art, Smithsonian Institution, roll D32, frames 184–185.

44. Sargent to Mrs. Daniel Curtis, 4 December 1882; quoted in Mark Evans, *Impressions of Venice from Turner to Monet*, exh. cat. (Cardiff: National Museum of Wales in association with Lund Humphries, 1992), 45.

45. Erica E. Hirshler wrote of the Americans of the 1870s and 1880s, that "once they came to Venice, they joined an international circle of artists, whose 'names are legion'" (Hirshler, "'Gondola Days': American Painters in Venice," 123; quoting F. Hopkinson Smith, *Gondola Days* [Boston: Houghton Mifflin, 1897], 56).

46. Frederick Wedmore, "Genre in the Summer Exhibitions," *Fortnightly Review* 33, no. 198 (1 June 1883): 868.

47. Claude Phillips, "Quelques expositions à Londres," *La Chronique des arts et de la curiosité* 7, no. 15 (12 April 1884): 121; "Royal Academy: Second Notice," *Times* (London), 12 May 1884, 4.

48. For a chronology and discussion of Whistler in Venice, see Margaretta Lovell and Marc Simpson, biography and entries in Lovell, *Venice: The American View*, 134–169.

49. See, for example: "The Academy of Design," *New-York Daily Tribune* 31 March 1888, 4; "Catholicity in Art, *New York Herald*, 31 March 1888, 4; "Portraits at the Academy," *New-York Times*, 8 April 1888, 10.

50. "London Pictures," *Atlantic Monthly* 50, no. 298 (August 1882): 259.

51. Henry James, "John S. Sargent," *Harper's New Monthly Magazine* 75, no, 449 (October 1887): 689.

52. Margaretta Lovell was the first to associate the James criticism with this painting, in *Venice: The American View*, 104. The fact that the work was for many years in the Subercaseaux family collection, the "friend from Paris" with whom Sargent painted on this 1880 trip, and whom Sargent painted as seated and sketching in a gondola, lends further support to this hypothesis.

53. Un Vieux Parisien [Antoine Genevay], "Salon de 1879. Cinquième article," *Le Musée artistique et littéraire* 1 (1879): 372.

54. Fitzwilliam Sargent to Tom Sargent, 20 September 1879, Archives of American Art, Smithsonian Institution, roll D317, frame 438.

55. Fitzwilliam Sargent to Tom Sargent, 15 August 1879, Archives of American Art, Smithsonian Institution, roll D317, frames 434–435.

56. Olson, *Sargent: His Portrait*, 77.

57. A. Genevay, "Salon de 1881 (Troisième article)," *Le Musée artistique et littéraire* 5, no. 21 (1881): 324.

58. This has been noted by writers of Sargent's time as well as our own. See, for a recent opinion to this effect, Gary A. Reynolds, "Sargent's Late Portraits," in Hills et al., *John Singer Sargent*, 149.

59. Maurice Du Seigneur, *L'Art et les artistes au Salon de 1881* (Paris: Paul Ollendorf, 1881), 204.

60. Subercaseaux recounted that seeing both the portrait of Madame Pailleron and *Fumée d'ambre gris* at the Salon of 1880 impressed him to the extent that he called on the painter's studio (Ramón Subercaseaux,

Memorias de ochenta años, 2 vols. [Santiago: Editorial Nascimento, 1936], 1:388).

61. Du Seigneur, *L'Art et les artistes au Salon de 1881*, 204.

62. Subercaseaux, *Memorias de ochenta años*, 1:388. Subercaseaux erroneously recalled the award as being a first-class medal.

63. Sargent to Ben del Castillo, June 1881; quoted in Charteris, *John Sargent*, 55.

64. G. B., *Indépendance Belge*, 1 May 1882 (Burckhardt Scrapbook; John Singer Sargent Catalogue Raisonné Archive).

65. For a thorough overview, see Mary Crawford Volk, *John Singer Sargent's El Jaleo*, exh. cat. (Washington, D.C.: National Gallery of Art, 1992).

66. The fullest discussion of the affair, based on the diaries of Sargent's friend J. Carroll Beckwith, is in Olson, *Sargent: His Portrait*, 87–92.

67. Vernon Lee to her brother, 5 July 1882; Vernon Lee to her mother, 5 August 1885; both quoted in *Vernon Lee's Letters*, 96 and 189, respectively. For an exploration of Lee's "immoderate, sometimes vindictive" assessments of the people she met, see Richard Cary, "Vernon Lee's Vignettes of Literary Acquaintances," *Colby Library Quarterly* 9, no. 3 (September 1970): 179–199.

68. This point is illustrated, for example, in Ormond, *John Singer Sargent*, figures 10 and 11.

69. Vernon Lee to her mother, 8 June 1882; quoted in *Vernon Lee's Letters*, 84.

70. The many portraits of artist and writer friends — Eugène Carrière (ca. 1880; Sheldon Memorial Art Gallery, University of Nebraska, Lincoln), François Flameng and Paul Helleu (ca. 1883–1885, private collection), and Edmund Gosse (ca. 1886; National Portrait Gallery, London), among many others stretching to at least 1914 — testify to Sargent's habitual recreation in this fashion, as do his portraits of various hostesses — Mrs. Daniel Curtis (1882; Helen Foresman Spencer Museum of Art, University of Kansas, Lawrence), Christine Blaze Buloz (1879; Los Angeles County Museum of Art), and Lily Millet (ca. 1886; private collection).

71. Vernon Lee to her mother, letter dated 22 June although describing a dinner on the evening of 24 June 1882; quoted in *Vernon Lee's Letters*, 91.

72. Vernon Lee to her mother, 16 June 1882; quoted in *Vernon Lee's Letters*, 87.

73. Olson, *Sargent: His Portrait*, 93, 101–102; Arthur Gold and Robert Fizdale, *Misia: The Life of Misia Sert* (New York: Morrow Quill, 1981), 24; Albert Boime, "Sargent in Paris and London: A Portrait of the Artist as Dorian Gray," in Hills et al., *John Singer Sargent*, 85–86.

74. Sargent to Henry James, 29 June 1885; bMS Am 1094 (396), by permission of the Houghton Library, Harvard University.

75. Albert Wolff in *Le Figaro*, quoted in Charteris, *John Sargent*, 62 n. To complicate the message, however, Madame Gautreau wears a crescent-moon headdress that alludes to Diana, chaste goddess of the hunt. For a complete discussion of the work, the gown, and the changes Sargent was to make in its disposition, see Trevor J. Fairbrother, "The Shock of John Singer Sargent's 'Madame Gautreau,'" *Arts Magazine* 55 (January 1981): 90–97. The work has been studied most recently, and intriguingly, by Susan Sidlauskas in "Painting Skin: Decay and Resistance in Sargent's *Madame X*," a paper presented at the 1997 College Art Association meeting.

76. Ormond, *John Singer Sargent*, 242.

77. Sargent to Vernon Lee, 10 February 1883; quoted in Ormond, "John Singer Sargent and Vernon Lee," 173.

78. It is not clear whether the change in the head was a part of the initial process (Ormond, *John Singer Sargent*, 242) or a later adjustment made at the sitter's request (Olson, *Sargent: His Portrait*, 100).

79. Perdican, "Courrier de Paris," *L'Illustration* 77, no. 1999 (18 June 1881): 412. This passage was the beginning point for one of the most interesting modern interpretations of the painting and its context, Albert Boime's "Sargent in Paris and London," 86–93.

80. Sargent to Ben del Castillo, undated (Charteris implies 1881); quoted in Charteris, *John Sargent*, 59.

81. Sargent to Vernon Lee, 10 February 1883; quoted in Ormond, *John Singer Sargent*, 31.

82. Sargent to Margaret S. R. White, 15 March 1883; Archives of American Art, Smithsonian Institution, roll 647, frames 856–858. As late as 29 March, a newspaper was reporting that Sargent was sending the portrait of Madame Gautreau ("Chronique des ateliers. Envois au Salon de 1883," *Courrier de L'Art* 3, no. 13 [29 March 1883]: 147).

83. Sargent to Vernon Lee, August or September 1883; quoted in Ormond, "Sargent and Vernon Lee," 174.

84. Sargent to Albert de Belleroche, summer 1883; quoted in Mount, "Carolus-Duran and the Development of Sargent," 398.

85. Sargent to Ben del Castillo, ca. 1884; quoted in Charteris, *John Sargent*, 59–60.

86. This follows the traditional thought concerning the Tate work. Trevor Fairbrother, however, observing that the Tate Gallery version does not position the strap, posits that it postdates the Salon exhibition and furor ("The Shock of John Singer Sargent's 'Madame Gautreau,'" 95).

87. Ralph Curtis to his parents, ca. 2 May 1884; quoted in Charteris, *John Sargent*, 61–62.

88. Vernon Lee to her mother, 8 June 1884; quoted in *Vernon Lee's Letters*, 143. The day before, she reported, Sargent had entertained Oscar Wilde and Paul Bourget — so he was far from secluding himself or avoiding people.

89. Five years later, Theodore Child, one of the truly gifted critics of his generation, wrote: "[T]he wild and coarse criticism with which the public honored [*Madame X*] proves only how dangerous it is for an artist to dare to produce something uncommon, instead of being content to be persistently and resolutely vulgar" ("American Artists at the Paris Exposition," *Art Amateur* 21, no. 6 [November 1889]: 106–107).

90. Marie Bashkirtseff, *The Last Confessions of Marie Bashkirtseff and Her Correspondence with Guy de Maupassant*, ed. Jeanette Gilder (New York: Frederick A. Stokes, 1901), 87.

91. Vernon Lee to her mother, 5 September 1885 and 16 July 1885; in *Vernon Lee's Letters*, 199, 177, respectively. For a discussion of Lee's novel *Miss Brown* and its effect on her career, see Léonee Ormond, "Vernon Lee as a Critic of Aestheticism in *Miss Brown*," *Colby Library Quarterly* 9, no. 3 (September 1970): 131–154.

92. In., "A propos de portraits de femmes," *La Vie parisienne* 24, no. 25 (19 June 1886): 349.

93. Sargent to Edward Robinson, 8 January 1916, Metropolitan Museum of Art Library.

94. Robert de Montesquiou, "Le Pavé rouge: Quelques réflexions sur 'l'Oeuvre' de M. Sargent," *Les Arts de la vie* (1905); translated by and quoted in Edgar Munhall, *Whistler and Montesquiou: The Butterfly and the Bat*, exh. cat. (New York: Frick Collection, 1995), 138.

95. Sargent to Vernon Lee, ca. February 1884, Colby College.

96. Sargent to Henry James, 25 May 1884; bMS Am 1094 (395), by permission of the Houghton Library, Harvard University. He is probably referring to his portrait of Kate Moore (1884; Hirshhorn Museum).

97. Fitzwilliam Sargent to Tom Sargent, 17 June 1884; Archives of American Art, Smithsonian Institution, roll D317, frame 477.

98. Fitzwilliam Sargent to Tom Sargent, 19 December 1884; Archives of American Art, Smithsonian Institution, roll D317, frame 479.

99. Sargent to Vernon Lee, 4 December 1884; quoted in Ormond, "Sargent and Vernon Lee," 177.

100. Henry James to Elizabeth Boott, 2 June 1884; quoted in *Henry James Letters, 1883–1895*, ed. Leon Edel (Cambridge, Mass.: Belknap Press of Harvard University Press, 1980), 42–43.

101. Vernon Lee provided a full report to her mother, 4 July 1884; in *Vernon Lee's Letters*, 152–153.

102. The fullest treatment of the work is James Hamilton, The Misses Vickers: *The Centenary of the Painting by John Singer Sargent*, exh. cat. (Sheffield: City Council Arts Department, 1984).

103. Henry James to Vernon Lee, 21 October 1884; quoted in *Henry James Letters, 1883–1895*, 50.

104. Charles Ponsonailhe, "Salon de 1885: La Peinture (Suite): III," *L'Artiste* 55, pt. 1 (June 1885): 452.

105. Sargent to Henry James, 29 June 1885; bMS Am 1094 (396), by permission of the Houghton Library, Harvard University.

106. Mrs. Stevenson wrote in 1885 to a mutual friend, concerning one of Sargent's visits: "[A]s I said to Sargent, 'I am but a cipher under the shadow,' to which he too eagerly assented" (E. V. Lucas, *The Colvins and Their Friends* [London: Methuen, 1928], 162).

107. Robert Louis Stevenson to Will Low, 22 October 1885; Sidney Colvin, *The Letters of Robert Louis Stevenson* (New York: C. Scribner's Sons, 1899), 428–429.

108. Fanny Stevenson to Sidney Colvin, 22 April 1887; quoted in Lucas, *The Colvins and Their Friends*, 164, there misdated to 1885. The manuscript is in the Stevenson Papers, Beinecke Rare Book and Manuscript Library, Yale University, MS B3650.

109. Fanny Stevenson to William Archer, 30 April 1887; C. Archer, *William Archer: Life, Work and Friendships* (New Haven: Yale University Press, 1931), 149–150. She did manage to have a photograph made of it before Sargent had the work framed, boxed, and ready for Fairchild to carry back to America. The preparations were completed when Sargent was in Paris; he wrote to Charles Fairchild with all the relevant details on 4 June 1887 (Boston Athenaeum, Sargent Papers, Box 1, Folder 18). See also Diana Strazdes, "American Paintings and Sculpture," *The Taft Museum: European and American Paintings* (New York: Hudson Hills Press, 1995), 296.

110. Curiously, in the Burckhardt Scrapbook there is a transcript of a letter from Sargent to Louise Burckhardt's sister that suggests that sometime in the early twentieth century the family proposed that Sargent paint out the figure of the younger woman (Sargent to Valerie Burckhardt Hadden, 8 March [no year]; John Singer Sargent Catalogue Raisonné Archive).

111. "Mr. J. S. Sargent, so lately an idol of the fickle Parisians, but whom, after unduly exalting, they had with equal lack of moderation cast down

from his pedestal . . . has migrated to England, where, as will be in the recollection of all, he has already 'imposed' himself with surprising success, considering the uncompromising character of his style. Paris is, it may be supposed, a little surprised, a little shocked, at the want of taste evidenced in such an abandonment; for . . . she delights in casting off her aspirants, but cannot brook that they should reverse the process and take her *bouderies* seriously" (Claude Phillips, "The Americans at the Salon," *Magazine of Art* [London] 10 [1887]: 421).

112. Henry Adams, *Handbook of American Paintings* (Kansas City, Mo.: Nelson-Atkins Museum of Art, 1991), 41.

113. Adams, *Handbook of American Paintings*, 41.

114. When grown, the Barnard sisters, neither of whom married, often traveled with Sargent and were among his close friends.

115. Edwin Austin Abbey to Charles Parsons, 28 September 1885; quoted in E. V. Lucas, *Edwin Austin Abbey, Royal Academician: The Record of His Life & Work*, 2 vols. (London: Methuen, 1921), 1:151.

116. Sargent to Robert Louis Stevenson; quoted in Trevor Fairbrother, *John Singer Sargent* (New York: Harry N. Abrams in association with The National Museum of American Art, Smithsonian Institution, 1994), 64.

117. Sargent to [Edwin] Russell, 10 September 1885, Tate Gallery, Archives.

118. Sargent to Emily Sargent, late September 1885; facsimile reproduced in Charteris, *John Sargent*, between 76–77.

119. Edmund Gosse to Evan Charteris, ca. 1925; quoted in Charteris, *John Sargent*, 74–75.

120. For extended discussions of the work and its progress, see Richard Ormond, "Carnation, Lily, Lily, Rose," in *Sargent at Broadway: The Impressionist Years*, exh. cat. (New York: Coe Kerr Gallery, 1986), 63–75; and Marc Simpson, "Reconstructing the Golden Age: American Artists in Broadway, Worcestershire, 1885–1889" (Ph.D. diss., Yale University, 1993), 307–339, 429–461.

121. Vernon Lee to her mother, 30 June 1887; quoted in *Vernon Lee's Letters*, 252. From the perspective of forty years, she summarized the work as giving her the same happiness as "the slow movement of certain Mozart quartets." She went on: "And when left to itself Sargent's outspoken love of the exotic was but the unavowed love of rare kinds of beauty, [such as] the heavenly loveliness of transient light and evanescent youth in his *Carnation Lily*. The endless labour on that (surely his true) masterpiece would have been justified by himself on the score of 'effects' of mingled twilight and lantern-light on faces and flowers and greensward; effects (he would have called them 'curious' and later 'amusing') — to be faithfully reproduced because such arduous conquests of 'reality' were the puritan painter's excuse for his art. But the result of it all was the most poetical figure-picture of modern times, a picture, as Mary Duclaux said on its first appearance, which was really an altar-piece, those Barnard children in pinafores becoming more than Botticellian angels lighting up the shrine of an invisible Madonna, a Madonna immanent in the roses and lilies and the fading summer afternoon" ("J.S.S.: In Memoriam," in Charteris, *John Sargent*, 252).

122. R. A. M. Stevenson wrote of it as "primarily a decorative picture in spite of its conformity to actual truth" (R. A. M. Stevenson, "J. S. Sargent," *Art Journal* [London] 50, no. 3 [March 1888]: 69).

123. Even the most negative and harsh review that Sargent has ever received, Roger Fry's response to the Royal Academy Memorial Exhibition of 1926, contained a germ of praise for the work: "Then came 'Carnation, Lily, Lily, Rose,' which seemed a new revelation of what colour could

be and what painting might attempt, and of how it could be at once decorative and realistic. When I look now at the thin and tortured shapes those lily petals make on the lifeless green background, I realize that what thrilled us all then was the fact that this picture was the first feeble echo which came across the Channel of what Manet and his friends had been doing with a far different intensity for ten years or more. This new colour was only a vulgarisation of the new harmonies of the Impressionists; this new twilight effect only an emasculated version of their acceptance of hitherto rejected aspects of nature" (Roger Fry, "J. S. Sargent as Seen at the Royal Academy Exhibition of His Works, 1926, and in the National Gallery," *Transformations: Critical and Speculative Essays on Art* [London: Chatto & Windus, 1926], 125–126).

124. Sargent to [Edwin] Russell, 10 September 1885, Tate Gallery Archives.

125. Fitzwilliam Sargent to Tom Sargent, 13 May 1886, Archives of American Art, Smithsonian Institution, roll D317, frame 486.

126. Vernon Lee to her mother, 25 June 1885; in *Vernon Lee's Letters*, 171.

127. Vernon Lee to her mother, 25 June 1881; in *Vernon Lee's Letters*, 65. She added: "He says I sit very well; the goodness of my sitting seems to consist in never staying quiet a single moment."

128. Edmund Gosse to Evan Charteris, ca. 1925; quoted in Charteris, *John Sargent*, 74–75.

129. Fourcaud, "Portraits," in Charles Carroll, ed., *The Salon*, 2 vols. (New York: Samuel L. Hall, 1881), 2:369.

This section attempts to document the works John Singer Sargent put on public display from 1877 to 1887. Exhibition information includes: city of exhibition; title of exhibition or, when not available, organizing entity; and dates of exhibition. Numbered captions for the illustrations include title of work shown (from catalogue or, when not available, reviews); catalogue number of work (number of comparable works in exhibition, as well as notes concerning owner or price);♣ title of work as it is now known, date, dimensions (in inches, height preceding width), and current location. Unless otherwise noted, works are oil on canvas.

For paintings in the present exhibition, catalogue numbers are provided. Objects that Sargent put before the public more than once have a corresponding number of entries.

In some instances scholars can only speculate as to which works were shown where: this is especially the case with the exhibitions of the various Parisian *cercles,* the Grosvenor Gallery, and the New English Art Club. In most cases, critical responses, witness accounts, traditional histories, and other non-document-oriented materials can lead to an informed guess, which is indicated by a question mark preceding the current title of the work; two question marks preceding the current title—most frequent before the Venetian genre scenes—indicate greater uncertainty in the proposed identification.

Appendix:
Sargent's Exhibition
History, 1877–1887

France

1877

A1. *Portrait de Mlle W . . .* 1912 (of 2192 paintings). ♧ *Fanny Watts,* 1877 (cat. 1). 41 5/8 × 32 7/8. Philadelphia Museum of Art.

Paris
Salon de 1877
1 May–20 June 1877

A1

1878

A2. *Portrait d'une dame.* Etats-Unis 88 (of 144 paintings and watercolors; in some editions: 94 [owned by Miss F. Watts]). ♧ *Fanny Watts,* 1877 (cat. 1). 41 5/8 × 32 7/8. Philadelphia Museum of Art.

A3. *En route pour la peche.* 2008 (of 2330 paintings). ♧ *Oyster Gatherers of Cancale,* 1878 (cat. 3). 31 × 48. The Corcoran Gallery of Art.

A4. Duran (Carolus): *Gloria Mariae Medicis: Plafond décoratif pour l'une des salles du Musée du Luxembourg.* 842 (of 2330 paintings). [Sargent's contribution was not acknowledged in the catalogue.] ♧ Carolus-Duran, *Gloria Mariae Medicis,* 1878. Musée du Louvre.

A5. *Fishing for Oysters at Cancale.* 23 (of 124 works; $200). ♧ *Fishing for Oysters at Cancale,* 1878 (cat. 2). 16 1/4 × 23 3/4. Courtesy Museum of Fine Arts, Boston.

Paris
Exposition universelle internationale
1 May–28 October 1878

A2

Paris
Salon de 1878
25 May–19 August 1878

A3

A4

1879

A6. *Portrait de M. Carolus-Duran.* 2697 (of 3040 paintings). ♧ *Carolus-Duran,* 1879 (cat. 4). 46 × 37 3/4. Sterling and Francine Clark Art Institute, Williamstown, Mass.

A7. *Dans les oliviers, à Capri (Italie).* 2698 (of 3040 paintings). ♧ *Among the Olive Trees, Capri,* 1879 (cat. 7). 30 1/2 × 25. Private collection.

A8. *A Capriote.* 37 (of 166 works; for sale). ♧ *A Capriote,* 1878 (cat. 6). 30 1/4 × 25. Courtesy Museum of Fine Arts, Boston.

A9. *Neapolitan Children Bathing.* 431 (of 615 works; owner: G. M. Williamson). ♧ *Neapolitan Children Bathing,* 1879 (cat. 8). 10 1/2 × 16 1/8. Sterling and Francine Clark Art Institute, Williamstown, Mass.

A10. *Scene in the Luxembourg.* One of 165 works. ♧ *In the Luxembourg Gardens,* 1879. 25 1/2 × 36. Philadelphia Museum of Art, John G. Johnson Collection.

Paris
Salon de 1879
12 May–30 June 1879

A6

A7

United States

Great Britain

New York
Society of American Artists First Exhibition
6 March–5 April 1878

A5

New York
Society of American Artists
 Second Exhibition
10 March–29 March 1879

A8

New York
National Academy of Design,
 then Leavitt: John H. Sher-
 wood and Benjamin Hart sale
December 1879; sale on 17 De-
 cember 1879

A10

New York
National Academy of Design
 Fifty-fourth Annual
 Exhibition
1 April–31 May 1879

A9

1880

A11. *Portrait de Mme E. P . . .* 3428 (of 3957 paintings). ✹ *Mme Edouard Pailleron,* 1879 (cat. 9). 82 × 39 1/2. The Corcoran Gallery of Art.

A12. *Fumée d'ambre gris.* 3429 (of 3957 paintings). ✹ *Fumée d'ambre gris,* 1880 (cat. 10). 54 3/4 × 35 5/8. Sterling and Francine Clark Art Institute, Williamstown, Mass.

A13. *Portrait of Carolus-Duran.* (Not included among the 162 numbered works in the catalogue). ✹ *Carolus-Duran,* 1879 (cat. 4). 46 × 37 3/4. Sterling and Francine Clark Art Institute, Williamstown, Mass.

A14. *Oyster Fishing at Cancale.* ✹ *Fishing for Oysters at Cancale,* 1878 (cat. 2). 16 1/4 × 23 3/4. Courtesy Museum of Fine Arts, Boston.

A15. *Portrait of Carolus Duran.* 27 (of 142 works). ✹ *Carolus-Duran,* 1879 (cat. 4). 46 × 37 3/4. Sterling and Francine Clark Art Institute, Williamstown, Mass.

France

Paris
Salon de 1880
1 May–20 June 1880

A11 A12

1881

A16. *Etude fait à Venise.* ✹?? *A Street in Venice,* ca. 1880 (cat. 11). 29 1/2 × 20 5/8. Sterling and Francine Clark Art Institute, Williamstown, Mass.

A17. *Etude fait à Venise.* ✹?? *Venetian Glass Workers,* ca. 1880 (cat. 12). 22 1/4 × 33 3/4. Art Institute of Chicago.

A18. *Portrait de Mme R. S . . .* 2108 (of 2448 paintings). ✹ *Mme Ramón Subercaseaux,* 1880. 65 × 43 1/4. Private collection.

A19. *Portrait de M. E. P . . . et de Mlle L. P . . .* 2109 (of 2448 paintings). ✹ *Edouard and Marie-Louise Pailleron,* 1881 (cat. 20). 60 × 69. Des Moines Art Center.

A20. *Vue de Venise:—aquarelle.* 3413 (of 3559 paintings and watercolors). ✹?? *Café on the Riva degli Schiavone, Venice,* 1880. Watercolor on paper, 9 1/2 × 13 1/2. Private collection.

A21. *Vue de Venise:—aquarelle.* 3414 (of 3559 paintings and watercolors). ✹?? *A Venetian Interior,* 1880. Watercolor on paper, 20 × 14. Collection of Mr. and Mrs. Harry Spiro.

A22. *Capri Peasant—Study.* 73 (of 147 works). ✹ *Head of Ana-Capri Girl,* 1878 (cat. 5). 9 × 10. Private collection.

A23. *Portrait of Mr. B.* 92 (of 147 works; owner: Mrs. H. Haddon). ✹ *Edward Burckhardt,* 1880. 21 3/4 × 18 1/4. Private collection.

A24. *Portrait* ✹ *Beatrix Chapman.* Destroyed during World War II.

A25. *Portrait* ✹ *Eleanor Chapman.* 21 7/8 × 18. Private collection.

Paris
Cercle des Arts libéraux
23 April–25 May 1881

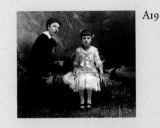

A19

A16

A20

A17

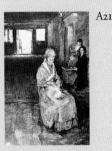

A21

Paris
Salon de 1881
2 May–20 June 1881

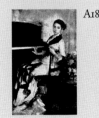

A18

United States

Great Britain

New York
Society of American Artists Third
 Annual Exhibition
17 March–16 April 1880

A13

Boston
St. Botolph Club Inaugural
 Exhibition
19 May–29 May 1880

A15

New York
Metropolitan Museum of Art,
 Inaugural Exhibition
April–October 1880

A14

New York
Society of American Artists
 Fourth Annual Exhibition
28 March–29 April 1881

A22

A23

Philadelphia
Works of American Artists
 Abroad: The Second
 Exhibition
8 November 1881–early January
 1882

A24

A25

1882

A26. *Portrait.* ♣ *Charles Edmond (Charles-Edmond Chojecki),* ca. 1882. Location unknown.

A27. *Portrait.* ♣? *Isabel Vallé,* 1882. 52 × 32. Private collection.

A28. *El Jaleo;—danse de Gitanes.* 2397 (of 2722 paintings). ♣ *El Jaleo,* 1882. 94 1/2 × 137. Isabella Stewart Gardner Museum, Boston.

A29. *Portrait de Mlle ***.* 2398 (of 2722 paintings). ♣ *Lady with the Rose (Charlotte Louise Burckhardt),* 1882 (cat. 22). 84 × 44 3/4. The Metropolitan Museum of Art.

A30. *Portraits d'enfants.* 95 (of 126 works). ♣ *The Daughters of Edward D. Boit,* 1882. 87 × 87. Courtesy Museum of Fine Arts, Boston.

A31. *Intérieur vénitien.* 96 (of 126 works). ♣?? *A Venetian Interior,* ca. 1882 (cat. 15). 19 1/8 × 24. Sterling and Francine Clark Art Institute, Williamstown, Mass. (Or A32 or A33?)

A32, A33. *Autre intérieur vénitien.* 97 (of 126 works). ♣?? *Venetian Interior,* 1882. 26 7/8 × 34 1/4. The Carnegie Museum of Art. Or ♣?? *The Sulphur Match,* 1882 (cat. 16). 23 × 16 1/4. Hugh and Marie Halff. (Or A31?)

A34. *Sortie d'église.* 98 (of 126 works). ♣ *Sortie de l'église, Campo San Canciano, Venice,* ca. 1882 (cat. 17). 22 × 32 1/2. Hugh and Marie Halff.

A35. *Une Rue à Venise.* 99 (of 126 works). ♣ *Street in Venice,* 1882 (cat. 18). Oil on wood, 17 3/4 × 21 1/4. National Gallery of Art, Washington, D.C.

A36. *Portrait de Mme A. J.* 100 (of 126 works). ♣ *Mme Allouard-Jouan,* ca. 1882 (cat. 24). 29 3/8 × 22 1/4. Musée du Petit Palais.

A37. *Pochade. Portrait de Vernon-Lée.* 101 (of 126 works). ♣ *Vernon Lee,* 1881. 21 1/8 × 17. Tate Gallery.

A38. *El Jaleo.* ♣ *El Jaleo,* 1882. 94 1/2 × 137. Isabella Stewart Gardner Museum, Boston.

A39. *El Jaleo.* ♣ *El Jaleo,* 1882. 94 1/2 × 137. Isabella Stewart Gardner Museum, Boston.

A40. *A Portrait.* 239 (of 861 paintings). ♣ *Dr. Pozzi at Home,* 1881 (cat. 21). 80 1/2 × 43 7/8. The Armand Hammer Collection, UCLA at the Armand Hammer Museum of Art and Cultural Center, Los Angeles, California.

A41. *Venetian Interior.* 135 (of 386 works; East Gallery). ♣? *Venetian Women in the Palazzo Rezzonico,* ca. 1880 (cat. 13). 17 3/4 × 25. Mr. and Mrs. Peter G. Terian. (Or A43?)

A42. *A Study.* 140 (of 386 works; East Gallery). ♣?? *Young Man in Reverie,* 1878 (inscribed 1876). 30 × 24. Private collection.

A43. *Venetian Interior.* 346 (of 386 works; Fourth Room). ♣?? *Venetian Bead Stringers,* ca. 1880 (cat. 14). 26 3/8 × 30 3/4. Albright-Knox Art Gallery, Buffalo, New York. (Or A41?)

A44. *Portrait of My Master, Carolus Duran.* 8 (of 14 paintings). ♣ *Carolus-Duran,* 1879 (cat. 4). 46 × 37 3/4. Sterling and Francine Clark Art Institute, Williamstown, Mass.

A45. *El Jaleo.* 9 (of 14 paintings). ♣ *El Jaleo,* 1882. 94 1/2 × 137. Isabella Stewart Gardner Museum, Boston.

A46. *A Portrait.* 10 (of 14 paintings). ♣ *Lady with the Rose (Charlotte Louise Burckhardt),* 1882 (cat. 22). 84 × 44 3/4. The Metropolitan Museum of Art.

France

Paris
Cercle des Arts libéraux
March–April 1882

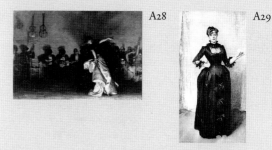

A26 A27

Paris
Salon de 1882
1 May–20 June 1882

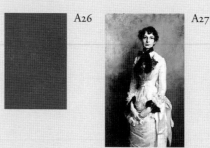

A28 A29

Paris
Société internationale de peintres et sculpteurs
20 December 1882–30 January 1883

A30 A31

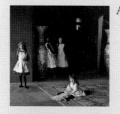

A32 A33 A34

A35 A36 A37

United States

New York
Schaus Gallery
7–17 October 1882

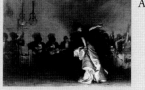

A38

Boston
Williams & Everett Gallery
22–29 October 1882

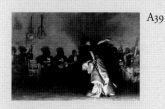

A39

Great Britain

London
Exhibition of the Royal Academy: The One Hundred and Fourteenth
1 May–7 August 1882

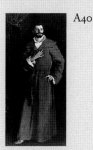

A40

London
Grosvenor Gallery
1 May–31 July 1882

A41

A42

A43

London
Fine Art Society, British and American Artists from the Paris Salon
July 1882

A44

A45

A46

1883

A47. *Conversation vénitienne.* 135 (of 173 works; owner: M. le docteur Pozzi). ♣? *Venetian Street*, ca. 1882 (cat. 19). 29 × 23 3/4. Collection of Rita and Daniel Fraad.

A48. *Portrait.* ♣ *Carolus-Duran*, 1879 (cat. 4). 46 × 37 3/4. Sterling and Francine Clark Art Institute, Williamstown, Mass.

A49. *Portraits d'enfants.* 2165 (of 2480 paintings). ♣ *The Daughters of Edward D. Boit*, 1882. 87 × 87. Courtesy Museum of Fine Arts, Boston.

A50. *Portrait of a Lady.* 103 (of 148 works). ♣ *Lady with the Rose (Charlotte Louise Burckhardt)*, 1882 (cat. 22). 84 × 44 3/4. The Metropolitan Museum of Art.

A51. *Portrait of a Lady.* 100 (of 144 works). ♣ *Lady with the Rose (Charlotte Louise Burckhardt)*, 1882 (cat. 22). 84 × 44 3/4. The Metropolitan Museum of Art.

A52. *Portrait of a Child.* 68 (owner: Mrs. Eleanor Jay Chapman). ♣ *Beatrix Chapman.* Destroyed during World War II.

A53. *Portrait of a Lady.* 50 (owner: Mrs. Eleanor Jay Chapman). ♣ *Eleanor Chapman.* 21 7/8 × 18. Private collection.

A54. ♣ *Edouard and Marie-Louise Pailleron*, 1881 (cat. 20). 60 × 69. Des Moines Art Center.

France

Paris
Cercle de l'Union artistique
6 February–12 March 1883

A47

Paris
Ecole des beaux-arts: Portraits du siècle
25 April–30 May 1883

A48

Paris
Salon de 1883
1 May–20 June 1883

A49

1884

A55. *Portrait de Mme la vicomtesse de Saint-P.* ♣ *La vicomtesse de Poilloüe de Saint-Périer (née Jeanne de Kergorlay)*, 1883. 51 1/2 × 37. Musée d'Orsay, Paris; on deposit at the Musée national de la Coopération franco-américaine, Château de Blérancourt.

A56. *Portrait de Mme ***.* 2150 (of 2488 paintings). ♣ *Madame X (Virginie Avegno Gautreau)*, 1884 (cat. 26). 82 1/8 × 43 1/4. The Metropolitan Museum of Art.

A57. *Mrs. H. White.* 788 (of 931 paintings). ♣ *Mrs. Henry White*, 1883. 87 × 55. The Corcoran Gallery of Art.

A58. *Portrait of Mrs. T. W. Legh.* 203 (of 431 works; East Gallery). ♣ *Mrs. T. W. Legh*, 1884. 47 × 37. Private collection.

A59. *Portrait.* One of 112 works. ♣ *Dr. Pozzi at Home*, 1881 (cat. 21). 80 1/2 × 43 7/8. Armand Hammer Collection, UCLA at the Armand Hammer Museum of Art and Cultural Center, Los Angeles, California.

A60. ♣ *The Bead Stringers of Venice*, ca. 1882. 22 1/8 × 32 1/4. National Gallery of Ireland.

Paris
Cercle de l'Union artistique
February–10 March 1884

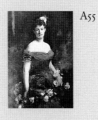
A55

Paris
Salon de 1884
1 May–20 June 1884

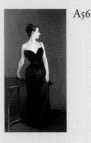
A56

United States

Great Britain ### Other

New York
Society of American Artists Sixth
 Annual Exhibition
26 March–28 April 1883

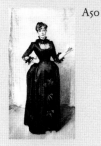

A50

Boston
Society of American Artists Sixth
 Annual Exhibition (at the
 Museum of Fine Arts)
7 May–3 June 1883

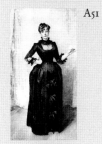

A51

Boston
Museum of Fine Arts, Fourth
 Annual Exhibition of
 Contemporary Art
16 October–27 November 1883

A52

A53

London
Fine Art Society
July 1883

A54

London
Exhibition of the Royal
 Academy: The One
 Hundred and Sixteenth
5 May–4 August 1884

A57

London
Grosvenor Gallery
May 1884

A58

Brussels
Les XX
2 February–2 March 1884

A59

Dublin
Dublin Sketching Club,
 Annual Exhibition of
 Sketches, Pictures, and
 Photography
1 December 1884

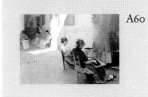

A60

A61. *Portrait de Mme T. L.* 126 (of 164 works; owner: M. T. L.). ♣ *Mrs. T. W. Legh,* 1884. 47 × 37. Private collection.

A62. *Portrait de Mme V . . .* 2191 (of 2488 paintings). ♣ *Mrs. Albert Vickers,* 1884 (cat. 28). 82 × 39. Virginia Museum of Fine Arts.

A63. *Portraits des Misses* ***. 2192 (of 2488 paintings). ♣ *The Misses Vickers,* 1884. 54 1/4 × 72. Sheffield City Art Galleries.

A64. *Portrait de Mme. W.* 97 (of 114 works). ♣ *Mrs. Henry White,* 1883. 87 × 55. The Corcoran Gallery of Art.

A65. *Portrait de M. Rodin.* 98 (of 114 works). ♣ *Auguste Rodin,* 1884 (cat. 25). 28 3/4 × 20 7/8. Musée Rodin.

A66. *Le verre de Porto (Esquisse).* 99 (of 114 works). ♣ *A Dinner Table at Night (The Glass of Claret),* 1884 (cat. 29). 20 1/4 × 26 1/4. Fine Arts Museums of San Francisco.

A67. *Portrait de Mme W.* 100 (of 114 works). ♣? *Mrs. Henry White,* 1884. Presumed destroyed during World War II.

A68. *Portrait.* ♣ *Edith, Lady Playfair (Edith Russell),* 1884 (cat. 27). 59 × 38. Courtesy Museum of Fine Arts, Boston.

A69. *Lady Playfair.* 586 (of 1160 paintings). ♣ *Edith, Lady Playfair (Edith Russell),* 1884 (cat. 27). 59 × 38. Courtesy Museum of Fine Arts, Boston.

A70. *Portrait of Mrs. Mason.* 32 (of 418 works; West Gallery). ♣ *Mrs. Alice Mason,* 1885. 61 × 41. Private collection.

A70a. *Portrait de Madame ?...* 169. ♣ unidentified.

A70b. *Portrait de Monsieur X .* 170. ♣ unidentified.

France

1885

Paris
Cercle de l'Union artistique
2 February–9 March 1885

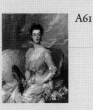
A61

Paris
Salon de 1885
1 May–30 June 1885

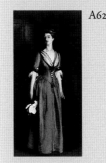
A62

A63

Paris
Galerie Georges Petit
Exposition internationale de peinture
15 May–June 1885

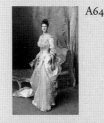
A64

A65

A66

A67

United States

Boston
Williams & Everett Gallery
September 1885

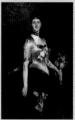

A68

Great Britain

London
Exhibition of the Royal
Academy: The One
Hundred and
Seventeenth
4 May–3 August 1885

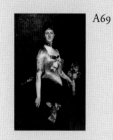

A69

London
Grosvenor Gallery
May 1885

A70

Other

Geneva
Musée Rath, Salon suisse
des beaux-arts et des
arts décoratifs de la
vie de Genève
18 August–18 September 1885

A70a

A70b

A71. **Portraits de Mme et de Mlle B . . .** 2128 (of 2488 paintings). ⚘ *Mrs. Edward Burckhardt and Her Daughter Louise*, 1885 (cat. 32). 79 1/4 × 56 1/2. Private collection.

A72. **Portrait of a Lady.** 95 (of 121 works; owner: Wm. Butler Duncan, New York). ⚘ *Mrs. Wilton Phipps*, ca. 1884. 35 × 25 1/2. Private collection.

A73. **Portrait.** 96 (of 121 works; owner: John W. Field, Washington). ⚘ *Mr. and Mrs. John White Field*, 1882 (cat. 23). 44 × 33. Museum of American Art of the Pennsylvania Academy of the Fine Arts, Philadelphia.

A74. **Portrait of Mrs. Barnard.** 17 (of 58 works). ⚘ *Mrs. Frederick Barnard*, 1885. 41 × 22 1/2. Tate Gallery.

A75. **A Study.** 37 (of 58 works). ⚘? *A Dinner Table at Night (The Glass of Claret)*, 1884 (cat. 29). 20 1/4 × 26 1/4. Fine Arts Museums of San Francisco.

A76. **Mrs. Harrison.** 78 (of 1111 paintings). ⚘ *Mrs. Robert Harrison*, 1886. 61 1/2 × 31. Private collection.

A77. **Mrs. Vickers.** 195 (of 1111 paintings). ⚘ *Mrs. Albert Vickers*, 1884 (cat. 28). 82 × 39. Virginia Museum of Fine Arts.

A78. **The Misses Vickers.** 709 (of 1111 paintings). ⚘ *The Misses Vickers*, 1884. 54 1/4 × 72. Sheffield City Art Galleries.

A79. **A Study.** 14 (of 378 works; West Gallery). ⚘? *Edith, Lady Playfair (Edith Russell)*, ca. 1885. 26 1/2 × 17 1/2. Private collection.

1886

France

Paris
Salon de 1886
1 May–30 June 1886

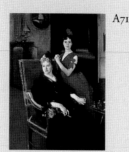

A71

United States

New York
Society of American Artists Ninth Annual Exhibition
May–October 1886

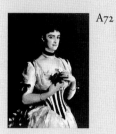 A72 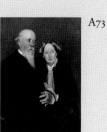 A73

Great Britain

London
New English Art Club
April 1886

 A74 A75

London
Exhibition of the Royal Academy: The One Hundred and Eighteenth
3 May–2 August 1886

 A76 A77

 A78

London
Grosvenor Gallery
May 1886

 A79

1887

France

A80. **Portrait R. L. Stevenson.** 21 (of 58 paintings). ❧ *Robert Louis Stevenson,* 1887 (cat. 31). 20 1/8 × 24 3/8. The Taft Museum, Cincinnati, Ohio.

A81. **Portrait.** 51 (of 58 paintings). ❧?? *Sally Fairchild,* 1885. 26 1/4 × 20 3/4. Private collection.

A82. **Portrait of a Lady.** 55. ❧ *Mrs. Cecil Wade (Frances Frew Wade),* 1886 (cat. 33). 66 × 54 1/4. The Nelson-Atkins Museum of Art, Kansas City, Missouri.

A83. **Portrait of Robert Louis Stevenson and Mrs. Stevenson. A Sketch.** 84. ❧ *Mr. and Mrs. Robert Louis Stevenson,* 1885 (cat. 30). 20 1/2 × 24 1/2. Collection of Mrs. John Hay Whitney.

A84. **Mrs. William Playfair.** 197 (of 1052 paintings). ❧ *Mrs. William Playfair,* 1887 (cat. 34). 60 1/2 × 39. Collection of Mr. and Mrs. Harry Spiro.

A85. **"Carnation, lily, lily, rose."** 359 (of 1052 paintings). ❧ *Carnation, Lily, Lily, Rose,* 1887 (cat. 35). 68 1/2 × 60 1/2. Tate Gallery, Presented by the Trustees of the Chantrey Bequest, 1887.

A86. **"Carnation lily, lily rose."** 213. ❧ *Carnation, Lily, Lily, Rose,* 1887 (cat. 35). 68 1/2 × 60 1/2. Tate Gallery, Presented by the Trustees of the Chantrey Bequest, 1887.

United States

Boston
St. Botolph Club, Loan Exhibition 1887
October 1887

 A80 A81

Great Britain

London
New English Art Club
April 1887

 A82 A83

London
Exhibition of the Royal Academy: The One Hundred and Nineteenth
2 May–1 August 1887

 A84 A85

Liverpool
Walker Art Gallery, Seventeenth Autumn Exhibition of Pictures in Oil and
 Water-Colours
5 September–3 December 1887

 A86

Index

Photo Credits

fig. 2. © Photo RMN

fig. 4. © Photo RMN — J. G. Berizzo/R. G. Ojeda

fig. 5. © Photo RMN

fig. 7. © Photothèque des Musées de la Ville de Paris

fig. 16, A18. Reproduced from Richard Ormond, *John Singer Sargent: Paintings, Drawings, Watercolours* (London: Phaidon Press, 1970), fig. 16.

fig. 21, A63, A78. Bridgeman Art Library, London.

cat. 7, A7. Courtesy Sotheby's

cat. 18, A35. © 1996 Board of Trustees, National Gallery of Art, Washington, D.C.

cat. 24, A36. © Photothèque des Musées de la Ville de Paris

cat. 28, A62, A77. Ron Jennings, ©1992 Virginia Museum of Fine Arts

cat. 30, A83. Jim Strong, Inc., NY

A25, A53. Adelson Galleries, Inc., New York

A42. © Sotheby's, Inc.

A79. Reproduced from Frederick A. Sweet, *Sargent, Whistler, and Mary Cassatt*, exh. cat. (Chicago: Art Institute of Chicago, 1954), fig. 54.

A81. Courtesy Sotheby's